·THE·
MATERIALS AND TECHNIQUES OF
PAINTING

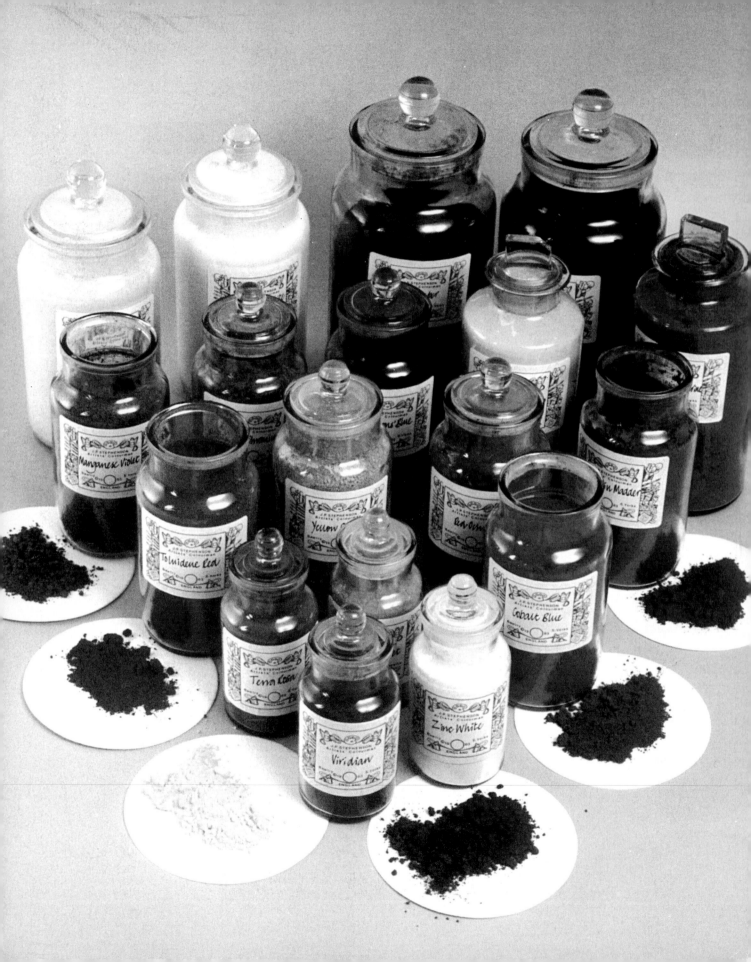

THE
MATERIALS AND TECHNIQUES OF
PAINTING

JONATHAN STEPHENSON

THAMES AND HUDSON

A note on health and safety

Painting cannot be described as dangerous, but it does involve the use of many materials that are a potential threat to the health and safety of the individual. Since the quantities employed are usually small the risks are not great, but they can be substantially increased by too casual an attitude on the part of the painter. It is important to limit direct physical contact with all artists' materials and to avoid taking them into the body by inhalation, ingestion or through the skin. Never eat, drink or smoke when painting or preparing artists' materials and always observe high standards of hygiene. Ensure adequate ventilation and wear protective clothing in appropriate circumstances. Keep artists' materials away from children.

All comments in this book on the toxicity of pigments and on the risks associated with artists' materials are intended for general guidance only. They assume the use of modest quantities, in a sensible fashion, within the normal context of painting. Different considerations may apply if large amounts are handled on a regular basis. In any event, expert opinion and the regulations of different countries do not always agree on such matters and it is difficult to make absolute pronouncements about health and safety in all circumstances. Painters should consult the sources indicated in the *Guide to further information* on p. 188 if they are in any doubt.

For Tricia, Amy and Sophie

© 1989 Thames and Hudson Ltd, London
First paperback edition 1993

Printed and bound in Spain by Artes Gráficas Toledo, S.A.
D.L.TO. 622–1992

Contents

How to use this book

Concerned with matters of fact and practice, rather than with artistic theories or aesthetic considerations, this book contains a body of knowledge that represents the science of the art of painting. It is designed to be read in a variety of ways, and you can use it either as a practical manual or as a reference tool.

As a textbook If read *continuously* from beginning to end, it presents painting as a single subject, thereby offering the greatest insight into the subject and showing the relationship between materials and techniques.

As a painting manual Alternatively, the book can be read *selectively*, using the Contents and Index as a guide. The different media can be considered separately, while any area of the text that is of special personal interest can be read either independently or in conjunction with related subject matter. Read in this fashion, the book yields valuable practical information that can be employed without any deep appreciation of the wider principles involved.

As a reference guide For all users, the information and guidance given stands as a permanent reference. Specific data can be extracted to inform, to remind, or to provide background knowledge that is of practical use. Here again the Contents and Index are designed to be of assistance, together with the systematic use of cross-references.

The Golden Key

Begin by reading the short introduction, which explains both the historical background and the contemporary circumstances of painting. Its purpose is to establish the context of the text that follows and to define its relevance for the individual.

Part 1

Next look at the Contents for Part 1, which is concerned exclusively with the *materials* and *equipment* of painting. In each section materials are grouped together according to the function that they perform. They are dealt with in sufficient detail to enable identification, assessment of quality and appropriate or efficient use. Painters using only readily available materials and equipment will find all they need here, but Part 1 also contains recipes and instructions for the preparation of artists' materials. A full understanding of the performance of materials, as well as the degree of control over them that is required by some painting techniques, can sometimes only be gained by such practical exercises. The recipes offer an alternative to commercially prepared materials and invite an individual approach in which the subtleties of particular materials can be exploited.

Part 2

Now run down the Contents of Part 2, which is concerned with painting *techniques*. Its opening sections deal with methods and technical principles that can be applied to a whole range of materials. Most of Part 2 is given over to fully illustrated and plainly expressed step-by-step descriptions of a comprehensive series of painting techniques. The purpose is not only to demonstrate the techniques themselves, but also to show how they are dependent on a knowledge of the materials employed and on the general principles that apply to their use. Armed with the complete picture you will be in the perfect position to achieve your objectives.

For the care and preservation of your finished painting, turn to the reference section beginning on p.184, which includes a Guide to further information and a full Index.

Glossary

Alla prima Technique by which the painter seeks to achieve the final effect at a single sitting, generally by applying opaque paint in a single layer.

Binder Ingredient of paints, pastels and grounds (such as gum, oil etc.) that holds the materials together and, in most instances, helps them to adhere to surfaces.

Bloom Bluish or whitish cast that appears on the surface of a varnish or layer of paint, partially obscuring what lies beneath.

Body Vague term referring to the solidity or physical presence of a pigment, medium or application of paint. A lightweight transparent pigment is said to have little body, whilst a thick liquid, such as stand oil, is said to be well-bodied. Body colour is paint that is opaque, either because of the density of its application or, more often, because it contains an addition of white.

Bole A coloured, usually red-brown, clay. A bole or bolus ground is one that contains either a natural bole or pigments with a similar colouring.

Broken colour When a trace of one colour is added to a large amount of another colour in order to move it slightly away from its original value. The term may also be applied loosely to any colour mixture where a powerful pigment, such as black, is added in small amounts, and to the effect of placing colours next to one another, so that one colour is visually modified by the presence of the other.

Cartoon Drawing of the same size as the finished picture, often worked out in full detail, and used to transfer the preliminary drawing to the support.

Chiaroscuro From the Italian, 'light-dark', this term refers to the handling of light and shade in a picture.

Covering power The ability of a paint to obscure what lies beneath it, or to extend over a surface.

Craquelure Characteristic pattern of tiny cracks that can appear on paintings as they age. This sometimes occurs naturally, but may also be caused by bad technique.

Dead colouring Specifically, this refers to the flat, 'dead' effect that results when oil paint is allowed to dry on a semi-absorbent ground; as this seals the ground, subsequent paint layers retain their medium and have more 'life'. The term is also used more loosely to describe any preliminary layer of paint applied as a foundation and guide for subsequent layers.

Dryer A siccative metal or metal salt that speeds up the drying rate of drying oils. The term also refers to an oil prepared with a dryer, and to any painting medium that accelerates the drying of oil colour.

Encaustic Type of paint that employs wax as a binding medium, and a method of painting with wax, where heat is used to liquefy the colour and drive it into the ground.

Extender A substance added to paint in order to reduce its pigment content, and so lower its cost. Extenders may be solid substances (*see* **Fillers**, *below*), or thickening agents.

Fat Broad term referring to the richness, greasiness or oiliness of a paint, painting medium, ground or priming. When an oil ground is referred to as 'fat', it is non-absorbent and has a slick, smooth surface. Fat need not refer only to oil-based materials, though the terms 'rich' and 'non-absorbent' are more likely to be used where other media are concerned.

Fat over lean The technique of making oil colour increasingly fat as more and more paint layers are applied, in order to avoid sinking in and cracking.

Filler Pigment-like material, usually white in colour (e.g., chalk), that has a very low tinting strength, allowing it to be used to extend pigments without much effect on the overall colour. In grounds, fillers are used to smooth out irregularities in a support, and may also provide tooth and absorbency.

Final (picture) varnish A protective layer of varnish applied to completed paintings when they are thoroughly dry.

Gesso Historically, a white filler made of gypsum. *Gesso grosso* is coarse plaster of Paris, while *gesso sottile* is a silky-smooth version of the product made by slaking plaster with water. The name is also applied to grounds composed of gypsum and glue, and in common usage it has come to mean any white, absorbent ground containing chalk or clay instead of gypsum.

Glair Watercolour medium made from egg-white.

Glaze A transparent layer of colour that allows whatever is beneath it to remain visible. Paints made with naturally transparent pigments are often referred to as glazing colours.

Gouache An opaque watercolour usually bound with gum, though any water-based paints can be used as a body colour simply by adding white.

Ground A foundation layer that acts as a barrier between the support and the painting, and makes the surface of the support more suitable for painting on. The term is also used to mean underpainting or dead colouring, especially where a painting is carried out on a coloured priming, and separate 'grounds' are laid for different colours.

Impasto A thick application of paint that stands above the painting surface, generally confined to oil or acrylic painting.

Intermediate varnish A thin layer of varnish or medium applied between layers of paint as a barrier, or to provide a key. The term may also refer to a temporary final varnish.

Isolating varnish A thin, colourless layer of varnish or medium that creates a barrier between different materials within a painting. For example, an absorbent ground may be isolated before it is painted on with oil colour, and tempera may be isolated before being glazed with oil. Historically, isolating varnishes were used to 'lock up' sensitive colours so that they could not be affected by surrounding colours or by the atmosphere. This is unnecessary with modern pigments.

Lay A stage in the painting process that represents a session of work or a single step in a sequenced technique. The first lay is roughly equivalent to dead colouring, and the exact nature and number of the lays depends on the technique. It is a convenient way of referring to the various stages in a continuous technique that cannot easily be divided into identifiable steps, such as underpainting, glazing etc.

Lean Quality of paints, media and grounds that is the opposite of 'fat'. The meaning is imprecise, but implies a low concentration of binding medium, a degree of absorbency and an absence of greasiness or richness. Lean may also imply a low adhesive strength and a dilute consistency.

Local colour The inherent colour of an object when unmodified by light and shade or other colours nearby.

Medium A substance, such as oil or gum, mixed with pigment to form paint (i.e., a binder). The term also refers to concoctions added to paint in order to modify its handling properties and finish, and to make it suitable for a particular painting method (i.e., a painting medium or vehicle).

Oiling out Rich, hard-drying paints and media will not accept further paint layers unless they are provided with a key. This is achieved by coating the dry colour with a thin application of oil before more paint is applied.

Optical mixture Colours produced by visual blending rather than by direct mixing. For example, by placing a coloured glaze over an underpainting of another colour, a third colour is created that has not actually been painted; a similar effect can be achieved by painting broken areas of colour in close proximity. Too many opposing colours combined in this way can result in an optical grey, which – though useful for creating neutral shadows – is not always desirable.

Permanence In relation to painters' materials, this refers to any changes that could affect the final image: their degree of lightfastness and chemical and physical stability, their tendency to crack or change colour.

Pounce To press powdered charcoal through the holes in a cartoon, in order to transfer the drawing onto the ground.

Priming (or *imprimatura*) A layer of paint, size or medium applied to a ground before it is painted on; it acts as an isolating medium and may modify both the absorbency and colour of the ground. The term is also used for a wash of colour placed over a white ground to reduce its brightness.

Retouching To apply the final highlights and accents to an otherwise finished painting, or to alter parts of it slightly.

Saturation A colour is said to be saturated when it is fully enclosed in medium and appears rich and glowing as a result. Generally, saturated colour means strong colour and implies the use of pure colours as opposed to shades and tints.

Scumble A half-covering layer of opaque paint. Scumbles may be thick, random applications of impasto or thin, veil-like coverings of stippled paint.

Shade A mixed colour that is lower in tone than its parent colour, usually achieved by breaking the latter with black.

Sinking in A dulling of oil paint during drying, leading to a loss of colour and an uneven finish. It is usually caused by an absorbent lower layer or the excessive use of thiners, though some pigments have a natural tendency to sink. It can be avoided by skilful use of painting media.

Size A weak solution of any form of glue (usually animal glue or gelatine) used to consolidate and impregnate the surface of a support, acting as a stabilizer, a protective layer and as a means of controlling absorbency.

Staining A technique particularly associated with acrylics, carried out on unprimed cloth, where the colour penetrates the fabric and creates a stain. Pigments that penetrate the ground and are difficult to remove are known as staining colours.

Stipple To apply a series of dots by dabbing with the end of the brush held at right angles to the picture surface.

Temper To mix pigment and medium to make paint; also, to mix paint with a painting medium or to work colours together. Tempering implies a thorough mixing, resulting in a very even consistency. Tempera is therefore any paint made by tempering, but the term now refers to an ill-defined group of water-based paints that use natural proteins such as egg, gum and animal glue as a binder. It generally refers to egg tempera.

Thinner (or diluent) A volatile solvent introduced to paint or painting media in order to reduce their consistency. On drying, it passes off, leaving the composition of the paint or medium unaltered.

Tint The opposite of a shade. A mixed colour that is lighter than the parent colour, especially one that is extremely pale; tints are usually obtained by adding white. The term is also used loosely to mean any mixed colour, especially a broken colour.

Tooth The surface texture of a support or ground that helps paint to adhere.

Underpainting Loosely, a form of dead colouring. True underpainting involves a deliberate sequence of painting in the lower layers of a work, which presupposes later steps that will bring about the desired visual result; for example, underpainting in one colour can be combined with different-coloured glazes to create optical mixtures.

Varnish Spirit varnishes, or ethereal varnishes, are solutions of resin in a solvent. They may also be called removable varnishes, as they can be cleaned away with solvent after they have dried. These varnishes may be used as a final picture varnish or as an ingredient in painting media. Oil varnishes – where resin is dissolved in a drying oil – are non-removable when dry. They are not recommended as final varnishes and are more important in painting media. Solutions of wax in spirit are also known as varnishes, and the term is sometimes used for qualities of drying oil that contain no resin whatsoever.

Wet in wet Painting into a colour layer that is still wet, so that the fresh colour can be worked with the existing paint.

Wet over dry Painting onto a dry paint layer, so that the fresh colour does not disturb the lower layers.

The Golden Key

Since the 18th century, many painters have been obsessed with the idea of a Golden Key – that is, a piece of knowledge, a formula or technical trick that would unravel the mysteries of the art of painting. A succession of artists, authors, historians and manufacturers have each, in their turn, claimed discovery of some supposed key that would unlock the secrets of painting so that it could be mastered effortlessly. None of the ideas put forward have wholly withstood the test of time; many have turned out to be little more than wishful thinking, while others have at best provided partial answers. Yet the idea persists and painters still seek a simple solution.

The answer is, of course, that there is no such thing. No materials, no secret recipe, no single piece of knowledge, can overcome a lack of technique or understanding. The true Golden Key is the possession of a complete body of information on materials and techniques that must be acquired at least in part before the secrets of the art of painting are revealed.

The reasons why so few painters today are possessed of this knowledge are many and complex. In recent times it has simply been unfashionable to 'know' how to paint, and knowledge about materials and techniques has been dismissed as unnecessary for the creative process and therefore irrelevant. This view has not been shared by the majority of practising painters, but it has played its part in conspiring to separate painters from an important aspect of their activities.

A workshop tradition

The painter working in isolation and developing a uniquely personal style is a modern concept. Until the close of the 18th century successful painters ran businesses in which methods of production, quality control and sales to customers were often very highly organized. In Medieval times and during the Renaissance these were conducted in places that were literally workshops, usually rooms on the ground floor of a building that could be opened onto the street by means of shutters or doors, thus acting as both a shop and a studio. Painting was carried out in these workshops as a commercial venture, equivalent to a modern trade or profession. Although there was clearly some scope for creativity and originality, it was confined within certain limits, and the emphasis was on craftsmanship and a mastery of materials that would bring about the desired quality of product. Such workshops belonged to masters who, if successful, would employ assistants and keep apprentices. Everything relevant to the production of paintings, from extracting pigments to laying on a varnish, would form part of the workshop's activities, and this body of accumulated knowledge would be passed on from master to pupil. As painters' studios developed, each new generation of painters carried with them not only their own experience, but also that gained by a long line of predecessors. The classic example is furnished by Cennini, who states that he received his instruction from Agnolo Gaddi, who had received his from his father, Taddeo Gaddi, who in turn had been taught by Giotto; and Giotto himself may well have been taught by Cimabue.

By the 16th century the more successful studios, like those of Titian and Raphael, for example, must have been effectively painting factories. They produced vast amounts of work, often on a large scale, a substantial part of which would be done by assistants. Large studios continued into the next century with painters like Rubens and Van Dyck, but at some stage during the 17th century the system began to break down. There was a

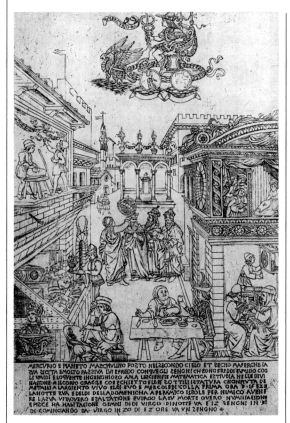

An engraving by the Master of the Planets (c.1460–65), showing the activities inspired by Mercury, of which one is painting. A metalwork shop open to the street can be seen, bottom left, and above, painters are shown executing a mural.

It was accepted practice for masters to employ a team of assistants to execute sections of their works. In this Baptism *by Verrocchio (c.1435–88), Leonardo is said to have painted one of the angels, and Vasari claims that Verrocchio was so impressed by the skill of his talented apprentice that he ceased to paint thereafter.*

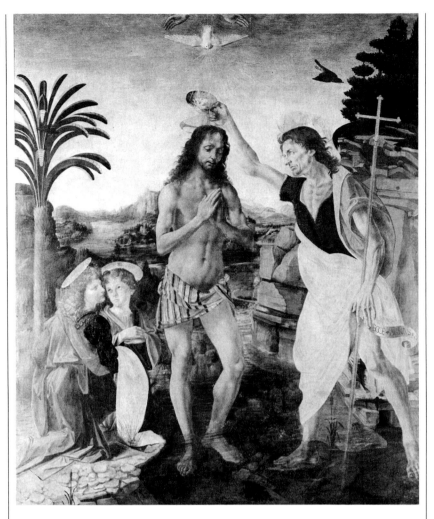

discernible decline in technical excellence, and painting methods became more abbreviated. Van Dyck appears to have been aware that this was happening, and some remarks attributed to him apparently censure his fellow painters for shortcutting on traditional techniques. At the same time, in his definition of a master painter he implies that such masters are few in number and that artists generally are straying from the basic technical principles of painting.

It is hardly surprising, then, that Thomas Bardwell, writing in the mid-18th century, states that the methods of Rubens and Van Dyck and of painters such as Titian and Rembrandt are lost to his generation. In contrast with Cennini, who can trace his knowledge through a series of masters spanning more than a century, Bardwell remarks: 'If we have no certain knowledge of their method of colouring who lived in the last century, how should we understand theirs who lived 2000 years ago? And why the method and practice of colouring which was so well known to Rubens and Van Dyck should not be continued down to the present masters is to me surprising.'

The status of artists

By the 18th century painting was still regarded primarily as a trade. Titian, Rubens, Van Dyck and many other painters had achieved personal success in terms of wealth and an elevation in status, however, and although this was uncomfortable socially, it confirmed that a higher standing was possible. In addition to material success, there was an

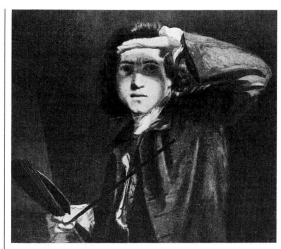

Sir Joshua Reynolds (1723–92), founder member and first President of the Royal Academy, did much to raise the status of artists in England. Although he enjoyed great success as a portrait painter, his works were often executed using bad technical procedures, and many were returned within his lifetime, because of faults.

During the 18th century, the studios of individual masters were gradually replaced as the training grounds for young artists by the more institutionalized framework of the Academies. The Drawing Academy, by Miguel-Angel Houasse (1680–1730), shows a typical life-drawing class in progress at the Madrid Academy.

increasing acceptance of the role of creativity in art; the recognition of personal genius, which was reserved at first for major talents, became something that all painters aspired to. Intellectualizing art in this way offered a socially acceptable route to greater status for painters as a class.

The changing status of artists can be demonstrated as a trend rather than as a simple sequence of events. A landmark was the Copyright Act of 1735, instigated by the painter Hogarth and sometimes referred to as Hogarth's Act. In recognizing copyright, the intellectual content of art was formally acknowledged and the scene was set for the final assault on the social barriers that denied artists the standing and recognition that they felt they deserved.

In Britain the process was completed by Sir Joshua Reynolds. Reynolds was successful, and his painting, though theatrical to our eyes, demonstrated to his contemporaries a scholarly approach. As first President of the Royal Academy he had a major influence on painting at the end of the 18th century, and the concept of the artist that he helped to promote has remained dominant ever since. A similar process occurred elsewhere in Europe, and the artist became universally accepted as an intellectual. This new-found status was not without its drawbacks, however. In order to separate painting from its trade connotations, any remaining links with the workshop tradition had to be severed. Painters were forced to turn their backs, at least publicly, on the practical side of their activities, denying the existence of manual labour in the creative process. It is interesting to note that Reynolds was an appalling painter technically. He used materials unwisely and recklessly, often with disastrous results. Privately, however, he was obsessed with the techniques of the Old Masters and even cleaned away a Caravaggio to nothing in an attempt to find out how it was done. His successor as President of the Royal Academy, the American artist Benjamin West, was obsessed with a supposed secret of the Venetian masters, while his own use of paint was distinctly lacking in sophistication.

Consequent and coincident changes

The accelerating social and economic changes of the 17th and 18th centuries, which reached a climax in the industrialization of the 19th century, were not without consequence for the artistic world. With the rise of the middle class, painters found a

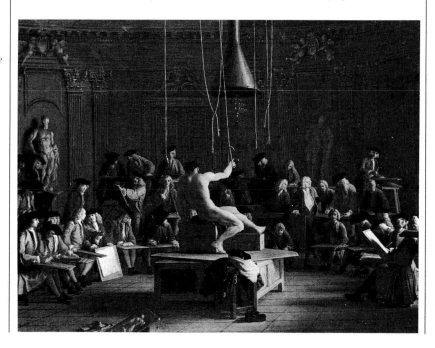

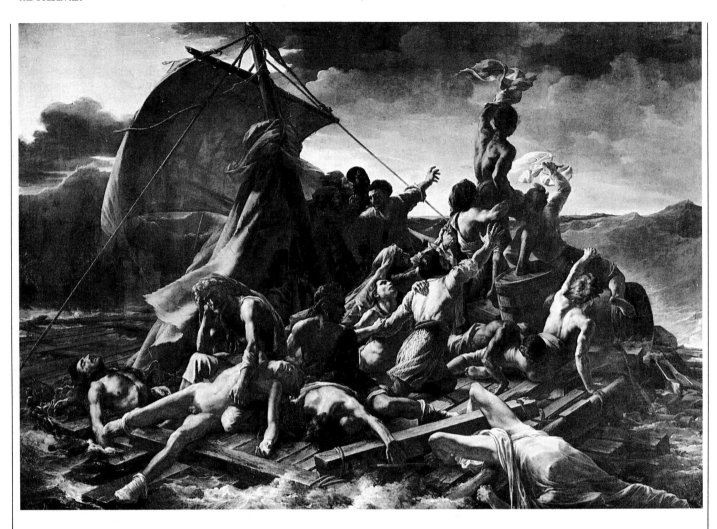

Théodore Géricault (1791–1824) reacted strongly against traditional training methods and current academic techniques – as did many artists of the Romantic period. He pursued a wholly personal vision in both style and subject matter, in spite of the lack of recognition he received within his own lifetime. His Raft of the 'Medusa' *caused a scandal when it appeared in 1819.*

vast expansion in the market for their works; art came to be exploited as a symbol of wealth and social status through which the new class could consolidate its position. This new source of demand did nothing to encourage excellence, however, as all that was required to satisfy the mass-market taste was a relatively bland standard product that could be made available in quantity.

To preserve their integrity and to protect their art from contamination by the vulgar concerns of the marketplace, artists tended to withdraw into an 'ivory tower', adding further impetus to the intellectualization of art. In order to raise their work above the level of bourgeois trinkets, painters encouraged the concept of the artist as a member of an exclusive elite: to appreciate or create art was something more than the mere ability to purchase it. Popularity and financial success became signs of weakness, and originality became the hallmark of true talent.

The increasing gulf between art as intellectual activity and commercial production had unfortunate side-effects. In seeking to dissociate themselves from the humble practicalities of their trade, painters contributed to the downfall of the supportive traditional system of artistic production, thereby increasing their own isolation; the ivory tower could also become a prison. As creative theory became more important than practical skills, art was left struggling to regain a clear sense of direction.

The 19th century also witnessed the growth of amateur painting – after all, if painters could achieve high status through their activities, there could be no shame attached to those who adopted painting as a pastime. The distinction between professional painter and gifted amateur became increasingly blurred, until such categories were virtually

meaningless. Many untrained painters have since been recognized as major artists; indeed, with today's overriding concern for originality, a lack of training and the denial of tradition are distinct advantages.

This search for the new has sent art in rewarding new directions, encouraging painters to experiment with new materials and ideas. But it has also meant that they now find themselves cut off from the body of traditional knowledge that ought, by rights, to form their heritage.

Artists' materials

Another factor that added fuel to these developments and contributed to the loss of the Golden Key was an alteration in the way that artists' materials were prepared, leading to changes in many of the materials themselves and in the ways in which they were employed.

Artists' materials were originally prepared within the studio. Although the materials were of a common type, each master probably had his own variants suited to his particular technique. Some of the raw ingredients may have been available in an extracted form, but further work was generally required to convert them into a usable state. Recipes such as those of Cennini suggest that pigments were often refined by the painters themselves, though there are also references – including one attributed to Michelangelo – to apothecaries as suppliers of colours. Painters were also connected with doctors through their patron saint, St Luke, and it is possible that the English Guilds of St Luke represented both professions. Some painting materials were even employed for medicinal purposes, which explains the detailed interest of the doctor Theodore de Mayerne in the materials and techniques of painters such as Rubens, Van Dyck and Mytens, with whom he was acquainted. Up until the 17th century there are also frequent suggestions of a link between painting and alchemy, which indicates that painting was originally closely linked with science, and that its materials were understood in as much detail as was possible for the time.

At first, painters may have sold and exchanged their surplus materials, and apothecaries, cloth merchants and brushmakers may also have supplied some ready-made products. This gradually developed into a trade: that of the artists' colourman. There were certainly professional primers of canvas in the 17th century, and by the 1680s prepared oil colour was readily available. Artists continued to prepare many of their own materials until well into the 18th century, however, and at first the commercial products probably did not differ greatly from their own. But as the trade of the artists' colourman developed into a manufacturing business, painters gradually lost technical knowledge, until neither party was able to assess the quality or suitability of increasingly standardized products. Painters no longer understood their materials and techniques in depth, and the colourman no longer acted under the supervision and with the advice of knowledgeable painters; each blamed the other for the declining quality of painting. By the end of the 18th century, the situation had degenerated to such an extent – in Britain, at least – that some form of official control was being demanded over the standard of artists' materials.

The colourman continued to flourish, of course – no doubt supported by the amateur market. From 1804 Rawlinson's hand-operated colour mill made it possible to mechanize paint production, resulting in a further increase in output, and by 1841, when mechanical grinding was combined with the collapsible metal tube, there was no longer any incentive for the average painter to become involved in the preparation of materials.

With these technical developments the nature of many materials began to change. The production methods and commercial considerations of the manufacturers were not those of the painter's workshop. Fresh, hand-ground oil colour, for example, handles fluidly and can easily be used in either a transparent or opaque manner; machine-ground colour, on the other hand, is inclined to be more opaque and must be stiff in order to give it a longer shelf life. This too had its consequences, as painters

adapted their techniques to suit the new generation of materials. It would be wrong to be entirely critical of the colourman's trade, however, as it has brought great benefits to many painters, not least because it has made the practice of painting available on a much wider scale. It has also perfected certain traditional materials, such as watercolours, and introduced entirely new ones, such as acrylics, helping art to develop in new directions. If, as some maintain, commercially produced materials are lacking in some respects, then the fault perhaps lies more with the painter than with the colourman, for it is the artist who creates the demand that manufacturers seek to supply.

Lost secrets and new directions

As the 19th century dawned, painters became acutely aware of the extent to which traditional knowledge had been lost. Some responded with an obsessive search for the secrets of the Old Masters, experimenting with all sorts of concoctions. The more successful products offered by colourmen rapidly assumed the supposed authority of tradition, in spite of their doubtful origins, and some highly unsuitable materials came into general use. Other painters responded by apportioning blame. Some accused the colourmen, whilst others named convenient scapegoats: the leading 18th-century portrait painter Sir Godfrey Kneller was an obvious target in Britain, while in France, Delacroix, amongst others, denounced David. The debate was never resolved and its legacy remains to this day.

Some authorities raised the real issue, which was the inadequate training and lack of skill of the painting profession, but the will and ability to correct that situation were lacking. Circumstances were further aggravated by the rigid and backward-looking attitudes of the Academists, who encouraged a style and method of painting for which they could offer no sound practical instruction. As they could offer no solution, painters began to react against their arbitrary and impotent authority. Painters who preferred to see art as an intellectual activity – especially those with other sources of income – began to develop painting as a personal experience, unconnected with the official schools of artistic skill and taste. For them, technical rules fettered individual creativity and they abandoned them without a second thought. Others, aware of their lack of technical expertise, sought safety in a simplicity of technique; Vibert, for example, recommended *alla prima* painting as durable and reliable. In this way, basic and simplified methods of painting came into general use, and artists made a virtue of necessity by abandoning all attempts to imitate the techniques of their predecessors.

Sir Godfrey Kneller (1649?–1723) is a typical example of the increasing commercialization of the artistic world. He ran his studio like a production line, employing standardized poses and materials, and a mechanical technique. His portraits of the Kit-Cat Club members were all executed on canvases measuring 36" × 28", designed to include the head and one hand. This has since become a standard canvas size, known as a Kit-Cat.

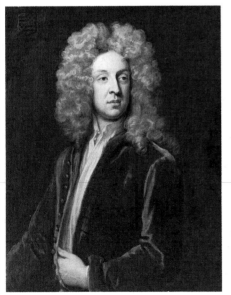
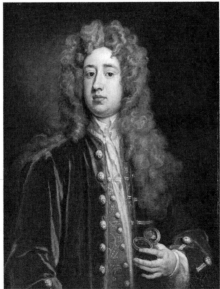

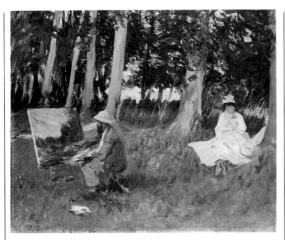

Claude Monet painting at the edge of a wood *by John Singer Sargent (1856–1925). The Impressionists determined to shake off the dry, academic restrictions, preferring to paint directly from nature in order to capture the effects of light and open air. They made use of rapid,* alla prima *techniques, bright colours and loose, flickering brushwork.*

All painters are products of their age, but this was never more true than in the case of the Impressionists. By the 1850s the chemical industry had provided a series of new, bright and reliable pigments, which significantly extended the available palette. Oil paint was now available in tubes, making it more convenient and more portable than ever before. It also had a new consistency, due to the widespread use of poppy oil and various additives, not to mention the effects of mechanical grinding. Add to this the advent of railways that could carry painters into the countryside, and a new breed of amateur intellectual artists eager to experiment with technique, subject matter and materials. The factors that had seemed to be working to the detriment of painting now combined to give it renewed life and vigour. Most modern painting derives ultimately from this fruitful period, and cannot claim an earlier tradition, for the development of painting since the Impressionists has been an entirely separate and self-contained process.

State of the art

As things now stand, there is both good and bad in the art of painting. Today's painters are ignorant and unskilled compared with those of the past, and their work is often technically incompetent and may therefore be short-lived. Paintings executed before the 18th century are generally in better condition, despite their age, than works that have been painted since that time, and considering the limited range and quality of the materials originally available, the efforts of some modern artists appear trivial alongside the achievements of earlier painters. More than ever before, painters are at the mercy of the manufacturers. The technology of artists' materials is currently based on the production methods of the late 19th century, but artists are no longer an important market for paint, and their materials are increasingly coming under the influence of a paint and chemical industry that has very different primary concerns. Whether or not this will be of benefit to painters in the longer term remains to be seen, but it is reasonable to suppose that it might rather work to their disadvantage.

Nevertheless, modern painters are much freer to paint as they choose, and in many respects artists' materials have improved, especially with regard to the range and reliability of pigments. What is required is a balance between opposing ideals. Creativity should be encouraged, but it is as nothing without technical skill, and artists who cannot express their intentions in paint might as well not paint. Painters need to understand their materials and techniques in order to take advantage of their intellectual freedom

Jackson Pollock's innovative use of paint demonstrates both the potential and the problems implicit in departing from traditional materials and techniques. Autumn Rhythm *(1950) is a typical example of his style of Action Painting, where paint was poured straight onto canvas stretched out on the floor. Though exciting, his work in metallic paints, commercial synthetic enamel and plastic paints, may prove fragile and short-lived.*

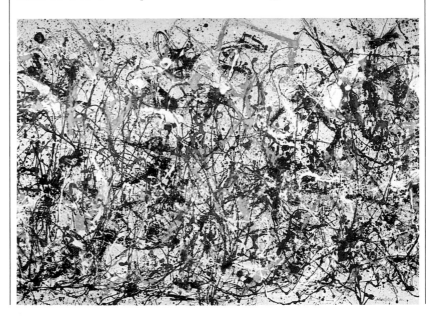

and to judge what is suitable for their own art. Such knowledge is equally important for painters who do not necessarily aspire to great art, but who simply wish to enjoy painting. It is this concern that lies behind our attempt to compile this body of knowledge representing the practical side of painting.

A door unlocked

As this book itself purports to be a Golden Key, a brief word should be said on its sources. Fortunately, although many painting skills have been abandoned, few of the secrets of the past have been lost. Painters have not always been anxious to pass on their hard-earned knowledge, especially when its possession offered them an advantage over rivals, but there have always been some who were willing to give at least a partial account of their practices, and contemporary observers have made records containing much valuable information.

The difficulty has always been the extraction and interpretation of what is relevant. The earliest records tend to be lists and collections of recipes, some of which include things quite outside the realm of painting. In other cases it is clear that a certain amount of knowledge is assumed, which is now no longer common. For example, we are now baffled by the likening of the colour of an oil to 'canary wine', though the reference would have been easily understood at the time it was written. These sources of information have been sifted and interpreted many times over. This has often yielded valuable results, but without sufficient background knowledge it is difficult to arrive at an exact meaning or to obtain a complete picture, and any interpretation must remain at best conjecture.

The techniques described here are based on information gleaned from contemporary sources combined with practical experimentation, leading, in some cases, to a full reconstruction of the method concerned. Further information has been gained from observing countless paintings, which are, after all, contemporary documents in themselves. Unfinished paintings in particular are exceptionally valuable sources that can quickly make sense of incomprehensible written statements. To these sources have been added technical data gathered during conservation work, and obtained from the modern paint and pigment industry and from manufacturers of artists' materials. This knowledge is further supported by the insight gained from actually making painting materials and through many years of practical experience as a painter.

The techniques described here are illustrated using historical examples. However, this should not inhibit you from applying the same techniques to more modern types of subject matter or from experimenting to find your own particular style. It is the basic principles and factual details of each method that are of most importance, and painters should feel free to explore variations on the examples given.

From a purely practical standpoint, the text deals only with modern materials, but recommends traditional methods of preparation wherever there is something to be gained from them. All materials referred to are theoretically available, though some items may be easier to obtain than others. (Certain natural and traditional products are no longer encouraged by the commercial colourmen, but painters should continue to demand them.) In case of difficulties, alternative materials have been quoted in the section on techniques, and it is hoped that sufficient information will be found throughout the book to enable you to make substitutions of your own if necessary.

Above all, the aim of this book is to encourage a new pride in craftsmanship among painters, and a new sense of responsibility for the quality and permanence of their works. By reuniting the practical and creative aspects of the science of painting, it hopes to stimulate new developments in art, and to enable painters to improve and enjoy their natural talents.

PART 1

Materials and Equipment

1.1 Pigments and fillers

The function of pigments

The function of a pigment is to provide colour. It follows that pigments are a major ingredient of many artists' materials, particularly paints and pastels. In theory, any substance which possesses colour may be used as a pigment, but in practice only those that also have certain other properties are employed in this way.

Painters' pigments are true pigments, unlike dyes, in that they possess body (meaning, in effect, that they exist as a solid). Usually encountered as fine, dry powders, they should be free from adulterants and impurities, and in each case should possess the best colour, handling properties and qualities of permanence that are possible for that named pigment.

Permanence is especially important in painting – the length of time a pigment retains its original colour value determines the life expectancy of the work of art. In order to be permanent the pigment must first be light-fast; that is, it must not fade or change its hue under the continual action of daylight. Daylight contains destructive ultraviolet light and many pigments will yield to it in a comparatively short time. Pigments must also be chemically and physically stable; they must not break down or change in any way as they age, interact unfavourably with other pigments and materials used in the painting, or react with the atmosphere. In fact very few pigments possess all these properties to the maximum possible degree and, if they are to perform well in paintings, they must be employed within their limitations.

Whites

Titanium white
Titanium white is not a pure white, but has a slight creamish cast. It has excellent covering power and high tinting strength, and can be regarded as permanent for artistic purposes; its only weakness is that it may chalk if exposed to severe weathering out of doors.
As pigment It is of medium weight and tends to cling to surfaces. It mixes easily with either oil or water and can be worked to a smooth consistency with comparatively little effort.
With media As an oil colour it is inclined to yellow, and a small addition of zinc white should be made during its preparation in order to preserve its whiteness. It has no apparent effect on the drying of oils. In storage it may become sloppy and lumpy, though when first ground it is stiff and smooth.

It works well in tempera, watercolour and acrylic and makes up very easily into pastels. As a watercolour it requires comparatively little gum and as a pastel it requires hardly any binder at all. Titanium white is the best white pigment to use in grounds because it mixes in very easily and its strength ensures a brilliant white finish (pp. 58, 63).

Zinc white
A stark cold white which is slightly transparent. It has comparatively poor covering power and an average tinting strength, but is effectively permanent.
As pigment The pigment is quite light and is a fairly loose powder with a tendency to form into small lumps. It should be stored in a tightly closed container as on exposure to the air it is inclined to become gritty. It mixes readily with both oil and water, but does not wet thoroughly when first mixed with oil.
With media As an oil colour it requires a reasonable amount of grinding and becomes increasingly fluid as it is worked; more pigment must then be added and the colour is reworked. The final consistency is still likely to be soft and in storage it can become quite runny. Zinc white slows the drying rate of oil and for this reason it is preferred in *alla prima* techniques (p. 105) where prolonged wet in wet working is desirable. It is the preferred white for watercolour, where its coldness can be an advantage. As a prepared watercolour, it is commonly known as Chinese white.

Zinc white is often recommended for use in grounds where its bulky volume makes it economical to use, but it is a poor second to titanium white and considerably more is required to achieve the same level of brilliance; it may also sometimes cause a ground containing boiled or fattened oil to congeal during preparation. The pigment has mild anti-septic properties and when present in large quantities can act as a preservative in grounds.

Lead white
The traditional artists' white, with a colour value lying between that of zinc and titanium whites. It is also known as flake white and silver white, and sometimes as Cremnitz white or Cremona white when an exceptionally dense and very high quality version of the pigment is involved. Good lead white has reasonable covering power and tinting strength, but its permanence is dependent on its method of use. This colour is toxic.
As pigment It is very heavy and is easily distinguishable for that reason alone. It clings to surfaces and has a slight tendency to form lumps; it mixes readily with oil, but wets less easily with water and must be thoroughly worked.
With media As an oil colour it has a tendency to yellow and, as with titanium white, it is advisable to add a small amount of zinc white during preparation. It makes a very creamy solid oil colour that lends itself to impasto and textural effects (p. 101). Lead white actually advances the drying rate of oil and this property improves with storage; it is also well suited for use in primings and lower paint layers where it can have a siccative effect on the superimposed paint. The colour loses some of its covering power as it ages, but is otherwise permanent in oil.

For other techniques lead white is less desirable, partly because of its toxicity and partly because it is at risk from the atmosphere and may blacken if it comes into contact with hydrogen sulphide (a common pollutant).

Mixed white
The name usually refers to a blend containing a substantial amount of zinc white. Today it is most likely to be a blend with titanium white, but mixtures of lead white and zinc white may still be found with this name.

Pearl white
Pearl white or iridescent white is a modern pigment blend used mostly in acrylic and gouache paints. It consists of a mixture of

titanium white and finely pulverized mica. The combined effect of these two materials is a white with an opalescent sheen that resembles the surface of a pearl.

Silver

Metallic silver can be employed as a pigment, but its applications are limited. Silver pigment and silver leaf can be employed to represent white metal, or added as purely decorative embellishments. Silver may also be used to highlight white and is therefore sometimes classed as a white pigment; as it reflects light, it can give the appearance of a far brighter white than could otherwise be painted. Silver pigment is normally obtained by hand-grinding silver leaf and mixing it directly with a water-based binder such as gum arabic. Paint made from metallic silver may be burnished when dry to improve its gloss, but it has a tendency to blacken as its surface oxidizes.

Marble dust

Powdered white marble is ordinarily used as a filler, but as it is a brilliant white in colour, it is more properly classed as a pigment. It is employed in grounds, in texture pastes, for acrylic painting and in the final coat of fresco plaster known as the *intonaco*, where it is used in place of sand. Marble is non-absorbent, which is a useful feature in grounds intended for oil painting.

Lime white

Slaked white lime is the only white pigment used in fresco. A purified version is sometimes prepared, known as *bianco sangiovanni*, but opinions differ as to its merits. Lime is not used in any other form of painting.

Reds

Cadmium red

Cadmium reds range in colour from a bright red tending towards yellow, to a deep red tending towards blue. The different shades carry names such as cadmium light red, cadmium vermilion, cadmium scarlet and cadmium red deep. The name 'cadmium red' applies to all these colours, but may also be used specifically to mean a bright red in the middle of the colour range. Cadmium reds are powerful pigments which cover well and offer good tinting strength. They may be regarded as permanent, compared with other reds, as they are reliable in tints and mixtures, and are reasonably lightfast when reduced, though they may turn black when mixed with a few rarely used pigments containing copper; they are also at slight risk from atmospheric pollution. Doubts have been expressed about the safety of cadmium colours.

As pigment All shades are of medium density, though cadmium reds are often cut with barite and are then much heavier in relation to their volume. Painters should avoid these extended pigments if possible, as they are less reliable than the full-strength versions. Pure cadmium reds mix easily with oil or water and can be worked to a smooth consistency with comparatively little effort.

With media At first the pigment takes up a substantial quantity of oil, but as it is worked on the slab, cadmium red becomes increasingly fluid; more pigment must then be added and the oil colour reworked. In fact, this can be done several times and even then, the resulting oil colour will have a soft consistency. It is fit to use when it resembles a thick but fluid paste which handles rather like warm butter. Cadmium red in oil benefits from a small addition of wax.

These pigments have no effect on the drying time of oil. They work well in tempera, watercolour and acrylic, and are also useful for pastels. As they are strong opaque reds, their potential as watercolour is limited, though they may still be employed in spite of this. In tempera, watercolour and pastel they are at

greater risk from pollutants, but this need not generally be a cause for concern. In fresco, the darker shades of cadmium red tend to be reliable, whilst the permanence of the lighter shades is dubious. All cadmium reds are liable to discolour if they are used in external frescoes.

Toluidine red

Seldom encountered under its own name; you may find it as scarlet lake, vermilionette, bright red, or with a trade name. It is an intense and brilliant scarlet which tends ever so slightly towards blue; there are a few variants, but all are bright reds. Toluidine red is a modern organic pigment with exceptional tinting strength, but it can only be relied upon as a pure colour. At full strength it is exceedingly lightfast, but as its concentration in mixtures is reduced, it rapidly becomes fugitive. When applied thickly it is reasonably opaque, yet its great strength also allows it to be used thinly as a transparent bright red. These combined properties make it an excellent red for glazing and for strongly coloured washes. In the interests of permanence its use should be restricted to applications of pure colour and to strong tints.

As pigment The pure pigment is a very lightweight substance with a tendency to cling to surfaces and it should be handled gently and slowly, so that a minimum amount of pigment becomes airborne. At first sight, it may appear quite coarse-grained, but it is in fact extremely fine. Because of its strength, toluidine red is often extended with fillers, but as this can seriously affect its performance, you should avoid such grades completely; they lack the light and fluffy character of the pure pigment, so are easily detected. This colour mixes well enough with oil, but does not wet easily with water. A mixture of alcohol and water will overcome this difficulty.

With media As an oil colour it requires a reasonable amount of grinding; it becomes increasingly stiff as it is worked and may continue to thicken during storage. It slows down the drying rate of oils considerably and will benefit from the addition of a small amount of dryer, either during preparation or during use. As watercolour, it is best prepared by working it directly into the gum solution. It should then be ground as finely as possible and tested before use.

In tempera, toluidine red needs to be started with alcohol and water. It must be well worked to begin with for tempera emulsions containing oil, otherwise traces of unwetted pigment will be collected by the oil, making the paint greasy and difficult to use. A high proportion of binder is needed when this colour is applied in tempera, and the resulting paint film may take some time to harden off. Toluidine red is stable in lime, so it can be applied in fresco. Alcohol and water is also used here to wet the pigment. It may also be used in pastels, though it is not reliable in tints.

Alizarin madder

A rich dark red with a brownish purple undertone. Versions of this pigment are also known as alizarin crimson, alizarin carmine, and as alizarin rose madder. This is a synthetic pigment which is related to the traditional rose madder. It is superior to it in terms of permanence, but does not quite match it in colour. As it is a transparent pigment, alizarin is at its best when used thinly in a glaze or wash. The pure colour can be considered lightfast in a reasonable concentration, but if used in mixtures or applied too thinly, its permanence will be impaired, and in very low concentrations it may become fugitive. Since the beauty of its colour is easily lost in mixtures, it is best in any event to restrict its use. A browner version of the pigment called burnt alizarin is occasionally available, as well as several other shades in which alizarin is combined with other pigments.

As pigment The pigment is very light and loose. Its colour is paler than you might expect, being a mid-toned pink with a bluish cast, but this darkens considerably when the pigment is

mixed with medium. It mixes quite easily with oil or water and makes up smoothly, but a little effort may be required to get the mixture started. A wetting agent can be employed, but is not normally necessary.

With media Alizarin prepared as an oil colour begins as a soft paste, and thickens during grinding to become quite stiff. After a short period of storage, it softens but retains its buttery character. It is a poor dryer in oil and may benefit from a small addition of siccative. As it is so frequently used as a glaze, it may also be ground directly with a suitable painting medium.

It is a charming colour in watercolour and is easily prepared. It works well in tempera, also, and can be employed in pastels, though neither medium brings out the full potential of the colour as oil and watercolour do. Alizarin pigments are not fast to lime, so they cannot be employed in fresco, but they are quite stable on dry lime plaster and can be used in *fresco secco*.

B.O.N. arylamide red

A modern organic colour which occurs in a range of shades between scarlet and deep wine red tending towards purple. The bright reds are more often encountered than the deep reds, but both are useful. At full strength, it offers a less than perfect degree of lightfastness, but it holds up tolerably well in mixtures. It can be used as an inexpensive alternative to cadmium and as an ingredient in blended colours. Its properties as a pigment and with media, are similar to those of toluidine red. Like that colour it is often encountered under brand names; it may also be known as naphthol red, though that name is loosely applied to several pigments.

Vermilion

Vermilion is the traditional bright red pigment which has now been substantially replaced by cadmium red. It is expensive, and its permanence depends on the method of manufacture and mode of use. It is inclined to turn black, apparently due to the action of light, and although it can give good results in oil, tempera and watercolour, its performance is somewhat unreliable. Its continued use relates to tradition, but it should no longer rank as an important pigment.

Vermilion is a heavy pigment. It requires an addition of wax when ground in oil, and in spite of the fact that it takes up very little oil, it is a poor dryer. Its tinting strength is good and it covers well, while if used thinly it offers a strong, yet transparent red. It is toxic.

Rose madder

Genuine madder lake is a natural organic pigment which occurs as a delicate rose pink, a deep crimson and a reddish purple. None of these are permanent, but the darker crimson madders survive reasonably well if they are employed carefully. In spite of this, some madder pigments remain in use, partly because they are traditional, but also, in the case of rose madder, because it is a charming and unusual colour. Alizarin madder has substantially replaced madder lake, and genuine madder in fact contains alizarin, along with purpurin; only the alizarin component is at all permanent.

Quinacridone pink

A modern synthetic organic pigment of an extremely beautiful, intense rose pink with the merest hint of a purple undertone. Its colour is very similar to genuine rose madder, though its variants tend towards purple or crimson. Its fastness to light is extremely good, and it is durable even when used thinly. A transparent colour, it is at its best as a glaze or a wash. It should replace rose madder, but its high cost tends to limit its use.

Carmine

A traditional red of natural organic origins, it is a delightful transparent crimson, similar to alizarin, but more luminous and

a shade nearer to bright red. It remains popular with water-colour painters but is totally lacking in permanence and should be avoided altogether. Some versions of the pigment are said to be a little more durable than others, but there is little case for its continued use. In oil carmine is a very poor dryer. The name is also applied to modern organic reds of varying quality.

Red ochre

A glowing, warm red-brown earth colour with a slightly orange appearance when used thinly, it has excellent covering power and high tinting strength. This colour is absolutely permanent but has a tendency to become more apparent in mixtures as they age, and to darken in oil. Red ochre is also known as Venetian red or light red, and is virtually indistinguishable from Mars red. Burnt ochre is another identical colour, though that name is sometimes applied to a dull brown earth.

As pigment A medium- to heavyweight pigment which looks a bright orange-brown when dry. It mixes easily with oil or water and can be worked to a smooth consistency with comparatively little effort.

With media When prepared as an oil colour, it should be worked up stiffly, as it is inclined to soften slightly during storage, and may even become quite runny. It does not affect the drying rate of oil, but like most earth colours it dries well and thoroughly in a reasonable period of time.

It makes up easily as watercolour or tempera and is well suited to acrylics, pastels and fresco. Red ochre is an extremely useful pigment for coloured grounds and primings, where it may be used alone or in mixtures. It is a less brilliant colour in water-based media than in oil.

Indian red

Indian red and Mars violet are virtually identical manufactured red earths which are similar to red ochre, but with a bluish undertone that makes them a slightly darker red-brown. They produce cool, greyish tones when mixed, whereas the red ochres produce warm, lively tones. Indian red is heavier and may be a little coarser than red ochre, but apart from its colour value, Indian red performs for all practical purposes in the same manner as red ochre. *Terra rosa* is sometimes given as a name for this colour, but it may also be applied to other red earths.

Burnt sienna

Another red earth colour, rather more brown than red ochre, which appears richer and more luminous because it is semi-transparent. This is especially noticeable in oil, where the colour takes on a fiery quality. This is good as a glazing colour and as watercolour. It can be used with all media and should be as durable as any red earth, but in oil it has a definite tendency to darken and may take longer to dry than red ochre or Indian red, due to the large amount of oil that it absorbs during preparation.

Blues

French ultramarine

A very rich and powerful mid-blue, said to be the bluest of all the blues; it tends fractionally towards red, whereas most blues tend towards green. French ultramarine is manufactured in several shades, though none deviate significantly from a central mid-blue; the extremes of this range are sometimes differentiated as ultramarine light and ultramarine dark. Ultramarines have an average to good tinting strength and are transparent, which makes them excellent for glazing. They are also versatile in mixtures and permanent, but are easily bleached by weak acid that may be present in the medium or in the atmosphere. In spite of this minor weakness, they are reliable colours.

As pigment It is quite light and has a tendency to clog into lumps. The paler grades have fine particles, though the darkest

varieties may be quite coarse-grained. It mixes easily with water or oil and works up smoothly. The colour appears much darker when wet and takes on a distinctive radiant quality.

With media Ultramarine stiffens during grinding when it is made with oil, but as it is stored, it gradually softens and becomes quite runny and lumpy. This can be prevented by adding a small amount of wax or reworking the colour with additional pigment, but it should always be made as stiffly as possible to begin with. Ultramarine has no apparent effect on the drying rate of oils. It can be ground directly into a painting medium if it is to be used exclusively for glazing. It is said to cause blooming in varnishes.

Ultramarine makes up easily in watercolour, tempera, acrylic and pastel. However, it can be affected by acid preservatives, especially in tempera where vinegar is sometimes employed, and may also be affected by egg if it begins to putrefy. If the colour is used fresh, this need not be a problem, but gum or glue binders are sometimes preferred to lessen the risk. French ultramarine is stable in fresco, but on walls it is easily affected by atmospheric pollution. This is also a danger with pastel, watercolour and tempera, but adequate framing should offer a degree of protection.

Genuine ultramarine

A very costly, traditional pigment made from lapis lazuli, a semi-precious stone. It would seem to be chemically identical to French ultramarine and is virtually the same colour. It is now almost obsolete, but is still produced for work in watercolour. Ultramarine ash or veinstone, a poor blue-grey by-product of genuine ultramarine, is also used as a pigment.

Cobalt blue

A cool mid-blue, paler and less intense than French ultramarine, cobalt blue is a transparent pigment with poor to average tinting strength. It is completely lightfast and can be relied upon in all media, though the yellowing of oils can make it appear green. This can be overcome by careful preparation and use.

As pigment A mediumweight loose powder whose colour might be described as pastel or sky blue. The pigment particles are fine and wet easily with either oil or water, though they tend to form larger, coarse particles that must be broken down during preparation if good results are to be achieved.

With media For oil colour, use oils that yellow less than linseed and make a small addition of beeswax. Cobalt blue should be ground twice to reduce the size of the pigment particles, and as this may make the paint quite fluid, more pigment should be added during the process; this reduces the oil content of the paint as well and so further helps to prevent yellowing. Even when well worked up, this colour will separate from its oil during storage and become hard, though the wax discourages this and helps to maintain a thick, fluid consistency. All cobalt pigments tend to make oily colours even when carefully prepared; this means that thick applications may wrinkle on drying, making lean painting media or thinners alone preferable, except for glazing. Cobalt blue accelerates the drying of oil.

It takes time to prepare as watercolour or tempera, because it must be ground repeatedly to achieve the necessary fineness, otherwise the colour may be gritty and dust off. In watercolour especially, it is well worth the effort. Wetting at first with alcohol and water can assist its preparation. This colour is also suitable for pastel, acrylic and fresco.

Cerulean blue

A charming greenish blue. A weak, opaque pigment that, nevertheless, works well as a transparent wash or glaze, but is easily lost in mixtures. It is completely lightfast and is stable in all techniques. Like cobalt blue it is at risk from the yellowing of oils.

As pigment It is a heavyweight pigment with a fine grain. When dry, it is a pale pastel blue, as its greenish undertone is less apparent. It wets easily enough, but requires a little encouragement to get started with water.

With media As a cobalt pigment, it behaves very like cobalt blue, and should be prepared in exactly the same way. It usually takes up a little less oil and produces a more solid colour as a result. This may be used thickly, as it is unlikely to wrinkle, but its high cost and colour mean that it is seldom used in this manner. Cerulean blue accelerates the drying of oil. As a watercolour it is capable of great subtlety but may produce a coarse effect if it is used too heavily. It is appropriate for use in tempera, acrylic and pastel, though other pigments are frequently substituted for it, for a variety of reasons. It is also stable in lime.

Phthalocyanine blue

A very strong dark blue with a green undertone, which becomes apparent when it is used thinly or made into tints with white; it then becomes a light turquoise blue not unlike cerulean blue. It is a modern synthetic organic pigment and, if pure, is transparent and has enormous tinting strength. It also has excellent resistance to light, even when substantially reduced, and is completely stable in all media. Its only drawback is its capacity to stain, which can make it difficult to remove if incorrectly placed; in tempera and gouache, it can be difficult to overpaint this colour without it penetrating the subsequent layer.

It is supplied under various trade names. Colour variations occur, but are not great, and the so-called red and green shades of this blue are very similar. Because of its permanence and strength, it is not unusual to find extended and blended pigments based on this colour, but these should not be your first choice, as they do not offer the colour strength and transparency of the pure pigment. Phthalocyanine is steadily replacing Prussian blue as an artists' colour, and combined with other pigments, it is frequently used as a substitute for cerulean blue.

As pigment An extremely lighweight pigment when pure; the particles will float in the air if it receives the slightest disturbance, and it should therefore be handled gently during preparation. This pigment is a dark, blackish blue which almost appears to glow. It does not wet easily either with oil or water, but once a little oil paste has been started, the rest of the pigment can be taken up easily enough. Alcohol and water are needed to start the pigment for use in water-based media, though it can also be introduced directly to the media themselves.

With media As an oil colour it does not require a great deal of grinding. It thickens considerably as it is worked up and may thicken further during storage. It can be softened by increasing the oil content, but this increases the likelihood of a shift towards green. It is an excellent colour for glazing, and is also good in mixtures. In theory it should not affect the drying rate of oils, but in practice it tends to dry thoroughly in a comparatively short space of time.

The pigment must be well worked up in watercolour and tempera, otherwise it forms oversized particles that can break open in the finished painting, causing a stain. If used too strongly in watercolour it has a blackish undertone, and may create an iridescent, coppery sheen if it is used too heavily in any medium. If tempera emulsions are used, the colour must first be finely ground in water, otherwise traces of pigment will be picked up by the oily part of the emulsion, making the paint greasy and a little difficult to use. This blue is excellent for pastels, as many tints can be extracted from it; it is also well suited to acrylics and can be applied in fresco.

Manganese blue

Also known as mineral blue, this pigment is a light, greenish blue, somewhat paler and greener than cerulean, but not unlike that colour. It is effectively permanent and transparent. Tempera painters prefer it to other greenish blue pigments because it makes up more easily. Its colour also suits the tempera medium because of its delicate tonal value. Manganese blue is toxic.

Prussian blue

Broadly the same colour as phthalocyanine blue, though it is perhaps a fraction duller. Its long tradition of use makes it a continuing favourite, but it is now unnecessary, as phthalocyanine blue is a better pigment; its importance will no doubt continue to decline. Prussian blue may be regarded as permanent in most media, but in very thin washes and pale tints it can bleach out. It is very sensitive to alkali and so cannot be used in fresco. In mixtures with zinc white it may fade in daylight, but will regain its colour in darkness; this seems to occur in water-based media only.

Indigo

This traditional natural organic pigment is a dark blue-black that looks almost black when applied heavily. It continues to be used in watercolour, where it offers moderate permanence, but is not reliable in other media and is no longer an important colour; it can be imitated by breaking phthalocyanine blue or Prussian blue with a small amount of black.

Violets

Cobalt violet

There are two versions of this pigment which are sometimes distinguished as cobalt violet pale and cobalt violet dark, though both may be referred to as cobalt violet. The paler version is a weak purple with a pinkish undertone. Its covering power and tinting strength are poor and it is normally employed as a wash or glaze, or as a strong tint with white. The dark pigment is a rich deep purple. Both cobalt violets are completely lightfast and are permanent in all techniques. They suffer, as do all blues and violets, from the yellowing of oil, however. The delicate pale cobalt violet is most at risk, and is also noticeably affected by the red-brown colour of alkyd media.

Doubts have been expressed concerning the safety of cobalt colours, but the small quantities employed by artists should cause no problems. In the case of cobalt violet there may be some confusion with a poisonous pigment that is no longer produced. Modern cobalt violet is thought to be non-toxic.

As pigment Cobalt violets are medium- to heavyweight pigments; the darker colour is denser than the pale one. Cobalt violet pale is a definite pinky purple when dry, but this becomes much less apparent when it is made up. These pigments mix with oil or water without difficulty, though like other cobalt colours they do not wet thoroughly to begin with.

With media Cobalt violet should be mixed to a stiff, almost dry paste when it is being tempered with oil. After grinding it will become soft and slightly runny; more pigment should then be added and the whole mixture re-ground. Always test the colour between finger and thumb to assess its fineness and, if necessary, work it up once more. (This also applies, incidentally, to cobalt blue and cerulean blue.) As an oil colour, cobalt violet is never very stiff. It should have a thick consistency, but even so, it will have a tendency to flow. A little wax should be added to prevent separation and hardening during storage. It is an oil-rich colour and is likely to wrinkle badly if used too thickly. Cobalt violet speeds up the drying of oil.

This colour must be well ground for use in watercolour, otherwise it will not be sufficiently fine. This is best achieved if the colour is worked directly into the gum. The pale cobalt violet is especially attractive as a watercolour. Both shades are useful in pastel, but more tints can be derived from cobalt violet dark. It is not an easy colour to use in tempera, though it is suitable for that medium, as well as for acrylic and fresco.

Manganese violet

Also known as mineral violet or as permanent violet; it may also be supplied under trade names. This is a deep purple which is very similar to the darkest shade of cobalt violet. It is lightfast, but cannot withstand prolonged exposure to moisture, as in damp conditions it turns brown. Despite this weakness, it may be used in most techniques except fresco, and its lower cost and good tinting strength make it an acceptable alternative to cobalt.

As pigment It is of medium weight and is inclined to collect into lumps. Ensure that it is kept dry, as it is vulnerable to moisture. It mixes easily with either oil or water and can be worked to a smooth consistency with comparatively little effort.

With media As an oil colour it is most reliable. It should have more pigment added after its first grinding, and when it has been reworked it should have the consistency of warm butter; it should be thick, solid and yet soft. Like cobalt violet, it requires an addition of wax if it is to be stored. Manganese violet accelerates the drying rate of oils.

It works well in tempera and watercolour, but since it cannot withstand damp, it must be freshly made immediately before use. As watercolour, it can also be prepared and kept as a block, but it cannot be stored in tubes. The moisture involved in its preparation and use should not affect it, and once the colour is dry, it is effectively permanent in both media. Manganese violet makes up easily into pastels which should be dried quickly in a warm place to prevent any discolouration. A good range of tints can be extracted from this colour.

Ultramarine violet

A mid-toned violet with a hint of blue, it is a derivative of French ultramarine that is rarely used as an artists' colour. Its main attraction is that it costs less than other violets, but it is a weak pigment of questionable durability. In theory it can be used in all techniques, including fresco.

Purple lakes

Violets and reddish purples are produced as variants of traditional organic lake colours and as variants and blends of modern organic colours. Beautiful though they are, colours such as purple madder, violet carmine, alizarin purple and unspecified purple lakes should be avoided. They are at best impermanent, and are often highly fugitive. The most reliable purple lakes are based on quinacridone, but these have a definite red shade and only just qualify as violets. Dioxazine violet is also used in reliable purple lakes, sometimes in combination with quinacridone.

Yellows

Cadmium yellow

Like cadmium red, cadmium yellow represents a range of colours rather than a specific tone; all are variants of the same pigment. Cadmium yellow deep is a dark yellow bordering on orange; above this is a rich yellow known simply as cadmium yellow, and above that is a light mid-yellow known as cadmium yellow pale. Cadmium lemon, a definite lemon yellow, is the palest colour in the range. You may also find names such as cadmium primrose and cadmium golden. This pigment covers well enough, especially in the darker shades, and has average to good tinting strength. It is effectively permanent in all techniques except fresco, where it must be tested before use. It may discolour, but opinion is divided as to whether this is caused by damp or atmospheric pollution. Cadmium yellow is not usually classed as toxic, but doubts are sometimes expressed concerning the safety of cadmium colours. This should not apply to the small quantities handled by painters. In many respects, cadmium yellow behaves like cadmium red during preparation and use.

As pigment It is a fairly loose powder of medium weight, which mixes easily with either oil or water and can be worked to a smooth consistency with comparatively little effort. Like cadmium red, it contains some barite naturally, but avoid cut

qualities to which further quantities of barite have been added.
With media This pigment is easy to prepare as an oil colour; it becomes increasingly fluid as it is ground, and it may be necessary to add more pigment to the colour to maintain its consistency. The finished colour is likely to remain soft and in storage can become quite runny. It has no obvious effect on the drying of oil, but is perhaps a little slower than average.

It works well in tempera, watercolour and acrylic, and makes up very easily into pastels. It is one of the easiest yellows to prepare in these media and is seemingly unaffected by the presence of moisture, in spite of its supposed vulnerability to damp.

Hansa yellow

There are two versions of this pigment, known as Hansa yellow pale and Hansa yellow deep, or as Hansa primrose and Hansa golden. (These often appear under trade names, and may also be known as arylamide yellows.) The pale shade is a brilliant lemon yellow with a greenish undertone; the darker shade is a rich mid-yellow which is very close to a middle-range cadmium yellow. As well as being different colours, these pigments also behave differently, though in general terms their properties are the same. Hansa yellows are transparent, the deep yellow more so than the lemon, but if applied heavily they will also cover well. They have excellent tinting strength and are inclined to stain. The full shade is lightfast, and in mixtures they retain a good degree of permanence. They are compatible with all media and are stable in lime.

As pigment These are very lightweight pigments, but the pale yellow is significantly lighter than the deep. Hansa pale clings to surfaces and has fine particles; it does not wet instantly, but will mix with either oil or water without too much difficulty. Hansa deep floats in the air if disturbed and its particles often cling together, giving the pigment a gritty feel. It does not wet easily or thoroughly to begin with, and so alcohol and water are necessary to get it started for water-based media. In oil, mixing becomes easier once some colour paste has been worked up, as this picks up the dry pigment better than plain oil.

With media As an oil colour, Hansa pale needs comparatively little grinding. When made it is thickly fluid, and though it may soften during storage it retains a butter-like consistency. Hansa deep must be well ground, but should not need more than one grinding. It stiffens as it is worked up and remains so. Hansa deep appears to slow the drying rate of oil, though not a great deal, while Hansa pale, on the other hand, dries quite well. After preparation or use, stains on equipment that prove difficult to remove with solvents may be released with ordinary oil. This is true, incidentally, of all the powerful organic pigments.

Some small difficulty may be encountered when preparing these colours as watercolour, tempera, acrylic or pastel. Hansa pale is the least difficult to prepare and gives the best results, but Hansa deep must be ground repeatedly in order to achieve the necessary fineness. Hansa pale may be worked directly into gum or egg, but Hansa deep should be ground first in alcohol and water. This is also necessary for pastels and fresco painting. If it is not properly prepared in tempera and watercolour, Hansa deep may retain oversized particles that break open and stain. In tempera emulsions containing oil, these will be picked up by the oil, in which case the paint can become greasy and take a long time to dry. This is not a problem if the pigment is thoroughly worked up in water before the medium is added.

Chrome yellow

This pigment has been in use for some time and has acquired the status of a traditional colour. It is, however, inferior to cadmium and Hansa yellow and is no longer necessary. It offers a range of colours from a deep yellow to a lemon yellow. Of these, the darker shades are the most permanent. The lightfastness of this colour is rather unpredictable, and all its colour values are inclined to shift towards brown as they age. Chrome yellows are otherwise stable in all media except lime; they cover well and offer a high tinting strength. One of their attractions is their low cost, but this is false economy since their initial brilliance tends to fade. All chrome yellows are toxic and are at risk from atmospheric pollution.

As pigment A heavy pigment which should be kept in an airtight container away from light, as it is vulnerable in powder form and may discolour. It wets easily with either oil or water and can be worked to a smooth consistency with comparatively little effort.

With media As an oil colour it benefits from an addition of wax. It does not age well and eventually becomes a dull and dirty brownish yellow. Chrome yellow accelerates the drying of oil. In watercolour, this pigment is fugitive, and in tempera it is at risk from putrefying egg. It is not suitable for use in pastels, because it is both toxic and impermanent.

Barium yellow

Also known as lemon yellow, permanent yellow and sometimes as yellow ultramarine, this is a light, whitish lemon yellow that has less of a greenish cast than most lemon yellows. Alone, it is completely lightfast, but in mixtures it is much less resistant. In practice it is effectively permanent in oil, tempera and watercolour. It is especially useful in tempera underpainting, as it makes up easily and its pale, opaque colouring lends itself to superimposed glazes. Barium yellow is toxic.

Aureolin

A dark lemon yellow with a rather peculiar greenish brown cast, also known as cobalt yellow, though aureolin is its more common name. It covers well and is permanent, but its unusual shade limits its appeal; it is also expensive compared with other more desirable yellows. It should be a good dryer in oils, and in watercolour it has the potential to create broken yellows, yellowish greens and brownish yellows, or the kind of colours that were once known as pinks.

Naples yellow

True Naples yellow is a traditional pigment derived from lead. The name is now applied to blended pigments containing cadmium yellow, white pigments and traces of red and yellow ochre.

Yellow lakes

Indian yellow is the name of a traditional organic lake pigment that once had an excellent reputation, but now no longer exists. The name is now misleadingly applied to variants of Hansa yellow. Hansa yellow broken with transparent red pigments is also known as gamboge, the name of another traditional transparent yellow which is a coloured gum only suitable for use in watercolour. It is still available, but is of no value, since it is not lightfast.

Yellow ochre

Like red ochre, yellow ochre represents the family of yellow earth colours, as well as being the name of a specific pigment. Natural ochres are no longer used extensively, and most of these colours are now manufactured products which are chemically identical to the originals. They are, however, purer and tend to be more transparent; because of this there are fewer variants available today than there once were. The most common shade is a golden yellow-brown, which looks more yellow or more brown depending on how thickly it is applied; it is sometimes known as golden ochre and is effectively the same as the pigment known as Mars yellow. Differences between these colours are negligible. Yellow ochre covers fairly well, but is semi-transparent, so in a wash or a glaze it takes on a quite different character. It has a good tinting strength and, like red

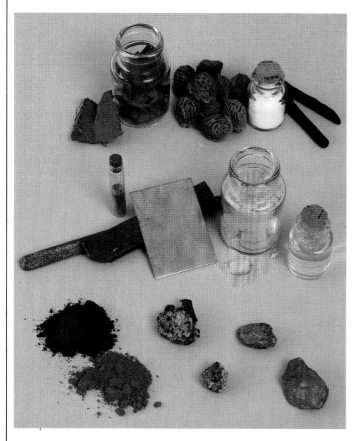

Pigments *Early pigments* (above left) *were of natural origin or were manufactured by simple chemical processes. Raw materials included minerals, such as malachite, and dyes were extracted from plants and insects. Metals were acted upon by vinegar or other acids, or heated with materials such as sulphur. Modern pigments* (left) *offer a wider range of colours, and in general are purer and more reliable. Some are versions of traditional colours, while others are new synthetic materials.*

Types of glue (above) *On the left are some prepared size, methyl cellulose and arrowroot starch. Below these, skin glue and gelatine are shown as sheets, and in pelleted and powdered form. Assorted animal glues are on the right.*

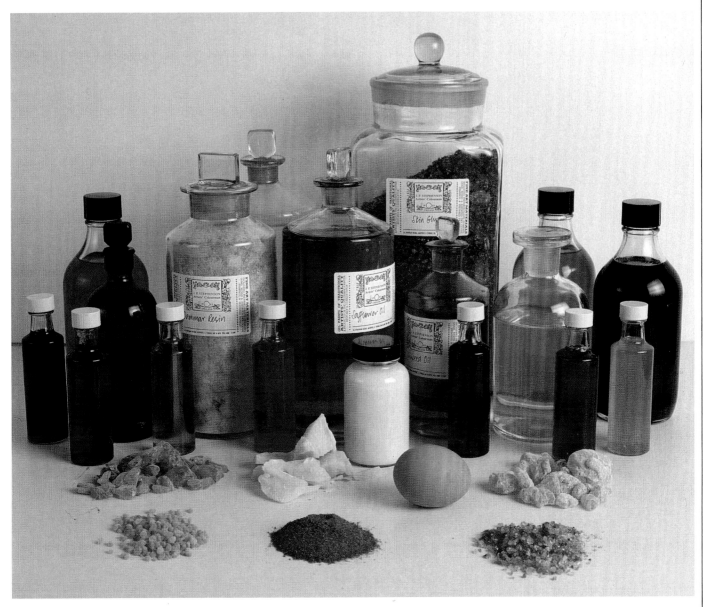

Types of medium

1. *Mastic tears*
2. *Animal glue*
3. *Gum arabic*
4. *Damar resin*
5. *Egg*
6. *White beeswax*
7. *Manilla copal resin*
8. *Fat copal medium (colour reduces on thinning)*
9. *Alkyd medium*
10. *Sun-bleached linseed oil (oil prepared over solid lead or white lead powder is about the same colour)*
11. *Linseed oil sun-thickened over litharge*
12. *Acrylic emulsion*
13. *Painters' boiled oil (clarified)*
14. *Gum arabic (may be paler if of a superior quality)*
15. *Damar varnish*
16. *Oil of turpentine*
17. *Alkali-refined linseed oil*
18. *Refined safflower oil (poppy oil is similar in colour)*
19. *Damar resin*
20. *Alcohol*
21. *Linseed stand oil*
22. *Water (distilled)*
23. *Finest skin glue*
24. *Walnut oil*
25. *Painters' boiled oil (not yet clarified)*

ochre, it becomes more apparent in tints and mixtures as the paint dries; this effect may increase as the paint ages. Yellow ochres are lightfast and permanent in all media, and are extremely useful colours. They are related to red ochres and will turn red if they are strongly heated.

As pigment Natural ochres vary in weight, but modern yellow ochre is a fairly lightweight pigment – though nowhere near as light as many modern organic colours. It has a tendency to clog into lumps, and is a much lighter and more brilliant colour when dry than when it is wet. It mixes very easily with either oil or water, and can be worked to a smooth consistency with very little effort.

With media It is easy to prepare as an oil colour and needs very little working up. It should be started as thickly as possible, as it softens a great deal during grinding. In storage it may become quite runny; this does not interfere with its performance, but if you wish, it can be corrected by adding further pigment or by adding a small amount of wax when it is first made up. Yellow ochre has no particular effect on the drying of oils, but like all earth colours it tends to dry thoroughly within a reasonable space of time.

It works well in tempera, watercolour and acrylics, and makes up very easily into pastels. It is not an especially useful colour in pastel, however, unless it is combined with other pigments, as its own shades and tints tend to be rather muddy yellows. In all other media it is very useful and easy to prepare. It is absolutely reliable in fresco, and if skilfully employed, can be made to imitate a much brighter yellow. It is a valuable pigment for use in coloured grounds, where it can contribute to grounds that are a dull brown, a warm red or a greenish grey, as well as producing grounds near to its own colour value.

Raw sienna

Classed as a yellow earth, though it is arguably a brown. It is appreciably darker than yellow ochre, and whilst it is certainly a yellow brown, it has a reddish cast which leads it further away from yellow. Until the introduction of modern ochres, the unique feature of raw sienna was its transparency; applied thinly, it is a brilliant colour with a warm golden-brown tone. If applied thickly, it may also be used to cover. It has average to good tinting strength and is completely lightfast. Raw sienna is stable in all techniques, but it darkens noticeably in oil because of the large amount of oil that it takes up during its preparation; as the oil darkens, the brown tone of this pigment is exaggerated. Yellow ochre is subject to the same fault, but it is less apparent since it is a lighter colour. If strongly heated, raw sienna changes colour to become burnt sienna.

As pigment It is of medium weight and sometimes possesses a slightly coarse texture. It mixes readily with both oil and water and is not difficult to work up.

With media It should be prepared as thickly as possible as an oil colour, in order to minimize its oil content. In any event it will soften in storage and become like warm butter. Raw sienna has no apparent effect on the drying of oils, but because it contains so much oil it tends to dry more slowly than the average colour.

It is a particularly desirable pigment in watercolour, especially for landscape painting, where its warm, transparent tone is most useful. It is easy to prepare, but must be well ground to prevent coarse particles from remaining, as these can collect in areas of heavy wash. Allowing the wash to stand for a short time before use prevents this, as the coarser particles sink to the bottom and are not picked up by the brush. Raw sienna is suitable for use in tempera, acrylics and pastels, and may be employed in fresco. It can also be used in coloured grounds, though it is less valuable for that purpose than yellow ochre; raw sienna alone is quite a pleasant colour to work over.

Gold

Sometimes classed as a yellow pigment, metallic gold has been traditionally used as an embellishment in painting. It is applied either as gold leaf, or as 'shell gold' – a paint made by grinding leaf directly into media, usually water-based (traditionally, honey was used). It can be burnished after application. Gold usually represents gold in painting, or is purely decorative, but it may be used to highlight dull yellows.

Oranges

Cadmium orange

A bright tangerine colour tending more towards yellow than red, it lies between cadmium red and cadmium yellow, and as it contains the same ingredients as those pigments, it can be mixed from them on the palette. Its properties are the same as those of the other cadmium pigments: it is permanent in most circumstances and, generally, reliable. Cadmium orange behaves a little more like cadmium yellow than cadmium red, and is sometimes classed as a deep variant of cadmium yellow.

Chrome orange

A deep orange bordering on red, which has some variants, though the differences between them are slight. It is an intermediate pigment blended from chrome yellow and chrome red, and as chrome red may be quite reliable, this orange is a fairly permanent pigment, especially in oil, where it acts as a rapid dryer. It is durable in watercolour, but in tempera it may be at risk from preservatives and from putrefying egg. It should not be used in pastel as it is toxic. Chrome orange is not fast to lime and so is unsuitable for fresco. As it contains chrome red, it becomes increasingly yellow, the more it is ground, and it should not, therefore, be overworked.

Alizarin orange

This delightful colour is a transparent golden orange with a very slight brownish undertone. It is rarely encountered, and its nature is uncertain, but it would appear to be a blend of alizarin madder and Hansa yellow deep and can be reproduced by mixing these colours on the palette. It appears to be permanent in oil and should be permanent in watercolour, though the lightfastness of the alizarin component may be impaired in too thin a glaze or wash.

Hansa orange

Said to be a modified form of Hansa yellow deep, though whether this is a genuine variant or simply a pigment blend is uncertain. Any orange pigment based on Hansa yellow should be reliable, so long as its red component also offers a reasonable degree of permanence. Alizarin orange is arguably a form of Hansa orange.

Greens

Viridian

A dark green which, as a glaze or a wash, appears a vivid emerald green with a slight blue undertone. It is a transparent colour that will only cover if applied thickly, when it takes on a duller, blackish green appearance. Its tinting strength is poor, but it is useful in mixtures with white or yellow where pale or bright greens are required. Viridian is lightfast and compatible with all traditional media.

As pigment It is a loose powder of lighter than average weight with a rather dry appearance. It is a pastel shade of emerald green when dry, but takes on a much richer colour when wet. It mixes easily with either oil or water, though it is inclined to float on the medium to begin with.

With media As an oil colour it requires a reasonable amount of grinding and becomes increasingly fluid as it is worked; more

pigment must then be added, and the colour reworked. The final consistency is likely to be soft and in storage it can become softer still. In spite of the large amount of oil it absorbs, it is a quick dryer, since it accelerates the drying rate of oil. It is therefore sometimes used with black to act as a dryer whilst producing an attractive green undertone.

In water-based media, viridian needs to be well ground, otherwise some of it will collect into oversized particles and interfere with the performance of the paint. It should be tested with finger and thumb to make sure it has lost all grittiness. Even when properly ground, it may be a little coarse, and it has a slight tendency to separate out from a wash or to collect where it is heavily applied. In watercolour and tempera, viridian gels and becomes increasingly stiff after preparation. It makes an attractive pastel, but the tints extracted from it are not very useful, so it is best to add yellow as well as the white base. In theory, it can be used in acrylic, but is seldom employed in that medium as the slightly acid nature of some versions of the pigment may cause a reaction. It is also suitable for fresco painting.

Oxide of chromium

An opaque, slightly dull greyish green which is a more useful colour than it might at first appear. It has excellent covering power and a high tinting strength; it is a valuable colour in mixtures, and with white, yellow or blue, its brilliance may be substantially increased. Oxide of chromium is completely lightfast and permanent in all techniques. It is, incidentally, related to viridian and may be called oxide of chromium opaque to distinguish it from viridian, which is sometimes known as oxide of chromium transparent or as oxide of chromium brilliant.

As pigment The pigment is rather heavy and inclined to form lumps and to cling to surfaces. It looks more brilliant when dry than when prepared with media, though its tonal value does not change a great deal. It mixes very easily with either oil or water and can be worked to a smooth consistency without difficulty.
With media In oil it has a richer colour than in other media. It should be made up stiffly, as it will relax considerably during storage and may become quite sloppy after a time. Like viridian, it accelerates the drying rate of oils quite significantly.

It is easy to prepare as a watercolour, and in spite of its opacity, it can be very effective. Its natural dullness may be exploited to dampen down excessively bright greens, for example. It is a very easy colour to use in tempera, and with an addition of white it is excellent for underpainting. It is the nearest modern colour to the traditional green earths, and whilst it is not an exact match, it makes an acceptable substitute in many instances. Used thinly, with a little blue, it is even more like *terre verte*. It makes up easily into pastels and is equally suitable for acrylics and fresco painting.

Phthalocyanine green

A powerful modern organic pigment of a deep and very brilliant emerald green. It is appreciably darker than viridian, but if substantially diluted, is of approximately the same colour. It appears under a variety of trade names, and is occasionally found simply as emerald green. It is frequently used as a substitute for viridian, as it is more economical to employ. Phthalocyanine green has excellent fastness to light when at full strength, and retains this quality to a large extent even in very low concentrations. It offers a high order of permanence in all types of media, and should be reliable in fresco. The capacity of this colour to stain is extraordinary, and when pure it exceeds even the staining power of phthalocyanine blue.
As pigment It is a very lightweight powder that becomes airborne the instant it is disturbed. It must therefore be handled gently, otherwise traces of colour may be carried throughout the studio, which in view of its staining power, is not desirable. The

dry pigment is a dark emerald green that is easily distinguished from viridian. It does not wet easily with either water or oil, but once started with oil it is reasonably easy to work. Water and alcohol are required to start it for water-based media, and it must be thoroughly ground in that mixture to ensure that it is completely wet. Because of the strength of this pigment it is not unusual for it to be cut, but for artistic purposes, the full strength pigment is to be preferred.
With media Phthalocyanine green thickens when ground in oil and may thicken still further during storage. If it is to be employed as a glaze it may be worked directly into a suitable glazing medium. It tends to dry well, but has no obvious effect on the drying rate of oils. This pigment is not seen to its best advantage as an oil colour, as it takes on a blackish appearance if applied too thickly.

When well worked up it makes a good watercolour which exceeds viridian in its intensity and brilliance. It is easier to prepare than phthalocyanine blue and is less inclined to form oversized particles of unwetted pigment, though its quality should still be checked during grinding. In tempera emulsions containing oil it will be picked up by the oil and become greasy if it is not thoroughly wet to begin with. Like most modern synthetic organic pigments, pure phthalocyanine green is much easier to prepare as a resin pastel than as a gum-based one. Its strength allows a considerable number of tints and shades to be extracted and it is also extremely useful in mixed pastel tints. For fresco it must be thoroughly ground with alcohol and water.

Terre verte

This traditional pigment is a blue-green grey which occurs naturally. It is related to the ochres and forms part of a pigment family once known as the green earths. The best of this colour appears to have been worked out, and the tone now employed can frequently be improved by mixing with viridian or other greens. It is lightfast and permanent in all media, though it darkens in oil and may develop a brownish undertone. In oil it is a transparent colour and appears bluer in watercolour or tempera, where it is semi-transparent, providing it is not employed too heavily. It has a tendency to gel when prepared as a watercolour or as tempera. In fresco, it dries very much paler than it appears to be during use. A version of *terre verte* may be called Veronese green earth, a colour traditionally used for underpainting flesh, but this name is also used to describe brighter mixed greens. Its subdued colouring is now out of place amongst brighter modern pigments and it is no longer as valuable as it once was.

Green lake

A general name for bright transparent greens that lie between emerald green and leaf green. Nowadays, it is likely to be applied to a blend of phthalocyanine green and Hansa yellow, a very reliable colour which can be mixed on the palette, though it is also supplied under trade names.

Chrome green

A mixture of chrome yellow and Prussian blue. It is no better than either of those colours and offers only moderate durability. Like chrome yellow, it has been employed since the 19th century, which gives it the apparent status of a traditional colour. However, it is of no real value to painters and its continued use is unnecessary. Chrome green accelerates the drying rate of oils and is toxic.

Cobalt green

A very weak, greyish blue version of emerald green. This is a permanent colour which is stable in all media, but it is little used, as its weak colouring and poor tinting strength do not find favour with painters. It has some potential where cool, delicate greens are required.

The choice of commercially prepared paints on offer has expanded rapidly since the 19th century. Tempera, acrylic, gouache and oil colour are all available in tubes (left), but quality and performance may vary. It is always worth paying a little extra for artists' quality colours, as these should contain the finest pigments and binding media, without unnecessary additives. It is advisable to try the products of various manufacturers, as some are better suited to certain techniques than others.

The colour range of ready-made pastels (right) is quite overwhelming, but remember that you will not need many tints and shades to produce a sequence of tones, as the thickness of the pastel layer can be varied. It is much cheaper, of course, to make your own.

Watercolour paint is available in both tubes and pans (below). Portable sketching boxes often contain pans, and have shallow mixing trays built into their lids and a central section for carrying folding brushes. They may also have a thumb-ring underneath to make sketching in the field easier. Tubed watercolour is more convenient for producing large quantities of wash.

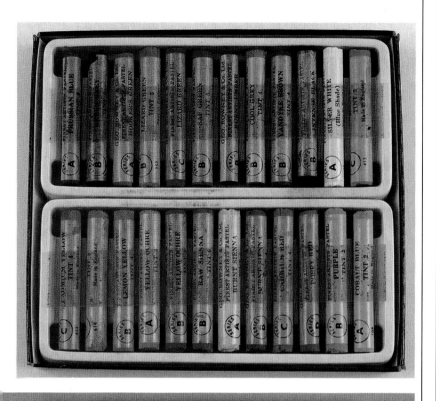

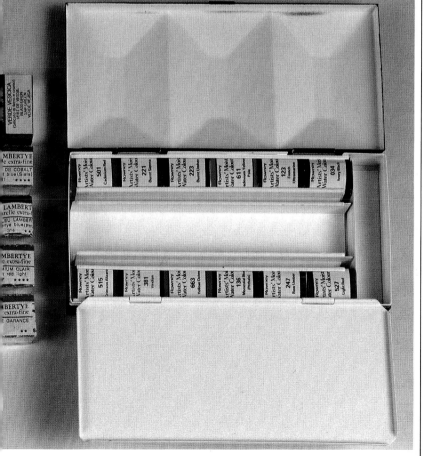

Double grounds *Traditional painting methods and materials can be reapplied without being mere repetitions of earlier practices. These contemporary double grounds use bright colours in place of the duller pigments originally employed, though the principle remains the same. A half-covering ground is applied over a ground of a different colour, in order to obtain an optical mixture. Here, the top ground is intended for a portrait, while the lower combination is destined for landscape painting. Both employ studio-prepared grounds, brushed on, then stippled or spattered over (see p. 64 and pp. 130–1).*

Cadmium green

Also known as permanent green, this is a blend of cadmium yellow and viridian. Depending on the shade of cadmium yellow that is used, it may be a rich mid-green or a lighter leaf green. This colour is permanent, but is a little unnecessary, as greens of this type are easily prepared on the palette.

Mixed greens

In addition to the blended greens already mentioned, there are a few other mixed greens which are occasionally available as pigments, though they can be created on the palette just as easily. Prussian green is a dull, blackish blue-green based on Prussian blue. Sap green is a bright, leafy green of dubious quality. (Note, however, that this name may also be applied to a reliable version of green lake.) Hooker's green is a mid-green with a blackish undertone; originally an unreliable pigment blend, this may now be based on more permanent modern pigments. Olive green is a dull, brownish yellow-green often derived from raw sienna.

Browns

Raw umber

A brown earth colour which is lower in tone than the brownest of the yellow ochres. It is a slightly dull mid-brown, but within that general description, quite wide variations are possible. Raw umbers can have a yellowish cast or a greenish undertone, and may even have a hint of dull, greyish black. They cover reasonably well, but are seldom used solidly as they are too dark. The colour is more apparent when it is used thinly, in which case it is semi-transparent. Its tinting strength is average to good, but its usefulness in mixtures is limited. With white it produces a dirty grey, and it is best employed to break other colours and lower their tone; employed in this way it gives warmer shades than black. Raw umber is permanent in all techniques, but is prone to darkening in oil. This can benefit a painting by enriching its shadows, but it can also destroy the subtlety of certain tonal values. If raw umber is heated it becomes burnt umber. Both pigments are effectively non-toxic.

As pigment The pigment is quite light, though not excessively so. It is a very dull muddy brown when dry, and darkens considerably when wet. It mixes very easily with either oil or water and can be worked up into paint without difficulty.

With media As an oil colour it should be prepared as thickly as possible. It will relax after grinding, and in storage will become softer still, while retaining a paste-like consistency. Its colour should appear very close to black, but when spread thinly in oil, it inclines towards a dull chocolate brown. It accelerates the drying rate of oils, and for that reason is sometimes added to blacks, and even to strong reds, as a form of dryer.

The yellowish and greenish tones of umber are most useful in watercolour and tempera, though it must be used thinly, otherwise it has a sooty and rather unpleasant appearance. It is an easy colour to prepare as it requires very little grinding. In watercolour, extra gum may be added during use in order to enrich its colour. In pastel, it is most valuable as a pure colour, since its tints are inclined to be muddy. It can also be used in acrylic and fresco. Raw umber may be used in coloured grounds, either as a dull, semi-neutral *imprimatura* or as an ingredient in mixed grounds, where it can tone down yellow and red colours which would otherwise be too lively.

Burnt umber

A rich chocolate brown, generally considered a more useful colour than raw umber, since it is darker, warmer and more glowing. It may tend towards red or black; both varieties are common. Its principal characteristics and uses are virtually identical to those of raw umber, and in most painting techniques the two colours are interchangeable. Burnt umber is also permanent, but has a tendency to darken in oil.

As pigment It is a mediumweight pigment, noticeably denser than raw umber and appreciably darker in colour when dry. It does not wet as easily with oil or water, and is inclined to be gritty if not well ground.

With media The warmth of this colour is most apparent in oil, and as a glaze it is ideal for luminous shadows. In thick applications it is dark, but easily distinguishable from black. Like raw umber, it advances the drying rate of oils and may be used as a siccative.

It must be well ground in watercolour or tempera in order to get rid of its grittiness, but apart from that it works well. In pastels and, indeed, in other media, it may be mixed with yellow and red earths to create a variety of browns. (It is more useful in mixtures than raw umber.) Burnt umber may also be used in grounds and is a popular colour in all media for creating thin tonal lay-ins. The fact that it is warm, transparent and yet dark when used thinly, makes it particularly suitable for this purpose, though other earth colours may be used in much the same manner.

Vandyke brown

Real Vandyke brown is a highly toxic natural earth colour which derives, in part, from degenerated organic material. It is also known as Cassel earth, Cassel brown and as Cologne earth. It is a dark chocolate brown, deeper than burnt umber, with a black undertone. Its desirable quality is its transparency, but it is not especially permanent. It can be imitated using burnt umber and black, with or without a small addition of a transparent red; modern pigments known by this name are likely to be such blends.

Sepia

A traditional colour no longer in use, which can be imitated using umber and black. It is a dull, brownish black which is only fractionally more brown than black. The name bistre, a traditional colour very like sepia, may also be applied to pigment blends of this type.

Brown ochre

Red ochre and its variants, such as Indian red and burnt sienna, yellow ochre and raw sienna, may all be nominally classed as browns. Here, however, they have been entered under reds and yellows since in practice they are closer to these colours. Raw and burnt umber are related to the ochres, and between the two colours there are in theory some dark ochres which are appreciably brown, but these are no longer common.

Alizarin brown

Also known as brown madder and as burnt alizarin, this pigment is a transparent, luminous red-brown. It may be either a variant of alizarin madder or a combination of alizarin and red ochre. The first form of this colour is obviously more transparent, and its permanence is roughly the same as that of alizarin madder. It can be produced by heating alizarin madder.

Blacks

Lamp black

An intense, absolute black which may have a slight bluish or brownish cast, only apparent in greys. The brown undertone used to be more common than the blue, but both are now encountered. It has excellent covering power and enormous tinting strength, while if used thinly, its fine grain makes it quite transparent. If applied too heavily, especially with lean media, lamp black takes on a sooty appearance. This is hardly surprising, since that is exactly what it is. It is lightfast and stable in all media. It is the pigment used in Indian ink. Lamp black is

also known as carbon black, though this is specifically applied to a particular pigment (*see below*), and the name may equally be applied to bone black, ivory black, peach black, vine black and blue-black.

As *pigment* This is a lightweight pigment that should be handled gently to prevent it from floating in the air. It is not a staining colour, but its dust may still be troublesome if it is allowed to dirty the studio. The dry pigment is a dull black, almost a dark grey, and is inclined to cling to surfaces. It does not wet easily with either oil or water, but once started it presents no difficulty. A wetting agent is unnecessary, though alcohol and water may be employed.

With *media* In oil the pigment becomes black as night. It works up to a pleasant creamy consistency and should be made as stiffly as possible, as it will later relax. In storage it can become quite sloppy, even runny. It slows down the drying rate of oils and may need a dryer. This can be in the form of an umber, viridian or cobalt blue, all of which produce blacks with a pleasant undertone. In spite of its high oil content, lamp black dries matt in oil and needs a little rich medium to compensate for this. Raw umber, incidentally, behaves in the same way.

Lamp black may be ground directly into gum arabic, and because it is fine, it makes an excellent black for detailed brush drawing and monochrome washes. It performs well in tempera and other media, and can also be employed in grounds. Alone, it produces a dark, sooty pastel and it is mixed with other colours to produce shaded pastels. In grounds it is used in relatively small amounts to produce greys, broken greens, and dull reds and browns. In some ground recipes it is interchangeable with umber.

Carbon black

Most of the black pigments are related, in that they are forms of carbon produced from different sources. Each of these has slightly different properties, and painters will prefer one to another, for their own reasons. Bone black is a brownish black which at first offers warm tones, but in time it becomes a grey-black. Ivory black is a purer form of bone black, said to be the most intense of all the blacks. It dries reasonably well as an oil colour, compared to other carbon blacks. Peach black is a dense black often favoured by tempera painters, and vine black is a weak, semi-transparent black employed more in artists' printing inks than in colours. Blue-black is finely ground charcoal, though the name is often given to any black broken with a blue pigment. The true colour is also known as charcoal black or charcoal grey.

Technically, the name 'carbon black' refers to a specific pigment made by burning organic solvents.

Mars black

This colour is also known as iron oxide black. It is preferred by some tempera painters because it is easier to prepare than carbon blacks, and it is commonly used in acrylic paints. It should be extremely permanent.

Payne's grey

Payne's grey is a very blue blue-black that gives a clear, transparent neutral tone providing it is used thinly. It was originally a mixture of red lake, raw sienna and indigo, but is now concocted from blue and black, with or without an addition of red. It is usually permanent but this depends upon its precise composition.

Davy's grey

This is a genuine grey with a greenish cast. The real pigment is a naturally occurring mineral, but it may also be imitated using fairly complex pigment blends. In either case, it should be permanent. The value of this colour is that it can be used to create shades without lowering the tone of colours excessively.

Crude imitations may contain white, in which case they will not have the translucence of the true pigment.

The function of fillers

Whereas pigments are intended to supply colour, fillers are merely intended to occupy space; they are used to cut or extend pigments, in order to make them cheaper to use. Cut pigments are often less permanent than the parent material, and valuable properties are often lost; for example, the intensity of the colour, its transparency or opacity, the tinting strength and the handling quality of a pigment are all likely to be adversely affected where pure pigment has been extended. For these reasons, you should use only the finest artists' quality pigments.

Fillers are used particularly in sketching colours, which are the cheaper manufactured paints intended for students and leisure painters. They give adequate performance for their price, but should not be employed for serious painting. You may, of course, prepare sketching colours for yourself by adding filler to full-strength pigment – you then, at least, have control over the colour and can limit the use of filler to ensure a reasonable quality. Note that certain full-strength pigments do contain a proportion of filler naturally. This has a separate function related to their method of manufacture and has no connection with the use of filler as a pigment extender.

The ideal filler for extending pigment should be cheap, bulky and colourless. Painters also employ fillers in grounds and as the base material of pastels (p. 78), again to occupy space, but also to provide absorbency, tooth and a limited amount of brilliance. White filling materials are best suited to this purpose, but since, in practice, they rarely have much tinting strength, the same fillers can be used for both purposes.

Types of filler

Whiting

Whiting is powdered chalk. It should be very finely ground and look as white as possible. When wet, its brilliance is much reduced, and it is likely to incline towards either pink or grey. If it becomes very dark on wetting, it is unsuitable. It is used both in grounds and as a base material for pastels; in both cases it performs best if white pigment is added to it. Without white, grounds containing animal glue or oil will be an off-white and may eventually become a brownish cream. Pastel tints without white will tend to lack brilliance and are liable to change colour during fixing. Whiting produces a hard, absorbent gesso which readily accepts the mark of a pencil or metal point. It may also be used in coloured grounds to provide body, and in a typical ground preparation, the effect of its own colour on the pigments involved is negligible.

Although it is white, whiting has hardly any tinting strength, so it can be used to cut pigments for sketching colours. Up to 50 per cent whiting should not affect the permanence of good pigments, though it will significantly reduce their transparency and, due to its absorbency, will increase the amount of the medium that is taken up, which, in the case of oil colours, can lead to subsequent darkening. It is also used to provide body in size colour when it is used for scene painting or for murals.

French chalk

French chalk and precipitated chalk are fine quality chalks which have greater brilliance than whiting. For this reason they are sometimes thought to be better in grounds and in pastels, but their whiteness is deceptive, and in the long term they perform no better. Like whiting, they are improved in grounds and pastels by an addition of white pigment. They are generally expensive compared to whiting and some other fillers.

Gypsum

Natural white gypsum is whiter than chalk but is rarely available finely ground, which prevents its use as an extender and limits its application to use as a ground filler on panels. With animal glue or oil it produces a brownish cream ground, and even with an addition of white pigment it produces a less luminous ground than an equivalent recipe using good whiting. This may be due to its coarseness, rather than its lack of brilliance. Gypsum produces a soft gesso which can be easily surfaced. However, a pencil drawing may dig too deeply into it and it is too soft to accept metal points.

Burnt gypsum, or plaster of Paris, may also be employed in grounds, and mixed with animal glue it is suitable for decoration applied to panels. Its real value, however, is as a base material for the production of *gesso sottile* (p. 63); this has a cristalline structure quite unlike ordinary gypsum, which makes it ideal as a filler for use on panels and in pastels.

Alumina

Also known as aluminium hydroxide or hydrate of alumina, this fluffy, lightweight filler is principally used as an addition to paint. It is a poor white without body used to extend pigments in cheap watercolours and added to oil colour as an extender and stabilizer. Alumina thickens media, especially oil, providing consistency without content, but its use is said to aggravate the yellowing of oil colours, possibly because it encourages too high an oil content. Alumina exists naturally in some pigments as a by-product of their manufacturing process.

Clay

Clay is a complex natural substance with a very fine grain, which occurs in various forms and is often coloured; natural ochres are in fact coloured clays. It is related to alumina but is not identical to it. Kaolin, also known as China clay, is the whitest of the clays. It can be used as a filler, but it does not generally give good results as in colours it becomes a greasy grey which kills their brilliance, whilst in grounds its capacity for absorbing moisture can be destructive. Clay can be quite useful in pastels, where its natural setting action reduces the need for a binding medium. Coloured clays or boles were once employed in grounds, but are no longer important. Armenian bole remains in use as a gilding material, since its colour and properties are particularly suited to that purpose.

Barite

Barite is a natural mineral, though it is also manufactured in a more refined form known as *blanc fixe*. Although it appears white, barite is virtually colourless, which makes it an excellent filler for extending pigments to make cheaper grades and sketching colours. Barite is very heavy and its presence in cut pigments can sometimes be detected by assessing their relative density, but it is intentionally present in some pigments as a result of their manufacturing process. Barite is not usually employed in grounds or pastels.

Pumice

Powdered pumice stone is a pale grey, slightly abrasive material. For artistic purposes it must be very finely ground, but it should still have an appreciable texture if it is rubbed between the finger and thumb. It can be used as a filler in grounds, but its principal use is as a coating for pastel supports, as it provides a fine tooth which increases the pigments' hold on the ground.

Chapter 1.1 has so far dealt with *practical* information about pigments and fillers. The following chart presents *technical* data intended to supplement, rather than duplicate, the text.

1 Under **Colour name** you will find the common names and alternative names applied to pigments and to the artists' materials made from them, as well as the names of related colour variants.

2 **Pigment type** identifies the colour class to which each colour belongs.

3 **Composition** lists the usual chemical composition and formula, or typical ingredients of the named colour.

4 **Colour index name** identifies the pigment according to the internationally recognized colour index compiled by the Society of Dyers and Colourists.

5 **Lightfastness at full strength** indicates the typical performance of the colour as measured on the Blue Wool scale (BS1006). This scale has a maximum of 8, and 7 is generally considered the minimum rating acceptable for a reliable artists' colour. Note, however, that good fastness to light at full strength does not necessarily indicate permanence in tints or mixtures.

A new method, known as the ASTM, is currently being introduced in America specifically for testing the permanence of artists' colours. Assessments of permanence should soon be available from most major manufacturers in accordance with that standard.

The composition and technical specification of pigments, fillers and named colours

Colour name	Pigment type	Composition	Colour index name	Lightfastness at full strength
Whites				
titanium white permanent white white	Inorganic	titanium dioxide: TiO_2 Two forms exist: rutile and anatese. Anatese is the whiter and is therefore preferred in artists' colours.	White 6	8
zinc white Chinese white	Inorganic	zinc oxide: ZnO Chinese white should be a very pure form.	White 4	8
lead white flake white Cremnitz white Cremona white	Inorganic	Basic lead carbonate: $PbCo_3.Pb(OH)_2$ Cremnitz or cremona white should be a very pure form.	White 1	7
Reds				
cadmium red cadmium light red cadmium deep red cadmium scarlet cadmium vermilion	Inorganic	cadmium sulphoselenide: $CdS.XCdSe$ The colour varies from orange to maroon, becoming redder as the proportion of selenium is increased.	Red 108	7–8
scarlet lake bright red vermilionette	Organic	toluidine red: 2-nitro-4-toluidine▷2-naphthol	Red 3	7–8
alizarin madder alizarin crimson alizarin carmine rose madder alizarin	Organic lake	synthetic alizarin: 1:2 dihydroxyanthraquinone Generally on an alumina base.	Red 83	7
crimson permanent red naphthol red Bordeaux cadmium red (hue) vermilion (hue)	Organic	Typically a B.O.N. arylamide red or a similar naphthol red pigment, of which there are many variants.	Reds 7, 12, 112, 160, 188, etc.	6–8
vermilion scarlet vermilion cinnabar vermilion	Inorganic	mercuric sulphide: HgS Genuine cinnabar is a natural version of this pigment that is no longer used.	Red 106	7–8
rose madder madder lake madder pink	Natural organic lake	Dye extracted from the madder plant: rubia tinctorum. Both alizarin and purpurin are present; the base is generally alumina.	Natural red 9	6
quinacridone pink permanent rose permanent magenta red rose	Organic	Linear quinacridone. Different forms offer pink to violet colouring. A red form also exists as C1 Red 207/209.	Violet 19	7–8

Colour name	Pigment type	Composition	Colour index name	Lightfastness at full strength
red ochre light red English red Venetian red red oxide Indian red Mars red Mars violet burnt sienna terra rosa red earth terra di pozzuoli	Inorganic	Basically ferric oxide: Fe_2O_3 Different forms and degrees of purity produce shades from a dull orange-red through dark blue-red to brown. The division between this group of colours and the brown ochres or umbers is indistinct. Both natural and synthetic versions of these pigments exist. The manufactured pigments are generally of a better quality.	Red 101 + 102	8

Blues

Colour name	Pigment type	Composition	Colour index name	Lightfastness at full strength
French ultramarine ultramarine ultramarine light ultramarine dark permanent blue genuine ultamarine ultramarine ash	Inorganic	A complex polysulphide of sodium alumino-silicate. Its exact composition is unknown, but is believed to be: $Na_{8-10}Al_6Si_6O_{24}S_{2-4}$ Genuine ultramarine is lapis lazuli, which is now rarely used.	Blue 29	8
cobalt blue	Inorganic	cobaltous aluminate of varying composition, typically: $CoO.Al_2O_3$	Blue 28	7–8
cerulean blue coeruleum	Inorganic	cobaltous stannate: $CoO.SnO_2$ Possibly with some $CaSO_4$	Blue 35	7–8
cobalt blue (hue)	Inorganic	Usually French ultramarine.	Blue 29	8
cerulean blue (hue)	Organic	Principally phthalocyanine blue.	Blue 15	7–8
phthalocyanine blue phthalo blue monestial blue mona blue hortensia blue	Organic	copper phthalocyanine Different forms tend nominally towards red or green, but the underlying tone of all variants is a greenish blue.		
manganese blue mineral blue azure blue	Inorganic	barium manganate on a barium sulphate base: 11% $BaMnO_4$ 89% $BaSO_4$	Blue 33	7
Prussian blue Antwerp blue Milori blue Paris blue	Inorganic	ferric ferrocyanide: $Fe^{III}[Fe^{II}(CN)_6]_3.X\ H_2O$ or $Fe^{III}[Fe^{II}Fe^{III}(CN)_6]_3.X\ H_2O$	Blue 27	7

Violets

Colour name	Pigment type	Composition	Colour index name	Lightfastness at full strength
cobalt violet cobalt violet pale cobalt violet dark	Inorganic	Forms of cobalt phosphate. $Co_3(PO_4)_2.8H_2O$ tends to pink. $Co_3(PO_4)_2$ is violet. $Co_3(PO_4)_2.4H_2O$ is dark violet.	Violet 14	7–8
manganese violet mineral violet permanent mauve	Inorganic	Usually manganese ammonium pyrophosphate: $Mn^{+3}NH_4P_2O_7$	Violet 16	7
ultramarine violet	Inorganic	Similar to French ultramarine.	Violet 15	7–8

Colour name	Pigment type	Composition	Colour index name	Lightfastness at full strength
mauve permanent violet magenta	Organic	Often dioxazine violet. Sometimes combined with quinacridone: C1 violet 19	Violet 23	7–8
Yellows				
cadmium yellow cadmium lemon cadmium primrose cadmium golden cadmium yellow pale cadmium yellow deep	Inorganic	cadmium sulphide: CdS May also be prepared as cadmium lithopone: $CdS.BaSO_4$ Lighter greenish yellow shades may also be cadmium zinc sulphide: C1 yellow 35	Yellow 37	7
Hansa yellow Hansa yellow deep Hansa golden arylamide yellow	Azo	arylamide yellow G or the improved arylamide yellow GX: 4-chloro-2-nitroaniline▷aceto-acet-2-anisidide	Yellow 1 Yellow 73	7
Hansa yellow pale Hansa primrose Hansa lemon	Azo	arylamide yellow 10G: 4-chloro-2 nitroaniline▷aceto-acet-2-chloro-anilide	Yellow 3	7
cadmium yellow (hue)	Azo	Usually arylamide yellow.	Yellow 1	7
chrome yellow chrome lemon chrome yellow deep	Inorganic	lead chromate: $PbCrO_4$ or lead sulphochromate: $PbCrO_4.XPbSO_4$	Yellow 34	6–8
barium yellow lemon yellow	Inorganic	barium chromate: $BaCrO_4$	Yellow 31	8
aureolin cobalt yellow	Inorganic	potassium cobaltinitrite: $2K_3(Co(NO_2)_6).3H_2O$	Yellow 40	6
Naples yellow antimony yellow Naples yellow light Naples yellow deep	Inorganic	lead antimoniate: $Pb_3(SbO_4)_2$ The genuine pigment is now very rarely used, but its name is applied to pigment blends.	Yellow 41	7–8
yellow ochre golden ochre yellow oxide Mars yellow light ochre transparent ochre raw sienna brown ochre yellow earth Italian earth Roman ochre	Inorganic	Hydrated ferric oxide: $FeO(OH).nH_2O$ Different forms and degrees of purity produce shades between dull golden yellow and yellow brown. Natural and synthetic versions of these pigments exist. The distinction between this group and the umbers is imprecise.	Yellow 42 + 43	8
Oranges				
cadmium orange	Inorganic	cadmium sulphoselenide Derived from cadmium red and yellow.	Orange 20	7
chrome orange	Inorganic	lead chromate sulphate-molybdate Derived from chrome red and yellow.	Orange 21	7

Colour name	Pigment type	Composition	Colour index name	Lightfastness at full strength
perinone orange	Organic	anthraquinoid orange	Orange 43	7–8
Greens				
viridian transparent oxide of chromium emerald green Guignets green	Inorganic	hydrated chromium oxide: $Cr_2O(OH)_4$ *or* $Cr_4O_3(OH)_6$ and $Cr_4O(OH)_{10}$ mixed with Cr_2O_3 and 0.5–10% boric acid.	Green 18	7–8
oxide of chromium chromium oxide green oxide of chromium opaque	Inorganic	chromium sesquioxide: Cr_2O_3	Green 17	8
phthalocyanine green phthalo green monestial green mona green emerald green viridian (hue)	Organic	halogenated copper phthalocyanine It is not uncommon for this pigment to be used in a reduced form, and it is frequently employed in mixed greens.	Green 7	7–8
terre verte green earth	Inorganic	Natural alkali-aluminium-magnesium-ferrous silicate of varying composition.	Green 23	7–8
chrome green chrome green light chrome green deep	Inorganic	Mixtures of chrome yellow with Prussian blue.	Green 15	6–7
cobalt green cobalt green deep	Inorganic	Complex mixture of cobalt and zinc oxides: CoO.ZnO	Green 19	7–8
cadmium green permanent green permanent green light permanent green deep Veronese green cadmium green (hue)	Inorganic Organic	Usually cadmium yellow and viridian, but phthalocyanine green is occasionally used. Permanent green and Veronese green may contain arylamide yellow and phthalocyanine green.	Green 18 Yellow 37 Green 7 Yellow 1	7
light green oxide cobalt titinate green	Inorganic	cobalt titanium oxide attached to a metal such as nickel: Co_2TiO_4	Green 50	8
Browns				
raw umber burnt umber brown ochre raw sienna burnt sienna Mars brown burnt ochre	Inorganic	Ferric oxide or hydrated ferric oxide with manganese dioxide and aluminosilicates: $Fe_2O_3 + FeO(OH) + MnO_2$ There is no clear division between these colours and red and yellow ochre.	Brown 6 + 7	8
Vandyke brown Cassel earth Cologne earth brown coal	Natural inorganic and organic mixture	Natural earth containing ferric oxide and organic substances. Frequently imitated with blends of other pigments, however.	Natural brown 8	5–6

Colour name	Pigment type	Composition	Colour index name	Lightfastness at full strength
Blacks				
lamp black carbon black vegetable black	Inorganic	Almost pure forms of carbon. Variants occur, but their nature is not fully understood.	Black 6 + 7	8
bone black ivory black	Inorganic	10% carbon 78% calcium phosphate 8% calcium carbonate, plus various impurities.	Black 9	8
blue black Frankfurt black vine black charcoal black peach black	Inorganic	Impure carbon derived from various organic and mineral sources. The properties of these blacks vary considerably.	Black 8	8
Mars black iron oxide black	Inorganic	ferroso-ferric oxide: $FeO.Fe_2O_3$	Black 11	8
Davy's grey	Inorganic	A special variety of slate or aluminium silicate and chromium oxide with iron oxide.	Black 19	8
Fillers				
whiting chalk French chalk precipitate chalk Paris white	Inorganic	Calcium carbonate: $CaCO_3$ Natural and synthetic forms exist; they vary in colour and performance. Magnesium carbonate and magnesium calcium carbonate are similar materials that may be substituted in some applications.	White 18	N/A
gypsum *gesso grosso* *gesso sottile* plaster of Paris	Inorganic	calcium sulphate: $CaSO_4$ Natural gypsum and *gesso sottile* are hydrated forms; *gesso grosso* and plaster of Paris are calcined gypsum.	N/A	N/A
alumina hydrate of alumina alumina white	Inorganic	aluminium hydroxide with some basic aluminium sulphate: $3Al_2O_2.SO_3.9H_2O$	White 24	N/A
clay white bole China clay kaolin	Inorganic	Natural, impure hydrated aluminium silicate: $Al_2O_3.2SiO_2$ Clay may also be a component of some natural pigments.	White 19	N/A
barite barytes blanc fixe	Inorganic	barium sulphate: $BaSO_4$ Blanc fixe is a manufactured version of finer quality.	White 21 + 22	N/A

1.2 Media for paints and varnishes

The function of media

Media have three separate but related functions. Their primary function is to act as a binder, surrounding and coating each pigment particle to give a workable mixture that will adhere to the painting surface. As the binding medium dries or sets, a permanent paint film is formed, consisting of coloured pigment held in place by the surrounding medium. In other words, a binding medium acts as a glue. Paint media are also referred to as vehicles, and in this capacity they serve to modify the basic properties of the paint. Although it may not require a great deal of medium simply to bind a paint, the resultant product may not have the desired finish or physical properties. Adding more medium can change the paint's 'character': for example, it might give it a gloss or matt finish, and make it opaque or transparent. At the same time the additional medium may improve the handling qualities of the paint (for example, by making it more flexible and fluid), though this can also be achieved by the use of a diluent or thinner, which modifies the thickness of the paint without altering its composition. (*See* p. 27.)

Most artists' colours are prepared in a base state containing a binding medium, which painters then modify to suit their own purposes using either painting media or thinners. Ideally, media should be colourless, flexible and permanent. In fact, very few media are entirely without colour, and some have quite pronounced colours of their own, which can affect the apparent colour of the pigments they enclose. The same pigment can have quite different colour values and optical properties in different media. Media that are initially flexible may become less so as they age or if they are subject to certain conditions, such as severe cold; they may also become more or less transparent. Permanence in relation to media means 'unchanging', which is not necessarily the same thing as 'irremovable'. The most desirable media are those which achieve a stable state soon after drying, although several media undergo slight changes as they age over a prolonged period. No perfect media exist, but those commonly employed will give results that approximate to the ideal, providing they are of the finest quality and their method of use takes account of their characteristic properties.

Varnishes may also be considered as a form of medium. Although their primary function is to act as a final protective layer for finished paintings, they can also be applied to modify colour effects, and they have several minor uses within specific painting techniques. Varnishes are also prepared from the same materials as paint media and their distinction as a separate class of product is therefore notional rather than factual (*see Glossary*, p. 9).

Oils

The oils used in painting are called drying oils. These are vegetable oils which combine with oxygen in the air to produce a solid film which is resistant to the atmosphere and to many solvents. The drying process is slow, and although the paint film becomes dry to the touch within a matter of days, it in fact continues to dry for many years. To begin with, the film is flexible, but it gradually becomes more brittle as it ages. All drying oils have some degree of colour, and though initially the effect of this on pigments is minimal, in the long term they have a tendency to yellow and darken as they decompose internally that may have a drastic effect. This type of yellowing – due to ageing – is irreversible, but a different form of yellowing may also occur soon after drying. This is due to a thin film of oil rising to the surface of the paint, and can be removed by exposure to strong daylight. It is said to be encouraged by drying in the dark. Oil paint films also become increasingly transparent as they age, due to a change in their refractive index. In spite of these drawbacks, drying oils may be regarded as one of the most permanent and durable painting media available to artists.

Linseed oil

Linseed oil is the most thorough-drying and durable of the natural drying oils. It becomes 'touch dry' in three to five days. Painters will get the best results from alkali-refined linseed oil, which is crystal clear and has a pale to golden yellow colour. A special grade, sometimes known as cold test linseed oil, is produced for artists which is processed at low temperatures to remove waxes. This is equivalent to the cold-pressed linseed oil traditionally used by artists and is probably superior to it.

Linseed oil has a marked tendency to yellow as it dries, and for this reason it is often avoided in pale colours, such as whites and blues. This does not apply to colours used in underpainting or in the lower layers of any wet over dry technique, however, where the thorough drying of linseed oil is a distinct advantage, as it reduces the likelihood of cracking later in the painting's life.

Poppy oil

Poppy oil dries more slowly than linseed oil, taking from five to seven days to become touch dry in a thin layer. It is also less durable and less thorough-drying than linseed, but it has much less tendency to yellow as it ages and has therefore traditionally been favoured for use with whites and blues. Poppy oil is a very pale yellow, and is frequently offered to painters in a bleached state which is almost colourless. It is valued for the soft, buttery consistency that it gives to paint. This, together with the length of time it takes to dry, makes it suitable for use in *alla prima* techniques, where lengthy periods of wet in wet working are required. It should not be used in the lower layers of works painted wet over dry, as it will cause bad cracking. In any event, thick applications of poppy oil colour are likely to crack eventually, giving the impression that the paint has shrunk.

Safflower oil

Safflower oil is very like poppy oil. It, too, is a very pale yellow and has little tendency to yellow as it ages. It does not dry as quickly as linseed oil, but is a better dryer than poppy oil; like poppy oil, again, it is less durable and less thorough-drying than linseed oil. All the same considerations about its use apply, though it seems to create a more stable paint layer than poppy oil when it finally dries.

Walnut oil

Walnut oil is a pale yellow-brown and has a pronounced, rather pleasant smell. When new, walnut oil is very pale with a greenish cast. It is thinner than the other drying oils and makes paint

which is more fluid. This is suited to thin, free-worked applications of colour and to finely detailed styles of painting. Walnut oil dries in four to five days and yellows less than linseed. Before the introduction of safflower oil and poppy oil, it was used in pale colours, but its popularity has since declined. It does not keep as well as other oils and may become rancid if it is not stored carefully.

Stand oil

Stand oil is a processed drying oil made, as a rule, from alkali-refined linseed oil which has undergone heat polymerization under controlled conditions, resulting in a viscous oil with improved properties. Linseed stand oil is a light golden yellow and may show a greenish sheen when caught by the light. It is made in various thicknesses, but the quality offered to painters usually has the consistency of black treacle. For most applications it is practical to thin stand oil with a diluent, but note that whilst stand oil will mix with all organic solvents, it will not dissolve in all of them, and separates out from some solvents if left to stand. It will dissolve in genuine turpentine, however.

Stand oil makes paint flow, and gives a glossy enamel-like finish which does not show brushstrokes. It is an excellent ingredient in painting media, especially in glazing media, where its body, low colour value and minimum after-yellowing are highly desirable. Stand oil dries slowly, taking around seven days to become touch dry, and even after it has dried it remains tacky to the touch for a considerable time, without being actually sticky.

As it is processed in the absence of air, stand oil has a different structure to its parent oil: once dry, it produces a tougher and more flexible film, which ages extremely well; it yellows very little, even after considerable time, and is most unlikely to crack. Stand oil also resists the atmosphere, moisture and heat well.

Sun-thickened and sun-bleached oils

The traditional version of stand oil is sun-thickened oil; this, painters can prepare for themselves (see Recipes, p. 46). It is a viscous, pale-coloured oil which dries well. Its exact properties depend on the method of preparation, and it varies between a light straw colour and water-white, with a drying time of one to three days. Like stand oil, it produces a durable, elastic paint film with an enamel-like finish. It ages well and yellows very little, but as it is not made to any standard specification, its long-term performance may vary from batch to batch.

Many original oil recipes include metallic dryers; these act as a potent siccative, which can be used to accelerate drying with minimal risk of undesirable after-effects. Such oils dry thoroughly and without any residual tackiness. It follows that, for a painter's purposes, sun-thickened oil is in practice superior to stand oil, even though it is technically less sophisticated. This oil is usually used in painting media, but it may also be mixed directly with pigment to make paint.

There is strong evidence that Rubens used sun-thickened oil prepared with a litharge dryer. The surface texture and visual quality of his paint are consistent with its use. If this is the case, then it is a strong recommendation for this oil, as Rubens' paintings are almost invariably in immaculate condition.

The sun can be used to refine oil and to bleach it. Linseed oil becomes a light straw colour when placed in the sun, but it becomes water-white and more drying if it is bleached over lead. The other painting oils which are already pale to begin with become almost completely colourless.

Boiled oils

Boiled oils are drying oils which have been heated, generally in the presence of metallic dryers, to produce faster-drying oils with a glossy and durable finish when dry. Their colour ranges from pale orange through orange, red and brown to a deep black. Commercially produced boiled oils yellow and darken considerably as they age, which makes them unsuitable for artistic uses, but these are quite different from the refined version of the product which painters can make for themselves (see Recipes, p. 47). Traditional painters' boiled oils may still affect colour values, but this should occur within acceptable limits. Their chief use is as a siccative in paints and painting media. They are best used selectively in lower paint layers, in dark colours and with slow-drying pigments, where their practical advantages outweigh their shortcomings.

Dryers

Several metals and their chemical compounds provoke a reaction within drying oils which accelerates the rate at which they dry. The most important are lead, manganese and cobalt; lead and cobalt cause the whole paint film to dry, while manganese causes drying only at the surface of the oil. Modern authorities favour manganese and cobalt dryers, as they have less colour and appear to age better, as well as being non-toxic. The reputation of lead dryers has suffered because of their incorrect preparation and use; properly employed, however, they are equal in quality to cobalt and superior to manganese dryers. Traditional lead dryers give a longer working time and less after-tack, which is quite desirable from the painter's point of view. Pigments containing lead, manganese and cobalt also accelerate the drying of oils, and such colours therefore have a siccative effect in paint mixtures (see Chapter 1.1).

Resins

Resin is the hard, glassy substance that remains once the natural solvent passes off from the thick, sticky, sap-like product secreted by certain trees. Resins will not dissolve in water, but they will dissolve either in organic solvents or in drying oils. Prepared in this way they are used in varnishes, painting media and paints, and certain resins may also be combined with wax for encaustic painting (see p. 177). As varnishes, their function is to provide a transparent protective layer, while in paints and painting media they can improve the gloss or clarity of the paint film and reduce the colour of the medium. They are also used to increase the durability of the finish, to add body to drying oils, and to reduce drying times. The suitability of particular resins for particular purposes varies considerably. Resins may be separated into hard and soft varieties.

Damar resin

Damar resin occurs in irregular lumps which on average are the size of a hazelnut or small peach stone, though much bigger pieces are not uncommon. They have a white, powdery surface, but when broken open reveal a clear interior of a very pale yellow colour. The lumps break and crush easily, and frequently contain particles of bark and similar impurities. This is considered the best natural resin for use in painting because it has very little colour and ages well. Damar dissolves in turpentine to produce a removable varnish, also suitable as a retouching varnish, which is unlikely to crack or bloom (see Recipes, p. 50). In this state it may also be blended with oils or added to temperas. Damar has a low melting point for a resin, and may be blended directly with oils or wax by applying heat.

Mastic

Mastic resin is made up of small drop-like lumps, often referred to as mastic tears. These have a thin covering of whitish dust, but the yellow colour of the resin remains clearly visible, and inside, the mastic tears are clear but quite strongly coloured. It was at one time an important artists' material, but it is now considered inferior to damar and is expensive. Mastic behaves in much the same way as damar, and can be used for similar purposes.

As a varnish, mastic produces a warm yellow glow, which has a mellowing effect on paintings and may be used deliberately to harmonize and subdue colouring. It is prone to cracking and further discolouration, however, and may occasionally bloom. When combined with a drying oil that has been boiled with lead, mastic produces a jelly-like substance called megilp (p. 49) which can be used as a painting medium, particularly in impasto techniques. Although interesting to use, in the long term it cannot be regarded as stable.

Amber and copal

Amber is a semi-precious stone which is actually a fossilized resin. It was an ingredient in early oil media, and has acquired an almost legendary reputation. Copals are a family of similar resins, some of which are also fossilized. These resins will only dissolve in hot oil. They produce oil varnishes which are dark in colour with considerable body; when dry they form a glossy, hard surface which is highly resistant to the atmosphere. Since they cannot be removed with ordinary solvents, they should not be used as a final varnish. They may be used in paints and painting media if they are of a sufficiently high quality, but should be employed cautiously if you are to obtain good results, as the strong colour of these materials can affect pigments from the outset, and copals in particular are inclined to darken later on.

Manilla copal is the most easily obtainable resin of this type. It is not unlike damar to look at, but the lumps are more angular, and there is a greater variety of size and colouring amongst the pieces. Manilla copal produces a thick, black oil varnish which is a warm brownish-orange when thinned down. Although it is a difficult process, painters will obtain the best results if they prepare resin-oil vehicles of this kind for themselves (*see Recipes*, p. 48).

Waxes

Beeswax is the most suitable type of wax for use in painting. It is a soft solid supplied in blocks, pellets or broken lumps, with a pleasant and distinctive smell. Natural beeswax is a bright yellow, but the white bleached variety is better for artistic purposes. Beeswax melts at a fairly low temperature, but it is otherwise stable and long-lasting.

Beeswax is used as the binding medium in encaustic painting, and can be blended with oils, resins and diluents for use in oil painting media. It makes varnishes and paints appear matt, and a small addition to oil paint is said to slow drying and reduce yellowing, as well as improving the stability of paint and making it more suitable for impasto effects. Beeswax may also be used as a final varnish and employed in temperas (*see Recipes*, p. 50).

Micro-crystalline wax may also be used as a matting agent for varnishes and paints. It has a high melting point when pure, but is too readily soluble to be a useful material. Paraffin waxes, of which there are many, are best avoided.

Diluents

Diluents are the materials used to thin paints, either to make them more workable or to give them a consistency which is suited to a particular technique. In theory a diluent is only a temporary addition to paint and should evaporate evenly and completely during drying, leaving the original composition of the paint unchanged, and producing no lasting odour or stain. It must obviously mix well with all the other ingredients involved, without reacting chemically with them. Although diluents are not necessarily solvents, in practice many of them are, and in that capacity the same materials appear in both paints and painting media.

Turpentines, essential oils and balsams

Spirit of turpentine, oil of turpentine, or genuine turpentine, as it is variously known, is the best diluent for oil paint. It is also a powerful solvent and mixes readily with all the materials that are commonly used in oil painting. Turpentine is the natural solvent of a tree resin called colophony, which is of little use to painters. It is separated from it by distillation, though even the best grades tend to contain traces of resin. Good grades are clear, colourless, and as fluid as water. These may be called rectified or double distilled turpentine. Turpentine has a pungent smell and is highly flammable.

Lavender oil – made from the flowers – and oil of spike lavender – made from the stems – of lavender plants has a strong smell, but is preferred by some painters who do not care for the smell of turpentine. It, too, is a powerful solvent and may be used as a diluent in oil painting. It is more resinous than turpentine and takes longer to evaporate, but this can be turned to an advantage in *alla prima* techniques where a prolonged working time is desirable. Lavender oils are a light yellow, but sometimes have a greenish cast. Rosemary oil and oil of cloves are similar essential oils, but they are seldom used.

Strictly speaking, balsams are not diluents, but they are included here because of their association with turpentine. A balsam is a liquid pitch which contains both a resin and a natural solvent. (Oil of turpentine is itself extracted from just such a balsam.) Venice turpentine and Strasbourg turpentine are both used in painting. These are not turpentine distillates, but thicker, more resinous liquids, and although they can be used to thin paint, they can themselves be thinned by turpentine. These materials have traditionally been used as ingredients in painting media and varnishes, but their popularity is related only to their ready availability, and their importance as media is strictly limited.

Mineral spirits and alcohol

Unfortunately, genuine turpentine is expensive, especially for mundane activities such as cleaning brushes, and turpentine substitutes are therefore widely employed. These are mineral spirits which are by-products of the petroleum industry. Clear, colourless liquids, they differ from turpentine in smell and in their individual properties. None of them are perfect substitutes for turpentine, and their solvent action on resins and ability to mix with fat oils is limited. The best of these alternatives are referred to as white spirits, though no precise meaning attaches to that name. It is best to test mineral spirits by placing a drop on paper and allowing it to evaporate; if there is no residue, smell or stain, it should be acceptable for use in painting. All mineral spirits are flammable, but they are less harmful to the health than pure turpentine.

Alcohol is an extremely powerful solvent: it will clean away oil varnishes and layers of oil paint, and will even dissolve acrylics; it will also dissolve amber and some of the copals. It evaporates very quickly and is extremely flammable. Ethyl alcohol or spirits of wine is an ideal product, but methyl (methanol) and isopropyl (propan-2-ol) alcohols are also acceptable substitutes which may be easier to obtain. Alcohols will mix with water as well as with organic substances. Their direct use as diluents is limited, but they have numerous applications as solvents and wetting agents, as ingredients in painting media and for equipment cleaning (*see Recipes*, p. 50).

Water

Ordinary water is, of course, the diluent in all water-based painting techniques; it is also the solvent for gums and glues. Ideally, distilled water should be used in painting, especially in watercolour techniques, where impurities can affect the performance of a wash. Otherwise, neutral (pH7) soft water should be used. A hard tap water will in theory give better results if it is boiled before use.

Gums

Gums are extracted from plants. Like resins, they begin as a sap-like substance which hardens on exposure to the air. The difference is that gums dissolve in water while being insoluble in oils or organic solvents. They are used in solution with water; this solution dries by evaporation, leaving a deposit of gum in an unaltered state, which remains permanently soluble in water. Like all solvent media, gum solutions lose volume as they dry and do not retain brushmarks or impasto effects. They are brittle and inflexible, and will crack if applied too thickly or if used on an unsuitable support. Gums adhere best to a lean surface. They can be emulsified with oils and resins, or intermixed with tempera and acrylic media.

Gum arabic

The most important gum is gum arabic, which is produced by a species of acacia and is sometimes referred to as gum acacia. In its raw state it takes the form of glassy angular lumps which vary in colour from water-white to shades of red and brown. Small pieces of woody matter are usually mixed in with the raw gum as well. For ease of use it is often supplied as a powder, which is an off-white; the nearer it is to true white, the better the quality.

The best way to assess the quality of gum arabic is to make some into solution. The finest gum produces an almost clear solution of a very light brown colour. A perfectly acceptable quality will be pale brown with a cloudy appearance, while a low grade may be a deep brown, approaching black. If such a grade becomes clear when allowed to stand and shows a reddish colouring when held to the light, it may be used in painting; grades which produce a jelly-like solution or which separate out into bands of different colour and clarity are too inferior for painting purposes.

Gum arabic is used as a binding medium for watercolour and gouache paints, and for pastels. It can also be employed as a painting medium and as a selective varnish in the watercolour technique. Other applications include use as a paper glue, as an addition to temperas, and as a main ingredient in gum tempera, where it is emulsified with a drying oil. An addition of glycerine, honey or sugar is frequently made to render gum arabic less brittle, and a preservative is necessary if the gum solution is to be stored for any length of time. If left to stand, some grades will deposit a brown mucus at the bottom of their container and the quality of the solution above will steadily improve.

Gum tragacanth

Gum tragacanth is an expensive material which begins life as ribbon-like pieces of either a white or yellow colour. It is most often encountered as a powder, in which case it is an off-white, tending towards cream for poorer grades; the whiter it is, the better. It does not dissolve directly in water, but must be soaked first in a small quantity of water, after which more water is added. As it continues to soak, it swells to form a sloppy paste (*see Recipes*, p. 51).

Tragacanth is most often used as a binder for pastels, where its softness is a desirable quality, but it can also act as a binder for watercolour and gouache paints, and can be used to create tempera emulsions. As a paint medium it behaves like size colour (*see* p. 117) and can be overlaid in layers with less risk of disturbance than gum arabic. Gum tragacanth is a little more flexible than gum arabic and can be used in watercolour painting media, where it may also retard drying.

Other gums

Painters are occasionally referred to other gums. Gum ammoniac is an obscure, aromatic gum resin which is used in water-based gold size for gilding in manuscript illumination. Cherry gum refers generally to gums obtained from fruit trees, such as cherry, plum and apricot. Gum lac and gum edere are defunct pigments. The only other product of any significance is dextrin, which is an artificial gum produced from starch, now used as a cheap alternative to gum arabic where fine quality is unimportant. It is trade practice to refer to both gums and resins as gums. Gum damar, gum mastic and gum copal should be understood to mean the resins of the same name.

Starches

Starch pastes made by cooking various types of flour with water have some applications in painting. They can be used as a size in place of animal glue, although they are inferior and likely to cause cracking and peeling of the paint layers. In addition they are susceptible to damp, and attract insect and rodent attack. Their attraction is that they can be used to fill the pores of an open-weave canvas, especially when made up as a thick paste containing a filler or white pigment. Starch pastes may also be used as painting media, as paper glues, as additions to water-based painting media, and as a base for tempera emulsions.

Some authorities are against the use of wheat starch; rye flour paste seems to be preferred, and rice starch is said to be the best; it has been used to introduce an unusual gloss finish and impasto effects into the watercolour technique. Arrowroot, which is an exceptionally pure starch, is used in the conservation of works on paper and ought in theory to be suitable for use in painting.

Traditional opinion is very much against the use of flour paste as a canvas size. Whether because of its own faults or because of its use on poor cloth, it is said to cause trouble within twelve years. A version of the recipe given by some Spanish and Italian authorities, which includes a drying oil, is more flexible and durable, however.

Glues

Glues are animal-proteins extracted from the inedible parts of carcasses. Their main use is as a size in the preparation of canvases and panels, and in the making of paper. They are also important in grounds and primings, and are a traditional binding medium for paints, where they may be used alone or in combination with drying oils, resins, gums and even egg.

Glues are water-based, but they are only fully soluble in warm water. Liquid when hot, they gel on cooling and must be reheated for further use. They dry by evaporation, but become solid soon after application due to their cooling. In warm conditions they become properly dry in a few hours, but it can take up to 24 hours for them to lose their moisture content completely. Animal glues are strong adhesives and must be used thinly if they are not to crack. (A very small addition of glycerine sometimes helps to overcome this.) Good quality glues are naturally more flexible than poor ones and are lighter in colour. Glues are offered in dry form, either as sheets, pellets or coarse powders, and they should be made up only as required, since in the wet state, they soon begin to turn bad. A small amount of preservative can be added when they are used in paints, but for sizing they should be acid-free. (*See* p. 26.)

Once dry, animal glues can be made virtually insoluble in water by treating them with formalin (p. 121). A four per cent solution ($\frac{1}{10}$ normal strength) is sufficient to achieve this. Note, though, that formaldehyde fumes are extremely unpleasant, and suitable space is essential if glues are to be tempered in this fashion.

Gelatine

Gelatine is the finest of the animal glues. It is available in the form of thin, transparent sheets or of honey-coloured granules resembling brown sugar. When made up it should be absolutely

clear with a light brownish-yellow colour, which is so slight that it will not show in a thin layer. It is therefore often used for sizing paper, and is the best glue to use in paints, and in grounds and primings where brilliance and colour quality are important. Gelatine may also be used as an intermediate varnish on tempera to prevent a change of colour when a varnish is applied.

Skin glues

Glues made from animal skins are superior to those made from bone. They vary considerably, but generally speaking are slightly more flexible and have a pale brown or honey colour. In solution they are turbid and a pale brown, which is noticeably darker than gelatine, but not sufficiently strong to affect the brilliance of a ground. The best skin glues are made up of small rectangular pellets which are either a clear brown or a translucent yellow. These seldom find their way into artists' hands, however, and a more familiar substance is rabbit-skin glue, a dark brown, cloudy-looking glue supplied either as sheets or as small irregular granules. It is reasonably flexible and has good adhesive strength, but its colour does tend to lower the tone of grounds. Rabbit-skin glue is expensive and it owes its reputation as much to the constant repetition of its name as to its actual merits. Many other glues are equally acceptable for a painter's purposes and, indeed, some are superior to it.

Bone glues

Bone glue is the least satisfactory form of animal glue, but it is acceptable if nothing else is available. It is much darker in colour – usually a deep golden brown – and may have a glassy appearance. In solution it does not appear much darker than a skin glue, but on drying, its colour becomes apparent and it can lower the tone of a ground substantially; it may darken still further as it ages. Bone glue has a noticeable smell. It is brittle to begin with and becomes more so later on. It is commonly supplied as round pellets, sometimes known as pearl glue, or as cylindrical pellets with a very muddy colouring. Bone glue is also supplied as a powder, in which case it is distinguishable by its dark colour and strong smell.

Blended glues

As the quality and performance of a glue can now be measured by more scientific means than was previously the case, it is not uncommon for manufacturers to blend glues to meet a specific standard. Blending also overcomes the problem of shortages in particular qualities of glue, and a standard product can be maintained from batch to batch, even when the actual mixture of glues is varied. If it is equivalent in quality to the average skin glue, a blended glue is perfectly acceptable for artistic purposes.

Glue blends are normally presented as small, chopped-up granules or as coarse powders. They can have a definite smell, which is due in part to their being crushed and does not necessarily indicate the presence of bone glue. A blended glue of the right quality will be golden brown when dry and a cloudy mid-brown in solution.

Casein

Casein is a glue derived from milk. It is a powerful adhesive, and once dry it is waterproof and reasonably resistant to the atmosphere. Because of these latter qualities, it has been employed as a binding medium for paint; it is thinned with water and used in a similar fashion to egg. It can be emulsified with various other media, but is said to turn yellow when mixed with drying oils. Casein can be used on most surfaces and is particularly suitable for mural painting.

Egg

Egg is the classic binding medium for tempera paint. The yolk and the white both contain albuminous protein which can be diluted with water, but egg also contains drying oil, most of which is present in the yolk. Egg yolk, therefore, is a natural emulsion. In use, egg is thinned with water and dries within minutes as that water evaporates, and the albumen hardens into a lattice around the egg's drying oil. This is only the first stage of drying, though; gradually, the oil dries too, and the albumen hardens off and becomes much less sensitive to water. This takes about a year, and when completely dry, the egg becomes extremely stable and undergoes no further change. Unless it is placed in adverse conditions, an egg tempera paint layer can be regarded as extremely durable. As it is already an emulsion, egg mixes easily with drying oils and varnishes, and can be intermixed with water-based media, such as gum or size, as well, to produce temperas with various different characteristics. (*See Recipes*, p. 51)

Either the yolk alone or the entire egg can be used as a binding medium. Documentary evidence on the use of egg in early tempera painting is ambiguous, but tests have confirmed that egg yolk, the whole egg and mixtures of egg and drying oil were all employed. The white can also be used as a medium for watercolour known as glair. Traditional advice on the use of light or dark yolks for different purposes is apparently nonsense, as the yellow colouring fades away quite quickly, although it is not correct to assume that egg undergoes no colour change at all; in fact, the egg medium becomes pink and can have a noticeable effect on areas of white.

A film of dry egg is not very flexible, and its use is therefore confined to certain types of support. Egg sticks best to a lean surface (though it will hold moderately well on a semi-absorbent ground), and will crack if applied too thickly. Hens' eggs are always used and they should be as fresh as possible, as this gives a longer working time; old egg sets very quickly. If an egg medium is to be stored for any length of time, a preservative must be added.

Preservatives

Gum, glue and egg media will all putrefy if kept for any length of time without a preservative. If preservatives are used their level must be kept low in order not to damage the painting in the long term. Ideally the concentration should not be more than 0.5 per cent (or 1 part in 200), though preservative strengths of 1 per cent are sometimes necessary. Certain powerful preservatives are sufficiently active at 0.01 per cent (or one part in a thousand); suitable substances are phenol, or household disinfectants based on phenol derivatives (indicated on their labels as halogenated or chlorinated phenols). Boric acid and sodium benzoate are less satisfactory, but are not difficult to obtain. The other alternative is alcohol – an extremely effective preservative if it is present in a high enough concentration. It has the added advantage of evaporating off when the medium is used, leaving no active ingredient behind in the painting. Alcohol will, however, provoke reactions with all gum, glue and egg media, and must be added to the water used in their making up beforehand, and never added directly to the mixtures, as it will cause them to congeal.

Synthetic media

Modern paint chemistry has produced a number of synthetic materials which extend the existing selection of media for paints and varnishes. These do not form a coherent group, nor do they properly belong to any of the existing families of materials. However, they are not a radical departure from what has gone before, and in function, at least, they can be considered as new variations on old themes.

Acrylics

Acrylics are plastics. Artists' acrylics are emulsion polymer acrylics based on polymethyl acrylate. They are in the form of a liquid polymer prepared as an emulsion, which undergoes emulsion polymerization as the paint dries. In plain language: the components of the acrylic plastic are suspended in water and undergo a rapid chemical reaction that transforms them into a continuous film once the water has evaporated. This produces a strong, flexible binding layer resembling colourless rubber.

This type of acrylic resin can be thinned with water, but becomes insoluble in water when dry. It is then resistant to most solvents, but can be dissolved using alcohol. Artists' acrylics quickly assume a stable state and do not subsequently discolour or darken. This, together with the original colourlessness of the resin, should ensure complete permanence. However, acrylic paint layers remain permanently tacky and throughout their life they pick up dirt, which dulls the colours; the effect appears to be progressive and permanent.

The plastic nature of acrylic resins means that they can, in theory, withstand impact and distortion without suffering any damage. However, at low temperatures they lose their flexibility and become quite vulnerable. Their ability to withstand the contractions that occur during drying means that they can be applied in thick layers as well as thin. They are powerful adhesives, but will not stick to all surfaces, preferring grounds which are lean, and are at risk on smooth and non-absorbent supports.

Emulsion polymer acrylics can be intermixed with other aqueous media to a limited extent, but they are totally incompatible with oils, natural resins and organic solvents. There is, however, another type of acrylic rarely used by painters, which is solvent-based. Acrylics are still developing and improving, and they appear to be a valuable addition to the range of media, but only time will tell if the claims made for them are correct.

Alkyds

Alkyd resins are used as binding media for paints and as painting media for oil colours. They are a development of the traditional resin oil varnishes, such as those based on copal, but they incorporate a resin which is synthetically produced instead of being a natural product. Alkyds dry quickly, and like other resin oils produce a durable finish with a high gloss. They are a cloudy brown – much lighter than a copal oil varnish but considerably darker than one made with damar. When dry they are resistant to solvents.

Alkyd media take the form of a semi-liquid gel. They brush out easily, but do not have the flow of a traditional resin oil. In the long term they should perform well, but at the outset they lower the tone of colours, making them appear slightly brown, and as they age alkyds shift towards a reddish-brown. Even so, these after-effects are said to be less severe than those which occur with ordinary oils. Modern alkyds may be technically superior to the old resin oils, but their handling qualities are less satisfactory, and some painters may therefore consider that a carefully prepared copal or amber varnish is better suited to their personal style.

Ketones

Ketones are completely colourless synthetic resins which will dissolve in turpentine or white spirit. They are used to make final varnishes and produce a film which is flexible, non-yellowing, non-blooming and completely clear. They are easily removed with solvent and would appear to be an ideal product. They are not, however, recommended for inclusion in painting media, largely because of the ease with which they dissolve.

Sun-thickened oil
1. *Place a shallow layer of drying oil in a glass dish with a lid, or a similar container.*

2. *Place the dish and its contents outside in the sun with the cover propped open so that air can circulate.*

3. *Stir the oil frequently to prevent it forming a skin. If a dryer has been added, take care not to disturb the sediment.*

4. *After some time in the sun the oil will begin to thicken. The length of time this takes will vary.*

5. *Keep a sample of the original oil to compare with that being thickened. This will help you to assess its quality.*

6. *Rainwater, insects and other debris may find their way into the oil while it is being thickened.*

7. *Large items can be removed by filtering through cloth. Finer sediment will settle out if the oil is allowed to stand.*

8. *To remove water, transfer the oil to a bottle and place it in the ice compartment of a fridge.*

Recipes
Sun-thickened oil

Sun-thickened oil is comparatively easy to prepare, although it can be a fairly tedious process in climates that do not have long hot summers. Any of the drying oils may be treated to produce more viscous, quicker-drying oils that are more elastic and durable than the originals, but the process is most commonly applied to linseed oil.

Sun-thickened oil may be made with or without a dryer. Most traditional recipes include dryers, however, since their presence accelerates the thickening process and also improves the oil in other ways.

Materials
A quantity of clean, good quality oil (e.g., alkali-refined linseed); a glass dish and cover (jars or trays can be employed); a dryer (piece of lead, litharge or lead white in powder form).

Method
Pour some oil into the glass dish until it is about $\frac{1}{2}''$ to $1''$ (1–2.5cm) in depth. The object is to expose a large surface area to the sun and air; the larger the dish and the shallower the oil, the more effective the process will be. If a dryer is being used, it should be added at this stage. The dish and its contents are then placed outside in a sunny position.

On fine still days the oil can be left uncovered, but at all other times the dish should be covered, with its lid propped slightly open to allow the air to flow through. This helps to keep rain and dust out of the oil, as well as limiting the number of insects that get into it. To begin with the oil should be stirred each day. After about a week, it should only be stirred lightly at its surface every few days to prevent it forming a skin. If it is hot and sunny the oil may thicken fairly quickly, but in a poor climate it can take a whole summer to achieve results; even then the oil may only thicken slightly. Further exposure to the air will continue the thickening process, however, and if you wish this to happen, once decanted and cleaned, the oil should be kept in half-full jars either inside or outside. It may take more than one season to produce an oil that is extremely fat.

The ideal consistency is that of a thin syrup, but the oil is acceptable as soon as it has doubled its original thickness. Consistency can be assessed roughly by letting some oil drop from a matchstick; if the oil flows quite slowly down the match and draws itself out as the drip falls, it has thickened sufficiently. If there is any doubt, a sample of the original oil can be used as a comparison. Do not attempt to judge the thickness of the oil when it has been in the sun, since the warmth will have made it fluid.

Dryers
The traditional dryer used in sun-thickened oil is lead. It can be introduced as pieces of lead, which are simply placed in the oil. Any lead will do, but lead foil and lead shot give good results. A whitish deposit will appear round the lead during the thickening process and will probably cloud the oil, giving it a hazy sheen. Given time this will settle out, leaving the oil perfectly clear. Oil standing over lead will thicken more quickly, become bleached, and in a very short time become almost as clear and colourless as water.

A more effective way of introducing a lead dryer is to add lead white pigment or litharge (a yellow oxide of lead). Both of these are powders which are stirred into the oil until they are well dispersed. After a short while they will settle to the bottom of the container and the oil above them will become clear. They should be stirred up again and allowed to settle each day for about a week, but after that they should be left undisturbed. If lead white is used, it will bleach the oil in the same way as lead metal. Litharge has a very pronounced effect on the drying qualities of the oil, but it does not bleach it; oils prepared over litharge are a pale straw colour and even the prolonged action of the sun does not seem to make them any lighter.

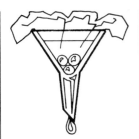

9. *Once the water has frozen, the oil can be separated from it quite easily by filtering it again.*

10. *Store the oil in strong bottles. Any air left above the oil will cause it to thicken further.*

Boiled oil: 1st method
1. *Fill the pan to no more than one third of its capacity with oil. Garlic and bread are also required.*

2. *Cut up the garlic and break up the crusts. Place them in the oil and heat it gently.*

3. *Keep heating the oil until the garlic and bread are cooked and blackened.*

4. *In the event of accidental fire, turn off the heat and put on the close-fitting pan lid to extinguish the flames.*

Boiled oil: 2nd method
1. *Place a shallow layer of boiled oil in a pan and heat it strongly until it fumes. Beware of fire.*

2. *Continue heating the oil until it foams. For a thick oil, allow it to cool a little before repeating the process several times.*

Purifying and storing

During thickening any heavy impurities will settle to the bottom of the container and it should be possible to pour the oil off gently, leaving most behind. Further standing will allow any that remain to settle and the oil can then be decanted again with a minimum loss of usable product. Insects and objects floating in the oil can be removed by pouring it through a sieve or a piece of muslin. If water has got into the oil it can be separated by freezing, after which the oil can be poured off or sieved to separate it from the ice. The finished oil should be stored in strong bottles. If you do not wish it to fatten any further, these should be kept full.

N.B. Lead and its compounds are toxic. Mark prepared oil clearly, and do not use the container in which it is made for anything else.

Boiled oil

Boiled oils are potentially dangerous to prepare because there is a risk of fire, and unpleasant fumes are produced when oil is heated to high temperatures. Unfortunately, these problems are unavoidable if painters are to obtain boiled oils with the right qualities for their particular purposes. There are two types of boiled oil that serve painters, the first, thin and fluid and the second, rich and thick.

Materials

Good quality refined oil (not the raw oils that are used commercially – alkali-refined linseed oil is recommended); a deep pan with a close-fitting lid; a small amount of litharge; some crusts of bread and some garlic.

First method

Fill the pan with oil to about $\frac{1}{4}$, or not more than $\frac{1}{3}$, of its capacity. Before the oil is heated, break up the crusts of bread and put them into it; at the same time add the garlic, peeled and chopped into pieces. As an approximate guide, use one complete crust and one good-sized clove of garlic to 20 fl. oz. ($\frac{1}{2}$ litre) of oil. These ingredients are intended to defatten the oil; they appear to work, though no sensible explanation for their action can be given. A very small amount of litharge ($\frac{1}{2}$–1oz maximum to 20 fl. oz. oil, or 15–30g to $\frac{1}{2}$ litre) should also be added and stirred well into the oil. Now heat the mixture slowly. As the temperature of the oil rises, its surface begins to move. It may bubble slightly to begin with while it loses trapped moisture and air, but it is not actually boiling. As it gets hotter, a swirling pattern appears on its surface and the garlic and bread will begin to fry. As the temperature goes up a little more, the surface of the oil may become quite still and begin to fume very slightly. At about this temperature, the litharge will suddenly incorporate into the oil, which will change colour and appear dark brown or black. Maintain the oil at about the same temperature and let it simmer for 10 to 15 minutes; then switch off the heat and let it stand. When it has cooled down it should be strained through a piece of closely woven cloth into a suitable container.

Clarifying and bleaching

At this stage the oil will still look very dark brown or black, but after it has been allowed to stand undisturbed for 3 or 4 days, it will begin to clear. Eventually it should appear crystal clear, and when held to the light it should be a warm red. This colour will partly disappear if the oil is placed in the light, but only if it is separated into small, shallow amounts; after about a week it should be a pale orange. When finished this oil should be very thin and almost as fluid as water.

Second method

Oil can be thickened by boiling, using a higher temperature, with plenty of access to air. A shallow layer of thin-boiled oil (prepared by the first method) is put into a deep pan, and heated slowly until it begins to fume. A very slight increase in the heat will make it

Boiled oils can also be thickened in the sun, and they become very fat quite quickly. Use a good quality, pale boiled oil for best results; the action of the sun will both thicken the boiled oil and substantially remove its colour. Commercially boiled oils can also be improved in this way.

boil. The oil will give off a lot of fumes at this stage and the risk of fire is quite high. Suddenly the oil will start to foam and rise up the pan like boiling milk. Switch off the heat and let the foam subside. With a very shallow layer of oil this is sufficient processing, but if the oil has any depth, the sequence should be repeated several times. While it is still warm and fluid, it should be filtered through a piece of cloth to remove any skin or lumps of dried oil that have formed during the boiling process. When cool it should be quite viscous, though it is difficult to predict its thickness in advance. Ideally, it should be like a syrup.

Resin oil

Damar and mastic resin can be blended with a drying oil by mixing a solution of resin in turpentine directly with the oil. A richer medium can be produced by melting solid resin into hot oil; this is the only way that hard resins like amber and copal can be dissolved. The following recipe is for Manilla copal, but the procedure is the same for all resins of this type. The syrupy resin oil that results is superior to commercially manufactured versions, which lack body.

Materials
Good quality Manilla copal resin; alkali-refined linseed oil, or a separately prepared boiled oil if a strongly drying version is required; a deep pan with a close-fitting lid; some sheets of clean white paper; a stick or metal rod.

Method
Begin by breaking the resin into small pieces. (A tidy way of doing this is to wrap it in a piece of cotton cloth, then strike it with a hammer.) Now cover the bottom of the pan with a shallow layer of resin pieces and melt them. As heat is applied, the resin will give off fumes, so good ventilation is essential. The melted resin will become a seething, stringy mass without turning completely liquid. Stir it with the stick or metal rod, and continue heating for about 5 minutes. It should become a little more fluid as it is stirred.

Now lay out some sheets of white paper on a surface that will not be damaged by heat. Turn off the heat and pour the molten resin onto the paper. Use the stick to help it out of the pan, but do not expect to remove it all. The resin will spread out on the paper and cool rapidly, becoming like toffee. After 10–15 minutes it will be cool enough to handle, and can then be peeled off the paper and broken into small pieces. It will have become a brown, splintery mass known as copal colophony. Any that remains on the inside of the pan can easily be chipped away with a knife, but will in any event dissolve in the oil in the next stage of the process.

Next crush up the heat-treated resin so that it can be roughly measured by volume. Using 1 part resin to 3 or 4 parts oil, put both ingredients into the pan. Do not fill the pan more than one third full. The procedure now follows the second method of boiling oil. Apply heat and slowly bring the oil to the point where it starts to foam. Stir the liquid immediately this happens and switch off the heat. If it begins to rise up the pan, vigorous stirring will make it subside.

Although it will melt at a lower temperature, the resin will only incorporate fully with the oil at its boiling point. If too much resin is used, the mixture will turn to a jelly on cooling. More oil must then be added and the mixture brought to the point where it foams again and stirred vigorously. This resin oil is completed by pouring it through a piece of cloth whilst it is still hot and fluid, to strain out the numerous impurities that are likely to have been in the resin.

N.B. Whenever oils are being heated there is a risk of fire. Water should never be used to extinguish an oil fire. Instead, use the pan lid to cut off the air supply, and turn off the source of heat immediately. The fumes produced by the oil can be extremely unpleasant.

Resin oil
1. *Wrap the resin in cloth and crush it with a hammer. Remove any obvious impurities that are large enough to pick out.*

2. *Place the crushed resin in a pan and heat it. Keep the pan lid handy in case of fire.*

3. *After a short while the resin will begin to melt and start to give off fumes.*

4. *Stir the thick, sticky mass with a metal rod or a stout stick, and continue heating.*

5. *The resin may not become fluid, but it should approach a liquid state. At this point it should be poured out onto clean paper.*

6. *Boil the heat-treated resin with oil and, while it is still hot, strain it through a cloth. Further standing improves the resin oil.*

Oil-painting media

As a general medium, ordinary linseed oil may be used to thin paint. Use alkali-refined linseed oil diluted by 2 or 3 times as much oil of turpentine. For consistency of effect, mix sufficient medium to complete the whole painting, and use it as a single additive, rather than introducing oil and turpentine separately in a haphazard fashion.

As a general medium for thinning colours – which may also be used as a glazing medium – use 'half-oil'. This is 1 part linseed stand oil diluted by 1 part oil of turpentine or a suitable grade of white spirit. This is unlikely to yellow, wrinkle or crack, but it dries slowly. It softens brushstrokes and increases the gloss of the paint.

Drying

To accelerate the drying of paint without radically altering its finish, use a medium composed of 1 part bleached boiled oil diluted by 5 parts genuine turpentine. Alternatively, to reduce the risk of after-yellowing, use 1 part sun-thickened oil containing a dryer, diluted with 5 to 8 parts oil of turpentine, depending on its original consistency. To accelerate drying without thinning the paint, add a single drop of sun-thickened oil containing a dryer to between 5 and 10 times its own volume of paint on the palette and work it in with a brush or knife. Boiled oil or resin oil may be used in place of sun-thickened oil with slow-drying reds or blacks, or any dark colours.

Glazing

The following painting media may all be used for transparent colour glazing or for thinning paint to a liquid consistency for use with a soft brush. The fattest of these media can be thinned with turpentine in the lower paint layers, and for use in non-glazing techniques where body is not essential.

Add 1 part damar varnish to 1 part linseed stand oil for a rich, non-yellowing glazing medium. For a medium that dries faster, but has a slight tendency to darken, use 1 part linseed stand oil, 1 part damar varnish, 1 part turpentine and a trace of thick-boiled oil. For glazing dark colours and in paintings where a mellow tone is acceptable, use 1 part thick copal varnish to 1 part turpentine, or 1 part thick copal varnish to 1 part linseed stand oil and 1 part turpentine. The latter has less tendency to yellow and darken, and more body. A fast-drying glazing medium with little tendency to yellow or darken can be made from sun-thickened oil containing a dryer, diluted with an equal part of turpentine or a dilute resin solution consisting of 2 parts sun-thickened oil to 1 part damar varnish and 1 part oil of turpentine.

Where viscous oils are included in painting media, a gentle warming of the ingredients can assist blending. Standing the bottle that contains the medium in warm water is sufficient for this purpose. The substitution of unsuitable mineral spirits for genuine turpentine can cause some ingredients to separate out.

N.B. Mixtures containing turpentine or spirit should only ever be warmed using hot water and should be kept well away from sources of ignition.

Impasto

To make a flexible and durable painting medium for creating impasto effects in oil, begin by melting 1 part white beeswax into 2 parts linseed stand oil over a very gentle heat. (A trace of thick-boiled oil may be included to accelerate the drying process.) This medium should be worked well into the paint on the palette before use. The results of this recipe vary according to the thickness of the stand oil: if the medium is too soft, add more wax; if it is too stiff, add more oil.

Megilp is a traditional, but not particularly satisfactory medium often used for impasto effects and thick, glaze-like applications of paint. It is made from 1 part boiled oil containing lead and 1 part mastic varnish (made from 1 part mastic and 2 parts turpentine). The mixture should set, but if it curdles, warm it gently and allow it to cool. Melting a small amount of wax into this mixture will thicken it still more.

Too much soluble resin or wax in a painting medium will put it at risk from solvents. Ready-made cobalt or manganese dryers can be added to painting media instead of the dryers indicated in these recipes.

Megilp
1. *Place equal parts of double mastic varnish (thicker than picture varnish) and a boiled oil containing lead in a jar.*

2. *Warm them gently in a water-bath and ensure they are thoroughly mixed. On cooling, the gel medium known as megilp will be formed.*

Making varnish

1. *Ensure that the resin and the varnish-making container are warm and dry.*

2. *Find a suitable container to serve as a volume measure and fill it with the crushed resin.*

3. *Tie the resin into a scrap of cloth or a piece of nylon stocking using a length of string.*

4. *Close the bag of resin tightly, leaving one end of the string quite long.*

5. *Suspend the bag of resin in a measured volume of turpentine, gripping the string under the lid of the jar.*

6. *After a few days the resin will have dissolved, leaving the worst of the impurities in the bag.*

7. *The finished varnish may be further diluted with turpentine to suit different purposes.*

8. *Damar varnish has a whitish sheen that may partially settle out as a waxy deposit. This can be removed by adding alcohol.*

White beeswax may be converted to a paste by melting it, then adding turpentine whilst it is kept warm using hot water. This can also be used as an impasto medium, but is best employed as an addition to other painting media or to the pigments as they are ground. Wax paste may also be used as a matting agent and as a final varnish.

Varnish preparation

The best varnishes for painters to prepare by themselves are made from damar resin. One attraction is their comparatively low cost, but the real advantage is that they can be made in different, known strengths to suit the particular purposes that the painter has in mind. The following method is for the cold preparation of varnish. A hot method also exists, which produces a slightly better varnish, but because of the high risk of fire and unpleasant fumes created, it is not recommended. The cold method is without practical risks other than those ordinarily associated with handling turpentine.

Materials
A quantity of the best damar resin in lump form; good quality distilled turpentine; a glass jar with a lid; a piece of light cotton cloth, muslin or an old stocking; a length of string. Alcohol and stand oil may be required for variations on the recipe.

Method
Firstly, ensure that the resin and its container are in no way damp, and if they are cold, put them in a warm place for an hour or more before making the varnish. Break up the resin into smaller pieces and crush it down into a suitable measure, such as an old cup. The approximate volume of resin represents one part in the varnish recipe. Now put the resin onto the cloth or muslin, or into the stocking, and tie it into a bag. Place 3 measures of turpentine in the jar and lower the bag of resin into it until it is half submerged. Still holding one end of the string, replace the jar's top so that it grips the string, keeping the bag in place.

The resin will begin to dissolve instantly and will create a shimmering effect in the turpentine around the base of the bag. Damar can take up to a week to dissolve properly, but most of the resin will have passed into solution within a couple of days. When all the resin has dissolved, lift out the bag and allow any remaining varnish to drain from it. It should now contain only the trapped impurities from the damar resin and can be thrown away. The varnish is ready for use at this stage, but it will improve if allowed to stand, as any small impurities will settle out.

Damar contains a natural wax-like ingredient that will appear in the finished varnish as an opalescent sheen. This white sheen has no effect on its clarity when it is applied, but it can be removed, if you wish, by adding a small amount of alcohol. This should be added little by little, with the varnish being shaken after each addition; stop the minute it becomes clear. (Clarified damar has a very pale yellow colour.) The wax may return, however, if the varnish is mixed with other ingredients to make painting media.

Variations
For a final varnish and for use in painting media, 1 part resin to 3 parts turpentine is suitable, while 1 part resin and 2 parts turpentine may be used in rich painting media and tempera emulsions. One part resin to 5 or 6 parts turpentine makes a satisfactory intermediate varnish for oil paintings that are less than a year old, and the same strength may also be used as a retouching varnish.

To make a varnish that will not crack or bloom, mix a very small amount of stand oil with the damar solution described above. Not more than 1 part stand oil to 20 parts varnish should be employed, and an even smaller amount is preferable.

Watercolour and tempera media

Gum arabic
1. *Place the gum in a glass jar and add twice its volume in water. Let it stand until the gum dissolves.*

2. *Impurities will form a stringy mass at the bottom of the jar. Remove these by filtering and then allow fine sediment to settle.*

Egg tempera
1. *The easiest method is to crack an egg into a screw-topped jar and to shake it vigorously.*

2. *Oil or varnish, or both can be added to the egg. These should be shaken in the jar with it until thoroughly mixed.*

Glue tempera
1. *Add some drying oil a little at a time to liquid size and beat the two liquids together.*

2. *The mixture will thicken and become opaque. Continue beating the mixture until particles of oil no longer rise to the surface.*

Gums

Gum arabic is dissolved in cold water simply by letting it stand. Add 1 part crushed or powdered gum to 2 parts cold water, and shake or stir the mixture to break up any lumps. After 24 hours the gum should have dissolved completely; if any lumps remain, agitate the mixture once more and leave it to stand. If impurities settle out, the gum should be poured off without disturbing the sediment. Glycerine may be added to the gum to keep it supple, using 1 part glycerine to 20 parts gum, or more when making watercolours.

Gum tragacanth is prepared as follows: take 1 part dry gum to 20 parts water and soak the gum in just half the water, to which a small amount of alcohol has been added. Once the gum begins to swell, add the rest of the water, and when it has all been taken up and the gum has become a slimy paste, squeeze it through a piece of cloth or pass it through a fine sieve to make it more fluid.

Watercolour media

Gum arabic solution further diluted with water gives greater depth to watercolours and increases their gloss. A weak solution must be used, however, otherwise the gum cracks, and the effect is too glassy. Gum arabic solution at half strength may be used to varnish the shadow areas of watercolour paintings to give them greater luminosity and depth. Glycerine added to the painting water will retard the drying of watercolours on warm days, while an addition of alcohol will accelerate drying when it is cold, and will improve the flow and penetration of the colour. Ox gall or a water-tension breaker made for use with acrylics will also improve the flow of the colour. Acrylic media diluted with water can be used to make watercolour paints insoluble.

Any dilute egg tempera medium may also be added to watercolours, but the specific watercolour medium based on egg is known as glair. This is made from egg white, beaten with a fork or passed through a sieve to make it more fluid, and then thinned with water as required.

Temperas

In addition to egg yolk and whole egg temperas, egg-oil emulsions can be used. A basic recipe involves one egg yolk and a teaspoon of linseed oil. Beat the yolk first to break it down, then add the oil a few drops at a time, beating between each addition. Once it has all been added, gradually add as much distilled water as there is egg and oil together, in the same manner as the oil.

A flexible tempera medium incorporates stand oil into the egg. Begin with 1 part stand oil to 1 part turpentine. Mix them well, then crack a whole egg into a clean, screw-topped jar. Put the top on and shake the egg until the yolk and white are broken down completely. Now pour into the jar as much of the stand oil and turpentine mixture as there is egg, and after replacing the top, shake the jar again. If globules of oil remain visible, repeat the shaking until they disappear.

A further variation includes damar varnish. Mix 1 part stand oil and 1 part damar varnish as before, but this time add them to the yolk alone. In this case use less oil and varnish than there is egg.

Gelatine and glue may also be emulsified with oils and resins. This must be done while they are warm and liquid. The oil or varnish is beaten in a little at a time, and the glue will become thick and cloudy as it takes it up. Glue tempera emulsions are less perfect than those made with egg, but they can be improved by the addition of a very small amount of a mild liquid detergent, as this helps to break down the oil and discourages it from oozing out of the glue once it has gelled. Typical recipes combine 2 parts glue with 1 part linseed oil; 2 parts glue with 1 part turpentine and 1 part copal varnish; or 1 part gelatine with 1 part stand oil, slightly diluted with turpentine to make it more fluid.

1.3 Supports

The function of a support

All paintings are carried by a support; it is the object on which they are painted. Its function is to provide a solid, durable and stable surface onto which paint can be applied. That a support must be solid needs little explanation. Durability is crucial to the life expectancy of a painting, and ideally the support should last from 500 to 1000 years. Even in a durable support, however, it is not uncommon to find changes in colour, and physical and chemical changes, which are bound to affect the painting that it carries. It is movement within the support that is most likely to cause damage. This occurs as a result of fluctuations in temperature and humidity, which alter the shape and size of the painted surface. It follows, therefore, that dimensional stability is a highly desirable feature of a support.

In selecting a support, all these factors must be taken into account. As there is no ideal support, however, other factors may also need to be considered; size, weight and cost are all relevant, as is compatibility with the intended paint type and method of working. In their natural state, almost all support materials are in fact unsuitable as carriers for paintings until they have been properly prepared. Appropriate preparation can improve a support's durability, stability and compatibility with materials. This generally involves the use of a ground, which physically separates the painting from its support (*Grounds and primings*, p. 58).

Wood and processed wood

Wooden panels are among the oldest forms of painting support. Panel paintings survive in good condition from the Byzantine period onwards. They have shown themselves to be durable, and if they are properly constructed and prepared, can have a life expectancy of up to a thousand years. They make stable supports compared with materials like paper and cloth, and though they have been used less since canvas became popular, enough examples exist to show that works on wood are almost invariably better preserved than contemporary paintings executed on other types of support.

Their stability makes panels ideally suited to brittle or fragile media like tempera, gouache and pastel, and the fact that they can be prepared with an exceptionally smooth surface makes wood panels particularly appropriate for such techniques. In fact, wood can be used with all media and arguably makes the best support for oil paint as well; a wooden panel prepared with a traditional gesso ground, for example, is compatible with all paint types.

Unfortunately, the use of panels is restricted by considerations of size, cost and weight, though processed woods overcome these problems to some extent. Another drawback is the risk that panels might warp or crack, or be attacked by wood-boring insects. However, if panels are suitably constructed and prepared, these risks are greatly reduced (*see* p. 59).

Natural wood
The traditional panel is made from solid wood either cut from a single plank or made up from two or three pieces of an identical quality. Natural wood must be properly seasoned, and the best quality pieces will have been quarter-sawn. When viewed from the end, suitable planks will show close, straight growth rings which are as nearly as possible aligned across its thickness. When viewed from the front, the grain should be straight, and there should be no knots or evidence of decay. Sap wood, resinous wood and wood with resinous knots should be avoided, as these will damage paint layers from behind in a relatively short time. If knots are unavoidable, which is sometimes the case, they should be drilled out and replaced by wooden plugs, which are then planed down into line with the panel surface. Sawdust and glue, or a suitable commercial filler can be used to smooth out small irregularities in panels.

Joints in natural wood should be tongued and grooved, then firmly glued. They should be made along the length of the grain only, and all joined pieces should have their grain travelling in the same direction. To reduce the risk of warping, the panel should have a reasonable thickness in relation to its size, and large panels made of solid wood should be 'cradled' on the back with stout batons or strips of wood mounted across the grain. These should be fixed in place in a way that permits a small degree of movement (for example, using an unglued, tapered, dovetailed joint, a system of raised slots or sliding screw fittings). These procedures take account of the fact that natural wood has a much greater tendency to move or distort across its width than along its length; severely restricting all movement in that direction can cause a panel to split. Integral framing and carved decorations may be attached to wooden panels using nails before they are prepared for painting. If metal fixings are used at all in the construction of the panel, they should be punched in and isolated from the paint layers using varnish and filler or small pieces of aluminium foil.

As a general guide, hardwood makes a better panel than softwood. Well-seasoned mahogany is best of all as it is durable and extremely stable. Walnut is unlikely to crack or warp either, but is occasionally attacked by woodworm. Oak, ash, beech, elm and chestnut are also durable and make stable panels, providing they are properly prepared. Maple has a tendency to warp, and birch is prone to excessive shrinking and warping. Balsa wood is soft and very light, but in planks of a reasonable thickness it is strong and can be used to strengthen and stabilize thin panels of other materials without adding greatly to their weight. Oak and poplar are traditional panel-making woods, but this is probably because of their availability in the past rather than their performance as supports.

Processed wood
To overcome the deficiencies of natural wood, which are chiefly the limitations on its size and its directional strength, methods have been devised for converting wood into a more usable product. Processed woods are produced in sheet form and have considerable potential as painting supports. They are easy to work with and are relatively inexpensive. The maximum size of a panel is still limited by the size of sheet, but for most purposes this is more than adequate, 8′ × 4′ (2.4 × 1.2m) being a standard size. It is also possible to use processed woods to create unusual shapes of panel.

The Marriage of Giovanni Arnolfini (1434) was painted in oil on a carefully prepared oak panel. Van Eyck's highly finished technique is made possible by the smooth, stable surface of the panel.

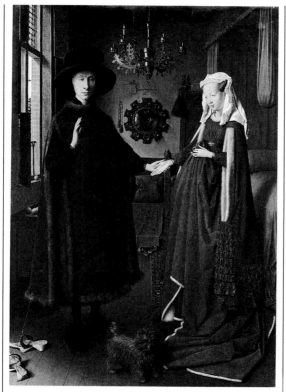

Note that none of the processed woods are made specifically for painters. They are manufactured as a general purpose material in building construction and for a variety of uses in manufacturing. Different qualities are available and the onus is on the painter to select one that is suitable. The only general guide that can be offered is that sheet materials intended for high performance applications in other fields are also likely to perform well as panels.

Processed woods have not been in existence long enough to permit absolute statements about their life expectancy. Early examples of these materials are now showing signs of weakness, but modern products are made to a higher standard. If painters select these materials carefully and prepare them well, there is every reason to suppose that they will make extremely long-lasting supports, though it has been noted that chipboard and hardboard become increasingly brittle with age, and that wood veneers are inclined to produce hairline cracks along their grain.

Plywood

Plywood is made from thin cuts and veneers of natural woods, bonded together in layers under pressure using glue. Each alternate layer is placed with its grain at right angles to that of the layer below, giving the finished sheet strength and dimensional stability in both directions. A good quality plywood will have at least five thicknesses, or ply, but seven or nine will provide an even better support.

Some types of plywood are constructed around a central core of sawn wood which is thicker than the outer veneers. This is said to prevent warping, but top qualities of plywood are frequently made using laminates of equal thickness, with almost twice as many layers for an equivalent thickness. In fact, all plywood has a slight tendency to warp, which often shows itself on a panel as a diagonal twist that is most visible when the panel is seen end-on. It is not usually enough to interfere with the use of a panel or with fitting it to a frame. Large plywood panels should be cradled to help avoid warping, but small ones will be

sufficiently stable, providing the sheet thickness is appropriate to the size of the panel. (*Preparing panels*, p. 59)

The most expensive forms of plywood tend to vary according to their country of origin, and may be more or less suitable for panel-making as a result. Grades intended for external use employ weatherproof glues and wood veneers that are resistant to decay. Marine plywood is more superior still, using durable glues and, as a rule, woods from the mahogany family. Birch plywood is less durable than marine quality, but is of a very high standard and offers great strength and stability.

Blockboard

Blockboard, or lumber-core plywood, is constructed in a similar fashion to plywood, but it has a more solid core made from narrow batons of solid wood pressed firmly together and glued to make a continuous sheet. To provide strength and a suitable surface, this composite core is sandwiched between thin sheets of plywood or a layer or two of thick veneer. The resulting sheet, though extremely stable and most unlikely to warp, is not as strong as plywood and may not always be made with reliable glues or good surface veneers. Nevertheless, when properly prepared it is an acceptable support material.

The main drawback of blockboard is its weight. As it is only practical to produce it in sheets of a reasonable thickness – 1″ (25mm) is a fairly standard sheet depth – blockboard panels are heavy in relation to their size. This is unfortunate as the material is otherwise suited to use on a large scale, where its robust construction and stability do away with the need for cradling or supporting frames.

Chipboard

This material, also known as particle board, is made by shredding complete logs using powerful mechanical jaws, then compressing the small pieces of wood into a sheet with an addition of glue or resin to create a bond. As the wood fibres then lie in a random pattern, there is no directional quality to the sheet, and its strength and stability are uniform. It is reasonably strong and fairly durable, although it may disintegrate in damp conditions; it is friable, and exposed edges are easily damaged. Its lack of flexibility means that it may snap under pressure, and its compacted form also makes it difficult to cut.

Another disadvantage of chipboard is that it produces heavy panels; however, the main drawbacks are its surface quality and tendency to stain. Although it begins with a smooth surface, odd particles of wood are inclined to swell during priming, resulting in a surface which is unsuitable for certain painting techniques, such as tempera. If water is present in the ground and in the paint layers, brown stains may migrate from the board, and it is therefore best to confine its use to oil painting.

Hardboard

Hardboard, also known as Masonite, is made from wood pulp compressed into thin sheets. It is dark or medium brown in colour and has one hard, smooth surface with a slight gloss, and one softer, rugged side with a deeply embossed, mesh-like texture. It is light and fairly flexible, with reasonable strength for its thickness, but it breaks easily compared with other processed woods. It offers a stable surface which should carry a painting well, but it is not thick enough to resist warping, and small pieces should be carefully prepared to prevent warping, while larger pieces are best mounted onto a wooden frame. Alternatively, hardboard may be bonded onto chipboard to combine the surface qualities of one material with the greater strength and stability of the other. Bonding two sheets of hardboard together, back to back, also makes a better panel.

Either side of the hardboard may be painted on, though the smooth side is usually preferred. Before preparation the surface should be lightly sanded to break open its surface a little, and

then wiped down with alcohol to remove any traces of resin or greasiness. (This is especially advisable where the grade of hardboard being used is intended for external use.) The rougher reverse side of the hardboard may be prepared to give a crude imitation of a canvas surface.

M.D.F.

Medium density fibreboard (M.D.F.), which may also appear under various brand names, is similar to hardboard, but is slightly softer and made in much thicker sheets. These are stronger and more stable, and are therefore unlikely to warp. Very often the sheets will have two smooth surfaces, which are leaner and less shiny than hardboard, and so accept ground preparations very well. Fibreboard is greyish brown – much lighter in colour than hardboard. It is fairly heavy, but otherwise appears to be a very acceptable material for painting supports. On balance, it is perhaps the best rigid support material available.

Cloth

Textile supports can be used with any type of paint, but the flexible nature of an oil or acrylic paint layer particularly lends itself to use on cloth. Cloth is not, in fact, an ideal support for paintings, but it offers several distinct advantages over other materials. It is lightweight in relation to its strength, and when stretched it presents a fairly rigid surface. It can be used in any shape or size, and even very large cloth supports are easily transportable, as well as cheap. The negative features of textiles are that their life expectancy is often poor; that they do not create a stable surface on which paint may lie; and that they are easily damaged. Paintings on cloth are thus dependent on the future action of conservators for their preservation. Nevertheless, the advantages of cloth as a support are generally held to outweigh the disadvantages.

Cloth is used in its unbleached state for painting, but in most circumstances it needs to be prepared before it is fit to receive paint. Closely woven, plain cloths make the best supports, although cloth with a texture or open weave may also be used. The quality of any given cloth is broadly expressed as a weight. Cloths employed in painting vary typically between 8oz (227g) and 16oz (454g). The terms light, medium- and heavyweight in the following text should be judged accordingly.

Portrait of Margaret Gainsborough (detail) by Thomas Gainsborough (1727–88). The texture of the canvas can often be exploited to great effect in paintings.

Linen

Linen is the best cloth for painting. It is a strong, durable fabric that, if well prepared, can last for a thousand years. In its natural state, linen is a pale grey-brown. Its surface quality varies; in a fine weave, it may be fairly smooth, while a heavy linen can be quite rough and hairy. Raw linen usually has small particles of woody material trapped in its weave; these should be left in place, for their removal may leave gaps in the cloth.

Linen is an expensive fabric, but when its superior quality is taken into consideration, it compares favourably with cheaper cloths. While it is not difficult to prepare, it does have an erratic response to moisture and heat, which has to be allowed for when it is being stretched (p. 61).

Artists' linen is made specifically for painters; it is a finely woven, quality cloth of medium weight and is generally available in two separate grades: fine artists' linen and extra-fine or super-fine artists' linen (also referred to as portrait linen). Extra-fine, as its name implies, has a very fine weave, with an exceptionally smooth surface. Artists' linen is not completely free from irregularities and impurities in its weave, but it presents a good surface that requires very little improvement during preparation. It may seem rather light for use on a large scale, but its strength does allow it to be used on canvases of a reasonable size. It can be given additional strength by being stretched double. Embroidery linen is a finely woven material that is almost identical to an extra-fine artists' linen, but is bleached and finished; it is a creamy-coloured cloth with a much softer feel. It makes acceptable canvases.

Flax is an alternative name for linen, but the name is often reserved for a particular quality of heavyweight linen with a rough, hairy surface in which slub threads and knots are much in evidence. Flax has a fairly open weave, and is much valued for its surface texture; this can be revealed to a greater or lesser extent, depending on the method of preparation. It is best suited to large canvases, where its weight and strength are an advantage. It is said to be subject to more vigorous movement during its life than lighter linen cloth.

Tow linen is a poor quality cloth that is made from low-grade yarn. At first sight it may resemble flax, but its irregularities are much more pronounced, and it should be avoided. Linen union, as its name suggests, is not made exclusively of linen. This affects its strength, so that when stretched, the cloth behaves unevenly. Superficially, linen union may resemble a mediumweight artists' linen, but it does not make a good support for painting.

Cotton

Cotton is less expensive than linen and is more readily available in qualities suitable for painting; this makes it a popular support. Though less durable and less stable than linen, in favourable conditions it will last well enough. In its raw state, cotton is a creamy white and is soft to the touch. Its surface is quite smooth, but peppered with tiny cotton seeds and knots that show on the finished canvas if they are not removed during preparation. Cotton cloths are generally made from quite fine threads even in the heavy weights, and are usually closely woven. Cotton is easy to prepare, for its response to moisture is predictable.

Raw cotton is known under a variety of names, which are applied loosely and can only be taken as a general indication of the quality of cloth concerned. You should therefore examine it carefully to determine its suitability. Cotton canvas should be a heavy, closely woven cloth that is strong and stable, with a fairly smooth surface and only occasional – and certainly not pronounced – slub threads or knots.

The term cotton duck is also applied to cotton canvas, but most of the cloth known as duck is lighter, middleweight cotton with a softer feel and sometimes a more open weave. While cotton duck can make an acceptable painting canvas, the lightest weights may have a much more open weave than is apparent at first sight, making them difficult to prepare. A variety of cotton

duck known as painting canvas is a lightweight cloth with a bulky weave. When prepared, it shows a definite grain, giving an impression of substance that the cloth does not have. This quality of cloth is popular and well priced, but heavier duck and strong cotton canvas make better painting supports.

Calico is a finely woven cotton that is usually fairly light, though there is some overlap between cloths that might be classed as heavy calico and those that might be considered to be light cotton duck. Except for use as small canvases, it is really too light, though the fine quality of the weave offers a very smooth and even surface that can be attractive. Calico may also be known as cotton sheeting or shirting, depending on its weight.

Hessian
Hessian, or burlap, may be made from either jute or hemp; today it is usually made of jute. It is a coarse cloth not unlike flax in its finer grades, but noticeably rougher. Hessian has a poor life expectancy and weakens considerably in quite a short time, becoming brittle and lifeless. Its roughness and open weave make it difficult to prepare, and its only attractive quality is its surface texture. Hessian is cheap and makes an acceptable support for scene painting, where it can be used on a large scale, but it should not be employed in circumstances where durability is a consideration.

Muslin, cheese-cloth and scrim
Muslin is a very lightweight cotton cloth with an exceptionally open weave. Cheese-cloth is like muslin, but heavier. Linen and hessian can both be made into scrim, which is a reinforcing material with a wide, open weave. None of these cloths are of practical use as supports, but they can all be used to reinforce thick applications of ground on a panel.

Synthetic fabrics
In theory, synthetic materials could be very useful to painters, since they are long-lasting and less affected by external conditions. In practice, synthetic fibres are very difficult to prepare. Acrylic paints perform reasonably well on some synthetics, but on the whole it is better to avoid cloth which is entirely or partly synthetic.

Prepared canvas
Artists' canvas is available in a prepared state both as cut lengths and as stretched canvases. It is more expensive to use this way, but convenient. Commercially prepared canvas varies considerably in quality; some good artists' linen and cotton duck is available, but poor quality cotton and hessian are also on offer. Some of the cheaper prepared canvas is clearly not intended for work of a high standard. Ready-made canvases are usually on lightweight stretcher pieces, and there is little choice of ground. Most prepared canvases have an acrylic ground which may also be referred to as a universal priming. This is theoretically acceptable under oil or acrylic paint, but is by no means the most appropriate ground in all circumstances.

Canvas stretchers
Stretcher pieces should be strong and make up into sturdy frames well able to withstand the forces exerted by a well-stretched canvas. The best wood for stretcher pieces is mahogany, but most stretchers are made of soft wood.

On all but small canvases, crossbars are desirable to improve the stability and strength of the stretching frame. The front edge of the stretching frame should have a raised lip, or its inside edge should be planed away so that the canvas is lifted clear of the frame when it is stretched. Stretchers with a rounded outer edge are said to create less wear and tear along the canvas margins.

Adjustable wedged stretchers are best, but rigid ones are perfectly acceptable if the cloth that is mounted on them begins its life as taut as possible.

Paper and card

Paper is an ancient product that has its origins in China. It is made of vegetable fibres matted together to form a sheet. Western paper was originally made from waste linen in the form of rags, but when cotton came into general use, cotton rags took over as the raw material. With the rise of synthetic fibres they too have grown more scarce, and cotton linters – fibres which are too short to be spun into thread – are used instead, resulting in rather hairy papers. If it is well made, using good materials, paper has a long life expectancy, but it tends to be fragile. In painting it is used as a support for watercolour, tempera, gouache and acrylics, and for pastel painting; if heavily sized it may even be used beneath oil paint. It can be prepared with a ground or combined with other support materials for use in specific techniques (see Watercolour on a prepared ground, p. 164, and Complete pastel painting, p. 168).

Although the term 'rag' continues to be used in relation to paper, it now simply implies the use of natural fibres. The best quality paper is now made from cotton, sometimes with the addition of other fibres, such as flax or manilla. The description '100 per cent cotton' is also used for some modern papers. Intermediate qualities are also produced with a partial rag content; these are described by reference to their actual contents and may be called, for example, 50 per cent cotton or 25 per cent rag, etc.

Since the 19th century, wood pulp has also been used as a raw material for paper. This is greatly inferior to rag and produces paper which yellows badly and degenerates physically in a very short time. Wood-pulp papers are of no use to painters, though a modern, improved paper type derived from wood does exist which offers an acceptable alternative to pure rag papers. It is called wood-free paper, or may be described as containing alpha cellulose or photographic wood pulp.

If papers are to last they must also be acid-free; in other words, chemically neutral (pH7 is neutral, but pH6.5 to pH8 is regarded as neutral for all practical purposes). Wood-pulp papers are likely to be acid, and acid may also be introduced into paper during sizing or if it is coloured. Pure rag and wood-free papers should be acid-free, and it is now the policy of most manufacturers and suppliers to state clearly that this is so when they offer their products for artistic use.

Hand-made papers
Traditional hand-made papers are still the best for painting on. There are now only a few manufacturers, and the paper is expensive, but it ages extremely well and its random surface texture adds character to a work. It is strong and more likely to dry flat after painting. Hand-made paper is made in single sheets with an irregular edge, called a deckle edge, on all four sides, and is generally tub-sized using gelatine. In common with all good quality papers, it carries an identifying watermark which can be seen when it is held to the light.

Watercolour papers
Most hand-made papers are intended for watercolour painting, and many machine-made papers are also produced for this purpose. The best are described as 'mould-made', indicating that they are made on a machine called a cylinder mould. These papers have only two deckle edges, but may be torn on the other two sides to imitate a hand-made sheet. Machine-made watercolour papers are much cheaper than hand-made ones, and offer consistent quality which lacks only the character and sometimes the strength of the traditional product. For this reason they are widely used, and all but the most discerning painters find them satisfactory.

The products of different manufacturers vary considerably in their surface quality, and in their type and degree of sizing. It is

impossible to state categorically that certain types are better than others as this depends on the preference of the individual painter and on the technique being employed. However, as a guide, rag watercolour papers sized with gelatine offer the best quality. Wood-free watercolour papers are also available at a lower cost. These perform well but may lack the subtleties of the better papers in some techniques. All qualities of watercolour paper should be acid-free.

Off-white papers are to be preferred to those which are stark white in colour, as they are more likely to maintain their level of brilliance as they age. Watercolour papers are available in a choice of weights and surface textures. Weights are expressed in pounds, or in grammes per square metre. The lightest are usually 90lbs (*c*.190gsm), while the most substantial are generally 300 lbs (*c*.610gsm).

Lightweight papers buckle and distort when wet and need to be stretched before use. This is done by soaking the paper thoroughly, keeping it flat, then taping it to a board with gummed tape and allowing it to dry naturally. Convenient blocks of pre-stretched paper are available as a commercial product. Heavyweight papers approaching the thickness and stiffness of card do not need this treatment.

The available surface qualities are as follows: 'not', also known as CP or 'cold-pressed', is the standard surface, which has a light random grain suited to most methods of painting. 'Hot-pressed', also known as HP and as 'fine', has a smooth surface with hardly any texture, which suits detailed styles of painting and flat, even applications of colour. 'Rough' has a pronounced surface texture which is particularly useful in some techniques, as it enlivens the effect by trapping pigment in an irregular fashion. The exact quality of the surface varies from manufacturer to manufacturer, and 'rough' in particular may be mechanically repetitive or pleasantly random in different ranges. All three surfaces are not necessarily available in all paper weights.

Watercolour papers may be described as 'tub-sized' or 'internally sized'. Tub sizing is done after the paper is made and is usually a traditional gelatine size. Internal sizing is introduced into the paper pulp before it is converted into sheets, and is therefore present in an even concentration throughout the paper. There are merits to both approaches, though some painters still regard tub sizing as superior. Papers may also be hand-sized by painters themselves to reduce the absorbency to a different level. Watercolour papers originating in Europe may be described as aquarelle papers. Although they may use local names to describe their surface qualities, they will still correspond to the not, hot-pressed and rough grades.

Pastel and gouache papers

Papers with a definite surface texture, or 'tooth', are best suited to pastel painting as they hold colour well. Coloured papers are also suited to pastel painting and to gouache painting, where the highlights are seldom, if ever, drawn from the ground. Ingres paper is a reliable, readily available paper that is usually made in a quality suitable for pastel painters. It is a laid paper, which means that its surface texture is made up of close parallel lines. A quite extensive range of tones is available, ranging from pale tints to strong colours, and versions with an internal colour fleck also exist. Ingres papers are available in light and medium weights, and need to be stretched or mounted for painting. Various brand-named pastel papers are also available, offering a range of colours and surface textures which are also suitable; those which clearly state that they are acid-free and that their colour dyes are permanent are to be preferred. Note that inexpensive coloured papers are likely to fade and become brittle in a short time.

Other papers

Many other papers exist which are of practical use in painting, though not all are intended for such specialized use, and care should therefore be taken when unusual paper supports are being selected. Cartridge paper, also known simply as drawing paper, is a semi-smooth, light- to middleweight paper for drawing and sketching. The heavier qualities can be used for painting if stretched. General purpose drawing papers are often of unspecified quality, but acid-free rag or wood-free versions are certainly available. Good quality tracing paper is obviously a useful product in the studio, and quadrille and graph paper may assist the process of squaring up (*see* p. 91). Also of interest are imitation parchments, hand-marbled papers and Japanese and Indian decorative papers.

Card

Where a more rigid support is required, card can be used in place of paper, though unfortunately, few qualities of card are of a sufficiently high standard for use in painting. Picture mounting board, also known as mat board, in museum, conservation or archival quality can be used, as it is acid-free and designed to have a long life. Foam board has a polystyrene core faced front and back with acid-free paper, and has the advantage of being very light and stable even when used in fairly large pieces.

Bristol board is a thin, smooth-surfaced card made from pasted up sheets of paper. Watercolour board, and line and wash board are types of illustration board made by bonding a sheet of watercolour paper onto a card backing. Each of these products is more likely to be aimed at commercial designers than at painters, and may or may not be of a satisfactory quality. Good quality papers may, of course, be pasted up or mounted by painters themselves, using materials that meet the desired standards.

Card faced with a primed and textured paper resembling canvas, and thin primed canvas bonded to card are sold for acrylic and oil painting as canvas board; these may also be referred to as canvas panels. Although popular with amateurs, they cannot be regarded as important supports as they fall well short of the performance both of a real canvas and a real panel.

Millboard

Millboard is a densely compressed variety of card, usually with a high resin or glue content, used for backing books, but it has been used now and again by painters for small panels and as a support for sketches in oil paints. It has shown itself to be a quite reliable material and may be used as a suitable alternative to, or even an improvement on, hardboard (Masonite) in some circumstances. Millboard is produced in several thicknesses, typically varying between 1 and 3mm in steps of $\frac{1}{2}$mm. It is brown in colour, and when sized or lightly sealed with varnish, offers a warm, dull tone that can be most effective as a ground. It can also be prepared in the same manner as a panel (*see* p. 59).

Walls

Painters seldom have much say in the selection or construction of a wall for a mural painting, as it usually already exists to begin with. If it is at all damp, no painting in any technique will survive on it. The wall should have a damp-proof course and should not be subject to penetrations of dampness from any external source. Any old plaster which is loose or crumbling should be removed (this is necessary anyway if the true fresco technique is being employed, *see* p. 180). Peeling coats of paint must also be taken back if the painter's own paint is to take a firm hold, and if the previous coats of paint are in oil, only oil paint should be used over them. Sometimes it is advisable to skim the wall with a fresh coat of plaster.

For wall paintings in acrylic and the various temperas, no

priming is necessary, though any wall will benefit considerably from a coat of size. Size should also be applied before oil paint, though alternatively the wall could be sealed with a dilute mixture of stand oil and boiled oil. Virtually all wall surfaces are alkaline, and only the careful selection of good quality materials able to tolerate this will ensure that a mural painting lasts. Exterior murals require very favourable conditions and extremely good materials if they are to last for an appreciable length of time.

This Portrait of Francis Bacon *(1952) by Lucian Freud is painted in oil on a metal support.*

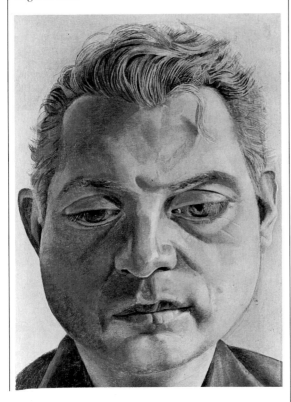

Frank Stella's Guadalupe Island Caracara *(1979) is executed on a honeycomb panel in a mixture of media.*

Stone

Various types of stone have been experimented upon as painting supports. Some fine examples have survived from the Renaissance, which are in excellent condition, executed in oil paint on decorative marbles, onyx and slate. Slate is obviously practical for use in sheet form, but the other materials offer a more interesting background which can be incorporated into the work. Non-absorbent stones require no preparation, but it is advisable to wipe them down with white spirit before starting to paint. Stone from the sea should be well washed to remove all traces of salt.

Metal

Thin sheets of metal make suitable supports for oil paint, especially on a fairly small scale. Copper and brass have been used traditionally, but stainless steel can also be employed today. Metal panels should be prepared by cleaning with alcohol and abrading their surface to remove all trace of an oxide layer, and to provide a 'tooth' for the paint layer. Some pigments can be affected over a period of time by the chemical action of metals, especially in the case of copper, and a ground is always advisable. Apply thin layers of oil paint, allowing each coat to dry before the next is put down, to build up a substantial ground.

Acrylics should not be used on metal in spite of the fact that this is sometimes recommended by manufacturers. They are unable to get a satisfactory grip on the surface, and the whole paint layer can peel away if it is loosened.

Ivory

Thin slivers of prepared ivory can be used as a support for miniature painting. African elephant ivory is used in pieces which are about $\frac{1}{2}$mm thick. The painting surface is prepared to a smooth, matt finish, whilst the reverse side shows the marks of the ivory saw. It is bleached before use and should have a cool white, opalescent appearance. Ivory should be properly prepared to prevent it from yellowing (*see* p. 183).

Genuine ivory is now expensive and in short supply, but a synthetic substitute call ivorine is more easily obtained. This is not as good as real ivory, but is accepted as the only practical alternative by many painters.

Vellum

Vellum is a paper-like substance made from calf-skin, which can be used as a support for water-based media – especially gouache and watercolour – for miniatures, small paintings and illuminated designs. Vellum is white, tending towards cream and when held to the light it reveals a vein-like pattern. Although stiffer than paper, it is still flexible. Its already smooth surface may be burnished before painting to give it an exceptionally fine finish (*see* p. 112).

Genuine parchment, made from sheep or goat skin, is similar to vellum. It is mostly used for calligraphy and is seldom employed as a painting support. The name vellum is also applied to smooth, good quality papers which vaguely resemble the real material.

Honeycomb panels

Various modern materials which employ a honeycomb structure in order to achieve a high degree of strength and stability at a low weight, offer potential as supports. Honeycomb aluminium,

used in the aircraft industry, can be made into panels by facing it either with aluminium sheet, or glass fibre and resin. Accurate machining is required to make such panels, and high strength epoxy resin adhesive must be employed in their construction. The only apparent drawback is the question of whether or not ordinary artists' paints can be encouraged to bond permanently to an aluminium or resin surface. This may require some new method of preparation. A satisfactory solution might be to bond other sheet materials over the top of such panels.

Some of the honeycomb products now available for use in building construction may also make good supports if combined with other materials and suitably prepared.

Picture boxes

The picture box is an ideal support for studio experiments in the fresco technique. A shallow wooden frame backed with chicken wire or plastic-covered wire netting, it provides a means of producing small portable works in fresco. Layers of lime plaster are built up within the box in the same sequence as they are put onto a wall (*see* p. 181). If a piece of cloth is pinned across the back of the picture box before the first layer of plaster is applied, the reverse of the plaster panel will have a smoother finish. The cloth is removed at a later stage to allow drying.

Plasterboard

Plasterboard, a sheet material used in building construction, consists of an even layer of pink- or grey-tinted plaster applied to a backing of light card. It breaks easily and cannot really be recommended as a support, though some painters have succeeded in exploiting its absorbent surface quite effectively. Plasterboard is a suitable support for studio experiments on mural techniques.

Glass

Glass is used as a support for very specific painting techniques (*see* p. 183), normally employing oil and resin oil colours. Acrylic paints are often recommended for use on glass, but as in the case of metal supports, there is a risk that the paint layer may lift. Plate glass is less likely to break, but it is heavy. Glass should be prepared by washing, drying and then wiping over with alcohol to remove all traces of dirt or grease.

Plastic

Unfortunately, plastics are unsympathetic towards most artists' materials, though they may have some potential as supports for acrylic. Oil paint will adhere to plastic, but may well crack or peel away in the long term. Specially prepared clear acetate sheet, which will accept most media, is supplied as a graphic artists' material, and dimensionally stable, non-ageing polyester is used as drafting film. It is theoretically possible that these materials could be adopted by painters, but no firm comments can be made on their suitability.

Grounds and primings

Few supports are ideally suited to accept paint in their natural condition, and most must therefore be prepared with a ground or priming. This serves several purposes. Firstly, it acts as a barrier between the support and the paint layer, preventing chemical interaction between them and preserving both the support and the painting on it. Oil paint, for example, will destroy support materials such as canvas or paper if it is allowed to penetrate them. Certain preservatives in paint can also be damaging, and some supports are themselves sufficiently active to damage sensitive pigments.

A satisfactory barrier can be produced by sizing the support or by putting down a thin layer of medium. This performs a second function, which is to stabilize the surface of the support by restricting its potential for movement. Cloth, for example, becomes more rigid and presents a much smoother surface once it has been sized.

The third function of a ground is to present a surface that is suitable to receive paint, either by reducing the absorbency of the support, so that the paint becomes more workable, or by filling irregularities to give a flatter, smoother working surface. In addition, grounds may change the colour of the support to provide a more suitable background for the paint. This third function of the ground is, in fact, a vital component of many painting techniques, where a suitable beginning brings about the desired result. This should become clear when the individual techniques are considered in Part 2 of this book.

Commercially produced grounds are basic and not always of good quality. They are intended to be acceptable for the widest possible range of techniques and consequently fall short of excellence in many applications. There is therefore a great deal to be gained by preparing supports for yourself using your own choice of ground (*see Recipes*, p. 63 and *Chapters 2.3–2.8*).

The term ground is quite general in meaning and may refer to either a simple preparation or a complex structure involving several layers. Strictly speaking, a priming is not the same as a ground; it is a further layer that goes over the ground to modify its colour and absorbency. (This is the *imprimatura* of traditional painting techniques.) However, in modern usage the terms ground and priming have become fused. The intended meaning in this book should be clear in each instance from the context.

Preparing panels: 1st method

1. *Check the panel carefully for warping and for defects that could cause problems later.*

3. *Cover the panel in light cloth that has been well soaked in size. Allow sufficient margin to wrap round onto the back.*

5. *Trim away surplus cloth at the corners to produce a neat finish, or fold it neatly and press it into the size.*

7. *Applying the ground with a knife also forces it into the panel surface and helps prevent pin-holes caused by air bubbles.*

2. *Give the panel a generous coat of warm size using a brush. Size both sides and the edges.*

4. *Use a knife to slash the cloth if it has to be fitted around an unusual shape, but keep cuts away from the face of the panel.*

6. *The first ground coat must be worked right into the surface of the panel. It can be scrubbed on with a stiff brush.*

8. *Alternatively, the ground can be rubbed on with the hand; any pin-holes that occur can be dealt with using the fingers.*

Recipes
Preparing panels

Panels made of wood or processed wood are usually prepared with a gesso ground. This gives an exceptionally smooth and brilliantly white surface which will accept any type of paint, and which is particularly suited to tempera. A further priming on top of the gesso ground may, however, be appropriate for some techniques. The account which follows describes the ideal method of preparing a panel. For good results this should be followed closely, and only those variations which are clearly indicated in the text should be considered.

Sizing
Panel-making should not be rushed. Begin by checking the panel core to ensure its quality, construction and cleanliness. If it is satisfactory, the first step is to size it using animal glue or gelatine at a strength of 1oz to 10fl.oz. of water (or 100g per litre). This is applied with a brush all over both sides of the panel and allowed to dry. The size layer can be applied in two coats if preferred, the first one being put on at half strength and at right-angles to the second. The size should be hot, so that it penetrates well into the panel and does not lie too heavily on its surface (*see* pp. 43–4).

Applying cloth
The following day, take a piece of light cotton big enough to overlap the panel by at least 2″ (5cm) on each side. Some shrinkage will occur once the cloth is wetted with size, and this should be allowed for when the cloth is cut. Reheat the size and coat the panel again. Immediately afterwards, soak the cloth in the remaining size and lay it over the front of the panel. Using the flat of the hand or a rubber-covered roller, smooth out the cloth, making sure that it is fixed firmly onto the panel surface. Now turn the panel over, and having applied size generously to the edges and back of the panel, wrap the margin of cloth around it. Stretch the cloth with the hands as it is wrapped around the edges of the panel to make up for potential shrinkage, and press it down firmly. Use a knife to trim away excess cloth at the corners and to give a neat finish. If the panel is of an unusual shape, the cloth margin may have to be slashed into sections to help it wrap around the panel. It is best to apply the cloth in a warm room which prevents the size from setting before the operation is completed.

This fabric layer helps to hold the ground in place when it is applied and, more importantly, cushions the ground against movement in the support. It is not absolutely essential, but if a cloth is not used panels made of plywood, blockboard or natural wood may shown hairline cracks in the ground corresponding to the direction of the grain. This is slightly disfiguring, although it may not be damaging in the long term. A cloth layer is less important on processed woods with no grain.

Applying the ground
When the panel and its cloth covering are completely dry, prepare some gesso following the recipe given later in this chapter (p. 63). First of all, apply a coat to the back and edges of the panel. (The risk of warping is considerably reduced if both sides of the panel are treated equally.) After about half an hour, when this has set and is no longer visibly wet, apply a further coat. The back of the panel should be well covered with gesso, and up to two more coats can be put on if desired. Later, the painted front of the panel should be balanced by a flat application of colour or a coat of varnish on the back; any changes in temperature and humidity will then have an equal effect on both sides of the panel.

When the back of the panel is dry, turn it over and begin work on the front. The first layer of gesso must be put on thinly and worked well into the surface of the panel, either by scrubbing the gesso onto the panel using a stiff brush, or by scraping it into place

9. *The back and edges of the panel should also be coated with ground to protect them from external influences.*

10. *A soft gesso containing gypsum can be surfaced with a knife. Any lumps should be scraped down before finishing begins.*

11. *Pumice, followed by fine sandpaper wrapped around a cork block will bring the surface to a smooth finish.*

12. *A wad of rag dipped in lukewarm water produces the smoothest finish. Do this after sanding.*

Preparing panels: 2nd method
1. *Heat some drying oil in a pan and keep it warm and fluid while it is in use.*

2. *Brush the hot oil onto the panel with a large brush and let it soak in. Repeat this until it will take up no more oil.*

Preparing a canvas
1. *Assemble the stretching frame and check that it is square. Have all the other necessary items handy.*

2. *Lay the cloth flat and place the stretcher over it to act as a guide during cutting. Allow a sufficient margin on each side.*

using a large palette knife. A third alternative is to rub the first layer in using the flat of the hand. This is one of the most effective ways of removing pinholes in the gesso, caused by air trapped in the cloth or in the bristles of the brush. These must be removed at the outset, otherwise they will penetrate every successive layer.

Allow around half an hour between coats of gesso, but be guided by its appearance and do not work over layers which still look wet. When the gesso layer takes on a matt appearance, a further layer can be put on. This should be done at right angles to the previous layer so that deep brushmarks do not build up in one direction. It is easiest to put gesso on with a brush, but a succession of thin, smooth layers can also be put on with a palette knife. At least four coats of gesso should be put on the front of the panel; six or eight will give a better finish, and up to ten or twelve can be used if the coats are thin. There should be at least enough gesso on the panel to obscure the weave of the cloth and to allow for some sanding back during finishing. Knowing when this point has been reached is a matter of experience.

Finishing
The gesso ground should be surfaced only when it is completely dry. This is likely to be a full 24 hours after the last coat was applied. First remove any roughness from the back and edges for the sake of neatness, and then slowly smooth down the front. In the first instance, the edge of a flat-bladed knife can be used to scrape down areas of roughness, followed by fine sandpaper wrapped around a cork block. If a soft gesso containing gypsum has been used, the panel will be easy to finish. Gesso containing chalk is harder and has to be taken down with sandpaper from the outset. The quality of the glue may also affect the hardness of the gesso. In a strong light it can be difficult to see whether or not the ground is smooth. Tilting the panel at an angle so that it catches the light helps to show up brushmarks. Another method is to slide powdered charcoal down the front of the panel so that it catches on patches of roughness.

When sanding has brought the panel to near perfection, take a clean piece of cotton rag and soak it in luke-warm water. Wring it out and form it into a pad, then gently rub over the surface of the panel in a circular motion. This will dissolve and redistribute the top of the gesso layer and bring it to a state of ivory-like smoothness. Any glassy shine brought out by sanding will disappear at this stage to leave a flat, matt finish.

The panel is now ready for use, but it should be left at least another 24 hours before being painted on. Faults in the gesso ground will show themselves very quickly. If no faults appear within 48 hours of a panel being finished, they are unlikely to appear at all, in which case the panel should age well.

Alternative method
Panels of wood and processed wood may also be prepared as follows when they are being used as oil-painting supports. Take some boiled linseed oil – commercially prepared oil is acceptable for this purpose – and heat it for a few minutes in a pan until the surface of the oil begins to swirl. Remove it from the heat and using a clean brush, paint the panel all over. The hot oil will penetrate deep into the wood. Once it is soaked up completely, brush on more oil and allow it to sink in. Remember to be careful whilst handling the hot oil and, if necessary, use a pair of tongs to turn the panel.

Keep feeding the panel with oil in this fashion until it will take up no more. Set the panel aside to cool, and when it is safe to handle, wipe off any surplus oil from its surface using a clean rag. It must now be left to dry for 10–14 days, after which time the panel will be completely sealed and isolated from outside influences; it is most unlikely to warp. At this stage the panel can be primed with lean oil paint in whatever colour is appropriate. The priming should be given as long as possible to dry before being painted on.

Preparing a canvas

This description of how to prepare a canvas does not go into detail about the types of ground and priming that can be applied, since these have infinite variety; their

3. *Shave down knots and slub threads by taking a pumice stone over the cloth. This will leave the weave clean and tidy.*

5. *Canvas straining pliers can be an advantage in helping to produce a taut canvas.*

7. *If you tack a canvas into the edge of its stretcher, prime the cloth before trimming it flush with the stretcher.*

9. *When the size layer is dry, skim over the canvas once more with the pumice stone to remove any remaining irregularities.*

4. *Begin stretching by placing a tack in the middle of one of the longest sides.*

6. *Stretch the canvas along each side at the same time, working outwards from the middle. Keep the weave of the cloth straight.*

8. *After stretching, apply a coat of warm size using a large brush. Two thin coats can be put on if you prefer.*

10. *A smooth finish can be achieved by applying a thin ground with a knife. Congealed size can also be put on in this way.*

application is treated here simply as a stage in the preparation process, and you should treat these instructions as an ideal method around which variations are permissible.

Cutting

First assemble the canvas stretcher (p. 55) and check with a set square (triangle) to make sure the corner pieces are properly aligned. The stretcher should have a lip or chamfered edge, which should face the canvas when it is stretched over it.

Once the frame is assembled, a piece of cloth should be laid out on a flat surface and the stretcher placed over it. Using the stretcher as a guide, cut a piece which allows a margin on all sides; if canvas straining pliers are being used, 2″ (5cm) is usually sufficient, but if the canvas is being stretched by hand, 3″ or 4″ (7–10cm) will be required.

Surfacing

With the cloth still on a flat surface, go over it with a piece of cut pumice stone or some fine sandpaper wrapped around a block. Do not rub too hard or you will damage the cloth, but ensure that every part of the canvas is skimmed to remove impurities and to reduce imperfections. Knots and slub threads can be rubbed more vigorously so that they are substantially shaved down, thereby also removing any hairiness and leaving the pattern of the weave clearly exposed. The surface of each thread will be lightly broken open by this procedure, and the threads will then take up size much better.

Stretching

Having pumiced one side of the cloth, turn the piece over and position the stretcher on the back of it so that the right amount of margin is left all round. Beginning on the longest side, fold over the margin in the middle and tack it in place. Then, on the other side of the stretching frame, tension the cloth directly opposite the first tack and put in another tack to hold it in place. Repeat this procedure on the shorter sides of the frame.

Working outwards from the middle of each side, systematically stretch and tack in the same manner, always pulling against a tack that has been placed on the opposite side. Do not work along one direction of the canvas at once, but stretch a distance along the length and then along the width. In this way an even tension is built up from the centre of the canvas outwards in all directions.

Avoid driving tacks through the joints when the final piece of cloth is folded over and tacked down at the corners. If you have to place the tack directly into the joint, shorten it by nipping off the point with some pliers. Whether the tacks are driven into the back of the stretching frame or into its edge is a matter of personal choice.

Linen canvas

If you are using a linen or flax canvas (p. 54), do not drive the tacks all the way home as the cloth is mounted, since you may need to remove them later. Once stretched, the canvas should be wet thoroughly with warm water and left a full day to dry out. First it becomes tight, then it will relax and its surface will buckle. Gradually, as it dries further, its surface will return to a flat condition, though small areas of buckling may remain where there is slackness in the canvas, and the overall tension of the cloth will now be less than it was when first stretched.

At this stage the tacks are removed one by one and the cloth is restretched. There will only be a small amount of slack to take up, but it is enough to affect the flatness of the painting surface. The same sequence occurs when flax or linen canvas is sized, but it is easier to take up the slack on an unsized canvas, having treated it with water alone. If the canvas is exposed to moisture again during its preparation, it will continue to behave erratically, eventually returning of its own accord to a state of even tension.

Sizing

Having stretched the canvas, the next step is to size it. Sizing is essential if oil paint is being used, since it prevents the oil from gaining access to the fibres of the cloth. Oil will hasten its destruction and ultimately cause it to rot. Whilst sizing is less important under

11. *Liquid ground materials should be applied with a brush. Brush them out thinly and work them well into the weave.*

12. *Thick ground materials can be put on using the palm of the hand to spread them smoothly over the canvas.*

13. *Once the ground is dry, any remaining roughness can be removed by skimming the primed canvas with the pumice stone.*

14. *An exceptionally smooth finish can be obtained from a gesso or tempera ground by rubbing it down with a damp rag.*

15. *When linen is being used, drive the tacks only half-way home to permit re-adjustment of the tension during preparation.*

16. *A ready-primed canvas may need wedges to make it taut, but with a well-stretched canvas they should only be tapped lightly into place.*

Making up glue size
1. *Allow the glue to soak in water until it expands and becomes soft.*

2. *Use hot water to warm the glue-and-water mixture until it melts. Stirring speeds up the process.*

other paint types, it is nevertheless a good procedure in all cases; it flattens the surface of the cloth and reduces its absorbency.

Canvas may be sized with gelatine, animal glue or starch (pp. 43–4). The first two give the best results and are normally used on canvas at a concentration of around 1oz per 15fl.oz. (70g per litre) of water. Size is normally applied with a brush, which should not be too heavily loaded, as you should try to prevent the size from penetrating to the back of the canvas. Size can also be put onto the canvas using a large palette knife, scraping it on when it is in a partly congealed state, but this tends to produce too thick a layer.

Resurfacing
When the size layer is dry, the canvas should again be rubbed over with the pumice stone. The size will have hardened any remaining impurities on the canvas surface and this will make them easier to cut away. This time, however, the pumice will not break open the fabric threads; it will simply glide over the surface attacking any obstructions. At this stage, knots and slub threads can be taken down even further while the canvas is supported from behind with the hand.

Usually this second pumicing will not break through the size layer, which will have penetrated deep into the cloth as a result of the first pumicing. If, however, it appears that it has broken through, a second application of size should be made.

Applying the ground
When the size is dry, the ground can be applied (pp. 59, 63–4) and, if required, a priming can be put over the top of that. If a thin ground is desired, it can be diluted and put on with a brush; for an even coverage, two very thin applications should be made, one after another, with the coats brushed on in opposite directions so that no patchiness occurs. Where a cloth has an open weave a ground must be used to fill its pores, and here it may be an advantage to apply it with a knife or to sweep it on with a sponge or rag so that it is pressed well into the holes in the cloth. The palm of the hand is also a useful tool in this process.

When the ground layer is dry it may again be pumiced to smooth out the brush marks and to improve its surface further. Thin grounds applied with a brush will reveal the texture of the cloth and, as a general rule, perform best. Where thick grounds are desirable (to obtain a very smooth or absorbent surface, for example), they should be applied by pressing them well into the surface of the cloth, as they have a tendency to peel and crack if they sit over the surface like a sheet.

Making up size

Glue size is made from animal glue or gelatine, and water. The ingredients should be measured, at least approximately, to give the right strength of size; if accurate weighing is impossible, use volume measures instead. One volume of glue in fifteen volumes of water is equivalent to 1oz per 15fl.oz., or 70g per litre; this is the correct strength for use on canvas. One part glue in ten parts water by volume is the same as 2oz of glue to 20fl.oz. of water, or 100g to a litre; this is the correct strength for use on panels. Lower strengths may be used for general purpose sizing.

Method
Put the dry glue and water in a heatproof container, preferably a metal pan or dish which will conduct heat well, and allow the mixture to stand. Depending on the size of the glue particles, it will take between half an hour and six hours for the glue to soak. When it is fully soaked it will have taken up water, becoming swollen and soft, without actually dissolving in the water. At this point the size container should be stood inside a larger heatproof container, and boiling water should be poured into the gap between them. This will provide sufficient heat to warm the glue, and in a few minutes it should become completely liquid. Stirring the glue will help it dissolve. The size solution is now ready for use. (*Glues*, p. 43).

Gesso

1. *The best gesso grounds contain white pigment, which gives them greater brilliance without affecting the leanness of the ground.*

2. *Use one volume measure of pigment and one of whiting. You will also need some dry glue to make up into size.*

3. *Mix the dry pigment and whiting powders in a bowl and add just enough water to form a soft paste.*

4. *Make up the glue size and gradually add one volume measure of it to the pigment and whiting mixture.*

Gesso grounds

The basic recipe for a gesso ground is simple. It consists of one volume measure of glue size mixed with two volume measures of white filler. Variations are introduced by using different qualities of size and, more importantly, by altering the composition of the filler. White gypsum is the traditional material, from which gesso gets its name, but finely powdered whiting is a more common ingredient today. In fact, any of the white fillers can be used, and blends between them will produce different qualities of ground. In addition it is good practice to replace up to half the filler content with white pigment. This produces a more brilliant and more permanent gesso (*Pigments and fillers*, p. 20).

Method

Place 1 part by volume of whiting and 1 part by volume of zinc or titanium white pigment in a large bowl. Stir them together whilst dry to mix the powders evenly, then add some clean water, little by little, stirring repeatedly. Add only enough water to form a thick, smooth paste. Now cover the bowl and let it stand for several hours.

When you are ready to use the gesso, make up some size solution, and while it is warm and liquid, add one volume measure of size to the contents of the bowl. This should be added slowly, stirring vigorously between each addition. At first the combined mixture will congeal, but as more glue is added it will relax into a thick, semi-liquid state. Adding the rest of the glue will thin the gesso mixture to the consistency of cream, at which point it is ready to use. If the glue is added too quickly the gesso will be imperfect and may contain lumps; if it is done properly, this method produces a very smooth gesso.

Gesso is usually applied warm and, like the size it contains, will gel on cooling, but standing the bowl in hot water will make congealed gesso liquid again. If gesso is prepared in winter or in cold and damp conditions, a lower concentration of glue is recommended, as this reduces the risk of cracking. One teaspoonful of glycerine added to 20fl.oz. ($\frac{1}{2}$ litre) of the size solution makes the gesso less brittle and also helps to prevent cracking.

Gesso sottile

Burnt gypsum is plaster of Paris. Added to size this produces *gesso grosso*, which is a coarse foundation coat for use on panels. *Gesso sottile* is an exceptionally fine, smooth finishing coat which is made by slaking the basic plaster of Paris; that is, by soaking a small amount of plaster of Paris in a large amount of water. Stir as it is first introduced and then every few minutes for the next hour to prevent it setting. After this it should be stirred every few hours, and finally once a day for at least the next few days. Then simply leave it to stand, and about three months later it will have changed its crystalline structure to become *gesso sottile*. At this point pour off the water and strain the sludge through a cloth. It is stored as dry blocks and crushed to a powder when needed.

Tempera or emulsion grounds

The gesso recipes may be modified to include a drying oil, which makes the ground more flexible and less absorbent. The ground is then suitable for use on canvas, while still retaining some of the desirable characteristics of gesso. Such grounds are known as half-chalk grounds, or as tempera, or emulsion grounds.

The recipe is the same as for gesso, except that the plain glue size is replaced by glue tempera (*see* p. 51). The amount of oil can be varied to achieve different results. It should represent a straightforward addition to the gesso ingredients, and the size content should remain constant at one part by volume. However, when large amounts of oil are added, extra filler can be included in the recipe to maintain the body of the ground. This type of ground should be left for 7–10 days before being painted on and will improve the longer it is kept. If it is kept reasonably lean, it will accept most paint types, but in its richer form it is ideally suited to use beneath oil paint.

Tempera and oil grounds
1. *Boiled oil, stand oil or plain linseed oil can be added to the glue size to create an emulsion ground.*

2. *A lean oil ground can also be made by working up pigment to a stiff paste, preferably using boiled oil as a binder.*

Glazed grounds
1. *First prepare a canvas with a white ground. It should be smooth, so that the glazed priming does not collect unevenly.*

2. *Tint any suitable medium with a small amount of colour and spread it thinly over the white ground.*

Double grounds
1. *Lay a coloured ground and allow it to dry thoroughly.*

2. *Apply a different-coloured ground over the first in a half-covering fashion so that both can be seen at once.*

Oil grounds

A tempera ground with a very high oil content can be classed as an oil ground, but a priming of lean oil colour also fits this description. To make such a ground, grind pigment and filler with boiled oil as thickly as possible. Then remove some of the oil by standing the resulting paste on blotting paper. When it has the consistency of putty, soften it with a little turpentine and spread it thinly over the support.

It is reasonably safe to paint on this type of oil ground after a month, but if it can be left for six months to a year, it will be more reliable. If any ground is painted on too soon it can seriously damage a painting later in its life.

Coloured grounds

To make coloured grounds, replace the white pigment in the ground recipe by one or more coloured pigments. A ground can be any colour, but the following have shown themselves to be useful.

Dark 'bole' grounds are made using red earth pigments or browns, while a livelier 'bole' ground can be made using equal parts of red and yellow ochre. Brick red and dull orange are achieved by increasing the proportion of yellow ochre, though these colours are usually broken using a small amount of black or umber to give them a mellower tone. Yellow ochre with a little red ochre, a trace of black and some white produces a dull tan grade which is neither too dark nor too strong in colour. Dark grey combines black and white pigment, and a dull near-black can be created from a random mixture of earth colours with small amounts of any other colours that are to hand.

Tinted grounds

A tinted ground contains some colour, while retaining a high proportion of white pigment in its composition. Traditional colours are pale grey and silver grey, made from white with a trace of black or charcoal; pink, made from white with a little red ochre; cream, made from white with trace of yellow ochre; and buff, made either from white and yellow ochre or from white and raw sienna. A very pleasant buff ground can also be made using white and the tan mixture described under coloured grounds above. A traditional grey-green is made from white, yellow ochre and a little black.

Glazed grounds

In a glazed ground a white ground is put down to begin with, then a thin transparent layer of pure colour suspended in medium is put over it. The visual effect is more brilliant, and some authorities consider such grounds to be more permanent. Glazed grounds may also be strongly coloured or tinted, typical colours being honey, pale pink, a glowing yellowish-tan and a warm brick red. The glazed colour can be put on flat, or the marks of a sponge or brush can be used deliberately to create interest.

Double grounds

A double ground consists of a thin layer of tinted ground placed over a coloured ground in a patchy or veil-like manner, resulting in a combined effect. It is usual to play off warm against cool, or light against dark to achieve some intermediate effect. Traditional double grounds include grey over red, pale blue or pale green over red, buff over red, buff over brown and cream over buff. Livelier colours could easily be used in modern adaptations of the principle (*see* p. 31).

1.4 Paints and pastels

Tempera

History

To appreciate the history of tempera it is important to understand that tempera is not a single paint, but a group of paints with certain properties in common, employed in the same techniques to produce similar results. Although individual temperas differ quite considerably in composition, their essential characteristics remain the same.

This becomes clear when the origin of the name is explained: 'tempera' literally means any substance that will serve to 'temper' pigment by binding it into a workable mixture. By this definition all paints are, in fact, temperas. In practice, oil colours, encaustic and fresco materials can be separated off as they are sufficiently different in character; what remains is generally known as tempera.

Tempera paint may have existed in Classical times, but its obvious origins were in the Byzantine empire, where by the 10th century it had replaced encaustic painting as the dominant medium. *Cera colla*, tempera containing wax, was then used on walls, and various temperas were developed for manuscript illumination and work on panels. These included paint tempered with egg, which eventually emerged as the most important tempera medium.

In the 12th century the methods and materials of Byzantine icon painting were adopted in Italy, where they evolved into a far less formal manner. Tradition attributes this new style of working to Cimabue (1240–1302?), but it is Giotto (1266–1337?) who is universally recognized as the painter who broke away from the Byzantine tradition. By the Renaissance tempera was considered to have attained the state of technical perfection,

and it retained its popularity until overtaken by oils, introduced from the Netherlands in the late 15th century.

There was a transitional period in which oil and tempera were combined, however, either in mixed techniques or as modified emulsions. In several works by Botticelli oil and tempera are used selectively for different areas of the painting, and such practices continued until well into the 17th century; there is some evidence that Van Dyck and Claude Lorraine employed oil and tempera together.

By the end of the Renaissance, the widespread use and importance of tempera as a medium had largely ceased, and it was not until the 19th century that tempera was 'rediscovered', and commercially prepared tempera paints were introduced. At this time considerable emphasis was placed on hybrid materials and techniques, which combined elements of oil and tempera painting, in the belief that they held the key to the success of earlier masters. Such theories were over-optimistic, but the attempted rediscovery of earlier materials resulted in a new generation of tempera paints and techniques.

Fortunately, the original methods were recorded quite accurately by Cennini (*c.* 1390), and though the finer points are open to interpretation, this has allowed a more or less accurate reconstruction of traditional tempera techniques, allowing modern artists to draw on the knowledge of both periods. The medium continues to enjoy a modest revival.

Composition

Artists' tempera should contain the purest pigment tempered with a chosen medium. Egg has always been popular and is still widely used, but paint made with glue size, gum, starch and any of these materials or egg emulsified with oil qualifies as tempera (*Gouache*, p. 66). Tempera paints may also contain a certain amount of water. Although egg is compatible with all pigments, it can react with those which contain sulphur if it begins to putrefy. The traditional advice for overcoming this is to apply certain colours in glue size. With reliable modern colours the risk is minor, so this is less necessary, but it illustrates how freely tempera media may be interchanged without affecting the end result.

Many painters prefer to make their own tempera and prepare it as required immediately before use. This overcomes the problem of storage, and gives the user a familiarity with the materials which some consider to be an important element in the painting process. All pigments are compatible with tempera media, but the relative ease with which some make up compared to others leads many painters to be selective. Commercially produced temperas, sold in tubes and, occasionally, in pots, are mostly egg-oil emulsions based on 19th-century recipes, though casein tempera is also available. Tube temperas tend to dry poorly compared to freshly made paint and the range of colours is often limited; they can also be greasy and may darken on ageing because of their oil content.

Some authorities attempt to narrow the definition of tempera by insisting on the presence of an emulsion, either natural or synthetic. This is unsatisfactory, because it excludes some members of the original family, while including the modern acrylic medium, but is not as ridiculous as it sounds, as acrylics have a great deal in common with tempera.

For Christina's World *(1948), Andrew Wyeth employed tempera on a gesso panel to obtain a fine degree of detail.*

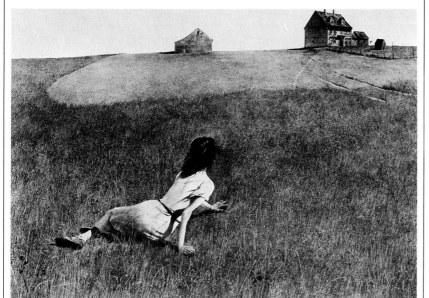

Properties

All temperas thin with water and dry very rapidly; some eventually become insoluble in water. They dry to a matt or semi-matt finish, which shows a marked difference in colour between wet and dry. Tempera is incapable of any great depth of tone, but it remains true to the original pigment colour, and its freshness can give light and brilliant colour effects. Most temperas age well – though the performance of individual paint recipes can vary – with little yellowing or darkening, except where egg-oil emulsions are used. Varnishing causes the colour values of tempera to change.

Generally, temperas are inflexible and can only be used in thin layers and on rigid supports. However, oil-rich emulsions produce a more flexible paint layer and are capable of quite pronounced impasto effects. The various tempera emulsions can be intermixed quite safely, and most temperas will also mix with oil colour provided they are introduced to each other in an undiluted state. Mixing tempera and oil paints does not always produce good results, but it is occasionally convenient. For example, tempera white alone is required to underpaint in tempera using subdued colours; tints can be produced using oil colour, or for that matter any other type of paint that comes to hand.

In use

Specific techniques have been developed to accommodate the properties of tempera; these are covered in detail in Chapter 2.4. The attractions of this medium are its speed of use and capacity for pale but brilliant colour, which lends itself to subtle atmospheric effects. The rapid drying of tempera means that colours cannot be painted into each other, but must be overlaid in layers of hatching. Tempera is thus best suited to a detailed manner of working, where its effects can be both delicate and sharp; but the flatness of tempera colour also permits a broad, loose technique if this is preferred.

Tempera may also be used to underpaint oil colour. Its speed of drying is an advantage, and it can be painted over as soon as it is dry. It is a sympathetic foundation for oil and will not be disturbed by subsequent applications of colour; it may also improve the ageing of a painting. When resin oil media are used, this process can be taken a step further, with tempera being used to interleave layers of colour between still wet resin oil glazes; this technique allows very fast working and can produce impressive results. On panels it gives rise to stable paintings, but on canvas it can lead to hairline cracking after only a few years. Excessive glazing with oil or resin oil on a tempera foundation may also give paintings a glassy appearance.

Gouache

History

The early history of gouache is really that of tempera, as gouache is in fact a member of that family of materials. Gouache is opaque watercolour, so it is in effect as much a technique as a type of paint.

Ancient Egyptian painting used some form of gouache, and its use in the Classical world may safely be assumed. Although painters did not differentiate gouache from other materials, temperas containing gum or glue would be closest in composition to the modern paint. These were used mainly for manuscript illumination, but were also employed on panels, canvas and even walls. (The name may derive from the term *a gouazzo*, which refers to painting with glue size.)

When tempera fell out of use, gouache continued as a material for manuscript illumination, and in the 16th century it became the 'body colour' of the miniaturist; this meant that it remained in use until the 18th century, when the general development of watercolour methods encouraged a fuller use of this kind of paint on a larger scale by artists such as Boucher, Turner, Bonnard, Degas and Matisse. Gouache has since been more or less recognizable as a medium in its own right.

The prepared paint now known as gouache, is nothing more than a form of watercolour, and it is impossible to say when it first appeared as a separate entity. Even today it is not always distinguished from other watercolours or from tempera paints. In the 20th century, gouache has been especially popular with designers and illustrators, because of its speed of use and the ease with which its flat, contrasting colours can be reproduced. It has also remained popular with ordinary painters, especially in mainland Europe, where the gouache technique was first revived and developed.

Composition

Any opaque watercolour can be regarded as gouache. In practice, some artists use tempera or distemper (another name for size colour) and many use ordinary watercolours with an admixture of white to make them opaque. Commercially produced gouache usually contains one or more pigments and a binder of gum arabic or dextrin. There is no uniformity between the products of different manufacturers, and some may also contain a filler or white pigment to give the paint body. In a top quality range, most of the pigments will be used pure, while one or two colours may employ pigment blends or additions of white. Because they are so often used by designers, gouache ranges often include interesting, but fugitive colours, and fluorescent, metallic or iridescent paints. They also tend to offer paints matched to the four 'processed' colours used by printers for colour reproduction.

Some European manufacturers do not differentiate between tempera and gouache, and describe their gum-bound paints as tempera; they may also supply other forms of tempera for use as a designers' and artists' gouache. Gouache products are frequently adaptable for use in pens and airbrushes, and several special-application gouache products are also available.

Properties

As the properties of gouache are almost identical to those of tempera, and similar to those of watercolour, it can be used in either technique. Gouache is especially liable to crack and scale if it is used too thickly. Most gouache remains permanently soluble in water, though an addition of acrylic medium will render gouache waterproof and reduce the risk of disturbing paint layers when more paint is applied.

In use

Gouache is used in much the same manner as tempera. Paper and card are most often employed as supports, though other materials are also possible. Gouache is suitable for underpainting oils, and may be used in combination with watercolour, pastels and charcoal (*Chapters 2.4* and *2.7*).

Oils

History

Drying oils and varnishes were known at an early date, and oil colour itself was in use well before the period when it is said to have been invented – by either Jan or Hubert van Eyck in the early 1400s. They were certainly connected in some way with the development of the oil technique, though one can only guess at the nature of their invention or innovation. In any event, the earliest oil paintings to have been recognized as such are by the Van Eycks and their contemporaries in Flanders. These paintings are immaculate works which have all the detail of tempera paintings, combined with a depth of tone and a richness of colour that other media cannot achieve. The secret of the Flemish technique has been a source of speculation ever since.

Theories that the sudden appearance of oil painting was due to some technical innovation are not supported by fact. There is more evidence to suggest that a natural development took place based on existing practices. An improved knowledge of metallic dryers would have assisted the process, and more careful preparation of oils can also be assumed, but the most plausible theory is that the use of oil as a final varnish for tempera paintings was combined with techniques derived from glass painting. All the elements of the early oil technique are to be found in these practices, and it was the Flemish who perfected the art of staining glass. According to tradition, Jan van Eyck was himself originally a glass painter.

Antonello da Messina is said to have learned the secret of oil painting from Jan van Eyck, though modern scholars doubt this. He was certainly one of the first to paint in oils in Italy, and through him oil painting was brought to Venice. Subsequently in Italy, and especially in Venice during the High Renaissance, oil painting was developed and explored. Titian in particular appears to have been highly innovative in his use of the medium, taking it to new heights of excellence in terms of technique, colouring, composition and scale.

It is possible that the secrets of Van Eyck's technique were never fully passed on to the Italians, and until well into the 17th century there is a definite technical divergence between Flemish and Venetian schools which is more than just a difference in style. It was the Italian influence which finally spread across Europe, sweeping away the remains of the Flemish technique. In the 18th and 19th centuries oil painting continued to dominate, though the methods became abbreviated and the quality of the paintings actually declined.

In the second half of the 19th century, commercial production methods and an assortment of technical innovations changed the nature of oil paint. This is a major factor in the development of the Impressionists, and from that point on very basic *alla prima* techniques, pronounced brushstrokes and heavy applications of paint became the norm. Modern oil colours and methods of using them are substantially derived from this period of the medium's history.

It should now be clear that oil paint is not a single material, and that oil painting is not a single method; nor is there complete continuity from the beginning of its history to the present time. The only common factor is the use of drying oils as a major ingredient in the paint. The relationship between the various strands of development in oil painting has been simplified here in the interests of clarity. In fact, a highly complex cross-fertilization took place between the different schools, their methods and materials, encouraged by the vision and breadth of knowledge of individual masters within them. The technical range and versatility of oil paint is such that at any time and place in history, you will find wide variations in style and countless developments in technique. Only when he or she has grasped its potential for experiment and innovation can a painter begin to explore oil paint in all its manifestations.

Composition

Traditional oil paint consists of fine quality pigment mixed directly with a refined drying oil, a blend of drying oils, boiled or thickened drying oil, or a combined medium of oil and resin; the exact composition is entirely at the discretion of the painter. Traditional oil colours are rich in pigment and are not ground to a particularly high degree of fineness. They are normally prepared to a thick consistency, but are not necessarily stiff paints. The finish and handling qualities depend on the precise recipe in each case, and the consistency of different colours may vary quite considerably.

Commercially prepared oil colours are widely available and are sold in tubes. Their quality, consistency and composition vary considerably from manufacturer to manufacturer and from range to range. Cheap ranges for students and amateurs may contain fillers or ingredients which thicken the oil, so that the pigment content can be reduced; they may also offer substitute pigments under the names of more expensive, and sometimes more reliable colours. An artists' quality range should contain only pigment and oil, though small amounts of wetting agent and stabilizer are sometimes unavoidable. The paint will be loaded with the named pigment to a point that is consistent with good handling qualities, and there should be a noticeable difference in the weight of tubes containing different colours, as well as in the consistency, tinting strength and handling qualities of the paint; in other words the character of the pigment should be apparent in the paint. Machine-made colours are often very finely ground and may be stored, matured and re-ground to produce a stable paint. This tends to increase the opacity of the paint and makes it more or less suited to particular techniques.

Excessive wrinkling as the paint dries on the palette indicates the presence of too much oil. Rapid darkening or yellowing soon after the paint dries indicates poor quality oil. A consistent drying time across the range of colours suggests the presence of dryers, which are normally excluded from quality ranges so that they can be added as the painter sees fit. Although there is an overall similarity between all manufactured oil colours, there may be quite noticeable differences between certain ranges which are theoretically of the same quality. This is simply a reflection of the wide range of recipes and production methods available to the manufacturers. The final choice is the painter's, and as there is no ideal oil colour, where ready-made oil paints are used, only experience will show which ranges are best suited to which techniques.

Properties

Contrary to popular opinion, oil colour does, in fact, change as it dries, becoming very slightly darker and a little less brilliant than when wet; this change from wet to dry is, however, less noticeable than with other media. Pigments in oil are saturated with medium and therefore appear darker than they are in their natural state. An average oil colour will retain brushmarks and can accommodate heavy impasto without cracking. Oil colours do not mix with water and can only be thinned with organic solvents. (*Media for paints and varnishes*, p. 40)

In use

A broad selection of oil-painting techniques are described in detail in Chapter 2.5. It need only be said here, in summary, that oil colour is immensely versatile: it may be used thickly or thinly, opaquely, transparently, and with or without dilution; paintings can be executed boldly in a single layer (*alla prima*), or more meticulously, in several superimposed layers (underpainting and glazing).

To gain control over the paint for particular techniques, painting media are often necessary. When these are employed, a traditional rule recommends that oil paintings should be constructed 'fat over lean'. This means that the proportion of oil in the medium should be gradually increased, as more and more layers are applied. The lower paint layers will tend to suck oil out of layers placed over them, and making the upper layers increasingly fat avoids the risk of excessive sinking and prevents cracking due to over-rapid surface drying. The same rule applies when diluents or very rich oil colours are used.

It is important to absorb such hints on technique before tackling a work in oils. Technical errors will not show up immediately, but major damage can be caused to oil paintings because of a lack of skill on the part of the painter.

Resin oils and alkyds

Resin oils are simply a variant on oil colour and have virtually the same properties, though they are said to offer richer and more brilliant colours and to age better than ordinary oils. The truth of this depends on the choice of resin and the precise composition

of the paint. Their obvious advantage is speed of use, as they have a shorter drying time and may be overpainted with minimal risks whilst they are still slightly tacky. Resin oils are included by implication in the above text on oils, and commercially manufactured resin oil colours are now in existence.

Alkyd paints are a modern version of the traditional resin oil colours, which dry in a matter of hours rather than days. They have yet to establish themselves as an important sub-category of oil colour, but their convenience guarantees them a certain following. All types of resin oil and artists' alkyd colour are compatible with other types of oil paint.

Watercolours

History
Watercolours are an offshoot of tempera and gouache. They have existed after a fashion for a very long time, but did not become established as a separate medium with its own techniques until the 18th century. They began as transparent finishing colours, often in the form of a liquid medium stained by a dye, and were used for the final subtle touches on top of tempera body colour. They were chiefly employed for the illumination of books and manuscripts, where their fugitive nature was less important.

As illumination evolved into miniature painting, these transparent colours continued to be used along with the gum-bound watercolours that were used for the major part of the painting. Although these were employed as a body colour by being mixed with white, they were actually prepared as pure colours. By the 16th century, when miniature painting flourished at the court of Elizabeth I of England, the recipes in use were identical to those later employed for the paints now known as watercolours.

Meanwhile, painters continued the long-established practice of using ink washes over drawings to capture the effects of light and tone. These monochrome studies were used as preliminary sketches and as patterns for printmakers, who could easily translate the line and wash into an engraved or etched form. The practice of adding transparent colour washes to these drawings may have started in the 17th century, but it was certainly an established technique by the beginning of the 18th century, and tradition credits Paul Sandby with a major role in the subsequent development of the watercolour method. He invented neither the methods nor the materials, but he does seem to have been responsible for consolidating and refining existing knowledge of these matters. He was employed by the Ordnance Survey to make maps, as stains were used to colour these at that time, and his approach to Middleton, the colourman, is said to have brought about the first commercial production of an improved watercolour paint. At the same time, paper-makers like James Whatman improved the supply and quality of paper. By the end of the 18th century, watercolours very like the modern paints were being made, and the full potential of the watercolour technique was beginning to be explored by painters of the time.

All the important variations on the watercolour method were developed in the late 18th century and early 19th century by English watercolourists such as Turner, Girtin, Cotman and De Wint. Watercolour was, of course, used elsewhere, but the pure technique was especially favoured in Britain. Minor improvements were made to the manufacture and packaging of watercolour in Britain and France from the late 18th century onwards, but it was not until well into the 19th century that any major change in their composition occurred. It was this change – the creation of moist or semi-moist watercolour containing a substantial quantity of glycerine – which paved the way for the introduction of tube watercolours. Overall, however, the methods and materials of watercolour painting have changed very little, and the modern use of the medium continues an established tradition.

Composition
A basic watercolour is virtually identical to a gouache and contains pigment with a gum arabic binder. From very early on, honey or sugar was added as well to prevent cracking by keeping the gum supple; glycerine is now used for the same purpose. Considering the thinness of the paint film, these ingredients are technically unnecessary, but they are of major importance in the formation of the colour block or paste and they assist the release of colour into the wash. Watercolour blocks made only of gum and pigment can split as they dry and may have to be rubbed on a hard surface to assist the release of colour. Ox gall, or a modern wetting agent that behaves in a similar fashion, may also be an ingredient of watercolour, as these improve the flow of the wash by breaking the surface tension.

Good quality watercolours are manufactured using stone grinding mills, and a few colours are still manufactured by hand, as this prevents unnecessarily hard grinding and reduces the risk of discolouration. Once made up as a paste, watercolour is partially dried and, as a thick, sticky paste, may be placed in tubes. Further drying produces a toffee-like mass which can be cut and moulded into blocks. These are placed in small plastic or porcelain dishes known as pans or half pans depending on their size, and are wrapped in foil to prevent any further drying before use.

Like oil colour, watercolours exist in at least two qualities. The artists' quality product should contain the very best pigments ground very finely with gum arabic, and permissible additives such as glycerine and ox gall, as the manufacturer sees fit. An artists' quality range will normally be available in both tubes and pans. The colours will be priced according to the pigment they contain and some will command a high price for a small amount of colour. Nevertheless, in practice, artists' ranges are economical to use; in no other medium is quality so closely related to cost, and only artists' quality colours will provide reliable, permanent and glowing washes.

Watercolours intended for students and amateurs may use dextrin or a similar substitute for gum arabic. They also contain less pigment and may include a filler, which will affect the transparency of the paint. Expensive pigments are usually replaced by substitutes, though the colour names used do not always make this clear. Indeed, in sketching-quality ranges, the substitution of colours by supposedly similar pigments is sometimes taken to such extremes that the actual palette on offer is extremely small. Lower-grade watercolours are offered as sets of tubes and are less likely to be available in separate pans. They are of no practical use to serious painters. The fact that watercolours were originally used for preliminary sketches of little long term importance, means that a number of fugitive colours are still included in modern ranges. This is a product of tradition and continued demand; the manufacturers cannot be faulted for it and painters who use them do so at their own risk.

The supposed difficulty of making watercolour paint by hand is greatly exaggerated. Although the convenience and wide availability of good quality manufactured products tends to discourage this practice, there are circumstances when it can be advantageous.

Properties
Watercolour is fast-drying and quick to use, and is therefore ideal for making rapid sketches or notes, and for making experimental studies. Watercolours thin with water to give clear but colourful washes. It is possible to vary the strength of the wash considerably and there should always be a glowing, transparent quality about the colour, even when it is used quite intensely. Ideally, a watercolour paint should wet easily and produce a strong wash from very little colour. Watercolours

remain permanently soluble in water, but in spite of this it is difficult to remove a wash completely once it has dried, as some pigments penetrate the support like a stain, and all watercolours rely in part on entrapment by the paper surface for their adhesion. Tones can be reduced, however, by blotting with a sponge, and as a last resort paper can be scratched away using a sharp knife. Pigments appear darker in watercolour than they are naturally and they may appear almost as dark as they do in oil, but this is only apparent in the concentrated colour, as when they are thinned the concentration of gum is substantially reduced. Colour changes do occur on drying, and there is no fixed pattern to this – some colours dry lighter, whilst others dry darker. As a rule, watercolour washes appear flatter when dry than when wet, but they are so dependent on the character of the underlying paper that it is impossible to generalize.

All watercolour paints share some of the properties of tempera and gouache and may be used as body colour if they are mixed with white. However, they are intended for a very specific use, and their essential properties are of little relevance outside their own technique.

In use

Pure watercolour painting is based entirely on the use of transparent washes of colour, with highlights being rendered by the white paper beneath. This puts very definite limitations on its method of use, and all watercolour techniques are variations on a set theme (*Chapter 2.6*). Watercolour is used almost exclusively on paper, and there is limited scope for the inclusion of painting media, though acrylic media are sometimes added to make watercolours insoluble when dry.

Watercolours may be combined with other media to produce quite unusual results; compatible media include gouache, tempera, pastel, oil pastel, waxes and encaustic colours, oil paints and acrylics. On a lean ground watercolour may be used to underpaint oil, and may even be used on top of a tempera underpainting before glazing and finishing with oil.

Liquid watercolours and inks

The most modern watercolour materials are in liquid form, very like the original transparent dyes. These liquid watercolours are most favoured by designers, illustrators and airbrush artists, but they are useful to painters of all kinds. Such products are not of a consistent type, however: some contain dyes instead of pigment, and some claim to be true watercolours, whilst others are described as alkali acrylics; some may also be called inks, and in practice it is impossible to differentiate between liquid watercolours and the more traditional coloured inks that are occasionally used in painting.

The only obvious advantage of liquid watercolours is that, as they are added to water using a pipette, the intensity of the wash can be exactly measured and duplicated if necessary. The disadvantage of some of these colours is their lack of permanence. This applies especially to dye-based liquid colours and inks, which offer extensive ranges of attractive but fugitive colours. These tend also to be less glowing than pigmented colours, as they stain and permeate the paper, rather than remaining as a luminous surface layer.

Pastels

History

Natural chalks and soft, coloured stones have been employed as drawing instruments since prehistoric times. White pastels of *gesso sottile* are referred to at an early date, but were simply used for marking out drawings on a dark ground. The development of pastels really begins in the 15th century, when chalks, crayons and pastels in a limited range of colours became popular for tonal drawing. Leonardo da Vinci is traditionally credited with the introduction of a warm red chalk known as sanguine, and he is also said to have used coloured chalks on some of his sketches for *The Last Supper*. Certainly, from that time onwards black, white and red chalks, the latter sometimes an earthy pink, were used for drawing on coloured paper or on paper prepared with a tinted ground. This permits a strong development of form and a suggestion of colour which is very useful as a reference for the painter, as well as being an attractive object in its own right.

It is difficult to say when tonal drawing became pastel painting. Blending and manipulating the colour once it has been set down is obviously a step towards it, but this still requires the introduction of full colour to separate it from drawing. Johann Alexander Thiele, Madame Vernerin and Mademoiselle Heid were, according to some authorities, responsible for the invention of pastel painting around the beginning of the 18th century. Thiele was certainly one of the first painters to take the medium seriously, but there are accounts of pastel painting and instructions for making coloured pastels a generation or two earlier in the 17th century. The spread of pastel painting throughout Europe can be attributed to Rosalba Giovanna Carriera, an Italian painter of the early 18th century. Her portraits were treasured prizes of the Grand Tour and her own travels in Europe introduced the method and materials to artists in a number of countries.

The 18th century was the great age of pastel painting, with Latour, Perronneau, Boucher, Chardin, Cotes and Liotard amongst others, exploring and exploiting the medium to the full. Its development parallels that of gouache, which was also becoming popular at this time, and several artists showed an interest in both media. This is hardly surprising since they offer similar advantages: speed, comparative simplicity and light, airy tones. Pastel and gouache were first used together during this period and there are some fine examples by John Russell, a pupil of Francis Cotes (although it is Degas who is now best known for this mixed technique).

In the early 19th century pastel painting fell into decline, but it was rediscovered by the Impressionists during the latter half of the century. Degas is particularly well known for pastel painting, but Renoir, Bonnard and Toulouse-Lautrec also made use of pastels. The medium has remained popular since that time, and modern methods are substantially derived from this second phase of development. Modern pastel painting is more akin to coloured drawing than to painting and does not fully exploit the delicacy or precision that are possible when pastels are carefully controlled.

Like watercolours, pastels instantly became popular with amateurs when ready-made materials became available in the 18th century. Commercially produced pastels were on offer almost as soon as the medium developed, and extensive modern ranges continue this form of supply. However, it would appear that the major pastel painters of the 18th and even the 19th centuries preferred the studio-made product.

Composition

There is no precise formulation for a pastel. It is pigment converted into stick form and held together by an extremely weak binding medium. Although it can affect the handling qualities of the pastel, technically the nature of the binder is irrelevant. As some pigments form too brittle a crayon when used on their own, and as their strength must be reduced to produce shades and tints, there is also a filler in pastels which gives body to the colour and provides the whiteness that is needed for the dilution of tints. This is generally called a base, and once again, though different colour and handling qualities result from different bases, its precise composition is irrelevant. Gum tragacanth and chalk would appear to be the most favoured materials of modern manufacturers, but traditional recipes for studio-made pastels vary considerably (*Making*

pastels, p. 78). Serious attempts to differentiate between pastels, crayons and chalks are futile, but as a very simple generalization, it can be said that crayons and chalks tend to be harder than pastels and that crayons are frequently smaller and more intensely coloured. Artists' pastels are frequently referred to as soft pastels, and have a crumbly, powdery texture.

Commercially produced pastel ranges vary considerably in size. They may offer as few as 2 or 3 dozen colours, shades and tints, or as many as 200 to 500 for an artists' range. This is made up of a palette of full strength colours equivalent to a typical paint range, with each colour accompanied by a series of set tints and shades that offer the equivalent of a mixed colour value in normal painting. In reality such large ranges are unnecessary, but they are suited to unblended techniques of pastel painting where a wide choice of pre-set tonal values is more important. The size, shape, softness and handling qualities of pastels, as well as the colour range vary from manufacturer to manufacturer, and individual painters may find that they have particular preferences.

Properties
Pastels are simply a convenient means of applying dry pigment to a surface. The pastel binder is ineffective once they have been applied and the pigment relies on being embedded in the surface of the ground and on static and frictional forces to keep it in place. Pastels, crayons and chalks vary in hardness, but all have a powdery surface, and colour should come away at the slightest touch. Soft pastels break and crush very easily, but studio-made pastels are not always so fragile and may be shaped and sharpened using a knife.

The colour of a full-strength pastel should be almost identical to the colour of the dry pigment itself, and as no drying is involved and no medium exists to saturate and modify the colour, pastel colours undergo no changes during use. In the pastel technique, light is reflected from the surface of the pigment and therefore offers a bright, but light, colour value. It is often said that the tonal range of pastels is restricted, because deep, rich shadows are not possible. In practice this is not strictly true, as the lighter tones are brighter than in other media, and a very acceptable range is possible between light and dark. It is true, however, that an unnecessary concentration on the tints or 'pastel shades' severely restricts the tonal range and limits the possibilities of the medium.

Although their use is shunned by purists, fixatives are used by some pastel painters to stabilize the fragile, powdery surface of their paintings. If used to excess, these can collapse the pigment particles into a flattened, saturated layer which no longer behaves in the same way optically, causing undesirable and unpredictable colour changes. Tints especially suffer in this way if their opacity is derived from a base without any white pigment present to give additional body. However, intermediate fixing helps build up a pastel painting by reducing the disturbance between separately applied layers, while final fixing stabilizes the painting surface and offers a limited degree of protection (*Pastel painting*, p. 168).

Pastels are the most exposed medium of all, and as well as the ease with which they can be damaged or disturbed, the unprotected pigments may be affected by atmospheric pollutants and exposure to light. This can bring about dramatic changes in the case of a few sensitive pigments. Temperature and humidity changes affecting the support can also result in a gradual shedding of pastel dust over a period of time, which may eventually affect the quality of the painting. Unfixed pastels are best framed beneath glass, but they can occasionally be affected by the static charge that is generated when glass is dusted vigorously.

In use
Pastel painting techniques are examined in Chapter 2.7. In pastel painting the colour can be rubbed, blended, smeared and scraped back in a variety of ways that resemble true painting, or it can be applied from the pastel stick in lines and blocked areas.

The long-term stability and permanence of a pastel painting depend very much on the choice of support and on the selection of a suitable range of colours. Rigid and semi-rigid supports with a textured surface are best, and most pastel painters find coloured grounds an advantage. Coatings of pumice or powdered glass may be used in grounds to improve the adhesion of the pastel colour and to permit comparatively thick, but stable layers to be built up.

Pastels tend to become dirty as they transfer colour from their surfaces to each other. The traditional remedy is to keep them in bran, which not only keeps them clean, but also protects them from accidental breakage. Pastels containing toxic pigments should be avoided for the health of the user, and painters who employ pastels frequently should be particularly attentive to health and safety matters because of the ease with which pigment dust can be taken into the system.

Pastels are often employed in mixed media techniques, with both painting and drawing materials. They should always be applied last, as overworking with other media destroys them.

Oil pastels
Oil pastels are a comparatively recent introduction. They employ a waxy or oily binding medium to produce a greasier and more robust pastel stick. They are nowhere near as soft as traditional pastels and vary considerably in consistency from range to range. They can be used in some of the traditional pastel techniques, although they cannot provide the same degree of subtlety, either in handling or colouring. As they are more heavily saturated, the pigments in oil pastels appear richer and deeper in colour and do not create the same lightness of tone as a traditional pastel. Even so, they do offer some bright, light colours which at first sight can be taken for conventional pastels.

Paintings in oil pastel remain permanently greasy to the touch, though there is a slight apparent hardening of the surface as they age. Because of their greasy nature, they cling to the support quite well and are not easily disturbed. They can also be built up in layers and overlaid, colour upon colour, in a way that is alien to conventional pastels. As this is done, colours may be smeared over and into one another, though this falls short of true blending. Once an oil pastel layer has reached a certain thickness, the adhesion of further colour is impaired by the softness and greasiness of the surface.

As well as imitating true pastels, oil pastels may also be employed in techniques of their own. They are capable of impasto effects and may be thinned with turpentine or white spirit to produce a wash. They can also be employed in encaustic techniques, and their waxy consistency lends them to use with water-based paints, especially watercolours, where the dislike of one material for the other can be exploited.

Oil pastels are growing in popularity, but the products are not all of a reliable quality. Modern technology is producing many variants on this theme, including water-soluble pastel sticks and oil paints in stick form. The future importance of all these materials has yet to be established.

Acrylics

History
Acrylic paints are a modern medium derived from materials produced by the plastics industry. The Mexican muralists Diego Rivera and David Alfaro Siqueiros are often quoted as the inventors of acrylics. They certainly experimented with modern synthetic materials as early as the 1930s, and Siqueiros delivered a paper on the subject to the American Artists' Congress. As a result, in 1936 he established an experimental workshop in New

Pool and steps, Le Nid du Duc *(1971): David Hockney's experiments in the acrylic medium have exploited its strong, flat colour and its versatility.*

York where artists are said to have manufactured acrylic paints for themselves. However, the modern artists' materials are based on emulsion polymer acrylics, which were originally developed as high-performance exterior coatings and were first employed to paint wooden houses in North America. The chemical company Rohm and Hass introduced the first commercially produced acrylic resin around 1953 and very soon after that it was adopted for use in artists' materials, though it was not widely available in Europe until the 1960s. The technology has since developed, and today's artists' acrylics are a significant improvement on the original products. Although they have been exhaustively tested, acrylics have not been in existence long enough to assess their long-term performance. They have not lived up to the claims originally made for them, and although their popularity is growing, it remains to be seen whether they will be considered a major medium in the future.

Composition

Acrylic paints are made by dispersing pigment, previously ground with water, around an emulsion that has been made separately. This process produces a fluid paint, but artists' acrylics are usually given a paste-like consistency resembling oil colour by the addition of a thickening agent. A few manufacturers supply acrylics in both forms. Because of their popularity with designers, an increasing number of acrylic ranges offer specialized colours similar to those referred to under *Gouache*, in addition to those intended for ordinary painters.

Commercially produced acrylic paints have complex formulations and contain many additives which produce precise performance qualities. They are made with a restricted range of pigments, because acrylic emulsions are not compatible with certain colours in their liquid state. Studio-made acrylics can be comparatively simple, however, and may be prepared in a similar manner to tempera paints (p. 75). Since the acrylic medium is stable when dry, painters may in theory employ any pigment so long as the paint is used within a short time of preparation.

Properties

In many respects, artists' acrylics are like the traditional egg tempera medium; this is hardly surprising, since both are based on an emulsion. Acrylics can be thinned with water and dry quickly, as their water content passes off and the paint film assumes a stable state soon after they are physically dry. Unlike traditional tempera, however, acrylics are very flexible, and their ability to withstand the contractions that occur during drying means that they can be applied in thicker layers. They are therefore suitable for use on canvas as well as other supports and will retain impasto and textural effects as they dry. Acrylics are said to offer very true and brilliant colour because of the clarity of the resins in which the pigments are suspended. Great permanence is also claimed, because the resins do not discolour with age. However, as acrylics dry, their colour does change noticeably and they become darker and flatter, losing much of the brilliance they possess in the wet state. If varnished, their saturated colour effects return, and this can give rise to practical problems where colours are being matched from wet to dry or when varnishing distorts carefully planned colour effects. The fact that acrylics cannot be rewetted once dry makes this more of a problem than with other media, which can be retouched by matching wet to wet.

The other notable properties of acrylic paints are that they are strongly adhesive and supposedly insoluble when dry. In fact, they should not be used on anything which is smooth, shiny and non-absorbent. Neither are they completely resistant to solvents, and most artists' acrylics can be softened or dissolved using alcohol. Acrylics pick up dirt as they age and so lose their brilliance. They also lose their flexibility at low temperatures, and severe cracking and lifting of paint can occur if an acrylic painting is subject to sudden stress when it is cold.

In use

The main attractions of acrylic paints are their speed and convenience, and the fact that they can mimic a wide range of technical effects normally associated with other paint types (pp. 174–5). To get the most from acrylic paints, you may have to employ specialized media, and in some techniques they can actually be quite troublesome to use. The drying time can be extended by use of a retarding medium, or by adding glycerine to the paint or the water it is thinned with. Their adhesive strength makes them suitable for use in collage, and because the dried paint film is inactive, they can be used directly on paper or unprimed canvas. When a priming is used it should be an acrylic gesso; acrylics should never be used on an oil ground or on top of a layer of oil paint. Theoretically, acrylic can be used to underpaint oils, but the long-term advisability of this is open to question.

Brushes and painting equipment must be cleaned immediately after use using warm water to wash away any undried paint, and methylated spirit to remove hardened pigment. Plastic and disposable palettes are best suited to acrylics, and synthetic hair brushes are recommended, as they are better able to withstand repeated cleaning in strong solvents. Plastic or stainless steel palette knives should be used to avoid staining the blade. Acrylics may be mixed with other water-based paints, but they should never be brought into contact with oils or the thinners and media that are used with them.

PVA colours

PVA colours, also known as vinyl paints, are near relatives of artists' acrylics. Their background and properties are similar, but they are generally regarded as a slightly inferior product, so far as artistic use is concerned. Most manufacturers supply PVA colours in pots and tubs, and recommend them for use on a large scale where economy is important. PVA colours have proved popular with scene painters and decorative muralists, whose work may be regarded as temporary, and are also intended for educational use, but are not always of a satisfactory quality for discerning painters.

Common emulsion paints based on PVA media are widely employed by the inexperienced for grounds and primings. Whilst many paintings on such grounds have survived well enough, they have not shown themselves to be particularly suitable for this purpose. Acrylic grounds intended for painters

are preferable, but are not to be recommended either, for techniques and materials that require a ground or priming with specific properties.

Encaustic

History

Encaustic gets its name from an ancient Greek word meaning 'burnt in'. The method and materials were used extensively in the Ancient and Classical world and are said to have been brought to perfection by a painter called Pausanias in the 4th century BC. The earliest surviving examples of encaustic painting are mummy portraits from Faiyum in Egypt; these are executed in coloured wax on thin wooden panels over something like a gesso ground. The wax appears to have been applied hot and has that unusual combination of texture and subdued gloss that is typical of the encaustic technique. Pliny describes three methods of painting with wax and states that two of them were already well established by his time.

Painting with hot wax and wax emulsions continued as far as the Byzantine era, but with the rise of tempera and fresco, the encaustic technique fell into disuse. As in the case of tempera, attempts were made to revive it, but unlike tempera, the decline of encaustic appears to have been absolute. In fact, little can be said with certainty about the original methods and materials, and although some reconstructions are highly plausible, they remain pure speculation.

The Battle of Anghiari by Leonardo da Vinci is though to have been an attempt to revive the encaustic technique described by Pliny. It was certainly an experiment of some kind, involving unusual materials, that went disastrously wrong when braziers were placed before it. The next notable attempt at revival was made in the 18th century by the archaeologist and artist Count Caylus; amongst the methods he devised was one which involved making wax into a paste with turpentine. The use of such pastes and blends of wax, oil, resin and turpentine in various proportions has since formed the basis of one approach to encaustic painting. In the mid-18th century a painter called Müntz attempted to improve on Caylus' methods. His complicated concoctions and improbable methods were typical of the obsession with lost techniques that was to take a firm hold by the end of the 18th century.

Certain successful methods of encaustic painting have now been arrived at, and techniques in wax are enjoying a sporadic and limited revival. Not all are true encaustic techniques involving the use of heat, however, and some fall more properly into the categories of tempera and oil painting. Since the 18th century wax has been used as a thickening agent and stabilizer for oil colour. Sir Joshua Reynolds and Vincent van Gogh are among those believed to have added wax to their colours deliberately, and in the later 19th century commercial manufacturers exploited wax, fat and tallow to the full, resulting in thick pasty oil paint of doubtful quality. In recent times wax and resin encaustic have been used by Jasper Johns in combination with other materials, and there has been a general revival of interest in waxy materials and encaustic effects because of the introduction of oil pastels and oil-paint crayons.

Composition

The main ingredient of any encaustic material must be wax; beeswax, preferably the white variety, has so far proved to be the only satisfactory material, though modern micro-crystalline wax looks promising. This has a whitish, opalescent colouring, a comparatively high melting point and a degree of flexibility; it is certainly cheaper than beeswax and may turn out to be a very acceptable alternative, but it has yet to be tried and tested in encaustic techniques.

Wax may be used alone, but is more usually combined with other materials to improve its finish or handling qualities. Combined with damar resin it produces a shinier, harder finish, which is more luminous and glaze-like. Wax melted into turpentine forms a paste which is easy to mix with pigment and easy to brush out, and which, more importantly, can be used cold. This gives the paint a longer working time and limits the need for heat in the process of burning in. Wax may also be made into a paste by combining it with a drying oil. This produces a workable paint, and though its surface may take some time to dry completely, it is considerably more flexible than wax alone and is therefore suitable for use on canvas. Intermediate effects can be achieved by combining these materials in a variety of ways. Ready-made encaustic materials are not at present available, though oil pastels and oil-paint crayons may be employed in the encaustic technique in a limited fashion.

Properties

It is difficult to generalize about the properties of encaustic materials, as the flexibility, gloss, hardness of finish and resistance to solvents vary according to the exact composition of the materials in use and the method of application. In all cases the dominant properties are those of the wax, and to that extent it can be said that these materials have a translucent, opalescent quality, a capacity for texture and impasto, and that they are sensitive to heat. Used without heat, they give a matt or satin-like finish, while heat applied during or after painting with encaustic media produces a glossy surface which has a smooth roundness brought about by the temporary flow of the wax. Encaustic materials will adhere to anything, but work best on a lean ground, and with the possible exception of mixtures containing oil, they are best suited to rigid supports. The colour values of pigments in wax are similar to those of oil paints, but this medium can produce soft pastel-like colour effects if used in a particular way.

In use

Once again it is difficult to generalize about the use of encaustic because of the variations in its composition. The section on encaustic techniques in Chapter 2.8 gives an introduction to the basic methods, but any painter employing encaustic will of necessity have to experiment independently to a certain degree.

Gesso panels make good supports for encaustic paintings, and the technique is traditionally associated with wall-painting. Electrically heated spatulas are convenient for manipulating wax, and small, shaped metal instruments that can be heated up are essential for the delicate handling of solid wax. (Painting knives can be converted in the studio for this purpose.) Hot wax can be applied with a bristle brush, but cheap industrial or educational quality ones are recommended, as separate brushes are needed for each colour and they may have to be disposed of after use. Wax pastes may be applied with better quality brushes, which should be cleaned as if they had been used with oil paint. In the interests of health and safety, painters should avoid naked flames when driving in encaustic colours. Hairdryers, electric irons and small electric fires can be used for this purpose and all offer a reasonable degree of control over the melting and burning in of the wax.

Grinding colours

1. *The basic ingredients of all paints are pigment and medium. These can be worked together by hand.*

2. *A traditional stone slab and muller are most efficient for grinding colours by hand.*

3. *Plate glass slabs and glass mullers are often supplied to artists. These are expensive and not as good as stone.*

4. *A flat-bladed palette knife and a tile or piece of glass are perfectly adequate for making small quantities of paint.*

5. *Begin by laying out some pigment and some medium on the slab. Use a palette knife to mix them.*

6. *Work the raw materials with the palette knife until the mixture no longer contains pockets of dry pigment.*

7. *Spread the mixture, a little at a time, beneath the muller, working it out across the slab.*

8. *When all the colour has been ground, rework it once more with the knife to give it an even consistency.*

Recipes
Preparing colours by hand

Making paint is by no means as difficult as you might suppose. It is the commercial manufacture of paint that raises technical problems; all that painters require is a good quality product that performs as they would like it to, in just sufficient quantity to satisfy their own requirements. Paints made in small quantities, using simple recipes and pure ingredients present no difficulty; only if paint is to be stored for an appreciable length of time need any account be taken of preservatives or methods of stabilizing its consistency. In fact, nothing could be simpler than making paint for immediate use.

The same basic principles apply to making all types of paint, and the equipment required is not complex. In fact, you can even make paint with a palette knife on the palette itself, though such a casual approach is not entirely recommended. The one thing to grasp at the outset is that all pigments behave differently and make up with more or less ease in different media. Chapter 1.1 supplies information on this subject, but there is no substitute for practical experience. This, in fact, is one of the great advantages of making paint by hand; it gives the painter an intimate knowledge of the materials, which will help him or her to use them wisely and skilfully. For this reason alone, all painters should experiment with making paint, even if they do not adopt it as a regular studio practice, as ready-made materials can then by approached with a better understanding and an ability to assess quality. There are, of course, other advantages to preparing colours by hand; namely, that it is very cost-effective and, quite frankly, often produces better paint.

Materials
You will need pigment and whatever medium you choose as its binder. (The exact proportions required in each case and the minor variations that are possible within each recipe are dealt with in the following pages of this section.) To work these raw materials into paint, you will also need a slab of some hard, non-absorbent material and an implement with which to work the paint. On a very small scale, a ceramic tile and a flat-bladed knife will suffice. A slab of plate glass about a foot square (30cms²) and a palette knife with a strong forged blade are more practical for regular use, and a proper grinding slab and muller are recommended for studios where materials are regularly made by hand. Some painters prefer a glass slab which has been sand-blasted or etched to roughen its surface, but the practical advantages of this are questionable, and it makes the paint-making process noisier than it need be. Glass mullers are available in a variety of sizes and these, too, are usually roughened on the base.

The best slabs and mullers are unquestionably the traditional type made of stone. A hard granite or marble is best, but white marble, which is easier to obtain and to shape, is perfectly acceptable. In the long term white marble will wear, but it will still give better results than equipment made of glass. Stone slabs can be improvised from old washstands and from marble taken from decorative fireplaces; alternatively, they can be cut to order by a mason. A piece two feet square (60cm²), with a surface which is smooth but not polished, makes an excellent studio slab. A stone muller should be heavy, with a flat base that has a rounded edge to guide paint beneath it. It can prove costly to have one made to order, but many masons discard drilled-out cores of stone which make excellent mullers once their edges have been rounded off by grinding; with white marble this can even be done by hand using a file. The great advantage of stone is its weight, which reduces the effort required to work the paint and reduces accidental movement of the equipment whilst it is in use. Paint can also be made in a pestle and mortar, but this seldom gives good results.

Method
Although it is frequently referred to as grinding, the process of working pigment and

medium to a usable consistency is more accurately described as tempering. The pigment should already be finely ground and need no further grinding. Minute lumps containing more than one particle of pigment may, however, need to be broken down before the individual particles can be dispersed around the medium.

Begin by placing a small mound of pigment in the centre of the slab. Little by little, add medium to it and work the ingredients together with a palette knife until they are thoroughly, but coarsely, mixed. It is as well to add only just enough medium at this stage to make up a soft paste, even if the recipe you are using aims at a runnier final consistency, as paint is easiest to work in this form; it can always be let down by the addition of more medium and then reworked if necessary.

Move the paste to one corner of the slab, then, taking a little of the mixture at a time – as much as can be scooped up on the tip of a palette knife – place it in the middle of the slab. Now, using the flat of the palette knife blade, or better still the base of a muller, work the paint in a circular fashion, spreading it thinly across the surface of the slab. Most colours become more fluid as they are worked, but a few actually become stiffer. All colours become smoother as the pigment is more evenly dispersed within the medium, and the look of the paint should tell you if it is smooth enough. If there is any doubt, scrape it back to the centre of the slab with a palette knife, along with any paint from the muller or the knife, and repeat the process. When you are satisfied with the consistency, scoop it up with a clean knife and place the finished paint in a free corner of the slab.

In this manner, working a little of the colour at a time, go through the whole pile of paste and build it into a heap of finished paint. To even out any inconsistencies, work the paint in on itself with a palette knife so that each separate working of paint is mixed in with all the others. As a final test, smear a trace of colour between finger and thumb to assess its fineness. If the paint feels at all gritty, repeat the whole process, preferably using a muller.

The paint is now ready to use, although in the case of some pigments and some media, it may be necessary to alter the proportion of the ingredients and repeat the whole process to incorporate these adjustments. Once a colour has been made, the slab, muller and knife must be thoroughly cleaned. Some pigments tend to stain the slab; try to remove this using solvent, and if that fails, use household scouring cream. This is important, as the next colour on the slab may pick up the stain, sometimes with a dramatic effect on its colour. Cleaning off between colours can be reduced to a minimum if the colours are carefully sequenced – for example, a pale yellow, followed by a deep yellow, followed by an ochre – but the slab must always be properly cleaned between colours which are quite different. Surprisingly, black has the effect of cleaning the stone and will remove any lingering stains from other colours without any effect on itself. All paint-making equipment must be spotless before it is used to prepare white.

Tubing

Some hand-made paints can be stored in tubes. Using a palette knife, scrape the paint a little at a time into the bottom of an empty tube, tapping it on its top to help the paint slide into the tube. Experience will teach you how much turnover to leave, but at least 1″ (2.5cm), is required. When the tube is full to this point, scrape any excess paint from the inside of the tube base and wipe it clean with a piece of tissue. With the finger and thumb of both hands, press the sides of the tube together and flatten them into a straight edge. Lay it on the slab and place the blade of a clean palette knife over the very end of the tube, allowing a little less than $\frac{1}{4}$″ (5mm) for the first step of the turnover. Lift the tube against the edge of the knife to form a crease, and make the first fold along this line. Repeat the process to make a second fold. Pressing this down flat under the blade of the knife using the full weight of your body will create a sufficiently good seal, but if you prefer, give the tube a final crimping in a vice or with a pair of canvas straining pliers.

Tubes which are too full will be messy to close and will spurt paint when the top is removed; underfilled tubes may contain air and the paint will quickly harden or putrefy. Some colours make up very thickly and do not squeeze out of a tube easily; but rather than changing their consistency just for the sake of using a tube, keep such colours in

Tubing colours
1. Fill tubes from the bottom with a palette knife, inserting the paint a little at a time.

2. When the tube is sufficiently filled, clean the opening and pinch it closed with the fingers.

3. Use a straight edge to flatten the end and to make a fold in the tube.

4. Close the tube with a double fold and crimp the end with canvas straining pliers or by using a vice.

Tempera
1. *Tempera binding media are very easy to make. One possibility is to shake a whole egg in a jar.*

2. *Pigment and water are the other ingredients of tempera paint. Adding alcohol to the water sometimes helps to wet the pigment.*

3. *The pigment and water are usually worked up alone before the tempera medium is added.*

4. *Pigment pastes containing water but no binder can be stored in pots until they are needed for painting.*

jars. As with making paint, tubing is something that improves with practice, and you should not be put off if your first few attempts are less than perfect. Remember, it is how well the paint works that matters, not how neatly it is packaged.

Making tempera

Tempera can be made by mixing pigment directly with medium and working it into a paint in the manner just described. This is practical when very small quantities are being made with the palette knife for immediate use. In the case of egg yolk or gum tempera it can also assist the take-up of pigment, where colours are being used that do not readily mix with water. As a very rough guide, use 1 part pigment to 1 part medium and add a little extra pigment if required to give the paint the consistency of a soft, semi-fluid paste. Thin a little of this paint with water to test it before use, and if it is too lean, add a little extra medium with a brush as the paint is thinned during painting. Temperas based on emulsions containing oil may also be prepared by this direct method, though pigments must be carefully selected to avoid greasiness.

The best results are obtained if the pigment is first worked up with the water alone, as this makes it fully wet and thoroughly dispersed before the medium is added. One part of this pigment paste is then added to an equal part of tempera medium, and the two are worked together with a knife or brush to give the paint a thin, creamy consistency. There are three distinct advantages to this method. Firstly, the paint does not dry while it is being worked, and any loss of moisture can easily be corrected. Secondly, as the pigment-and-water paste contains no medium, it can be stored in a tube or pot almost indefinitely; tempering this paste with medium takes only seconds, so that fresh colour is almost instantly available. (Keeping a selection of colours made up with water greatly adds to the convenience of tempera painting.) The third advantage concerns the use of 'oil-loving' pigments. Some pigments prefer oil to water, and if ground directly with an emulsion they may pick up part of the oil content in an uneven fashion, giving the paint a greasy quality which makes it less satisfactory to use and which requires solvents, followed by soap and water, to clean the brushes thoroughly. Working such pigments with water first ensures that every pigment particle is thoroughly wet with water before it is introduced to any oil, thus preventing any direct contact between the two.

Lightweight pigments, which also tend to be oil-loving colours, do not wet easily with water alone; they tend to float on top of it, and although they will come together with repeated working, the effort involved can be quite considerable. The problem is overcome by adding alcohol to the water – in the first instance 20–25 per cent of the liquid content should be alcohol. This wets the pigment instantly and thoroughly, though some working of the colour will still be necessary to break down the particle size, and will also preserve any tempera paint made up from the paste, providing it is tempered and tubed before the alcohol evaporates. A trace of mild detergent will also assist pigment wetting, but this is less desirable as there is a risk that it will darken the colours as they age.

Traditional recipes sometimes call for the addition of vinegar or wine, both of which assist wetting and act as preservatives. Vinegar cannot, however, be recommended except in the most minute quantities, and only white distilled vinegar should ever be used. The milk of fig plants and oil of cloves are also included in some traditional recipes, as these are said to improve the handling of the paint and may also have some preservative action (*Media for paints and varnishes*, p. 44).

Making oil paint (including resin oil colours)

Oil colour is made by working pigment and a drying oil on a slab in the manner already described. Lean oil colour is made using a thin, refined drying oil loaded with pigment to

Oil paint
1. *The secret of good oil colour is to make it as stiff as possible to begin with.*

2. *The handling qualities and storage life of some colours can be improved by melting beeswax into the oil used for grinding.*

3. *Fresh oil colour will keep on the palette for several days.*

4. *Oil colour will keep almost indefinitely in tubes, but the consistency of the paint may alter with time.*

make a stiff paste. Linseed oil is used for most colours, though safflower or poppy oil are often used for whites and blues. Blends of these oils may also be used where a compromise is required between thorough drying and minimum after-yellowing.

The secret of good oil colour is to keep the oil content to a minimum. When the pigment and oil are first mixed, they should be as stiff as possible. As this mixture is worked across the slab it will become more fluid and then quite soft, while still retaining its paste-like nature. A few colours – cadmium reds and yellows, for example – will relax considerably during the tempering process and should then have more pigment added to them in order to restore stiffness. Such colours will never make particularly solid paint, however, and it is a matter of discretion as to how much additional pigment should be added. A few colours, especially lightweight modern pigments, may actually become stiffer as they are worked, and experience will teach you to make the initial mixture a little slacker to allow for this, so that the paint does not become too stiff and solid to work. Each pigment behaves differently; this is more noticeable in oil than in other media, and you should not expect every colour paste to have exactly the same consistency or handling qualities.

Hand-made oil colour brushes out easily to begin with, but most paints will also relax during storage, becoming softer still. (This is one of the reasons why pigment pastes should be made fairly stiff to begin with.) In one or two cases, such as French ultramarine and yellow ochre, the paint actually becomes quite runny after it has been stored for some time. This is perfectly acceptable to use, but you may, if you wish, remake such paint, adding further pigment to restore its stiffness and to further reduce its oil content. Good solid whites can be made in this fashion as well, cramming them with extra pigment after they have matured to ensure maximum opacity and minimum oil content, with a minimum of yellowing. In the case of some other pigments, notably those derived from cobalt, there is a tendency for the oil and pigment to separate out during storage. These colours are inclined to be rather gritty, and repeated working and reworking on the slab may be necessary to give them the required degree of fineness. This will also improve their stability, though the best method of ensuring this is to add a little wax to the colour.

Colours which separate out, become runny or do not naturally form into very stiff pastes can all be improved by an addition of wax. All colours may be improved by this means, so far as long-term storage is concerned, and in many cases it also has a desirable effect on the handling qualities of the paint; according to some authorities, a small addition of wax also reduces yellowing. Two per cent wax added as a paste made with turpentine is generally recommended, but in practice this is not enough to improve all colours. Five per cent wax melted directly into the oil has proved to be more effective, but this proportion of wax should not be exceeded when general-purpose oil paints are being made. Drying oil bodied with wax has a paste-like consistency to begin with, which makes it rather difficult to judge its pigment loading, and it is important to ensure that it is well packed with pigment as it is made up into paint. If in doubt, warm the oil to a liquid state before using it. Tradition in fact recommends that all oils be gently warmed to increase their capacity for taking up pigment.

None of these technicalities need concern you if you are making and using oil paint within a short time span. Special types of oil paint can also be made for immediate use: for example, pigment may be ground directly with sun-thickened oil, stand oil, boiled oil or resin oil vehicles (p. 48). These paints are likely to be much more fluid than normal, though they should still be made as thickly as possible. Most paints of this type have a tendency to flow, but if properly made they should not actually run. These fat oil colours lend themselves particularly to techniques involving a rich, smooth finish and translucent or transparent use of colour. If lean paints are to be made from these materials, they must first be diluted with turpentine to lessen their concentration in the finished paint. Lean resin oil colours may also be made by tempering pigment with a blend of ordinary drying oil and varnish. Ten to twenty per cent varnish is recommended as the maximum addition.

Freshly made oil colour remains usable on the palette for about a week. It can be stored in tubes or jars almost indefinitely, though some colours destabilize within a

matter of days. Colour which has been re-ground with a high proportion of pigment, and oil paint which contains wax can be kept in pots and tubes for many years. To prevent colours in pots from forming a skin, they should be covered with a piece of greaseproof paper or a thin layer of oil. Some colours can be stored under water, but this practice is best confined to solidly prepared white paints, as several other colours will release their oil under water and take up some of the water in its place, rendering them unusable as oil colours.

Watercolour preparation

Whereas quite coarse preparations are perfectly acceptable for use in oil or tempera, they are not satisfactory for the watercolour technique, and watercolours must be worked well to ensure a fine, even distribution of pigment. Sometimes this means working and reworking the colour on the slab, though a surprising number of pigments make up very easily as watercolours, and you need not be put off on account of the work involved. The best results are obtained using a stone slab and muller, as these produce the right degree of fineness with the least effort.

Very small quantities of watercolour – which are, after all, all that is needed – may be prepared by mixing pigment directly with gum arabic to make a soft, semi-fluid paste. This will then mix easily enough with water, though it is inclined to settle out while standing in the dish, in which case it should be stirred with a brush each time it is used. For a less casual approach, work the pigment to a paste with water alone, as in the case of tempera, and mix this with gum arabic in roughly one to one proportions when the paint is required for use. Ox gall, which improves the flow of watercolours, can be added directly to the painting water if it is required, and additions such as glycerine, honey and sugar are unnecessary if the paint is used immediately.

To make watercolours in pans, blocks or tubes, begin by dissolving 1 part sugar and 1 part glycerine in 1 part water. A little heat may be required to assist the formation of a solution. Now add 1 part of this solution to 2 parts gum arabic solution made up at the standard strength (*Chapter 1.2*, p. 51). Note that this should ideally contain a preservative, which, in any event, is essential in the case of tube colours. When this is thoroughly mixed, add it to the pigment and work it up on the slab in the manner already described; use approximately equal proportions of the gum binder and pigment. Some variation will occur between colours, but aim for a soft, semi-fluid paste rather than one that is too runny or too stiff. In the case of a few colours, most noticeably white, reduce the strength of the binding medium by a third to a half with plain water before making up the paint. This will prevent it from being too brittle and glossy. When you are satisfied with the consistency of the colour, transfer it into empty pans or tubes for storage.

You may, if you wish, allow such colours to dry for a day or two before they are packaged. The paste becomes sticky and thick, which makes it more stable in tubes and less likely to crack in pans. (Cracking of pan colours as they dry is difficult to overcome completely, but from the practical point of view, this is irrelevant as the colour will still work well enough as a paint when it is applied.) Watercolour blocks can be made using paper moulds. Taking a small oblong or square of watercolour paper or lightweight card; fold and glue it to make a shallow trough. Pour the semi-liquid colour paste into this and allow it to dry for a number of days. Contractions in the block pull the card or paper inwards, rather than causing a crack in the paint. When the watercolour has dried to the consistency of toffee, the paper mould can be peeled away and discarded, and the semi-solid block can be manipulated in the hands or with the blade of a palette knife to improve its shape or to cut it down in size. Such blocks can be made to fit an existing watercolour box or simply formed into a size or shape that suits the individual. It is practical to make several blocks at once, producing a year's supply of any one colour in a very short time. Watercolour blocks that are to be kept for some time should be wrapped in tinfoil to prevent their drying out, otherwise they form a hard, brittle crust and may fracture, owing to their continued contraction.

Making watercolours
1. *To make moulds, cut and fold light card or heavy watercolour paper. Glue the ends lightly.*

2. *Fill these moulds with hand-ground colour and tap them gently to remove trapped air.*

3. *As the paint dries, it will pull in the sides of the mould, which can be peeled off once the colour is solid.*

4. *While they are still soft, press the blocks into a more regular shape and wrap them in foil to prevent over-drying.*

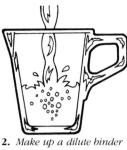

Making pastels

1. *Pastels contain pigment and filler bound with a weak gum or glue.*

2. *Make up a dilute binder by adding more water to a standard solution of a gum, such as gum arabic.*

3. *For the first colour value, place equal quantities of pigment and filler on the slab.*

4. *When the dry materials are well mixed, separate off half of the mixture. Tints and shades will be extracted from this.*

5. *If fine results are required, the pastel mixture can be ground with the binding medium using a slab and muller.*

6. *It is usually adequate to work the mixture in a bowl using the back of a spoon.*

7. *Very acceptable results are achieved by working the materials with a palette knife.*

8. *Place the pastel paste on blotting paper to remove excess moisture. It should be moist but not sticky.*

Note that though the above instructions will work well enough for all practical purposes, for perfect watercolours the recipe must be adjusted slightly for each individual colour. There is no substitute for experience where these minor adjustments are concerned.

Making pastels

Making pastels is not difficult, but perfect results are seldom achieved at the first attempt. Once familiar with the process, however, most painters will be able to make excellent pastels with intense colour and versatile handling qualities (pp. 168–73). They are, incidentally, very cheap to make.

Materials

There are several variations on the basic recipe, but the essential ingredients are pigment, a base (such as chalk or clay) and a very weak binder. Toxic pigments should not be used and those which are at all lacking in permanence should also be avoided. Any filler may be used as a base, but it is an advantage if it has a slight setting action of its own. Gesso sottile and China clay are both good base materials for pastels, but finely powdered whiting is the most readily available material that is suitable. Various substances can be used as binders as long as they are used in a very weak concentration. Gum tragacanth is favoured commercially because it has a soft binding action. Gum arabic produces a harder pastel which tends to form a crust around its outside; this can be an advantage as the pastels are less likely to break, but they may have to be started with a knife or on sandpaper to expose the soft interior of the pastel. Weak gelatine and skimmed milk can be used, but both produce a crumbly mixture which is difficult to make into crayons. Crude methyl cellulose in the form of wallpaper paste or a traditional starch paste may also be used. All these binders are water-based, but the best pastels are actually produced using a very dilute resin solution such as damar resin in white spirit or turpentine.

Method

First, make up a binding solution. Begin at a strength of 1 to 20 (e.g., one part gum arabic dissolved in 20 parts of water). This will be an acceptable strength for the majority of colours, though some will require dilution of the binder to about half this strength and a few colours will need virtually no binder at all. This is only an approximate guide, because the actual strength required is affected by the pigment, by the choice of base and by the relative proportions of pigment to base. Only the experience of making a few test pastels will confirm whether or not the binder strength is right for the materials being used.

Although it is possible to make pastels out of pure pigment, it helps to have at least a small amount of base in the first colour value which represents the pigment at its full strength. This helps in the formation of the crayon and, in the case of a very strong pigment, it can prevent its looking too dark. With whiting as a base, 2 parts pigment to 1 part whiting is generally an acceptable starting point. Put these materials onto a mixing slab or into a bowl and stir them dry so that they become well mixed. Now separate off half the mixture and put it to one side. Add the binding solution to the remaining part a little at a time and work it in with a palette knife to form a smooth paste. Ensure that the colour and consistency are even throughout. If you wish, it can be worked on the slab with a muller to achieve a perfect consistency. If the ingredients are being mixed in a dish, they can be creamed against its side using the back of a spoon to smooth out any lumps and to remove any unevenness in the colour.

The object is to produce a paste which is neither too wet nor too dry. It should be soft and dough-like and should stick to itself, but not to the hands. If it is too dry, add a little more binder; if it is too wet, spread it on blotting paper and allow that to soak up some of the excess moisture. When the mixture can be handled like putty, it is ready to make into crayons.

Take a small lump at a time and place it in the centre of a strip of blotting paper. Cup the hands underneath this strip and close them round it gently so that the palms face each other, while gripping each end of the piece of blotting paper under the thumbs. Now move the hands up and down against each other so that a rolling action is produced in the middle of the blotting paper. After a few seconds open the hands and examine the crayon and, if necessary, roll it again. Try not to make the crayon too long or too thin, and if needs be, cut a piece off to improve its proportions. Unless it is very small, this excess can be rolled separately into another crayon, or mixed with other off-cuts to produce a piece of the right size. Do not expect to produce a perfect shape, but aim for a roughly even cylindrical stick.

Now roll the pastel gently off the blotting paper onto a hard flat surface. If the ends are ragged, trim them with a palette knife and then, with the tip of each index finger, gently roll the pastel backwards and forwards, touching it obliquely at the ends so that they are rolled into a soft point. Check that the pastel is still straight and then leave it to dry for at least 24 hours to harden off. If the strength of the binder is correct, it is then ready for use. If it is too hard it can be made back into a paste simply by wetting it, and then remade with more pigment and base added to correct the proportions. A test pastel can be force-dried in a warm place to give an early indication of the batch's quality.

Producing shades and tints

The second half of the pigment mix, separated off at the beginning, is used to create different tonal values of the same colour. To make tints, combine the dry mixture of pigment and base with an equal quantity of base. This is then split again into two parts; one is made into pastels and the other is mixed with an equal quantity of base once more. This is mixed and split again, and the procedure is repeated as many times as desired, until a series of systematically reduced colour values has been set up. In practice, better tints and more permanent pastels are produced if a mixture of white pigment and base is used instead of plain base material.

Shades are produced in a similar way, but in this case small amounts of black are added to the mixture as it is separated off, instead of additional base. In this way a series of increasingly darker tones is created. In some cases, of course, you may get a better colour by not using a straightforward tint or shade. For example, more brilliant greens can be produced by extending them with a base containing yellow instead of white. Colour mixtures and broken colours (pp. 97–8) can also be produced in pastel form by varying the details of this method.

Encaustic recipes

To make wax colour, melt beeswax in a water bath and disperse oil paint around it in order to give it colour. To make a wax and resin encaustic medium, use 1 part damar resin to 2 parts beeswax. Melt the damar in a pan, and when it is completely liquid remove it from the heat and add the wax. Stir until the wax is melted and then strain the mixture while it is still liquid to remove any particles of bark that may have been trapped in the damar. This must be reheated and mixed with pigment or coloured up with oil paint when it is in use.

Wax pastes are made by preparing wax, or wax and resin, in the above fashion and then adding turpentine when they are still liquid. This must be done away from the heat, and the mixture should be stirred while the turpentine is added to prevent the wax congealing prematurely. A third, a half or an equal quantity of turpentine may be used, depending on the consistency of paste required. This is allowed to cool and is mixed cold with pigment in the normal fashion. A drying oil may be used in place of, or as well as turpentine.

A drying oil will also convert wax and resin into a paste. A mixture of 1 part beeswax, 1 part damar resin and 1 part stand oil has been shown to be a good all-purpose blend for encaustic painting. All these ingredients should be melted together as follows. First, melt the damar into the stand oil using no more heat than is necessary; then, remove it

9. *Cut off small pieces of the pastel paste and place them on strips of clean blotting paper.*

10. *Roll the pastel paste in the blotting paper to form crayons. Do not make them too long or too thin.*

11. *Tidy the ends of the pastels by rolling them back and forth under the finger tip.*

12. *Lay the finished pastels on blotting paper and leave them to dry in the air for 24 hours.*

Encaustic media
1. *Beeswax can be melted over a fairly low heat and kept liquid using a water-bath.*

2. *Beeswax and damar melted together give a tougher, harder and more glossy encaustic binder.*

3. *Cold wax pastes are produced by diluting molten wax or a wax and resin mixture with oil or turpentine.*

4. *Cold wax pastes can be mixed with pigment using a palette knife, to make easy-to-use encaustic colours.*

Although most of the materials used for encaustic painting do not present any major hazards if used correctly, painters should at all times be mindful of hot objects in the studio, and of the risk of flash fires caused by overheating or by the careless use of turpentine.

from the heat and add the wax in the form of pellets or cut pieces. Stir the mixture until this dissolves, and, if necessary, continue heating over a gentle flame until all the ingredients are fully liquid and well blended. This mixture becomes very stiff and virtually solid on cooling, and if it is to be used as a paste, it should be diluted with turpentine away from any heat source, whilst it is still in a liquid state.

Encaustic crayons can be made as follows. Take 1 part stand oil and work it up with pigment on a slab. Aim for a thick but flowing consistency which is rich in colour, but by no means loaded to capacity; if this pigment paste is too stiff, it will not disperse easily around molten wax. Now transfer this paste to a small pan and add a quantity of wax equivalent to 2 parts measured against the original 1 part of the oil. Melt these ingredients together and stir to ensure that they are well mixed, then place this mixture into empty paint tubes or moulds made from pieces of metal tubing. When they are cool, remove the crayons by slitting open and peeling off the paint tubes, or by pushing them out with a dowel, in the case of a mould made of metal tubing. Wrap the finished crayons with gummed paper to prevent them from drying out, and peel this covering back from one end as necessary.

Encaustic crayons can be drawn with and then driven in, or melted down and applied hot. A faster-drying crayon can be produced by blending the stand oil with boiled oil, rather than using it in its natural state. This also produces a more flowing line, as the crayon is rather softer and less clinging when drawn with.

An enamel palette with troughs for colour, or an ordinary domestic baking tray with partitions, make good palettes for encaustic materials when they are made and applied hot. This can be kept on top of a pan of simmering water to keep the colour liquid, and a selection of colours can be made conveniently by placing a little pigment or oil colour in each of the partitions and then adding the uncoloured wax or wax and resin mixture from a separate source.

1.5 Equipment and studio furnishings

Drawing instruments

As this is a book about painting, it is only appropriate to deal with drawing instruments in so far as they are used for the preliminary sketches and underdrawings that serve as the foundation of a painting. Many more drawing instruments exist than are listed here, but painters will find that the following products are of most practical use.

Pencils

A wood-encased artists' pencil has a lead made of graphite and clay bonded into a casing of cedar wood. A good quality pencil has a high proportion of graphite in the lead and draws a smooth line. Up to 20 degrees of pencil hardness are on offer, ranging from 9H (H equals hardness) to 9B (B equals blackness), with HB and F occupying the middle of the range. The darker B grades are best for pencil studies and preliminary sketches, as their softness allows for a great sensitivity of line. The higher degrees of B pencil are most suitable for drawings shaded to record tone, and their leads usually have a large diameter to allow for broad, shading strokes. In ranges intended for artists and designers, lead thicknesses of up to $\frac{1}{8}''$ (3mm) are not uncommon. For underdrawing, H pencils offer a finer, more discreet line which is more easily covered and lost beneath the paint film, though you should take care not to score the painting surface too deeply. All pencils are best sharpened with a craft knife or razor blade, and should be frequently repointed between sharpenings on fine sandpaper. Try to avoid dropping them as this can fracture the lead within its casing.

Artists' pencils are usually round in section although a few are made with oblong bodies and leads, and designers' and some artists' pencils are hexagonal. This prevents them from rolling off drawing boards and desks, which can be helpful both in the studio and in the field. Clutch pencils and fine lead pencils are practical for carrying in the pocket, which suits them to sketching, but they do not offer the range of lead qualities that is ideally suited to a painter's purposes.

As an alternative to graphite, coloured drawing pencils are available with soft, crayon-like leads in white, sanguine and black, and a limited number of earth shades. These are ideal for tonal drawings on tinted paper, which make valuable sketches for certain techniques, and can be successfully combined with watercolour and gouache; they are not suitable for underdrawing, however, except in the case of pastel painting. Charcoal and pastels are also available in the form of wood-encased pencils, making them cleaner and easier to handle.

Watercolour pencils deserve a passing mention as they may be of interest to some painters. These have coloured leads which are soluble in water, and the marks drawn by them can be redistributed as a wash using a wet brush. They offer the possibility of combining drawing and painting in a single work, and can be used successfully with graphite and ordinary coloured pencils which are not soluble in water. Note, however, that water-soluble graphite pencils have recently been made available, and an increasing number of hybrid drawing and painting instruments of this type are being developed.

Pens

Pens can be used for preliminary drawings and for underdrawing. Combined with wash from a brush they can also be used to record tone, and may even be used in finished paintings along with watercolour and gouache.

The traditional dip pen is of most use to painters; it can be used with any type of ink and may even be used to deliver paint. Drawing pens with metal nibs are made in a variety of sizes and styles, the finest of which are known as mapping pens. These are all designed to have flexible, smooth-drawing points, but they seldom match the springiness and sensitive response to the hand of a simple quill. Goose and turkey quills, which are really intended for writing, are most easily obtained, but traditionally, crow is the favourite quill for drawing. Quills can be cut to a fine drawing point, though they will not retain it long. Reed pens and calligraphy pens can be used for bold or stylized drawing and sketching, but are of limited use in the context of painting.

Pens should be used with pigmented ink, such as Indian ink, or a strong solution of watercolour, as dye-based inks may migrate through other colours and are not always permanent. Since many modern marker pens employ this type of ink, they cannot be recommended for use in painting. For underdrawing, ink can be thinned so that it is more easily concealed by the overlying paint.

Charcoal

Charcoal is a very ancient drawing material used for sketching and for executing preliminary drawings directly onto the painting support. Charcoal is partially burned wood that has been heated in a restricted supply of air to convert it into carbon; it retains the original shape of the twig or branch from which it has been made. Artists' charcoal is usually made from willow and has up to four thicknesses commonly known as thin, medium, thick and scene-painter's. Regularly shaped crayons of compressed charcoal and pencils with charcoal leads are also available; these offer degrees of hardness which may suit some users and are a little less messy to use than natural charcoal, but they can be more difficult to remove when correcting mistakes.

Charcoal works best on a textured surface which has enough of a tooth to hold it in place. It can be smeared and blended in the manner of a pastel to produce tonal effects, and is particularly dramatic when combined with white chalk to heighten the contrast of light and dark. Charcoal is especially helpful for the underdrawing of paintings, as on a smooth surface the charcoal can be dusted away to leave a very faint trace. All preliminary drawings executed on the painting ground should be fixed or replaced by ink before paint is applied, however, as charcoal is also a pigment – now very little used, but once known as blue black – and the smallest amount picked up by colours will significantly lower their tone and deaden the overall effect. Alternatively, the traces of charcoal dust can be deliberately exploited as a shading pigment in the dead colouring. Powdered charcoal is also used for transferring drawings onto the painting support. (*See Transferring drawings*, p. 90; *Classic tempera*, p. 116; *Early oil painting*, p. 124 and *Alla prima on a white ground*, p. 140.)

Chalk

On a coloured or tinted ground, white chalk can be used for underdrawing or for preliminary drawings carried out directly on to the ground, and on pale grounds a sanguine chalk may be used as an alternative to charcoal. Like charcoal, chalk has the advantage of being easily removed, so that alterations can be made as often as necessary. However, it also has the same quality of being a pigment, and chalk drawings should be fixed or dusted down to a mere trace before paint is applied. White chalk is a powerful pigment that can have a pronounced effect on colours; it will kill shadows, depriving them of depth and clarity. Too much powdery chalk of any kind will also interfere with the adhesion of the paint. (*See Oil painting on a toned ground*, p. 128; *Oil painting on a dark ground*, p. 132.)

White chalk can also be used to highlight sketches in other media on coloured paper, and can be successfully combined with charcoal, red chalk and chalks in earthy tones for tonal drawings on a coloured or tinted background. Such studies are especially helpful as preliminary sketches for portraits and figure paintings.

Porte crayons

Chalks and charcoal are much more convenient to use if they are mounted in a holder,

and if studio-made chalks are used, which are firm enough to sharpen to a point, very clean and precise drawing instruments can be made in this way.

Holders for chalks are known as porte crayons. They are occasionally available to accompany pastel ranges, but modern designs are rather stumpy and lack the balance that is desirable in a good drawing instrument. A piece of brass tubing the length and thickness of a pencil makes an ideal porte crayon. Its end should be split and prised slightly open, and the base of the chalk should be slightly shaved down to fit into this opening. A sliding ring made from wire or a small piece of tubing of a slightly larger diameter can be placed behind the chalk to ensure that it is gripped tightly. A porte crayon with a chalk at either end – one white and the other red or black – is very practical for tonal drawings, and this design was extremely popular with painters of the 17th and 18th centuries.

For work on a large scale, especially on murals, a bamboo stick with a split end makes a convenient holder for chalk or a large stick of charcoal. About 18″ (45cm) is an ideal length, as this suits both large- and medium-scale work, but there is obviously no restriction on the length of stick and some painters may find it an advantage to draw at a distance. As a basic improvisation, charcoal can be taped to a stick, though this offers less protection to the drawing point and has to be frequently readjusted as the chalk or charcoal wears down.

Metal points

The forerunner of the pencil was the metal point. This uses a small, pointed metal tip to make an extremely delicate mark on a prepared surface, such as hard gesso or a priming of white or tinted gouache. Silver, gold and lead are most often used for the point, and of these, silver is the most popular; it produces a very fine line, which is at first grey, but gradually oxidizes to a brownish black. Gold produces a yellow-brown line, and lead produces a dull, flat grey mark, not unlike that of a modern pencil. Lead can, in fact, be used on paper that has not been prepared, where it gives quite a soft and pleasant line; on a prepared ground it is inclined to be a little coarse.

Metal points are chiefly of interest because they allow the painter to prepare a very meticulous underdrawing which can be followed precisely in a detailed painting technique, and is so faint and delicate that it is easily lost beneath thin layers of paint and may even not show beneath a glaze. Very similar results may be achieved on a gesso ground using a very hard graphite pencil sharpened to a fine point, though the line is inclined to be more dominant than with a metal point.

Metal points are occasionally available commercially; otherwise they can be improvised by substituting a piece of silver wire for the lead of a clutch pencil. The tip of the metal point should be very fine, but not actually sharp, otherwise it will cut rather than draw. Before it is used for the first time, a metal point benefits from being dragged lightly across fine emery paper to remove any roughness from the tip. There is no appreciable wear on a silver point for a considerable period of time, but a lead point is quickly blunted and needs to be reshaped fairly regularly.

Brushes

Brushes are the main tool of the painter. They are used above all, of course, for applying paint, but it should be noted at this point that brushes can also make excellent drawing instruments. Some painters may find the response of a flexible brush point better suited to their manner of drawing than the rigid points of more conventional materials. A small, soft brush with a fine point is ideal for making a finished drawing, or an underdrawing in ink or dilute colour, which can easily be developed into a form of dead colouring. Brushes can also be used for spontaneous preliminary drawings sketched directly onto the support; these transient 'first thoughts' can subsequently be taken up and absorbed into the painting, or altered as more and more colours are applied.

Brushes come in a wide variety of shapes and sizes, and are also made from different types of hair. Certain brush types are suited more or less to particular types of paint and

particular methods of applying it. Although painters can call upon a vast range of brushes, intended not only for artists, but for scene-painters, decorators, sign-writers and specialized purposes such as stencilling or lacquering, they normally confine themselves to their own special types of brush, which are made to the standards they require. It is these that are considered here.

Hair types

Painters' brushes employ several hair types, which can be broadly categorized as hard and soft. Soft-haired brushes are suited to thin paint, or at least to paint that handles fluidly, such as tempera and watercolour. They also point and shape more precisely, so that considerable control can be exercised over the brushmark as paint is applied, making them ideal for detailed work. Hard or stiff hair holds plenty of colour and is robust enough to withstand fairly rough usage. This type of hair is therefore suited to thick paint and to work on a large scale. It makes brushes which create a less precise brushmark, but which are strong enough to allow scumbling and stippling. They are most often used for covering large areas of canvas, for blending and for the deliberate production of brushmarks. All of these involve a manipulation of the paint surface which requires some strength and resilience on the part of the brush head.

Sable is the very best of the soft hairs. It is obtained from the sable marten, a mink-like creature, and for a painter's brush the hair should be taken from the tail. The red- or yellow-brown hairs taper to a natural point; they are soft, but at the same time strong and springy, and also durable. Red sable from Siberia, also known as Kolinsky sable, makes the best brushes, but it is extremely expensive, and for many painters good pure sable of a slightly lower quality, or sable blends which include Kolinsky hair, are a more practical alternative. Sable brushes can be made with an extremely fine point, which because of its strength and flexibility allows precise control over the paint as it is set down.

Squirrel hair, which is usually dark brown, is much softer than sable and is vastly inferior to it so far as control over paint is concerned. It is, however, much cheaper and is attractive to painters for that reason. A large brush made of squirrel hair will perform better than a small one, as the mass of the brush head adds strength and stability, thereby giving greater control over the delivery of paint.

Pony hair is dark brown or black and feels rather coarse. It does not make very good brushes except in large sizes, as it is unable to take a very good point or shape. It tends to be used on its own or in mixed-hair blends to produce low-cost brushes which give a limited standard of performance. Mixtures will no doubt be resorted to increasingly as the natural products become more expensive and more scarce. (Products with discouraging descriptions like 'imitation squirrel' are already on offer to painters, for example.)

Ox hair is a yellowish brown with some lighter-coloured hairs apparent. It is strong and springy like sable, but it does not taper to a fine tip, and is therefore mostly found in square-ended brushes or in large brushes with a rounded shape, rather than any definite point. Ox hair is also long, and this, combined with its strength and springiness, creates brushes which deliver a long, fluid stroke that can be controlled in width and direction with considerable ease.

Camel hair is a trade term applied to soft hair of various types. As its use varies in different countries and from manufacturer to manufacturer, it is difficult to define it precisely. According to some authorities the term should properly be applied to a particular variety of ox hair, while others regard it as an alternative name for squirrel. Painters must obviously assess the quality of such brushes for themselves.

Bristle is the most important hard hair. It is obtained from the back of the pig, the very

finest bristle coming from a particular area along the pig's back. The bristles themselves are very strong and springy, and taper towards their point. The point itself is unusual as it splits into several smaller points known as flags, giving bristle its huge capacity for carrying colour. On a painter's brushes, the flags should always be intact; they should be visible on close inspection when the brush is held to the light. Low-grade bristle brushes may reveal cut ends instead of flags.

The best bristle is white; poorer grades are an oatmeal colour, and the coarsest bristle is black. Colour is not always a guarantee of quality, however, as it can be bleached out. Bristle can be quite long, but some artists' brushes use exceptionally short lengths to give greater stiffness; this makes them more suitable for manipulating stiff paint which has not been thinned or modified with a medium. Bristle brushes can be shaped, but will not come to a precise point or edge, making exact control over the brushstroke impossible. For good results a new bristle brush should be worked in by deliberately flexing, stubbing and splaying it repeatedly in order to make it more responsive. A good brush will not be damaged by such treatment and the bristles can be eased back into their original shape using the fingers.

Pig bristle may also be referred to as hog. Hog fitch generally refers to a low-grade brush containing an inferior bristle, which may have less strength and spring, and be cut rather than flagged. It is very difficult to generalize, as the terms hog and bristle are used indiscriminately to refer to good quality bristle and to lesser, but occasionally acceptable grades of pig hair. As surely as there is no substitute for sable, there is no substitute for good bristle, and professional painters will find the finest quality bristle brushes are well worth the additional expense.

Fitch as applied to hog is a trade term loosely applied to oversize brushes, possibly with cut hair. Traditionally, however, fitch refers to the hair of the polecat, and nowadays both mongoose and polecat are used as a source of hair. It is likely to be mottled in colour with a dark brown tip and a creamy brown middle. Neither a stiff hair, nor really soft, fitch offers a compromise between the two qualities; it is strong enough to manipulate fairly stiff paint, yet can be formed into a point or particular shape which will maintain its form during use. You are most likely to find brushes made of polecat or mongoose hair in the ranges of manufacturers based in mainland Europe.

Goat hair is a white, coarse hair, which makes a stiff and not particularly responsive brush. It is found mostly in large mop brushes, which can be used for blending or for dusting away charcoal and chalk. Goat hair is also used in oriental brushes where a particular form of construction is used to create large brushes with a small, manoeuvrable point.

Badger hair is a hard, strong fibre approaching the stiffness of bristle. It has a mottled colouring, with shades of grey and white in bands along its length. Genuine badger is expensive and in short supply, and as a consequence imitation badger hair is also found. Traditionally, badger-hair brushes are used for softening and blending wet paint rather than for laying it down, as the stiff, springy nature of the hair is particularly suited to this purpose.

Synthetic hair was introduced in order to overcome the high cost and increasing rarity of good natural hair. These brushes imitate the qualities of sable and bristle, and have a tapering filament which mimics the structure of natural hair. Good synthetic hair is either stark white or a golden yellow reminiscent of the colouring of the natural products it seeks to replace.

No modern synthetic hair can yet match the performance of bristle or sable, but synthetic hair brushes have proved popular with leisure painters and students because they are relatively inexpensive. They are particularly desirable for painting in acrylics, because they are able to withstand repeated cleaning in strong solvents, and their low cost means that they can simply be thrown away if thorough cleansing proves difficult. A recent development is the blending of synthetic hair with high-grade natural products,

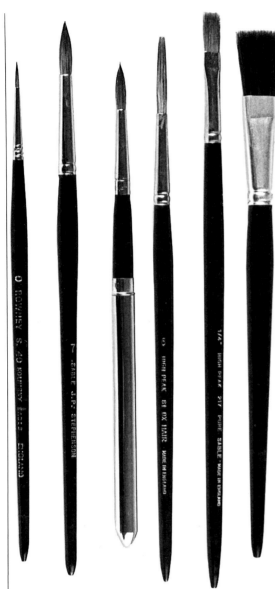

Types of watercolour brush: from left to right, a small Kolinsky sable, an artists' sable, an artists' pocket brush (the top folds into the handle), an ox-hair writer, a flat sable one-stroke, and a mixed-hair flat.

such as sable, offering a balance between cost and quality which may prove attractive to an increasing number of painters in the future.

Brush shapes

Painters' brushes are made in the following regular shapes: rounds, mops, flats, short flats (also known as brights), filberts and fans. Rounds are round in section, have a reasonable length of hair and come to a point, which makes them ideal for touching in small areas of detail. (In the case of a good sable brush the point will be exceptionally fine, even when the brush head itself is quite large.) Mops are also round in section with a good length of hair, but rather than coming to a point, they finish in a dome-shaped tip. A true mop is quite large; more or less the same shape in a small size is known as a wash brush. Some small round brushes also feature a domed tip rather than a point, and a cross between a mop and a flat made in soft hair is known as a domed flat.

Flats have a shallow oblong section of generally medium-length hair ending in a straight edge. Angular marks can be made with the tip or side of the hairs, while the flat of the brush head can be used to deliver long, broad strokes or to work neatly into an outline. Flats hold a lot of paint – especially when made of bristle – and in a large size can quickly lay down flat areas of colour, making them ideal for bold *alla prima* styles of painting. A long-haired flat is known as a one-stroke brush, and a short-haired flat is also known as a bright.

Filberts consist of a shallow oblong section like a flat, but end with a rounded tip instead of a flat edge, which makes a more interesting mark than a flat. To some extent a filbert offers the possibilities of both a flat and a round: used on its side it can make quite a thin stroke, while across its width it delivers a fairly broad line; a glancing or tapering stroke results in a highly expressive brushmark.

Fan-shaped brushes are solely for blending. They have a thin, flat head in which the hair is spread into a semi-circular shape resembling an open fan. The feathery edge of this shape is used to tease paint into position after it has been applied, blending colours and removing brushmarks. Fans are made in bristle and sable, and occasionally badger.

A round pointed brush is the dominant shape in soft hair, though flats, brights and filberts are also made. An artists' brush with a round, pointed head, generally has a reasonable length of hair for its size, though shorter- and longer-haired versions are also found. Those with short hair are often known as miniature-painting or retouching brushes, as they allow very accurate control over the point, while those with longer than average hair are known as designers' points or riggers; their ability to deliver a long fine line very easily made such brushes particularly popular in marine painting – hence, the name 'rigger'.

Although rounds are also made in bristle, flats, brights and filberts are especially popular. One-stroke brushes are mostly made of soft hair – usually ox, though sable is used as well. Two further shapes usually found in bristle are the Herkomer – a thinner than average, rather square flat – and a flat with a straight but angled end, known as a sword or a slat-cut fitch. A stencil brush has short, stubby bristles and is excellent for thin, veil-like stipple effects.

All of the common brush shapes are now available in synthetic hair.

Fitting and sizing

Most modern brushes are fitted into a metal ferrule, or housing, that holds the hair and attaches it to the handle. On a good brush, it will be seamless and made of a non-corroding material such as cupro-nickel. Ferrules were originally made of quills, hence the name 'pencil' sometimes used for a small brush. Quill-mounted brushes are still made, and are preferred by some painters, as they are light and the ferrule itself is slightly flexible; it is also less damaging to the hair. Quill brushes are fitted with a removable stick, but other brushes carry a fixed handle. Traditionally, short handles are intended for watercolour, gouache and tempera, whilst long handles are used for oil and acrylic. Some brush types, such as sable rounds, may be supplied in both lengths of handle.

Brushes are sized according to the fullness of their head. Typically, there are between 14 and 17 sizes in a range of sable brushes and up to 12 sizes in a range of artists' bristle

brushes, but a small, medium and large size in each brush shape should be ample for most painters. Slight differences may occur in sizing from supplier to supplier, and brushes from Continental Europe are likely to be sized smaller than elsewhere. Quill-mounted brushes are sized according to the quill, the smallest being a lark and the largest, a swan.

Palette knives

Palette knives are used for mixing paint, for applying thick impasto, and for scraping back areas of wet oil colour in order to make corrections. Ideally, a palette knife should have a forged blade diminishing in thickness towards its tip, thus giving it great flexibility. It should have a sturdy and comfortable handle which is firmly attached to the blade. Unfortunately, good knives are expensive and many painters make do with palette knives that have a simple pressed blade.

A basic palette knife has a flat blade shaped rather like an elongated lozenge. Knives with a crank in the blade just before the handle are convenient for applying paint and for working up colour, as they lift the hand clear of the working surface. Knives with small blades are available in an assortment of shapes mounted on a long shank; these are purely for applying paint and may be known as painting knives. With some modifications these can also be used as tools for encaustic painting.

Steel-bladed knives should be used with oil colour. Antique dinner knives which are of no great value can actually make very good palette knives because of the quality of their blades. Stainless steel is recommended for use with water-based materials, such as acrylic paints, however, and plastic palette knives, which are cheap and disposable, can also be used with acrylics and for very general use within a studio.

Easels

An easel is not absolutely essential, but is the most convenient means of holding a canvas or panel whilst it is being painted on. Sketching easels consist of a simple tripod with adjustable carrying brackets that will house canvases or panels in a wide range of sizes. They can be adjusted in height and can tilt the painting surface to any angle between vertical and horizontal. As the name implies, sketching easels are intended for use out of doors; their tripod legs equip them for rough terrain and their light weight makes them convenient to carry. (A sketching easel can be given greater stability by hanging a weight from its central pivot once it has been erected.) When not in use they fold away.

For the average painter a sketching easel also makes an acceptable studio easel, as they will carry quite large paintings reasonably securely, and the majority will also hold a drawing board, either at a tilt or on the level. Sketching easels are made of wood or metal; the lightest are made of aluminium, while the heaviest, and strongest are made of steel. Wooden sketching easels should be oiled or varnished before they are used out of doors, to prevent warping.

Where the size of studio justifies it, a good studio easel is a worthwhile investment for an established painter. These are made of wood and are strongly constructed so that, if necessary, they can carry large, heavy works. There are several patterns of studio easel, which vary in complexity. The simplest is a large A-shaped easel, like a blackboard easel. Others may feature castors, to make them movable; screw-operated raising devices to lift or lower the painting as required; and some may have an attached paint box or brush tray. Decorative display easels of studio proportions are also manufactured, and can enhance the appearance of paintings being sold.

For small works, for painters who prefer to work sitting down, and for painters in wheelchairs, table easels are recommended. These are mounted on a table top and will sometimes carry quite large paintings. Those which fold away into a compact unit are especially handy when travelling.

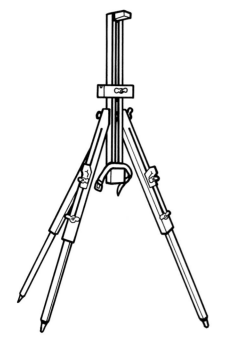

A typical sketching easel has tripod legs and folds down into a compact unit for carrying. It may be made of wood or metal and will hold quite large canvases. Many portable easels can be adjusted to hold a drawing board. Hanging a weight from the central pivot often improves their stability.

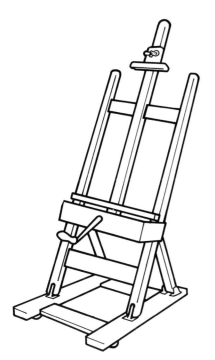

The design of studio easels varies. They are sturdily constructed and usually accommodate larger canvases very well. They may be fitted with castors and have mechanical systems of adjustment. Some have paint trays or similar practical features as part of their design.

There are many designs of palette for use with oil colour or acrylics. The patterns shown here are traditional, but even these have their varieties. A mahlstick steadies the hand and keeps the painter's hand away from areas of wet paint. Single and double dippers can be clipped on to the palette to hold oils, media or diluents. Watercolours employ china palettes, with separate wells for each colour, and saucers, with or without compartments. These items are also available in plastic.

Useful studio equipment might include canvas straining pliers, which have specially designed extra-wide jaws; a mouth diffuser for spraying thin paint, fixative or varnish; and lay figures. Lay figures are jointed wooden mannikins, usually 1' (30cm) high, used to mock up poses. In the past life-size lay figures were used, especially by portrait painters and their drapery men. Lay figures of horses and hands are also produced.

Palettes

Although any non-absorbent surface can be used for the laying out and mixing of paint, the traditional painters' palette is made of wood. Solid cuts of wood are still used, but most palettes are now made of plywood, which is both light and cheap. There are numerous palette patterns to choose from, only a few of which are available as ready-made items. The various shapes and sizes suit different temperaments and methods of working, but any good palette should be well balanced and, when held properly, should exert little pressure on the hand. (A large palette may need to be counter-balanced with a small weight to make it more comfortable to hold.) Most patterns are held by means of a thumb-hole, with the body of the palette extending along the forearm so that the colours are held in the painter's line of sight. Many palettes have a notch along their front edge, known as a brush notch, which allows spare brushes to be held in the same hand as the palette.

Painters seldom pay enough attention to their palettes. They should always be kept well ordered and clean, and painters should ideally have several palettes which can be laid out separately for the different stages of painting. Light woods, white enamel or plastic palettes should be used for painting on a white ground, otherwise it is very difficult to judge the colour values correctly as they are transferred from palette to painting. Dark woods like mahogany should only be used when painting on a dark or tinted ground. New palettes should be oiled or varnished before use, and should be primed with white undercoat if they are to be used with white grounds.

Disposable paper palettes, plastic palettes and special moist palettes can all be recommended for use with acrylic paints. Metal and plastic palettes with wells for liquid colour are also available, but watercolour, gouache and tempera are more often mixed in china or plastic mixing trays which are not hand-held.

Dippers

A dipper is a small pot which clips onto the edge of a palette. It is used to hold medium or thinners, which can be added to the paint as required by dipping the brush into it. Though their use is well established, it is not necessarily to be encouraged, as this method of adding medium to paint is rather haphazard; double dippers which have two pots – one for oil and one for turpentine – encourage a particularly erratic use of painting medium. Dippers are made in plastic and metal, and the best have close-fitting tops which can be put on to prevent evaporation and drying that would bring about a change in the character of the medium.

Mahlsticks

The mahlstick is a means of steadying the hand whilst painting. It is useful for painting intricate details, or where large areas of the painting are wet and must not be touched accidentally as further colour is applied. Typically a mahlstick is around 3' in length (c. 1m), strong and light with a small pad at one end, which is rested against the edge of the painting, the easel or some other convenient point of support whilst the other end of the mahlstick is held in the free hand. The hand holding the brush is rested against the mahlstick and thereby steadied. If the mahlstick is held by the little finger of the painter's free hand, so that part of it rests against the underside of the arm, it is possible to hold the palette, the mahlstick and some spare brushes all at once.

Most painters make mahlsticks for themselves, using bamboo or a length of dowel with a wad of scrap cloth tied onto one end. Commercially made mahlsticks sometimes have a cork head and may be a little more sophisticated; some are made in sections, whilst others are telescopic, allowing them to be altered in length to suit the requirements of the user.

PART 2

Painting Techniques

2.1 Useful beginnings

Transferring drawings

Drawings and preliminary sketches are by no means essential to the production of paintings, but many painters use them to develop their ideas. A great many painting techniques begin with some form of drawing that acts as a guide for the subsequent application of paint. The transferring of a drawing is therefore an important preliminary procedure to painting. A modern way of doing this, for which the camera obscura is a historical precedent, is to use a projector of the type that will project anything placed on its object tray. Some would regard this as unethical, but whatever your views, the following manual methods are more practical for the majority of painters.

Making cartoons

A cartoon is a drawing made specifically as a pattern for a painting. It is the same scale as the painting and is used to duplicate its own design onto the support in outline form. Cartoon transfer works best with a linear drawing or any composition that has crisp outlines. Firstly, assess which are the most important lines and outlines in the design. Then place the drawing on top of a clean sheet of paper at least as large as the original. These should be held together firmly so that they cannot move and then placed on a soft surface which will not resist the point of a needle or stylus as it is forced through the paper. A blanket, a piece of carpet, a thin sheet of foam rubber or a designers' cutting mat will all serve the purpose.

The whole of the drawing is then pricked out systematically, in such a way that a series of holes is made along the important contours of the drawing. How close together these are will be dictated by the size and detail of the drawing, but take care not to run them together so that they actually cut the drawing along its lines. When all the main outlines have been pricked out, remove the original drawing from the bottom sheet. The holes in the original can be more or less closed up by rubbing the thumb-nail over the back of it.

The bottom piece of paper will now have the main outlines of the drawing rendered as a series of holes, and can be used to transfer the drawing onto the support by holding it flat against the support and using it as a stencil. One way of doing this is to dab firmly onto the lines of holes using powdered charcoal in a muslin bag; this is called pouncing. Charcoal dust penetrates the pounce bag and is forced through the holes in the cartoon onto the support beneath. Another method is to rub over the holes with a large stick of soft charcoal and to smear the charcoal powder up and down the lines of the drawing, using a finger to ensure it has penetrated well and left a good mark. Strong red drawing chalk can also be used in this way, and may make a better impression than charcoal. A further alternative is to repeat the pricking-out process, pushing a pencil or pen through each hole to make a small mark.

When the cartoon is removed from the support, it will leave behind a duplicate of the original drawing as a series of dots. These can then be joined up to make a complete drawing, using whatever instrument or medium the painter desires. The original can be referred to if necessary to supply any details that the transferred version may lack, and the drawing can be developed further at the same time. Chalk or charcoal can be dusted away to leave a clean duplicate of the drawing in place. The cartoon itself may be destroyed during the transfer process, so an intermediate version is often made. This can be used without causing substantial damage to the original allowing any number of transfer cartoons to be made from the original drawing without destroying it.

To reverse a drawing, simply make an intermediate cartoon and turn it over before it is used. It will then transfer a mirror image of the original drawing.

Squaring up

One of the easiest ways of making an accurate drawing is to use a drawing frame (p. 92). This is a rectangular frame with a series of holes at regular intervals around its edge. Strings are threaded through these to create a network of square or oblong divisions within the frame. The same device can be made from pieces of card and cotton or by drawing grid lines directly onto a sheet of glass or clear plastic.

When this frame is put between the viewer and an object, the latter is experienced as a divided image, and the grid pattern supplies an ample number of reference points against which it can be assessed. If a matching grid is then drawn onto a sheet of paper, the artist can systematically copy what is seen in each division of the frame, taking one section at a time and concentrating only on the content of that particular portion of the frame.

Using this system, an existing drawing can be transferred, enlarged or reduced by increasing or decreasing the relative size of the squares. Squaring up can also be done without a frame, simply by drawing a grid pattern over the original drawing. Corresponding lines are then drawn on the surface of the support and the drawing is copied square by square onto its surface. A drawing frame has the advantage that the original drawing need not be marked by the lines that square it up. If the drawing is being transferred at the same size as the frame, the support surface can be squared up by dusting the strings of the frame with chalk or charcoal and then snapping them against the support so that they leave marks corresponding to their own lattice.

Tracing

Probably the simplest method of transferring a drawing is to trace it onto the support surface. The drawing can be used to transfer its own image simply by rubbing over the back with a soft pencil or red chalk. It is then held flatly against the support, and the drawing is repeated using a pencil or stylus from the front. When the whole drawing has been gone over in this way, it can be lifted away to reveal a traced image of the original. This can be reinforced by drawing over it again on the support, though it will usually be sufficient to act as a guide for subsequent painting.

If the original drawing is to be saved, a second drawing is made using tracing paper. This is laid over the original and the main outlines are re-drawn onto the tracing paper. The tracing paper is then coated on the back with red chalk or pencil in the same manner as before, and drawn over yet again, held against the support. A separate tracing taken from an original drawing can also be used as the basis for a squaring-up procedure to enlarge or reduce it, and if it is turned over and re-drawn from behind, it can be used to reverse the image.

Aids to composition

Even in the case of abstract painting, good composition is essential if a work is to be attractive or striking to the eye. As with every aspect of painting, it is the individual approach which singles out genius, and there are no absolute rules governing composition. Often, good composition is the result of a natural, intuitive process: a painter will create something that is pleasing, which is only on subsequent analysis found to conform to traditional rules of composition. Nevertheless, it can take much hard work and practice to develop a good eye for composition, and it is helpful to be aware of the following 'short-cuts' and hints on where to begin. There are certain technical tricks and set frameworks that make good composition much easier to achieve.

Using a frame

This is a method of choosing a composition rather than creating one. It is rather like

This Dürer engraving of 1538 shows an artist at work with a drawing frame. With his eye held at a fixed point, he transfers what he sees through each square of the frame onto the grid mapped out on the working surface.

using a drawing frame as an aid to draughtsmanship (*see* p. 91), in that it allows the painter to concentrate on a specific area by excluding all the surrounding distractions. The painter can then assess more accurately the compositional quality of what lies before him.

When working from life, take a drawing frame, a window mount or picture mat cut from card, or even the frame intended for the finished painting; for the best results, the proportions of the frame should correspond exactly to the proportions of the final painting. Set up the frame and adjust its position until **what** you can see through it creates a satisfactory image. The position of the frame and **your** own position should then be marked, so that the viewing distance remains constant. When working from a sketch, cut a window into paper or card, or better still, cut two L-shaped pieces of card which can be laid together to make an adjustable rectangle. Move this frame over the surface of the sketch until you hit upon something that appeals to you; then, holding the frame in place, transfer what it contains onto your support as a preliminary drawing. A drawing can be cropped in a similar way by laying sheets of paper over its edges, and adjusting their position until a more satisfactory image is achieved.

Using a mirror

Another simple aid to composition is a plain mirror; it also helps to detect errors in drawing, tonal values and colouring. All you have to do is look at your painting in the mirror, and in its reversed state you will find that minor errors become far more glaring. Errors in composition are particularly noticeable, as only a well-balanced composition remains harmonious when reversed. This does not mean that compositions have to be symmetrical, but that they should be visually balanced. Turning a painting upside-down or on its side has a similar function.

Such effects can be explained by the fact that most people seem to have a leading eye, which dominates what they see, ignoring minor irregularities within the field of vision. Whether or not this is the case, it seems to work in practice, and simply covering one eye whilst looking at a painting is often enough to highlight deficiencies. The brain also appears to compensate for images that are not quite right, and if you look for too long at the reflection of a painting in a mirror, you will no longer be able to see the errors as clearly. The technique therefore works best if the mirror is used to create a visual shock, where the normal view of the painting is suddenly replaced by its mirror image.

Random blots

It is often difficult to create a composition from nothing, so some painters make use of random images as a starting point. Like staring into the fire or gazing at clouds in the sky, concentrating on such imprecise forms acts as a focus for the imagination, and all

manner of compositions can be created from them. This creative process can be deliberately stimulated using random blots or splashes of colour on a piece of paper. These may suggest a particular scene or collection of objects, which can then be developed to create a satisfactory composition. It may seem strange to start with the abstract and work towards the real in this way, but in fact it makes a great deal of sense. Successful compositions usually rely on proportional relationships and geometric patterns that underpin the surface detail; what is appreciated in a well-composed painting is often an abstract image concealed within a naturalistic one.

The Golden Section

The Golden Section is the name that has been given since the 19th century to a theory of composition based on a mathematical relationship that has fascinated philosophers and scholars since ancient times. The proposition concerning the Section was first set down by Euclid, but is said to have been originated by Plato. It is linked to the construction of regular solid shapes as well as to the division of space, and it was known to the learned painters of the Renaissance, though whether or not it was systematically applied is open to debate.

In simple terms, the Golden Section depends on the division of a straight line into two unequal parts that have a special relationship: the ratio of the smaller segment to the larger is equal to the ratio of the larger segment to the length of the whole line. A line divided in the proportion 5:8 corresponds approximately to the Golden Section, and compositions based on it generally make use of a bold vertical which crosses a horizontal sight line at the appropriate point. This device is effective even when it does not use the precise proportions. In fact, painters are quite likely to hit upon the Golden Section by accident, simply because they instinctively find such proportions visually appealing; controlled tests have shown that the Golden Section is more pleasing to the human eye than many other divisions of line and space. Various other mathematical relationships have shown themselves to be useful aids to composition in abstract, as well as figurative painting.

Leading the eye

At the heart of many apparently sophisticated paintings there are often extremely simple compositional devices that lead the viewer's eye to a given point. For example, take a rectangle – the shape of most paintings – and draw a diagonal line from corner to corner in both directions, making a large cross. Whenever you look at it, your eye is led to the crossing-point of the lines, which also happens to be the very centre of the rectangle. Change the position of the lines somewhat or increase their number, even substitute curved lines for straight lines, and the same result can be achieved so long as there is a focal point to which all lines lead. Now imagine a painting on the same rectangular surface with objects and areas of light and shade composed so that they roughly correspond to portions of those sight lines. These will quite literally point the eye in the right direction, leading it to the focal point, even though a complete network of sight lines does not exist. Take this a step further by placing the most important element of the painting at the focal point; the viewer's eye is then directed into the picture, to the point where attention should be focused. Clouds, foreground foliage, the roofs of buildings, even striking brushstrokes can all be used to direct the eye.

Another way of focusing the viewer's attention is to place a shape within a shape, confining the movement of the eye to a certain area of the painting. Imagine once again that you are confronted by a plain rectangle; draw a large triangle within that rectangle, and you will find that your eye tends to look towards the centre of that triangle and to confine itself within its boundaries, for the most part ignoring the remainder of the rectangle. By suggesting sight lines within the triangle, the eye can be led around within the internal shape so that it never leaves it. There is no need to lead the eye in from the edge of the painting, as the viewer tends to look straight into the second shape, taking the line of sight instantly within the boundaries of the painting.

If the inner shape is made larger than the rectangle that surrounds it, then another compositional device is employed, known as breaking the frame. Although not all of the

Leonardo's compositions are often based on regular geometric shapes. In the Virgin and Child with St Anne *the figure group forms a pentagon, divided by the vertical axis created by St Anne's head and foot. In his notebooks, Leonardo also betrays a fascination with mirrors, and he advised painters to explore natural patterns, in rocks and clouds, and random blots to stimulate the imagination, as an aid to composition.*

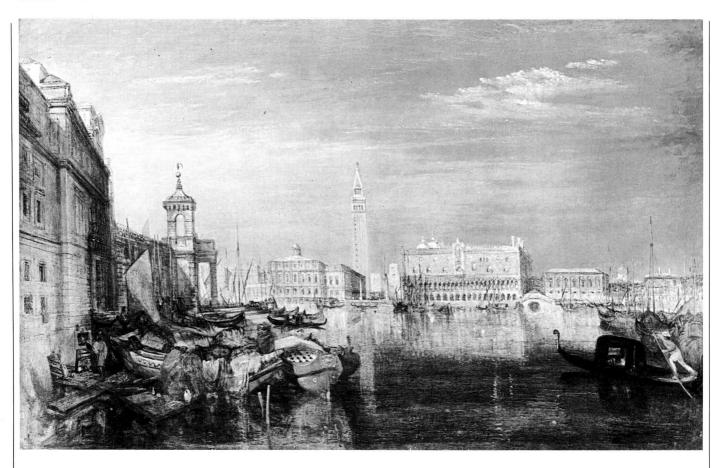

In spite of their grandeur, Turner's paintings often follow deceptively simple rules of composition. In Bridge of Sighs, Ducal Palace and Custom House, Venice *(1833), the boats and buildings on the left, and the clouds and gondola on the right, create diagonals that lead the eye to the bell-tower.*

shape can be seen, if the indication of its presence is sufficiently strong, the eye will assume its existence beyond the frame, and will focus its attention correspondingly within it and towards its centre. Once again, the viewer tends to ignore the edges of the painting, in this case because the suggestion that the inner shape continues outside it implies that the frame simply does not exist.

Aids to colouring and tonal relationships

All paintings, whether figurative or abstract, are fundamentally concerned with the relationship of colour and tone. Tone is a degree of light or shade. It exists independently of colour and can be measured on a scale which progresses from white, through grey, to black. The sensation of colour is created by the eye's response to light of certain wavelengths; pure colour exists only as light, and so far as painters are concerned, all colours are also modified by a tonal value. The real tonal values that exist in nature cannot be matched in painting. The same is true of colour; since true colours of nature exist as coloured light their palette is, quite literally, the rainbow. Pigments, on the other hand, are not pure colours, and their range and behaviour pattern are entirely different. Painters can only imitate nature, they cannot match it, and skilful use of the palette involves nothing more than the exploitation of visual tricks which satisfy the eye. Paintings are not mirrors, but abbreviations of reality, which make sense if key colours, tones and outlines have an internal logic and consistency.

Intellectual theories about colour and tone have been readily adopted by artists, and attempts have been made to convert them into theories of painting. Some colour

Candlelight is soft and diffuse, as well as highly atmospheric. In this self-portrait, Goya shows himself wearing a hat equipped with metal clips to hold candles. In the biography written by his son, he is quoted as saying that 'the final touches which give a picture its whole effect were added at night by artificial light'.

theories are highly questionable, whilst others lack sophistication or confuse the behaviour of light with that of pigments. For example, most painters will be familiar with the colour circle and its associated theories; in fact, an accurate colour model is three-dimensional, and the relationships which unquestionably do exist between certain colours do not always follow the simple patterns suggested by the colour circle. Tone is a very important factor which is ignored completely in certain colour theories. Any theory should be tested against experience, and should never be rigidly adhered to. Experimentation is by far the best way to achieve original and satisfying colour effects.

Selecting or controlling lighting

Since colour and tone are both dependent on light, it is a great help if both the lighting of the subject and that under which the painter works can be brought under control. Some painters, especially portrait painters, have found that working with light habitually falling from a fixed direction is extremely helpful, as they become so familiar with the way the light falls, that colours and tones can be placed with minimal reference to the subject. Another favourite technique is to paint only at certain hours of the day when the lighting conditions are of an average quality, and the length and intensity of shadows are of the painter's choosing.

Another traditional practice is to diffuse light, which takes away its directional quality and harshness. The light that remains will not remain constant throughout the day, but for a major part of it, the light will not deviate greatly from an average quality. Paper, thoroughly impregnated with drying oil, then allowed to dry, can be used to cover studio windows or may be pasted onto frames to make screens. This diffuses light admirably, while allowing most of it to filter through. Pale, coloured paper will diffuse light with a slight tint, which will help to harmonize the colouring of the subject. A professional quality tracing paper in a heavy weight, or a canopy of white, lightweight cotton cloth may also be used. This is valuable in areas that get plenty of sunshine without cloud cover, as the full light of the sun is often too strong to paint under.

Studios that are not well lit will benefit from being painted white, as this reflects whatever light there is repeatedly around the room. Strongly coloured decor should be avoided as it tends to affect the way in which colours are perceived. Artificial light is not as satisfactory as daylight, but if necessary, special lamps are available which approximate to daylight. Paintings carried out under normal domestic lighting are likely to appear quite different in daylight, and may have to be partially repainted to correct colour values.

Using a Claude glass

A Claude glass is a black-coated mirror used to assess tonal relationships. Because it is black, it negates the colours of the subject reflected in it and shows them only as variations in tone. It is then easy to see how the tonal values relate to each other, as the fact that one tone is darker or lighter than another can be recognized instantly without any visual confusion caused by the colours involved. Any errors in tonal relationships will be shown up when a painting is viewed in a Claude glass.

You can make a Claude glass by applying gloss black paint to the reverse of a clean sheet of glass. Alternatively, a piece of tinted or smoked glass can be mounted in front of a mirror to achieve a similar effect. A piece of shiny black glass or plastic will also work. The fact that as you look through such filters, the subject matter is viewed directly, rather than being reflected, can be an advantage in some circumstances. Smoked glass makes an acceptable filter, and orange plastic is especially effective. Note, however, that where coloured filters are used, an interaction takes place between the colour of the subject and the colour of the filter, and some distortion of the relationships may then occur. A Claude glass intended for landscape painting will benefit from having a curved surface, as it will then take in a much broader scene, and the whole of the landscape being painted can be viewed in the glass as a single image.

Selecting an appropriate palette

Whatever methods and devices are adopted, and regardless of any theories you may

choose to follow, there is no better aid to colouring and to the correct use of tone than the careful selection of an appropriate palette of colours. You must know what mixtures can be derived from what colours, how far they can be shifted in tone and how far they relate to each other. In short, you must be familiar with your palette and should confine yourself to what it can do. Good colourists are invariably selective, employing very few colours, but with great virtuosity. Basically, this is just a question of discipline, coupled with the knowledge that the eye of the observer will happily settle for the right tone, even if the right colour is not actually on the palette. Good colourists often exploit favourite colour effects whenever they can, and ignore what is in front of them where it does not suit their purpose.

The knowledge of colours as they exist in paint and of how they are selected and used is a subject in itself. What follows can only be considered an introduction, and it cannot be stressed too much that accumulated experience is the real key to success.

Knowing how colours work

The appearance of a colour is dependent on how and where it is placed; it may be enhanced or altered by another colour placed near to it, and its brilliance and intensity are only relative to the other colours that surround it. For example, if yellow ochre is put down thickly and flatly, it appears a dull yellow brown; if it is applied thinly as a glaze it has a golden glow; and if, as a glaze, it is placed next to blue, it appears positively yellow. If, on the other hand, it is placed next to blue as a body colour, it actually appears duller, while if it is combined with red ochre in a broken fashion, so that both colours are exposed, they are both enlivened. If it is used as a tint against a broken blue or purple, it will make any white which is in close proximity appear brighter than it actually is. Finally, consider yellow ochre on a background of a darker colour and then consider it as a background to a lighter colour, such as yellow or white. The brilliance of the yellow ochre is relative in each case; in the first instance it represents the brighter colour, while in the second, it appears the darker colour. Yet it is the same colour on both occasions. All colours work in this way, and the conversion of each colour into a shade, tint or mixture adds further possibilities to the range of effects.

As coloured pigments represent tones as well as colours, they can be thought of as members of a group, instead of being treated as individual colours. Lemon yellows, bright yellows, golden yellows, oranges and yellow earth colours are all varieties of yellow; they can be substituted for one another in mixtures or be used to shade each other in the development of form. Such groupings are not absolute, and there are areas where they overlap. However, this is a very practical way of treating colour and it helps reduce the use of colour to a set of basic principles.

A further consideration is that many coloured pigments possess an undertone; that is, because they are not pure colours, they contain an element of another colour within them. Where this is sufficiently strong, its effect will be quite pronounced. A red may tend towards yellow or blue, for example, whilst a blue may tend towards red or green. Undertones can also be introduced deliberately, as when a black is made warm or cold by the addition of brown or blue.

Colours are highly suggestive. There are some well developed theories on the psychology of colour, but in practice it is observation rather than theory which produces effective colour stimuli. Take as an illustration the case of a landscape covered in snow. If the shadows on the white snow are painted grey, the impression is that of a dull winter's day; if they are painted light blue, the scene becomes cold, but bright, like a crisp winter's morning. Now change them to green, and the snow becomes icy and desolate. Finally, change the shadows to purple, and the scene changes to a winter's evening. All this is suggested by subtle variations in colour.

Choosing and laying a palette
Each individual is at liberty to choose his or her own palette, but it is unwise to use colours that lack permanence, or to lay a palette with more colours than you actually

need. The fewer the colours, the more impressive the colouring is likely to be. The maximum number of colours should be ten or twelve, and a palette of seven or eight colours is more than adequate for most purposes. Select colours that suit the subject, and avoid putting unnecessary colours on the palette. Try to avoid any near duplication of colours, but allow for subtle variations where they are required.

Laying a palette is extremely important. If it is done properly, in a manner appropriate to the technique being used, it can make painting easier. If the palette is dirty and untidy, there is a good chance that the finished painting will be too. For complicated techniques it helps to have several palettes laid out separately for different stages in the painting process. It is especially advisable to have a separate palette for glazing which has no white on it, as this prevents accidental clouding of the glazes. In any event, colours should always be set out systematically, with some thought given in advance to how they will be used, and with each colour sufficiently separate from the next to avoid any unintentional mixing. Colours should be mixed in a clearly defined area of the palette, well away from the parent colours, so that they remain pure.

There are several ways of laying a palette, but the usual procedure is to lay colours in a line along the top of the palette, grouping them according to colour or in order of usefulness. This puts important colours in the line of sight and well within reach, with those that are little used at the far end of the line. It is generally practical to place white nearest the thumb, with sufficient space for a large quantity of it, though some painters prefer to place white in the middle of the line of colours.

Where certain set colour mixtures are anticipated, these can be laid out beforehand as a second line of colours. One or more lines of tints and a line of shades may also be added beneath each colour. This establishes set tonal relationships on the palette, so there is no need to search for them during painting; they are simply selected and transferred systematically with a minimum of alteration. Palettes should be cleaned and relaid frequently to keep the colours fresh and well ordered.

Colour mixing

It is possible to paint without mixing colours at all, but most methods of painting call for at least some mixing of colours. Most pigments are less permanent in mixtures and some are extremely impermanent below a certain concentration. This is a very good reason for excluding doubtful colours from the palette in the first instance. Colour mixtures should, whenever possible, be kept simple, as this aids permanence and colour quality. Ideally, mixtures should not contain more than three separate pigments, otherwise they will appear muddy and dull. Bear in mind that some commercially prepared paints already contain colour mixtures, which will affect any further mixing.

Colours can be mixed in four ways. They may be introduced to each other in equal quantities, in which case a straightforward mixture results, and a new colour is created. Alternatively, one of the colours may be added as a mere trace, causing a shift in colour, but not a radical change; this is a broken colour, and the small addition is said to 'break' the dominant colour. The third colour in a mixture often serves to break the colour that results from an equal mixing of the first two. Broken colours are essential for achieving subtlety and harmony. The other types of colour mixture are shades and tints. Shades are colours in descending tones arrived at by mixing increasing quantities of black with colour or colour mixtures; tints are rising tonal values achieved by mixing increasing quantities of white with either pure or mixed colour. In practice, shades are often muddy and only a few broken shades are of value. Lower tonal values are best represented by a complete change of colour or by mixtures including dark colours other than black. Tints are valuable, but they often result in mixtures that differ appreciably from the parent colours and are inclined to be insipid when derived from certain colours. Brighter tones can often be achieved without loss of colour by mixing with more sympathetic colours.

Colours that appear to 'kill' one another in mixtures are said to oppose each other. This can be exploited in broken colours in order to remove harshness or to slightly dull the brilliance of a mixture. The excessive killing of colours, however, leads only to a dull painting. Great care should be taken when colours are being mixed, and also when

they are applied, to avoid any unintentional destruction of their purity. This most frequently occurs when traces of colour from a previous mixture or from a wet area of the painting are allowed to remain on the brush. Even very small amounts of certain colours will effectively kill large quantities of others. Although the range of possibilities is extensive, in practice, only certain combinations of colours produce useful mixtures. Because pigment colours are not pure colours, the value of any mixture depends on the precise pigments employed and on their undertones. As different pigments have different tinting strengths, and as the quality of prepared paints varies, no firm guidance can be given on the amounts of colour required in mixtures, and this is something painters must experience for themselves. (*See Chapter 1.1*, for comments on individual colours.)

Some useful colour mixtures
White broken with yellow ochre gives a warm white, like ivory; more yellow ochre produces cream. White broken with a trace of blue gives a cool white, and, as a stronger tint, a blue-white makes an excellent first shade for white. White broken with blue and a trace of yellow ochre or raw sienna gives a pale duck-egg blue, which is useful for reflections in flesh and for painting the far distance in sky. French ultramarine mixed with white and broken with a trace of yellow gives a lively sky-blue.

Cadmium red with white makes a reliable pink. White broken with red ochre makes a salmon pink. Both of these may be used in flesh. A flesh tint is produced from white mixed with yellow and broken with red, while yellow ochre in a flesh tint gives a more natural colour. Reds broken with yellow give bright reds, whilst reds broken with blue give crimson. Alizarin madder mixed with Hansa yellow gives a warm, glowing orange, while mixed with yellow ochre it gives a duller version of the latter colour. Alizarin madder and cobalt violet pale give a purple-pink that resembles genuine rose madder, and alizarin madder broken with umber gives a deep, warm crimson that tends towards brown.

Green mixed with yellow gives bright green. Green and yellow broken with blue give a rich mid-green. Blue and yellow broken with black or with any dark earth colour give a dull green for shading. Blue mixed with yellow ochre and white gives a pale, dull green which gives an impression of distance. Pale greens produced as tints with white are useful in flesh painting. Yellow ochre broken with black produces olive green, whilst viridian and blue produce a strong dark green. Lemon yellow broken with a trace of green gives an acid yellow tending towards lime green, which is a valuable colour for highlighting greens.

Red and yellow earths broken with white give a deep tan. Hansa yellow deep broken with raw sienna and a trace of red or black gives versions of yellow-pink. The same mixture with a greater proportion of raw sienna gives brown-pink, and a similar colour may also be made from a mixture of Hansa yellow and umber. Red ochre mixed with raw umber or burnt umber produces tawny brown. Black broken with umber gives a warm black, and black broken with blue or green gives a cool one. Raw sienna mixed with black or burnt umber gives a warm glowing brown like the traditional Vandyke brown or Cassel earth.

2.2 Applying paint

The methods of applying paint described below should be viewed as general principles, and are not necessarily linked to particular techniques or media. In practice, some lend themselves more readily to certain ways of painting than to others, but it would be wrong to categorize or limit their use because of this. The technical knowledge required where methods of application are used outside their normal sphere will be found at various points throughout this book. (*See* particularly *Chapters 1.2* and *1.4*, and *2.4* to *2.8*.)

Body colour

Specifically, the term 'body colour' refers to paint which has been given body; that is to say, it has been made opaque by an addition of white. The name is applied more generally at times, and can include any colour which is applied in a dense covering manner, though body colour is not necessarily thick paint.

Body colour may be used in all techniques except pure watercolour. It is pehaps the simplest way of using paint as it does not depend on the ground or on underlying colours for its effect. Colours and tones are simply mixed and set down as they are intended to be seen; because body colour is opaque, light reflects from its surface, and the painted area is perceived as flat colour without visual depth.

Scumbling

To scumble is to drag paint over the support in a half-covering fashion, so that it leaves irregular broken traces of colour which allow the underlying paint or ground to show through. In theory, paint of any quality can be applied in this way, but most often body colour is set down as a scumble, because of its ability to cover well in the areas which are actually touched by the paint.

Scumbles may be applied thickly, in the manner of impasto, or exceptionally thinly, to produce a veil-like covering of the lower layer, resulting in an optical mixture of colour. Scumbles are normally applied with the brush, though a palette knife can also be used. With thin colour, the brush is squeezed dry and then dragged, rolled or pushed in a haphazard fashion across the surface of the painting. When thick paint is used, the brush or knife is heavily loaded and skimmed across the painting surface with a light touch to encourage a random deposit of paint. A fine, veil-like scumble is best achieved by stippling: using a firm, lightly loaded brush held at right-angles to the painting surface, apply the paint with a gentle stabbing action.

Frottie

Frottie is a term commonly used to describe the preliminary laying of colour as a thin, transparent or semi-transparent covering. More precisely, the term refers to a deliberate application of semi-transparent paint, which falls between body colour and a glaze. The visual effect is similar to a veil-like scumble, but the paint film is actually continuous, with its translucency dependent on a low pigment content finely distributed through the medium. Alternatively, a frottie might be thought of as a glaze containing white.

The frottie is used mostly in traditional techniques, where it may occur in delicate passages of underpainting or as a finishing layer over a well-developed dead colouring; in both cases it retains the overall character of whatever lies beneath it, and on close inspection it appears to float like a mist of colour. It is possible to base an entire technique on the use of frotties, but this is rarely done as they require considerable skill: it is difficult to judge how translucent they will appear until they are dry, and they are easily lost beneath subsequent paint layers if they are applied too lightly. Opaque paint smeared into place so thinly that it can be seen through may also be regarded as a form of frottie. In fact, the name probably derives from the technique of rubbing paint into place with the fingers in order to make it exceptionally thin.

Scraping back

First, an area of paint is set down in any chosen manner, and then, whilst it is still wet, the edge of a straight-bladed palette knife is drawn across the painting surface to remove virtually all the paint, leaving only a smeared trace. Scraping back produces an extraordinarily thin coating of colour, rather like a stain. If transparent colour is used, the result resembles a wash, and if body colour is scraped back, the effect is like that of a frottie or thin scumble. There is a flatness about the result, however, and a directional quality which set the technique apart from either of those methods. A very slight texture to the surface of the support is essential to produce successful results, although a smooth, absorbent ground may also provide a satisfactory base, depending on the type of paint being used.

This may not sound a particularly efficient method of applying a thin film of paint, but it has the advantage that it does not require a delicate touch on the part of the painter. It is true that the thin layer of paint is less controlled than if it were applied directly, but this random quality is actually part of the charm of this technique. Repeated scraping back can produce considerable subtlety of colour and form, lending outlines a hazy, ethereal quality which can make an interesting contrast to sharp drawing. On a white ground, strong colours can be scraped back to produce a paler tint, while scraping back to reveal an underlying colour will produce very subtle modifications. It is also possible to make corrections by scraping back, providing the paint is still wet enough to yield to the knife.

Rubbing

Children paint with their fingers, but so do great artists. Leonardo da Vinci, Titian and Turner certainly did, and there is plenty of evidence to suggest that it has always been a widespread practice. It is a very valuable technique, but it is important to remember that certain pigments are toxic and that some media can act as irritants. On these grounds, you are advised to avoid bringing paint into contact with the skin, except when the delicacy of the sought-after effect demands it.

*Nocturne in Black and Gold:
The falling rocket: scraping
back was a favourite
technique of Whistler's. Here
it is combined with
spattering and scoring into
wet paint to create a highly
evocative image.*

No other method of application gives such an even, controlled and uniformly thin covering of colour. It also allows less medium to be used, and so enables you to put down fat colours very thinly without dilution, and in the long term it can mean a more durable and permanent paint film. It also gives an unrivalled degree of control over colour intensity, as a pigment-rich paint rubbed into place produces a much more powerful glaze than can be achieved using painting media. What is more, the fingers can be used to wipe back the paint selectively, so that its thickness and colour intensity are varied. This is especially helpful in areas of shading and modelling, where the edges of the paint can be wiped away with the fingers until they tail away into nothing, creating a subtle transition from light to dark, or from colour to colour.

Rubbing paint is a highly satisfactory method of applying a frottie using body colour. In the early stages of a painting, colours may be rubbed in to achieve an atmospheric dead colouring, while towards its completion, the fingertips allow very delicate finishing operations. In pastel painting and some oil techniques, rubbing in colour also has a definite technical function, as it helps it to adhere by forcing it into the underlying surface. The same effect can be achieved with the stump of the pastel, but the finger allows greater variations in pressure. Rubbing pastel powder into the grain of the support not only induces a softness of colouring, it also traps the pigment physically and makes it far less likely that it will come away. In oils, especially where fat colour is being used, rubbing paint into

*In his late works, such as
Diana and Actaeon (1560s),
Titian's handling became
increasingly free and
impressionistic, and it was
said that in the last stages of
a picture 'he used his fingers
more than his brush'.*

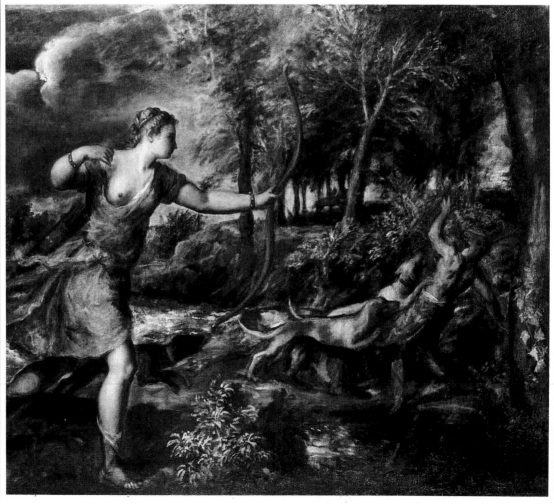

Van Gogh probably added wax to thick, commercially prepared oil colour to achieve the expressive impasto brushwork of this self-portrait (1889–90).

place is sometimes the only satisfactory method of applying further colour to dry paint layers.

As an alternative to the fingers or ball of the hand, wads of cloth can be used to rub paint into place. This is more difficult to control and can deposit fibres in the paint layer, but it does overcome any potential health hazards.

Glazing

By its most precise definition, a glaze is a layer of transparent colour that has body, or richness, derived from its medium, resulting in great depth and intensity of colour. Pigments which themselves lack body tend to make the best glazing colours, but contrary to some opinion, all colours can in fact be used as glazes. Nowadays the description 'glaze' is occasionally applied to any paint which is thin, whether or not it is transparent, and whether or not it has body. This is a total misuse of the term, which fails to recognize the essential qualities of a glaze.

A glaze is the complete opposite of body colour. It has no covering power, only colouring power, and whatever lies beneath it remains clearly visible, though it may be modified in tone as well as colour. Glazes are most often used in combination with paint applied as body colour, scumbles or as a frottie. Visually, a glaze tends to advance, and this feature may be exploited to trick the eye into thinking it sees distance. The same effect means that dark glazes used in finishing may appear to advance, and must therefore be applied with care to avoid creating a disjointed appearance. To work well, glazes require light, and paintings which employ glazes are seldom seen at their best when poorly lit. This does, however, depend a great deal on the expertise and technique of the painter.

Glazing is principally a technique of oil painting. It can be employed in other media, but as a rule, outside the oil technique a glaze is better described as a wash; only oil can offer sufficient body and saturation to the colour to create a true glaze.

Washing

A wash is a thin and extremely fluid application of colour made by diluting paint to excess with a suitable thinner. Washes are often confused with glazes, but there are two important differences. In a wash no extra medium is added to compensate for the reduction of the colour, resulting in a very lean paint film. Furthermore, although a wash *is* often transparent, it does not have to be, and there is no reason why opaque colour should not be applied as a wash. Washes are used mostly in techniques

using water-based paint, but oil colours may also be diluted to wash strength using turpentine or a similar solvent. Dilute ink is also referred to as a wash when it is used in the manner of watercolour paint.

A wash is normally applied with a well-charged brush and is laid as broadly and flatly as possible. If too small a brush is used, or if insufficient paint is applied at one go, the final effect may appear broken and irregular. Because of its extreme fluidity, a wash is more difficult to control than a glaze, and its edges are inclined to flow in an uncontrolled manner. (This is particularly true of oil washes as their diluents are also wetting agents, and the addition of alcohol or ox gall to a watercolour wash may aggravate this effect.) A wash will run if it is applied too heavily or if the support is inclined at an angle. This does not occur with a glaze as the body of the medium limits its capacity to flow.

In the watercolour technique transparent washes are used throughout, and their effect is similar to that of glazes, though they lack the lustre and depth of glazes. In tempera, gouache and acrylic, finishing washes may be applied as a frottie, or as a pseudo-glaze. (Washes are also used for the staining technique employed with acrylic paints, *see* p. 176.) When oil colour is applied as a wash it is usually to provide a lean lay which is subsequently covered with thicker paint. To use washes rather than glazes in the final stages of an oil painting would be contrary to the principle of fat over lean.

Impasto

Impasto is an application of thick paint which stands well clear of the painting surface. It is favoured for its texture and for its own form, as well as for its strong colour. Paint set down as impasto is suggestive of other things beside the colour or tonal value that it represents; for example, the directional pattern of textured impasto brushstrokes can suggest form, while the contrast between an area of thick impasto and a surrounding area of thin glaze can imply depth. The texture of the impasto can also directly mimic the texture of the subject being painted, and its strong physical presence can be used to make one area of a painting more striking than another.

For technical reasons oil and acrylic paints are mainly used for impasto, though similar effects can be achieved with other media. Paint that is applied as impasto is not bound to be opaque, but in practice it almost always is. It may be scumbled into place or applied more precisely using a brush or knife well loaded with thick, creamy paint. Thick paint can even be applied directly from the tube, drawing with the mouth of the tube as its body is gently squeezed. Applications of impasto are more sound if they are built up in several layers, but most painters prefer the spontaneity of *alla prima* impasto. Heavy areas of paint built up from repeated applications of thin colour may also be referred to as impasto, even though they lack surface texture. Impasto has often been combined with glazes to provide a variety of texture and contrasting effects. However, since the 19th century, impasto has also been explored for its own sake and has shown itself to be an extremely expressive means of applying paint.

Dabbing

Random textural effects can be achieved by applying paint from a textured object rather than a more conventional implement like a brush or knife. A sponge or a wad of cloth is the obvious choice, as these hold colour well and have pleasant surface textures. Ideally, they should not be overloaded with paint, otherwise the mark they make will tend to be too heavy. Dab repeatedly with the sponge or rag in a random fashion, turning the hand between each dab to help prevent repetition of

These two works, though similar in subject, demonstrate contrasting styles of brushwork. Ingres would probably have used a blender to remove all traces of brushwork from his Odalisque à l'esclave, *while Delacroix's* Woman with a parrot *stresses the painterly quality of the brushstrokes.*

identical marks. If the surface texture of the paint dabber is sufficiently fine, a veil-like scumble of opaque paint can be applied in this way. Optical greys and broken colour effects may be achieved by dabbing one colour over another, and areas of thin, flat colour may be enlivened by dabbing over their surface with another layer of the same colour; this produces a pattern of varying intensity of colour, which can be more stimulating to look at. Flat, even layers of colour can also be achieved by repeatedly dabbing on paint from different directions.

A natural sponge gives the most unusual effect, though a synthetic sponge offers a greater variety of surface textures, and may be cut to a specific shape if required. Generally, cotton is the best cloth for dabbing, as it has comparatively little surface lint, but cheesecloth and muslin also deliver interesting marks, and the most suitable cloth texture is really a matter of personal

choice. Note, however, that as the solvents used with oil colour can attack synthetic sponge and cloth containing synthetic fibres, it is best to use a separate dabbing implement for each colour and to discard any materials which will not clean thoroughly after use. For very rugged effects, paint can also be dabbed into place using crumpled paper or a wad of shredded rags.

Pulling

Pulling paint is really the opposite of dabbing, and is similar to the technique of scraping back. The paint is simply put down by whatever means you choose and then partially lifted away using an absorbent material which is placed over the wet paint. If paint is dabbed at with a dry sponge or rag, or even a wad of dry blotting paper, it will be picked up in a random manner, producing interesting textural effects. An area of wet paint may also be dabbed repeatedly until all but a trace of colour has been lifted to give the effect of a thin scumble; the covering of colour will be even thinner and more even, because it has been achieved by taking away, rather than putting down paint. Another way of pulling paint is to lay a sheet of an absorbent material, such as cotton cloth or blotting paper, flatly onto a layer of wet colour. When the absorbent sheet is peeled away, it will take some of the paint with it, and if the process is repeated, the colour may be reduced to a very even and very thin layer. This produces airy, ghost-like effects, rather like scraping back, and since it lifts the paint away vertically, there is less displacement of colours, and the position of the remaining stains can be more accurately controlled.

Colour can also be pulled using an absorbent object soaked in solvent, or by washing over dry colour with solvent immediately before using an absorbent material to pull the colour. This is obviously an advantage where fast-drying materials are in use, though it will only work if the paint film is at least temporarily reversible. Pulling colour with a solvent tends to leave irregular patterns in the paint layer, which can be highly desirable for their own sake.

Blending

Blending is a method of mixing adjacent colours after they have been applied, so that the abrupt divisions between them are lost. It is usually carried out with a clean brush, which may be a special blending brush, though any brush with a slightly spiky tip lends itself to blending, provided it gives an irregular and barely noticeable brushmark when gently applied to the surface of the paint. Blending may be carried out selectively to achieve soft transitions of colour and tone in certain areas of a painting, or it may be executed throughout, so that all evidence of brushwork is removed. Blending is occasionally referred to as 'sweetening', a traditional term that includes blending, but which may also be applied to any method of softening a painted image.

Controlled blending is most easily achieved using wet colour, and as oil colour stays wet longest, it is the material that is most frequently blended. Fairly thin applications of colour can be blended into each other by thorough working with the brush. However, delicate blending, and blending of thick applications of paint, is usually achieved by a gentle disturbance of the paint surface using the very ends of the hairs of a clean brush. With oil colour, smoother blending is possible if a diluent or colour medium is added to the paint, and a partial blending will occur automatically where particular types of rich painting medium are used, as these encourage the paint to flow so that surface texture and precise brushmarks are lost. Blending in acrylics is assisted by the use of a retarding medium, but even then the process is difficult, as the paint dries so quickly. Watercolour, gouache and

tempera are difficult to blend for the same reason, though this can be overcome by working over the area to be blended with a moist brush, or by flooding the area with water, so that the colours flow into each other. Even using these methods, however, blending is difficult to achieve, and the softness of the effect may be marred by watermarks. Optical blending, using broken areas of colour, is therefore more usual where fast-drying media are involved. Dry pigments applied as pastels can be blended using either a brush, a stump or the fingers.

Leaving brushmarks

Brushmarks, or for that matter knife-marks, can be deliberately exposed in order to add interest or expression to the painted surface. Well-placed brushmarks are a testimony to the skill of the painter; they can create striking effects with the minimum of effort, though if over-simplified, exposed brushwork can look crude and unnecessarily casual. Historically, confident and economical use of brushmarks has sometimes been dismissed as slickness or arrogance on the part of the painter, yet brushmarks are recognized by many as the handwriting of painters, and good brushwork is invariably admired.

Brushmarks retain most character when left visible in thick oil or acrylic paint. Not only the shape of the brush and its stroke are recorded, but also the surface texture of its hair. With other paints, brushmarks are generally more regular and controlled, though a great deal depends on the shape of the brush and on the action of the painter's hand. The size, shape and, equally importantly, the length of the brushmark vary not only with the choice of brush, but also according to the type of paint and to the extent with which the brush is loaded. Experimentation is the best way of gaining knowledge on this subject.

Teasing

Teasing involves the manipulation of paint after it has been set down in order to make it appear as if it had been applied somewhat differently. In other words, it is a cosmetic adjustment to the paint surface to improve the visual appeal of the finished painting. Examples of teasing include working into wet paint with a clean, dry brush to introduce brushmarks that look spontaneous when in fact they are contrived; extending and improving the shape of brushmarks by reworking them with a brush loaded with the same colour, perhaps of a larger size, so that a tentative brushmark appears more certain; using a clean, fine brush or a small painting knife to draw out the edge of a wet colour to make it more or less precise, depending on which you prefer; taking a clean palette knife over a wet scumble or impasto in order to adjust the random effect to your own purposes. Strictly speaking, the reworking of dry paint with the same colour is not teasing, but overpainting; however, the principle is the same.

Hatching

Hatching is the creation of a systematic pattern of parallel brushmarks which only partially cover the ground or paint layer beneath because of the gaps left between the brushstrokes. Cross-hatching consists of two sets of parallel brushstrokes laid one upon the other in roughly opposite directions; this allows less of the underlying colour to show through, and therefore increases the intensity of the colour being hatched in any optical mixture that results. Hatching may be carried out on a large scale using quite bold, deliberate brushmarks, but it is normally employed on a small scale. Hatching and cross-hatching are best done using a round, soft-haired brush that comes to a fine point.

In combination with fluid paint, this sets down a delicate line which is more effective than a firm brushstroke. Hatching is generally intended to blend visually when seen from a distance, and tends to be used with fast-drying paints, such as tempera, to represent transitional tones and subtle divisions between colours (*see Chapter 2.4*, p. 112), though oil colours can be hatched wet-in-wet to create a form of blending. Hatching is also a helpful technique for shading where a brush is used as a drawing instrument.

Spraying and spattering

Airbrushes, which apply paint as a controlled spray, are a fairly recent development, and as yet they are regarded as items of equipment for designers and illustrators, rather than as tools for ordinary painters. Their use is, of course, developing but their limited technical range and the complexity of certain airbrush techniques render them less appropriate in the field of fine art than in the context of commercial art.

Spattering is a cruder method of spraying paint: the fall of colour is far less controlled, as paint droplets of various sizes fall in a random pattern. Spattering can be highly effective as a means of introducing texture into an otherwise flat area of colour and as a method of breaking colours visually. Paint can be spattered from any stiff-haired brush – scrubbing brushes and toothbrushes with separate tufts of bristle deliver the best spray patterns – by flexing the brush with the thumb, or by drawing the blade of a palette knife along the bristles. The pattern is affected by the extent to which the brush is loaded with colour, and its degree of dilution. Droplets of thin paint are inclined to spread and will dry transparent or translucent, depending on the colour; droplets of thick paint may stand above the painting surface, thus adding genuine, as well as visual texture to the finished work. (The term 'thick' is used relatively here, as all paint for spattering or spraying must be fairly liquid.)

When using a brush to spatter paint, please note that it will spatter everywhere, and it is advisable to provide some protective covering for clothing and surrounding surfaces. Any areas of the painting that are to remain free of spattered paint should be carefully masked, to prevent accidental spraying, and stencils can be used to confine the spattering to specific areas. A more directional spray of paint can be produced with an artists' mouth diffuser of the type used to apply fixative to pastels. However, more accurate placing of paint and finer control over the quality of the spattering are achieved by the use of a brush.

Masking and stencilling

Stencilling is seldom used for creative painting and is normally confined to decorative use, but it is not without potential. It involves applying paint through shapes cut out of an impervious sheet, which is held flat against the painting. Good quality paper makes an acceptable temporary stencil, but thin plastic sheet is more suitable. You can cut any shape you wish, though complex shapes require thoughtful design to prevent complete removal of parts of the stencil mask; this can usually be overcome by leaving narrow supports in place that hold the stencil together as a sheet. Groups of co-ordinated stencils can be used to build up complex designs using a series of colours, and one benefit of the technique is the ease with which a pattern can be repeated. A proper stencil brush gives the best results, and a thin covering of stiff paint allows the greatest degree of control. If paint is applied too thickly, it tends to run under the edge of the stencil and to spoil the neatness of the design.

Masking is precisely the opposite of stencilling, although the principle is the same. Here, an area of a painting is deliberately

shielded as paint is applied, so that when the masking is removed, an area of ground or dead colouring remains untouched. The same method can be used to protect finished areas of a painting while surrounding sections are painted in a broader manner. Masking is commonly used to reserve areas when paint is being sprayed or spattered, and when large areas of wash are being applied. Reserving areas in watercolour by using a temporary mask is generally referred to as 'stopping out'. Special stopping-out media are made for painters, and low-tack masking films are available for use with airbrushes. For large areas, paper edged with masking tape is normally satisfactory. Always take care when using masks, as damage can be caused to the underlying paint and even to the ground, if the masking materials are incompatible with the paints being employed. Masks should be moved as soon as possible after use, as their ease of removal tends to decline with time.

Resist techniques follow the same principle as stopping out; here, one type of paint or medium is used as a permanent barrier to another that is incompatible with it. The most obvious example is the use of waxy media, such as encaustic crayons or oil pastels, employed in combination with watercolour; the watercolour washes can only occupy those areas of the support untouched by wax. The principles of stencilling and masking may be combined if a stencil is employed to guide the application of a stopping-out medium or of colours intended to form part of a resist technique.

Scoring into wet paint

Like scraping back, scoring into wet paint involves removing colour rather than applying it. Whilst paint is still wet, any instrument can be used to draw into it, pushing away the paint to reveal the ground or layer of colour beneath. The most obvious tool for scoring paint, and the one most frequently used, is the end of the brush handle. (Those which come to a fairly sharp point are best, as they score a definite and accurate line.) Obviously, oil paint or acrylic colour with a retarding agent is best suited to scoring, as both are thick enough to retain a mark and remain wet long enough for scoring to take place. However, it is possible to score watercolour and tempera paints, if suitable conditions are deliberately encouraged (*see Chapter 2.5 and Chapter 2.6*).

Scoring is frequently used in painting facial hair on a portrait; if a layer of flat colour is applied over a dry flesh tone, scoring into this while it is wet can suggest individual hairs, and by revealing more or less flesh tone in different areas, a varying thickness of beard can be implied. Fine creases in flesh may also be represented by scoring rather than by direct painting: remove a little of the wet flesh colour to reveal the coloured ground or underpainting beneath. In landscape painting, squiggles scored into wet glazes can suggest the play of light on foliage in the middle distance; this is particularly effective when representing foliage which is partly in shade. A similar technique can also be applied to pastel (*see Chapter 2.7*).

Adding texture

Paint may have a texture of its own or derive texture from its support, but it is also possible to mix ingredients into paint in order to give it additional texture. This has proved a popular approach amongst modern painters seeking to extend the conventional boundaries of painting. Well-washed dry sand is possibly the most suitable material, while sawdust also produces a sticky mass that can be built up in relief to give an unusual surface. Other materials may damage the paint because of their own short life expectancy or because they are insufficiently stable to remain in place. Any materials added to paint should be worked in with a palette knife or repeatedly stirred with a brush or stick to ensure that all the particles are well covered. Sprinkling loose materials onto wet paint to provide surface texture may look attractive, but is a doubtful technique where permanence is a consideration. Such methods may also be classed as varieties of collage.

Collage

Although it is not strictly a means of applying paint, in recent times collage has been exploited as an exciting extension of conventional painting. A collage is an image built up from scraps of various materials, such as cloth and paper, which are glued into place on a support; any object can be attached to the picture surface, providing the support and the glue are strong enough to hold it firmly in place. Where collage is combined with painting, the paint itself can be used as glue; oil colours, encaustic colours and acrylic paints all make acceptable adhesives for collage, though acrylics are perhaps most suitable as they have good adhesive strength and are quick-drying. Collage, added texture, and stencilling have been successfully combined in some abstract works.

One of the appealing aspects of collage is the way in which objects that already possess satisfying colour and texture can be incorporated into the surface of a painting. Questions of stability and permanence are raised by the introduction of foreign materials, however, and it is doubtful whether such works can be preserved in their original condition, but as collages are clearly not 'paintings' in the traditional sense, it is perhaps inappropriate to assess them using the same values.

Charlene (1954) by Robert Rauschenberg. In a collage, or assemblage, paint can be combined with virtually any other materials or objects.

2.3 First principles

This chapter presents a number of general principles and technical approaches which lie at the heart of all painting techniques. They may represent techniques in their own right (such as *alla prima*), or more basic elements, such as the three-tone system or making use of the ground, and they may be variously combined in different media to produce a great variety of effects.

As with methods of applying paint (*Chapter 2.2*), the basic techniques described here should be thought of as adaptable to all media, even though, in practice, the physical limitations of some materials render certain techniques more practical than others in the various media.

Alla prima

Classic *alla prima* painting is almost an attitude of mind. It literally means 'at the first attempt', and implies rapid, spontaneous painting, resulting from careful forethought and preparation, which aims directly at a final effect within a single session. This, at least, is the traditional meaning of the term, and is the type of *alla prima* demonstrated in the work of Rubens, Velazquez and Hals. It requires confidence and a certainty of touch, combining natural talent with experience. The result should be perfectly controlled and yet offer as many subtleties as more complicated and time-consuming techniques. It is quite different from the *alla prima* of later generations (*see Direct painting*, below).

Fa presto

With practice, *alla prima* can be developed into a form of painting known as *fa presto*. This involves a rapidly applied, single layer of opaque paint in which all aspects of design, form and colour are dealt with simultaneously. The spontaneity with which the paint is applied is usually valued for its own sake as a feature of the finished work. However, some aspect of the painting generally suffers and, at the very least, detail is often sacrificed to speed. Even the very best *fa presto* painters are seldom able to control every aspect of a painting as it progresses, and minor faults invariably occur in the drawing, composition, colouring, modelling or tonal relationships.

Some might argue that *fa presto* is not a distinct technique, but it is interesting in that it represents a transitional stage between classic *alla prima* and the modern definition of *alla prima*, also known as direct painting. *Fa presto* painting is normally executed on a coloured ground, which it exploits to varying degrees for the finished effect. If such subtlety is abandoned, however, in favour of a uniformly opaque layer of paint, then the technique becomes virtually indistinguishable from the modern *alla prima* method.

Direct painting

In modern *alla prima*, the painter aims to complete the picture surface in a single session, usually with little preparation beforehand. Direct painting does not depend on a combination of different paint layers, as it invariably employs opaque body colour which makes no use of the ground and is not modified by any underpainting. The success of the method depends on the painter's ability to mix and place colours exactly

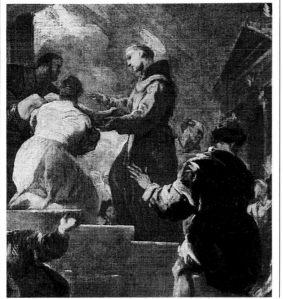

St Anthony of Padua *(detail): known as Luca 'fa presto', for the speed and facility with which he worked, Luca Giordano's method of applying a single layer of paint over a coloured ground has much in common with modern direct painting.*

Monet's On the Beach at Trouville *(1870) is a typical example of modern* alla prima *techniques. Opaque paint is applied in a broad, sketch-like manner to create a spontaneous effect.*

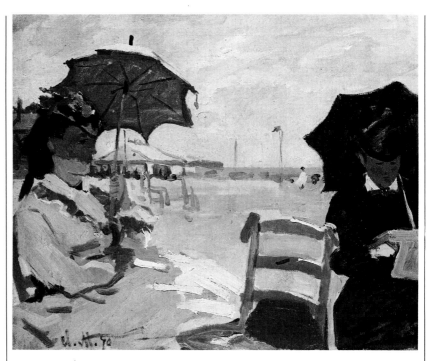

as they are intended to be seen, so that no further modifications are required. The technique is characterized by an appearance of speed and spontaneity, both of which may be more contrived than actual. Such paintings are sometimes criticised as appearing unfinished, but the sought-after effect can be immediately destroyed if the painter is obliged to rework areas of the painting in order to overcome errors.

Since the direct method seeks to complete all or part of a painting at a single session, some aspect of the work must generally be sacrificed for the sake of speed – often, the elaboration of content and degree of detail. To compensate for this simplification, such works often concentrate on tonal or colour effects, resulting in a striking semi-abstract character, or on the quality of the drawing, to give the painting a unifying feature. Direct painting is perhaps most successful, however, where brushwork, impasto and texture are stressed as the dominant components. Any abbreviation in the content of the image then becomes irrelevant, as the painting is no longer a naturalistic representation of reality, and any comparison with highly finished paintings then becomes pointless.

The modern *alla prima* approach is represented by the paintings of the Impressionists and their imitators up to the present day. The factors which led to their adoption of a more direct method of painting are explained in *The Golden Key* (p. 17), but not least among these was the lack of technical knowledge and skill which left painters no option but to adopt such simple, straightforward techniques. The progressive changes in the nature of *alla prima* painting can therefore be viewed as a reflection of the decline in painters' materials and techniques. The modern direct technique can produce excellent paintings, but it does so in a manner which is often uncertain, and even crude by comparison with the confidence and skill of the original *alla prima* and *fa presto* methods.

The three-tone technique

Working to a set sequence of tones has been discussed, recommended and practised by painters and authorities on painting throughout history, but opinions on the number of tones required vary: Cennini and Thomas Bardwell prefer three, while Hogarth describes seven. However, the principle remains the same, and, as you will see, all these variants can be accommodated by the notion of an expandable three-tone system. The

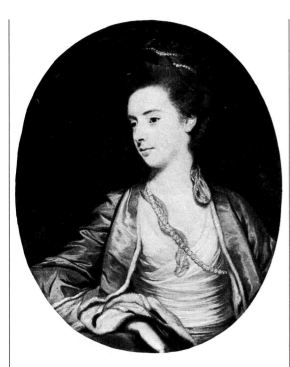

The drapery (left) in this portrait of Lady Melbourne *by Reynolds shows how the three-tone technique can be used to model folds, by separating out areas of light and shade into shifting sequences of tone.*

three-tone technique involves representing form and colour simultaneously by separating each colour on the palette into three values: a light, a middle, and a dark tone. These can be placed systematically – with areas of light indicated by the lightest tone, areas of shadow, by the darker tone, and anything in between represented by the middle tone – to create a persuasive illusion of form. Within each colour the gradual transition from light to dark will be perfectly convincing, whether or not it conforms to perceived reality.

The three tones can be achieved in three ways. The first is to take a pure colour and to derive two other values from it by mixing as tints or shades. The second is to use three separate mixtures, not necessarily derived from the same colour, which are related to each other in a sequence suitable for the intended context. The third method employs three separate colours employed more or less pure, which are once again related in an appropriate sequence. (Examples of each of these approaches will be found under the description of specific techniques in the following chapters.) It often helps to set out the sequence quite deliberately on the palette, rather than preparing the tones ad hoc as the painting progresses.

It is for the individual painter to decide how rigidly systematic a three-tone system should become, and, in practice, greater subtlety can be introduced by increasing the number of tones to five or seven. In an expanded three-tone system, colours representing a half-step in tone are introduced between each of the three original colour values, with yet brighter highlights and deeper shadows reserved for final touches. Where painters aim at natural realism, they might also add reflective tones to the sequence, as colour in shadow tends to look different from colour in light, and it is also common to introduce completely different colours as the ultimate shadow and the brightest highlight. A common shadow colour is often employed throughout the painting in order to give it unity, and in such cases, the expanded three-tone system for each separate colour should always end with the same tone. Pure white is the final highlight where a three-tone system is expanded to its ultimate conclusion.

A continuous sequence of three-tone groupings can be used to represent colour and form over a broad range of graded tone. This is best illustrated by imagining five sequenced tones. The first three represent light, mid-tone and dark within the areas of shadow. By adding the next tint up, you will alter the relative positions of the original tones and produce a new sequence of three: the darkest tone now drops out of the sequence, the mid-tone becomes the shadow tint, and the brightest tone, the mid-tone. Repeat this process, moving the sequence up by one more tonal value, to produce a new set of three tones which can be used to model form in areas of light. Thus, from five tones, three separate sequences of three are obtained.

The three-tone system is most frequently found, and most clearly apparent, in *alla prima* methods, but is, in fact, fundamental to all realist painting techniques. In more complex methods of painting the separate tones may be placed in different layers of paint and occur as optical mixtures, instead of being placed directly as straightforward colour and tonal values; nevertheless, the system still remains the basis for the tonal modelling.

Painting wet in wet

Painting wet in wet involves applying fresh wet colour into, over or alongside existing areas of paint which are still wet. It is chiefly an oil-painting technique, though it can also be employed to a limited extent in other media, because only oils allow sufficient working time for the paint to be manipulated and blended. The technique tends to inhibit precise outlines and to limit the paint's capacity for detail, so paintings carried out entirely in this manner tend to be broad in their handling; but if thin paint is applied with a soft brush it can be worked to a high degree of finish. Working wet in wet is technically sound, as the colours mingle where they touch and form a continuous paint film as they dry. Severe cracking can occur, however, if too thick a layer of colour is built up or if fast-drying colours are allowed to dry over areas of slow-drying paint which are

still wet. If this cracking exposes any underlying colour, the effect will be extremely disfiguring, so it is important to work systematically, paying attention to technical matters in order to avoid the risk of damage. In general, thinly executed paintings worked wet in wet will age extremely well.

Where oil paintings are being worked *alla prima* wet in wet throughout, materials may be used selectively to prolong the available working time – for example, zinc white, poppy oil and oil of cloves will retard drying, as will a non-absorbent ground – but these may all increase the risk of faults developing. Acrylics can only be painted wet in wet by using a retarding medium. With watercolour and other water-based paints, the wet in wet technique is only employed using paint in the wash state. This allows the colours to flood into one another and produce pleasant random effects, but the painter has little control over the result.

As with all basic techniques described in this chapter, painting wet in wet may be employed as a technique on its own, or selectively, wherever appropriate, in particular stages or areas of a work. In watercolour painting, for example, the technique is rarely used exclusively, but often provides a loose, atmospheric foundation which is worked upon further once dry.

Painting wet over dry

Painting wet over dry is the basic approach of most traditional techniques, and it also applies to any fast-drying medium where wet in wet blending is impractical. It simply involves allowing each layer of colour to dry thoroughly before subsequent painting is carried out over it. The wet paint is therefore not mixed directly into the existing colour, and only optical colour mixtures are possible. In traditional techniques wet over dry painting is a premeditated step which allows the painter to approach the desired finish with considerable accuracy. It allows greater control over tonal values, colours and surface detail, and permits the systematic build-up of visual effects which are dependent on optical mixing between the different layers of paint.

The technique is also found in *alla prima* work, where opaque colour is applied in order to make corrections. This is very different from the use of wet over dry in a carefully planned sequence of paint layers, where a complex effect is gradually built up. In the case of *alla prima*, the dry paint is simply covered with another layer of direct painting, which may then itself be worked wet in wet. If the paint is scumbled into place, some of the lower layer will, of course, show through, and by the strictest definition that passage of work can no longer be considered *alla prima*. In traditional *alla prima*, where a coloured ground and a sketchy underpainting are first set down, the painting method may also be described as wet over dry, but in practice, of course, virtually the entire paint layer that is seen in the finished painting will actually have been put down wet in wet. The dry underpainting does not function in the manner of, for example, a glazed underpainting; it serves only as a guide and not as an active paint layer.

Painting to completion and painting in sections

Painting to completion is a method of working, rather than a technique, which suits some painters and not others. It involves working on all areas of a painting at the same time, so that all parts of the work advance steadily and equally, arriving at a state of completion during the final session. One of the benefits of working in this way is that you can constantly adjust and balance visual effects as the painting progresses to create an overall harmony. Painting to completion is particularly suited to *alla prima* painting and to direct methods which employ body colour applied in layers.

Painting in sections involves developing only one part of the work at a time and taking each part in isolation through to a finished state. This allows the painter to concentrate

In Michelangelo's 'Manchester' Madonna, *certain areas are highly finished, while other sections are barely begun. Note how the flesh has been dead-coloured flatly in green, awaiting flesh-painting, while the draperies of the Madonna have been underpainted in black, in preparation for a blue glaze.*

My Parents *(1977) by David Hockney illustrates a sophisticated use of layers using body colour – in this case, in acrylics.*

on one area at a time, which is important where a fine finish is required or where a great deal of detail is being applied. The main drawback is that this method can sometimes produce a slightly disjointed appearance, because of slight variations in style or quality between one area of the painting and another. The divisions between the various self-contained areas of the picture surface may also result in a two-dimensional pattern-like effect, but this can be overcome by careful handling. A clear preliminary drawing which defines the outlines of the composition will be of benefit here. It is often impossible to detect whether or not a work has been painted in sections, and this method is sometimes the only way in which a detailed and well finished product can be achieved by *alla prima* methods.

Painting in layers

Although some forms of *alla prima* do make use of more than one layer of paint, in general it can be said that painting in layers is the opposite of direct painting. It is the basic principle behind many traditional techniques, and is the usual way of painting wherever a work has been carefully planned, or where a fine finish is required. This applies equally well to works in watercolour, tempera, gouache, acrylic and pastel, as to works in oil, though as some media do not involve lengthy drying periods, you may not be aware of working in separate layers.

The techniques which follow are chiefly concerned with painting in layers, though some aspects of underpainting and dead colouring are also relevant to *alla prima* techniques, and it is also possible to make use of a ground where only a single layer of colour is involved. This will become apparent as you study the techniques described in Chapters 2.4–2.8.

Layers using body colour

Body colour need not be used *alla prima*; it can be employed in slow, deliberate methods of painting involving several layers of colour. The difference is that in *alla prima* painting there is always the intention of completing the work at the first attempt, with each successive layer applied wet in wet and intended to be fully covering. Where body colour is set down so that several layers remain visible in the finished painting and combine to complete the image, its use cannot be described as *alla prima*.

An obvious example of a layered technique using body colour is tempera painting – especially in its more modern manifestations. (The work of Edward Wadsworth, Maxwell Arnfield, David Tindle and Andrew Wyeth can be cited as examples.) Modern oil painting and works in acrylic also employ this method extensively, though its presence is sometimes masked by a superficial resemblance to *alla prima* painting. A straightforward use of body colour layers can be found in paintings by David Hockney and Peter Blake.

Refining a foundation and finishing with glazes

There are two principal methods of completing a painting which has been built up in layers of body colour: the first continues in body colour, while the second employs glazes. In both cases the roughly completed foundation is modified and refined during the final stages of work to bring out the image which the painter desires. These small additions of paint are simply the finishing touches to the work; the vast majority of the body colour remains visible and largely determines the visual effect of the finished painting. For these final touches, soft-haired brushes, the fingers and pieces of rag may be employed.

Where a body colour foundation is refined using more body colour, it is simply painted with increasing subtlety of colour and tone, with more and more detailed touches of colour placed with ever greater delicacy. Where glazes are used, the appearance of areas of body colour is modified, either through a lowering of tone or an enriching of colour. Drawing may also be added using glazes of strong colour.

Unlike the use of body colour underpainting glazed with colour, in this technique the body colour layers do not presuppose glazes, so the painting is worked up in its intended colours. When the painting is finished, most of that work remains visible, with thin, selectively applied glazes used merely to increase definition and add subtlety or crispness, as desired. This technique is much in evidence in Titian's early paintings, and in Rembrandt's work.

Varying the paint thickness

This basic technique involves varying the thickness of body colour by means of deft brushstrokes or additional layers of paint, to produce variations of tone and colour. The body colour in use remains constant throughout, but as it is acted upon to a greater or lesser extent by what lies beneath it, varying optical mixtures result. In this way painters can limit the number of colours on the palette without limiting the range of effects at their disposal. It is a technique for skilful but lazy painters, as it does away with the need for much colour mixing. This generally makes the work more harmonious, and may even assist in its preservation.

Traditional *alla prima*, in both its classic and *fa presto* forms, makes extensive use of this technique, and it is frequently found in layered structures using body colour, where the lower dead colouring is refined by frotties of varying thicknesses. It works best on a coloured ground or on dead colouring with deliberately placed undertones, but it can also work well on quite a light ground, providing appropriate colours are used.

Underpainting and dead colouring

Dead colour is the first application of paint to be made in a layered technique. It consists of a flat, broadly applied lay of colour that acts as a foundation for subsequent paint layers. This initial lay will acquire more body as the painting progresses, and will be built up either into a final section of work or into underpainting.

Underpainting is a more specialized form of dead colouring, in that it presupposes a later stage in the painting process, when it will combine visually with subsequent layers to produce a particular effect. An obvious example is the use of underpainting beneath a glaze to separate out tone, colour and line, with each facet of the finished area being worked upon separately. For example, a monochrome underpainting, using black and white only, can be used to define the tonal values and form of an area of drapery, before a transparent glaze of, say, blue is floated over it. The two layers are then seen together, so that the folds and tonal variations appear to be in shades of blue. Moreover, the colour quality of the blue will be quite different from a blue of the same tonal value obtained by mixing the same pigment with white.

A coloured underpainting can be used either to enhance the colour of a glaze or to alter it completely. A green glaze might be underpainted with shades of pale green highlighted with yellow, for example. This has a most disjointed appearance until it is glazed with a dark green, when the colours and tonal values mix optically to produce a shimmering green which glows in the highlights while creating rich, colourful shadows. A more calculated use of optical mixtures can be achieved by underpainting in one colour before glazing with an entirely different one, applying, for example, yellow beneath red, red beneath blue, yellow beneath blue, or green beneath yellow. Even more complex variations are possible if more than one coloured glaze is used. By using these optical mixtures, rather than producing colours directly on the palette by intermixing paint, it is possible to produce an enormous range of colour effects from a

small number of pigments. As you might expect, glazed underpaintings feature strongly in traditional painting methods, but their use is by no means restricted to such techniques.

Underpainting may also contribute to particular visual and colour effects by being combined with body colour or thin frotties. Here, the colour of the later layer is deliberately broken or subtly altered by the underpainting beneath it. One example is the use of green, blue or grey in the shadows of flesh. Where pink is taken over the coloured painting of the shadows it is opposed by the lower colour value and appears to tail away into a neutral tone. In other words, the underpainting breaks the superimposed colour. Similarly, when dull, creamy tones are set down for the highlights, a thin covering of pink is mellowed and made more natural by the hint of yellow that lies immediately beneath it. Another interesting variation is to underpaint in very strong reds and pinks, applying silvery tones thinly over these to create a complexion which is light in colour, yet warm. This particular method was employed by the 18th-century Scottish painter Allan Ramsay, whose portraits still retain life and freshness, thanks to the warmth of the underpainting.

Underpainting can also be used simply as a guide for subsequent applications of paint: this is its role in traditional *alla prima*. In fact, it follows the same basic principle of all underpainting, by introducing a separate stage in the work, where composition and form can be contemplated in isolation. Once this has been clearly worked out, paint can be applied with greater certainty, so avoiding the need for substantial reworking.

Making use of the ground

Grounds are all too often neglected, yet they can be an important component in a finished painting. When painted on thickly or entirely covered by opaque paint, they have little effect, but they can be carefully exploited for their colour, brilliance or tone. For example, a brilliant white ground can keep colours light and bright, and, if partially exposed, can create a flickering highlight. Coloured grounds have even greater potential: they can behave like dead colouring or underpainting, and may be used to represent tonal values by varying the thickness of the underpainting to leave areas of the ground exposed. The effect of varied paint thicknesses in the final layers of a work may also depend on the colour of the ground.

Skilful use of a coloured ground can save much time and effort, as the viewer can be tricked into seeing paint where none exists. This is clearly demonstrated in works by Gainsborough, which at only a short distance, appear complete in every respect, while on close examination they are found to be composed of nothing more than a light covering of paint, riddled by spaces occupied by the ground alone. The surrounding touches of paint are so well placed that they are readily accepted as the middle tones or shadows.

The physical properties of a ground, its absorbency, elasticity and surface texture, are also relevant to the way in which it is used; the importance of such matters in selecting grounds should become apparent as you read through the following chapters.

2.4 Tempera and gouache

Miniature painting and illumination

Miniature painting, once known as 'painting in little', generally describes painting on a small scale involving a great deal of detail. In fact, the term 'miniature' has nothing to do with size, and is derived from minium, or red lead, which was originally used to decorate illuminated manuscripts. Another name for miniature painting is limning, a corruption of illuminating, which again indicates its development from the materials and techniques of the illuminator. The original materials were basically gouache, although some of the paints employed were more like watercolour, and in later developments, pure watercolour and even oils were employed.

The first miniature paintings were often exquisitely worked and mounted in elaborate, costly settings embellished with silver and gold. A decorative, jewel-like quality was deliberately sought in these works, with a luxurious abundance of rich colour and fine detail. The original miniatures were portraits, intended not for public display, but to be treasured and looked upon in private. They were intimate possessions, often exchanged between lovers, friends and political allies, which explains why it is not unusual for them to be full of symbolic visual references. Later, the technique was also used to reproduce larger works on a more portable scale. Nowadays, though it is no longer a major art form, miniature painting is once again becoming popular. Limning techniques, in particular, are attracting renewed attention, thanks to revived interest in calligraphy, which is, of course, related to miniature painting through illumination.

The method described here is based loosely on the techniques of Nicholas Hilliard and his near contemporaries, such as Isaac Oliver and Edward Norgate. It offers an example of a detailed style employing gouache, which you can easily adapt to less formal uses. Similar methods can be used to decorate lettering or documents in the manner of an illumination.

The paintings shown on pp. 114–5 employ a variety of materials, including watercolours and tempera, gouache and acrylics. This demonstrates the extent to which members of the tempera family are interchangeable, and as you read this chapter some of the basic similarities between the different techniques should become apparent. There are even some similarities between miniature painting and certain methods of oil painting. In fact, the basic approach, which is to begin in body colour and to finish with frotties and glazes (or, in this case, washes), is adaptable to work on any scale using various combinations of materials.

Materials

A sheet of hot-pressed watercolour paper; gelatine size; a small selection of hand-ground watercolours; some very fine, round pointed sables mounted in larks' quills (any small, finely pointed brushes will do). Cheap, commercially produced gouache paints and students' quality watercolours should be avoided, as these frequently contain fillers and are not of sufficient quality for such a delicate approach.

To apply gilding to an illumination, you will require gold leaf, *gesso sottile* and an agate burnisher. Dutch metal leaf can be used as a cheap alternative to gold leaf, and some of the modern bronze pigments also make convincing substitutes. Gold and silver leaf ground in honey and vellum are the traditional materials for miniature painting, and can be used if available. As gilding is such a specialized activity it is not dealt with here, but plenty of practical manuals give a clear account of the procedures involved.

Support

The original support for this form of painting was vellum. Genuine vellum, made from calf-skin, can still be obtained but is not always readily available. For the demonstration on p. 114, a hot-pressed watercolour paper was substituted for vellum and treated in essentially the same way. The paper was of a medium weight with a smooth but not quite perfect surface, and it was mounted onto a much heavier watercolour paper using weak, freshly made gelatine size. Both pieces were coated with the size, and a roller was used to ensure that the bond between them was free from air pockets. This mimics the traditional method of pasting vellum onto card in order to give it greater strength. Museum board could also be used as a backing, as could illustration board, providing it is acid-free. You could, in fact, simply use a heavy, hot-pressed watercolour paper, but mounting one sheet onto another in this way allows you to select a paper for its surface quality. It also overcomes wrinkling and buckling by restricting the penetration of moisture during painting.

Once mounted, vellum should be burnished to give it an immaculate, ivory-like finish. Paper can also be burnished, but a more modern approach is to compress its surface using an ordinary domestic iron. This should be fairly hot and should be taken over the paper quickly, applying slight pressure. Even the best hot-pressed papers will benefit from this treatment, offering an even smoother surface as a result. Good cotton papers are sometimes slightly fibrous, and ironing helps to suppress their surface, which is extremely helpful where painting is being done on such a small scale.

Another support suitable for miniature painting is gessoed card. Here, the vellum or facing paper is replaced by an extra-smooth and brilliantly white layer of gesso. This is used on a slightly larger scale for *Watercolour on a prepared ground* (p. 164), and similarities between that technique and certain aspects of miniature painting will be obvious.

First sitting

There should be no preliminary drawing for delicate, small-scale works, as it would require undesirably heavy painting to obscure it, but you may find it practical to use a separate drawing as a guide. Where genuine vellum is being used, a drawing can be made in Indian ink on the card over which it is mounted, and the outlines can then be followed through the translucent vellum. Work begins with a lay in of opaque colour; this can be lighter than the intended tones, or equal to them, but on no account should it be darker. As body colour is used very thinly in this method, a heavy application of paint required to recover lost highlights at a later stage, would be totally out of place, and may lead to cracking.

In the case of a portrait miniature, the first lay of colour is simply a patch of pale flesh pink. The basic features and outlines

of the face are drawn in with a fine brush, using a slightly darker flesh tint. At this point a larger brush, dipped into clean water and wrung out, can be used to wipe away any excess flesh colour, leaving a slight stain on the ground which is easily obscured by overpainting. In the case of a portrait it is always advisable to work up the head first, to avoid any wasted effort if the face does not prove successful. The next stage is to apply a lay of flat colour to any substantial and easily defined areas, such as the hair and costume.

This method depends for its success on the quality of the paint. Although opaque, it must be diluted virtually to the consistency of watercolour and should dry as a thin, half-covering layer. Constant reworking to refine the image will gradually build up a thicker, more solid layer of paint, but if this is applied at a single stroke, the delicacy of the image may be lost. Some pigments tend to appear dark and dull when they rely entirely on their own body for opacity, so a trace of white is added to all colours, not simply to make them opaque, but also to bring out their hue.

If you are using hand-ground watercolours, it is important to check the quality of the white before beginning to paint. White pigments generally require very little gum, and too much will give them a glassy appearance and encourage cracking as soon as a layer of moderate thickness is built up. Both of these undesirable properties can be communicated to other colours if an unsatisfactory white is mixed with them, thus seriously interfering with the gradual build-up of the paint layer, that is the whole basis of this method. The traditional test for white is to paint some of it onto glass and to dry it quite rapidly in the sun; if it cracks, it is no good. If you prefer to use ready-made paints instead of hand-ground colours, then it is probably best to use artists' watercolours plus a tube of white gouache, as water-colours are specifically intended for thin painting. They also offer a psychological advantage over prepared gouache, in that painters tend to think of watercolour as a more delicate medium. It is all too easy to be heavy-handed when using ready-made gouache, though it is perfectly acceptable providing it is thinned sufficiently.

To complete the first sitting further work would be done on the face. This might consist of a little deliberate underpainting in the shadows using green and grey, and a light touching of the flesh with the basic flesh colour and slight variations on it to tidy up the drawing and to introduce the vaguest hint of modelling.

As the materials involved in this technique dry quickly, there is no real need to separate the painting process into a specific number of sittings or working sessions, but the small scale of the work demands extreme concentration. (In the case of portrai-ture, the tolerance of the sitter is usually limited, also.) It is therefore best to take a break after two or three hours.

Second sitting

Once work on the face is considered to have reached a stage when it is clear that it can be completed successfully, further work can begin on the rest of the painting. The background should be set down at this stage, before any final details are applied to the head, as this allows the finishing colours to overlap it very slightly, giving a clearer division between the background and the subject. The blue backgrounds which are such an attractive feature of traditional portrait miniatures rely for their effect on the intense, even quality of their colour. This is achieved in a particular manner, which is described below.

First, make up a thick wash of colour by mixing blue and white. In this case French ultramarine was used to create a fairly dark blue, but paler, greenish-blue backgrounds can be equally effective. Whichever colour you use, be sure to make it in sufficient quantity, as it is virtually impossible to match into a layer of gouache without leaving a visible change in colour or a pattern of brushmarks.

Taking a small brush, carefully paint round the edge of the

main subject with this blue; then, with a larger brush, fill in the rest of the background. As this dries, overlapping brushmarks and differences in the thickness of the paint will become apparent, giving a patchy and uneven effect. To correct this, you will need two brushes, one loaded with blue, and the other, a slightly larger brush, well charged with clean water. Starting at one edge of the background, go over the area using water alone, taking the brush right up to the outlines of the surrounding areas and moving steadily across the background until a thin layer of water sits over the whole area. Now, before this layer of water has had time to sink in, touch it at regular intervals with the brush containing blue paint. Some of the blue will be released into the water and will spread evenly through it to give a smooth covering of blue. It is essential to do this quickly. The leading edge of the water must not be allowed to dry out before the whole of the background has been completed, and ideally the starting point should still be wet as the last touch of colour is applied. The illustration on p. 114 shows a blue background in which the second flood of colour has been applied to only one half of the image. Brushmarks are apparent on the left-hand side, while the right-hand side is much flatter and more intense.

The remainder of the second sitting is devoted to advancing the painting, but without yet introducing any fine detail. Thin frotties of flesh colour should be applied to the face. These contain plenty of water and very little colour, so that they dry with a delicate colouring. By building up these veil-like layers over the lightly modelled flesh tones, it is possible to achieve extremely subtle transitions between light and shade. (Strong shadows should be avoided in miniature paintings as they tend to dominate the image.) These thin layers of colour can be applied as hatching or as tiny spots using the tip of a very fine brush. Place them with great care, repeating them with an ever-increasing delicacy of touch until you achieve the desired degree of subtlety.

Next you can begin to plan some of the detail using thin frotties of body colour applied over the preliminary lay of local colour. Always begin applying detail in a restrained way, as the stronger colours used for finishing can make correction difficult.

Finishing

For the final session all colours should be used pure, without white, and in a very dilute state. Body colour is replaced by watercolour. Subtle modifications can now be made to the colouring and modelling, using washes of the utmost delicacy hatched or applied as spots wherever they are considered necessary. Next, fine pointed brushes can be used to draw in detail using coloured paint.

In the last stages of finishing, solid white body colour can be introduced for items such as pearls, lace or embroidery to make them stand out from the surface of the image. This lends them both a stronger decorative quality and greater realism, since such details cast their own shadows. Gold and silver should be applied last, either to represent themselves in jewellery or to add rich, decorative touches. Silver was originally used to highlight pearls, as when light strikes a spot of silver in the right direction it can give the effect of an iridescent white that is far brighter than white pigment and resembles the lustre of a real pearl. Unfortunately, silver tarnishes, and on some old miniatures these highlights now appear as black spots. Good quality aluminium paint will produce the same effect, but its perma-nence cannot be relied upon.

Variations

Miniature painting techniques are ideal for illustrative work. The illustration on p. 115 shows a rocky seashore partially painted in an extremely detailed style, which, although not obviously a miniature painting or piece of illumination, is on a similar scale and of a similar character to the main example. A light pencil

Right: *The opening of St Mark's Gospel from the Book of Kells (8th to 9th century). Miniature painting was directly descended from the art of manuscript illumination, or 'limning', and shared many of the same techniques and materials. Gouache and forms of watercolour were employed on vellum or parchment, and extensive use was made of gold. The decorative style of many miniatures is a direct consequence of the art form's origins.*

1. Below left: *The first lay of colour for a portrait consists of an opaque, pale flesh pink. Details are then drawn in with a slightly darker flesh tint.*

2. Below: *Brushmarks give a patchy appearance to the background (left-hand side), until the second flood of colour has been applied (right-hand side).* .

3. *The demonstration below exposes the different layers of work to show their sequence of application. The face was completed first using thin gouache over the brush drawing of the features, and its colouring is derived from the pink foundation beneath it. The hair was deadcoloured and sketched in after a flat background had been painted in. The pearls have been deadcoloured in grey, in readiness for a thin covering of white, and white will also be used to paint in a lace collar on top of the blue background.*

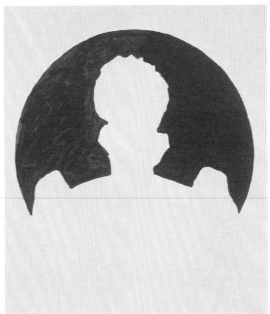

Right: Young man among Roses *(c.1587) by Nicholas Hilliard (c.1547–1619), one of the greatest English miniature painters, who claimed that the finished work should appear 'even the work of God and not of man, being fittest for the decking of princes' books or put in jewels and gold'. Hilliard was also of the opinion that heavy shadows should be omitted from miniature paintings, since they are inappropriate in a work designed to be seen at close quarters.*

Left: *Isaac Oliver (d.1617) was both pupil and rival to Hilliard. His unfinished* Portrait of Elizabeth I *(c.1592), probably taken from life, would have required only a few hours to reach this state. It may have been intended as a model for the Ditchley portrait by Marcus Gheeraerts. Collaboration between painters was not uncommon, and there are obvious advantages in taking a likeness quickly 'in little', to avoid laborious sittings for a large-scale portrait in oils.*

It is quite simple to adapt traditional methods to more modern materials and subjects. This unfinished picture of a rocky seashore – though neither a miniature nor an illumination by the strictest definitions – was executed using a similar technique, and employed acrylics in the manner of gouache and watercolour.

drawing which recorded the main outlines of the subject was sketched directly onto a not (cold-pressed) watercolour paper, and then washed with watercolour to determine tone and colour. (See, for example, the rocks in the background.) Using this as a foundation, the image was built up in body colour which completely obliterated the initial lay in where necessary in order to bring out the lights. Fine details were then added over the top of the gouache modelling in a combination of washes, frotties and body colour. (This can be seen in the foreground rock which has been painted to completion.) Acrylic paints could be used in the manner of gouache and watercolour to achieve these effects. The advantage of acrylics is that the paint can be added to continually in order to rectify the colour or modelling without any risk of cracking. It is a wise precaution to map out the composition in watercolour beforehand when using acrylics, as this will enable you to place the colour more or less correctly from the outset. Acrylics are irreversible, and the correction of errors could lead to an unpleasant build-up of heavy body colour.

Classic tempera

Tempera is not capable of great depth, and the method is best suited to the production of paintings with soft and subtle colouring and an overall lightness of tone. It lends itself to a linear style, and although modern versions of the technique are often softened in their effect, it works best where compositions are based on a well-executed drawing.

The classic tempera method employs quick-drying paints and makes use of opaque and translucent applications of colour. Egg tempera is normally associated with this technique, but any water-based paints may be used, including acrylic (p. 174). Size colour gives very similar results to egg, and both media were employed during the early history of the technique.

The best support for a tempera painting is usually a wooden panel prepared with a smooth white gesso ground. Textiles are less suitable, but may be used if the ground is applied thinly onto a fine, closely woven cloth. Heavy, good quality paper with or without a layer of gesso could also be used, and paper mounted on canvas is another possibility (*See* p. 168).

Materials
A prepared panel; charcoal; Indian ink; a clean feather; a selection of round pointed soft hair brushes, including several in small sizes; dry pigments (including red ochre, yellow ochre, oxide of chromium, French ultramarine, lamp black and titanium white); fresh egg to bind the pigments; a glass mixing slab; a palette knife and clean water to dilute the colours.

Support and ground
The tempera method requires a brilliant white ground, which will reflect light through the thin, semi-transparent applications of paint. It must also be absorbent and should have a smooth surface in order to make use of tempera's potential for detail. A heavy gesso ground is the traditional foundation and this is best supported by a rigid panel. In this instance a piece of $\frac{1}{2}''$ (1cm) thick laminated wood was coated with about six layers of gesso, composed of finely powdered whiting, animal glue and a third part of titanium white to increase its brilliance. When dry it was sanded and ragged to a smooth finish and painted on within a few days of its preparation.

Drawing and shading
This painting was begun by making a drawing directly onto the ground, although it could have been started with a transferred drawing taken from a cartoon or preliminary sketch. It is best to use charcoal for the drawing, because it can be brushed away with a feather or clean brush, leaving only a faint image of the lines behind. This allows corrections and alterations to be made and keeps the ground relatively clean. Once a satisfactory drawing has been produced, it must be fixed. In this case, very dilute Indian ink was used on a fine brush, but pencil or black tempera paint could also have been used. Any remaining charcoal is then brushed away and a slightly damp rag is used to remove any stubborn charcoal marks from the ground. Take care not to disturb the drawing, and if any faint charcoal smudges remain after the ground has been cleaned, leave them as they are. The original drawing may take the form of a simple outline, as in this case, or it may be elaborated with hatching to indicate form; this is purely a matter of personal choice.

The next step is to make up a colour known as verdaccio using a small amount of black and red earth tempered with egg. The object is to produce a neutral olive green or brown that can be used for shading, but there are other colour combinations that work just as well. The verdaccio will also act as a guide for subsequent applications of colour. Following the drawing, apply the verdaccio thinly to indicate areas of shadow and to produce an illusion of solid form by varying the tone of the white ground. (In oil techniques a brownish wash is often used in a similar way). Alternatively, shading can be applied as an ink wash whilst the drawing is being fixed. This preliminary shading is sometimes omitted, or amalgamated with the underpainting – the next stage in the process – which is then applied selectively as shading rather than as a flat covering tone.

Underpainting
Once the whole composition has been worked out using verdaccio, various areas are underpainted in order to lay a foundation for the colouring. Flesh, in particular, is underpainted to create cool, neutral and pearly effects in the shadows, and as the flesh tones are to be pink, the underpainting is done in the direct opposite of pink, which is green; where they interact, they negate each other and produce an optical grey.

Traditionally, flesh was underpainted using green earth, but in this example a little oxide of chromium mixed with white was employed. It was thinned down to a fairly watery consistency and put on with a good-sized brush, the object being to lay a flat, even coat over the flesh areas without totally obscuring the verdaccio shading and the original drawing; the underpainting will then take on the shadow tones that have already been set down beneath it. After a few minutes, further underpainting can be carried out in the flesh areas using a strong red where the flesh colouring needs to be robust, such as in the cheeks. This is set down heavily enough to cover any green that is beneath it.

At this stage other areas may also be given a preliminary dead colouring with a thin application in the palest tint of the appropriate colour. This is simply to map out the colouring of the painting and to serve as a guide for more solid layers of paint. All underpainting and dead colour should be kept neatly within the boundaries of the drawing and should not be so solid that they obliterate the verdaccio shading.

First painting
The tempera paints should only be mixed immediately before they are needed, and each colour should be split into three tonal values by adding an increasing proportion of white to produce a dark, medium and light version of the colour. Try not to make any more colour than you need and include at least a little white even in the darkest value to make it semi-opaque and to bring out its colour. The three separate colour values should allow for any intermediate tones that may be required and for a yet lighter highlight at the top of the range and for a dark accent of pure colour at the bottom. Do not prepare the colours for the whole painting at once as most of them will dry before they can be put to use; instead, prepare the separate tonal values for just one or two colours at a time and apply them systematically throughout the painting wherever they are required.

As it is not possible to work on more than one area of colouring at a time, the painting process must be split into stages. Whether the painting is taken through to completion piece by piece or worked on as a whole and gradually brought towards a finished state is a matter for the individual. In illus. 7 on p. 119, for instance, the flesh of one figure could be painted through to completion in a single session, or the foundation layer of flesh colour could be put down on all three figures at the same time; either way, it is just the flesh tones that are being applied, and an item like the blue drape would not be worked on at the same time. (*See also* p. 109.)

The flesh tones were made from a light red ochre mixed with white. This is a traditional flesh mix for tempera, but there is no reason why it should not be enlivened with a brighter red. The application starts with the darkest flesh tone, applied using a small- to medium-sized brush with a good point. The colour is hatched on, because it dries too quickly to blend, and the first tone is set down in the darker areas of the flesh where it begins to fall into shadow; the verdaccio will show you exactly where this should be. The hatched colour should leave gaps through which the green underpainting can be seen, and as the darkest pink falls into shadow, more and more green should be left exposed to tone down the warmth of the pink. The process is then repeated using the middle tint, which is set down in the areas where the flesh is emerging out of shadow into light. This lighter shade is hatched over the first dark pink, leaving both dark pink and perhaps a little green to show between the brushstrokes. Finally, the palest flesh tint, which should be a very soft pink, is put down in the lightest areas of the flesh, overlapping into the previous tone as before.

The applications of colour should be reasonably opaque, because they must cover the green underpainting solidly in the areas where its effects are not wanted; but it is as well not to put the colour down too heavily. Instead, for each colour value make two applications of translucent paint, gradually building up to a semi-opaque or opaque finish as more layers are applied. Taking the middle tone underneath the lightest tone will also help to obliterate the underpainting from the highlights. Eventually, although the green should be most pronounced beneath the darkest pink, overall there should be a coolness to the flesh that is drawn from this underlying colour. The divisions between the colour values should not be crude, but it should be possible to see clearly that they have been put down separately.

Where underpainting is not involved, the sequence is very similar. The three colour values are put down in turn, starting with the darkest, and with the middle and light tints slightly overlapping the previous tone each time. The blue drape on the left of illus. 7 has been blocked in to show light and shade using a single dark tone. On the far right this has been overlaid with heavier paint in three tones of blue as a first refinement of its shape and colour. Once again, at all stages the boundaries of the drawing were strictly adhered to.

Second painting

The second stage actually involves a repetition of the first painting, but this time with smaller brushes and with the tempera paint in a thin and translucent form. The paint has so far been set down thinly but solidly; the next stage is to bring it to a more perfect finish. The speed at which tempera dries dictates the way in which this is done, since the paint does not stay wet long enough for it to be blended.

Using a fine pointed brush made of soft hair, go over the three colour values again using the same paint. This time the hatching lines should be much finer, and the thinness of the paint means that they cover less, so the effect is more subtle. The hatching is taken repeatedly over the dividing areas between the colours, from the dark pink into the green, from the middle pink into the dark pink and from the light pink into the middle pink so that the colours appear to blend. The thinner these applications of paint,

the more translucent they will be, and the more subtle the effect. In the flesh shadows, instead of seeing pink and green, you will now begin to see a neutral grey which results from the combined effect of all these different colours being seen through each other and through the spaces in their hatched application. Delicate translucent layers should be superimposed in this manner several times until the desired finish is achieved. At the same time, redefine the outlines and details of the painting using the point of the brush to reinforce the drawing with colour.

The same refinement of the painting is carried out over all other areas using the appropriate colours. On the part of the blue drape that hangs behind the central figure, repeated hatching and overlaying of the three tones of blue have brought that small area of the drapery near to completion. The contrast between this section and the part of the drape visible on the right (which has only had its first painting) should be immediately apparent.

Finishing

The final stage is to add finishing touches as and where they are required. Final accents, if they are necessary, can be drawn in with the brush using pure colour without white. Pronounced highlights can be set down in pure white or in a lighter shade of colour that has yet been used. Any fine detail can be drawn in over the existing paint using a very fine brush and an appropriate colour, and if the drawing has been lost at all, it can be reinforced with suitably dark paint, bearing in mind that tempera tends to lighten as it dries. If the result is rather flat, forms may need to be brought out by a darkening of the shadows and a crisping up of the outlines. There is a limit, however, to how dark tempera can be made to look, and it is unwise to make the image too harsh by introducing black or any heavy colour to excess. The original verdaccio, which is only a relatively dark shade, can be re-introduced in finishing to give this kind of emphasis to the painting, and it has been used in illus. 6 to re-emphasize the outline of the face and to separate the chin from the neck. This final touching should be left until the whole painting is in its final state, otherwise some of the finishing work will be lost as other areas are brought towards completion.

Varnishing

Egg tempera dries with a matt finish, which enhances the light, bright quality of the colours. If the dry paint film is lightly buffed with a soft rag, it will take on a satin-like sheen which some painters regard as a desirable finish. Tempera paintings are best framed under glass to protect them from dirt. If they are to be varnished, it should be done in one of two ways, otherwise the paint will become saturated, the colours will darken and the relationships between them will alter. One way of avoiding this is to use an intermediate varnish of gelatine which prevents the final varnish from penetrating into the paint. This is not without risk to the painting if it is done too soon; the traditional solution is to age the painting for at least a year, or more if possible, before any varnish is put on. By that time the tempera colour should have hardened and developed a more resistant and impervious surface. Varnishing will then have a less dramatic effect on the colours. Some painters prefer matt and wax varnishes on tempera because they are more in keeping with the paint's natural finish.

Size painting

Size painting, or distemper, as it is sometimes known, shares many of the characteristics of tempera and gouache. The binder involved is animal glue or gelatine, which gives a very soft, pastel quality to the colours. Size colour is cheap, and though it can be a little troublesome to use, as it gels on cooling and is liable to crack if applied too heavily, these problems can be overcome

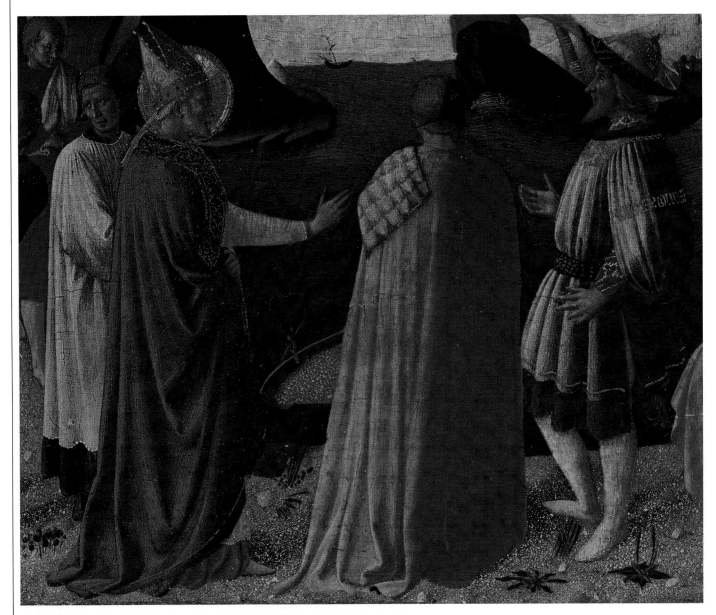

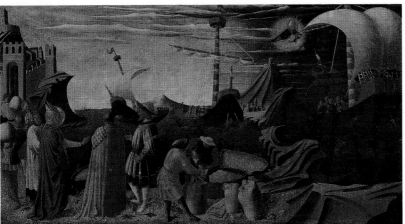

Miracle of St Nicholas of Bain *(c.1400) by Fra Angelico (c.1387–1455). The detail* (above) *taken from this altarpiece shows the strong, clear colour and sharp, linear detail that can be achieved in tempera. Note how the drapery folds are modelled in light and shade by delicate hatching using a three-tone technique. The texture of the ground was probably achieved by stippling with the brush point. Compare this with the detailed painting of the grass and leaves in the work of Tindle* (opposite). *Tempera lends itself to pattern-like textures of this kind, which can also be achieved by spattering paint or by dabbing it from a sponge (see p. 122). The extraordinary rock formations* (below left) *suggest how the medium might be adapted to more modern, abstract compositions.*

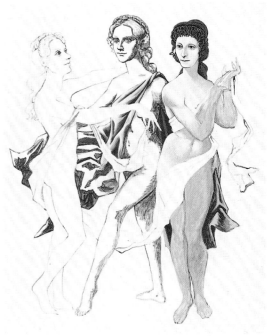

1. *Brush away the charcoal, after the drawing has been fixed, using a feather.*

2. *Block in areas of light and shade using verdaccio to model the forms.*

3. *Apply underpainting to some areas, but do not obliterate the verdaccio shading. Other areas may be blocked in with colour.*

4. *Apply the final colours on top of the underpainting or preliminary blocking in, leaving some areas showing through from beneath.*

5. *Complete the painting with cross-hatching and thin applications of colour, deriving shadows from the underpainting.*

6. *Add final accents, as necessary, in the appropriate colours. Here, verdaccio is used to emphasize the face.*

7. *This painting shows the classic tempera technique in various stages, and illustrates how the finished work remains faithful to the original drawing because of the fast-drying nature of the medium. Tempera is often worked up in sections in this way.*

Gardens – Clipston 1983. *David Tindle (b.1932) has successfully revived the classic tempera technique within a modern context. Here, he has used egg tempera on board, exploiting tempera's capacity both for softened colouring and for sharply detailed texture.*

without too much difficulty. Size painting has a long tradition and it is reasonable to assume that it was used extensively at one time. It was perhaps more common for less important or decorative works, although a few examples exist of fine quality paintings that employ distemper. In recent times, size colour has remained popular with scenery painters and has also been employed for decorative murals. (It is particularly suitable for this purpose when emulsified with oil.) The main attractions of size colour for large-scale work are the low cost of the materials, especially where whiting is used as a filler, and the flat, even quality of the colour, which lends itself to a monumental style of painting.

In theory, size colour is less permanent than tempera, though an addition of oil or treatment with formalin will render it more durable. There is no reason why it should be any less permanent than gouache bound with gum, and its poor reputation in this respect probably derives more from its use as a decorator's product than from any analysis of its use as an artists' medium. Dieric Bouts in the 15th century and Bonnard and Vuillard in the 19th can be mentioned as painters who are known to have used this medium, and as its close resemblance to egg tempera confuses the issue somewhat, there may well be more size paintings in existence than is commonly thought.

The two examples shown on p. 122 could equally well have been painted in tempera or gouache, or, for that matter, in acrylic. The first example has obvious similarities with *alla prima* painting in oil on a white ground (p. 140), while the second closely resembles the egg tempera method, though it employs a less formal approach.

Materials

Both examples employed size colour made of artists' quality pigments bound with gelatine (including green lake, viridian, manganese violet, titanium white, yellow ochre, French ultramarine and burnt umber). The colours were first worked to a paste with alcohol and water, and then diluted with glue to the consistency of thin cream. Warm water was used to thin the paint as required. In addition, the first method required bristle brushes in assorted shapes and sizes, a pencil, cotton duck, illustration board and a plain solution of glue. The second method made use of various soft-haired brushes, an old toothbrush and some torn strips of paper.

Support and ground

The first example was executed on a support made from a piece of illustration board, selected for its light weight and strength, coated in size and covered in cotton duck which had been soaked in size solution. The cotton duck was deliberately selected for its rough surface texture, speckled finish and off-white colour, which were all intended to add extra interest to the finished work. The canvas was pressed down firmly to remove any air bubbles and wrapped over the edges of the board. A final coat of size was applied when the cotton duck was in place, and once dry, the support was placed under a heavy book, between sheets of clean paper, to restore its flatness.

Sized and mounted canvas makes an acceptable support for all types of water-based paint and may also be employed beneath oil colour, providing the coating of size is sufficiently strong. In this example the cloth acts as a ground, as well as forming part of the support. Although this is visually effective, such a support cannot be considered particularly permanent, as both the cloth itself and the size coating may discolour as they age. For best results, the backing board should be acid-free and the finished work should be framed beneath glass.

The second painting was executed on a heavyweight watercolour paper which was perfectly satisfactory for work on such a small scale. Larger works using the tempera family of materials are slightly at risk on paper, because large sheets tend to buckle in response to atmospheric changes, and a brittle paint film,

especially if it is too thick, cannot cope with this degree of instability.

First method

The first example (p. 122, above) was based on two sketches of the same subject: one in pencil and watercolour, the other in a combination of crayon and and watercolour. Both were done on site in an attempt to capture the mood of the location. This size painting adopted and developed the best features of each sketch while seeking to retain their spontaneity.

First, a free-hand pencil drawing was made onto the support, as it was not necessary to reproduce the exact proportions of the original sketch. If you wish to transfer a drawing more precisely, it is best to use the squaring-up method (p. 91), as a cartoon is likely to dirty the cloth, leaving traces of charcoal trapped in the weave. A 4B pencil was used in this case, so that a strong black line would remain visible wherever the ground was left uncovered. This was intended to emphasize the layered structure of the painting so that the viewer could study the technique more easily.

For this painting an equal quantity of water was added to the size colour whilst it was still warm. On cooling this mixture forms a soft gel, which can be manipulated with a bristle brush, and there is therefore no need to keep the colours warm. Using the preliminary sketches as a guide, the paint was set down using flat brushes and filberts to give boldly shaped brushmarks that represented the rugged surface of the stone bridge and the tree bark. At this stage the brushwork had little texture, however, as the colour must be applied thinly. Elsewhere in the painting colour was applied more flatly as a foundation for further layers. Throughout, a lightly loaded brush was used so that many of the brushmarks tailed away, leaving an irregular patch of exposed ground.

As a rule, size colour takes only minutes to dry, but in cold weather it is as well to allow 20–30 minutes between paint layers, as a heavy build-up of paint can crack if too much moisture is retained. Animal glues are surprisingly strong, and once they reach a certain thickness, they can fracture and pull away from the support; no more than two layers of size colour should therefore be applied at the same strength. The size should be increasingly thinned with water as each layer of colour is applied to prevent the paint layer from taking on a glassy appearance and to discourage cracking and lifting.

A second layer of size colour was then applied on top of the initial blocking-in, using smaller brushes and slight variations on the original colours in order to soften and vary the effect of the first layer of paint. Once again, strongly shaped brushmarks can be retained, but the paint must still be applied quite thinly, with no attempt at texture or impasto. So far, any very dark colours should have been avoided. These may now be introduced to accent the forms and reinforce the outlines of the design. Smaller brushes were used for this, but a rough brushmark was employed to promote the impression of texture and solidity, especially within the stonework of the bridge.

All that now remains is a little strengthening of the colours and tones, and a restatement of the drawing, where necessary, to separate and define the objects within the scene. This finishing process, which unifies the painting as a whole, should involve dilute paint applied as washes, frotties and thin layers of body colour.

Second method

The second example of size painting has much in common with modern forms of egg tempera, and draws on the classic tempera technique, employing some unusual colour combinations derived from traditional practices. It should be viewed as an example of the variations that are possible within all forms of tempera.

Although the work was executed in the studio, it was based on

a rapid sketch made from life through the window of a Hovercraft. The painting restates the drawing in a stylized manner using only four colours – titanium white, viridian, manganese violet and French ultramarine – to recreate the scene. Though these colours are not a natural reflection of reality, the viewer's mind readily accepts them as a form of colour code; the sea is rarely that particular shade of pale green, or storm-clouds that particular purple, but the slightly forbidding atmosphere which these colours evoke is familiar, and the controlled manner in which the tonal values are set down reinforces this impression of reality.

As only four colours were in use, it was quite practical to keep them warm using a partitioned metal baking tray as a palette, placed over a deeper baking tray filled with hot water. In an adequately heated room, this hot water need only be renewed every hour or so to keep the colours liquid. The warm water used to thin the paint was also replaced at regular intervals. After a prolonged period of working, size colour which has been kept warm in this way may begin to dry out, forming a crust around the edge of each colour which will make the paint lumpy if it is picked up on the brush. Loss of moisture also increases the concentration of size in the paint and, as the size must become weaker as the layers of paint are built up, rather than stronger, this must be corrected by adding a little hot water to each colour every time you change the water that warms the palette. Mix this in well and use it to soften any colour that is becoming thick and unmanageable. On no account thin size colour with size; this is a classic mistake which can ruin a painting entirely. You should only ever add more size to the colour if the binding strength is too weak, allowing the colour to dust off.

All the colours in this painting were mixed as tints with white. Firstly, a couple of bristle brushes were employed to lay in the main areas of colour. Immediately afterwards, the clouds were reworked using a lightly loaded brush that was lifted away from the paper with a twisting motion as the paint was applied to produce a jagged brushmark which suggested the edges of the clouds. From this point on, soft-haired brushes were used, as well as an old toothbrush; this was employed to spatter paint in order to soften the colours and harsh outlines of the basic lay in.

The blue across the centre of the sky was at first far too strong, so some of the white size colour was diluted with hot water until it resembled a milky wash and then spattered onto the blue several times, until it was suppressed by a hazy layer of white. The toothbrush was brought close to the painting in order to limit the area of spattering, though inevitably some paint fell outside the intended area. Sometimes this may work to your advantage, as it can harmonize colour effects, and in the final stages of this painting different colours were deliberately spattered over each other to obtain just such a random effect. However, if you wish to control the fall of paint more precisely, use a stencil (p. 103). A cut stencil can produce a rather harsh line, so in the early stages of this painting pieces of paper were torn roughly, and then held just a little above the surface of the work.

Paler tints of purple were then mixed and repeatedly hatched over the dark line of cloud along the horizon with a fine brush to modify its colour and tonal value. Again, to suppress areas of colour that were too strong and to encourage an atmospheric effect, very pale tints of colour were once again reduced to the consistency of a milky wash and applied with a good-sized, soft-haired brush as thinly and evenly as possible over whole areas of colour. As these washes settled onto the underlying paint they became much less opaque, creating a translucent veil through which the underlying colour could be seen. The painting progressed with each of these techniques being repeated several times using variations on the basic colours and varying thicknesses of paint.

Gradually, satisfactory atmospheric effects were developed and the desired colour and tonal values were achieved. In the process, however, something of the original design was lost, and more accurate overpainting was required to reaffirm the subject. Here, this involved reinforcing the drawing with green paint. (Note that the green used to outline waves in the distance is paler than that used in the foreground to suggest recession.) A pale violet was then used to hatch quite broadly over parts of the waves, with blue and a shade of purple being hatched into the wave patterns to emphasize the swell of the sea. Hatching is, of course, typical of tempera painting, and note also that the use of lilac against green is an adaptation of the pink on green used in tempera flesh painting (see p. 116). Finally, to reinforce the sense of a cold, wind-tossed sea, the various colours were spattered over each other quite boldly to break up any remaining flatness in the colouring and to harmonize the overall effect. Blue was spattered onto the sea along with pale purple and white, and the purple and white were also spattered over the sky to suggest spray or blustery rain filling the air above the sea.

Curing

Size paintings are not normally varnished, although size colour used on a panel might well be. Varnishing is a difficult operation, as size colour changes quite markedly once it becomes saturated. The solution is to apply an intermediate varnish of gelatine, which reduces the absorbency of the paint layer. This must be applied very carefully, however, as the warm, watery gelatine can release the binder in the paint; speed and a light touch are essential.

Alternatively, size colour can be cured with formalin to improve its chances of survival. Animal glue and gelatine undergo a change when treated with formalin which renders them insoluble in water and more resistant to mould and bacteria. A 4 per cent solution of formalin is sufficient to bring about this change, and since the standard strength solution is 40 per cent, 1 part of that should be reduced by 9 parts water in order to arrive at the correct strength. This is sprayed onto the dry size colour, or brushed over it with a large varnishing brush, but it should only be applied after the painting is completely finished, as formalin renders paint unworkable. As cold water is used, there is only a minimal risk of disturbing the paint, but if the formalin is brushed on, it should not be worked too heavily over the surface or it could disturb the surface layer. It takes about 24 hours for the formalin solution to evaporate, after which time the glue will be cured and the painting will, in theory, be more permanent. Size colour murals are sometimes treated in this way and it can be a wise precaution to fix the paint layer before applying a gelatine varnish.

Note that the active ingredient involved is formaldehyde. This is an extremely unpleasant gas, which in a confined space will attack the eyes and nose and any organic materials which are present. The safest procedure is to apply the formalin quickly and then leave the room, allowing several hours before your return and, if possible, leaving the treated work undisturbed overnight. If you do not have a suitable space in which to apply formalin, do not use it.

Gesso panels, or any ground containing glue, can be tempered, or cured, in the same way. Sometimes, curing with formalin provokes hairline cracks, probably due to a sudden contraction of the glue. Once cured, a ground or layer of size colour will easily take on a polish that cannot be removed with water as in the case of uncured glue. This means that you must be careful not to scratch any surface which has been cured. Of the two examples shown here, the first will benefit most from being cured as a large amount of glue is present, when both the support and paint layers are taken into account. Neither painting need be cured, and they will be adequately protected if they are framed under glass and kept in dry conditions.

The unfinished view of a bridge (opposite, above) *demonstrates the various stages of a typical work painted in size colour. The original pencil drawing is visible on the canvas-covered support in the background, and the first flat layers of colour, applied with boldly shaped brushmarks, can be seen on the left-hand side. The natural oatmeal colour of the cotton duck serves as a ground, and its weave adds texture to the paint surface. On the right, the second layer of paint has introduced greater detail and texture, and the outlines of the design have been reinforced.*

Right: Lunch at Villeneuve-sur-Yonne. *Edouard Vuillard (1868–1940) was a master of large-scale decorative painting. His work for the theatre may have encouraged him to experiment with size painting (distemper), and he was particularly fond of its unusual matt tones and potential for a textured finish. Size colour cracks easily when used this heavily, and paintings should be built up wet over dry in several layers to achieve a similar effect. Even so, size can be used with great speed, especially on a monumental scale.*

Based on a rapid sketch made through the window of a Hovercraft, this painting (opposite, left) *uses only four basic colours to create an abstract, yet atmospheric image. Hatching and spattering were used extensively to soften harsh outlines and to break up areas of flat colour. The detail* (opposite, right) *shows how a milky wash was spattered over the clouds to imitate the effects of sea-spray.*

Right: Entombment. *Dieric Bouts (c.1415–75) is known to have made use of distemper, and this painting is thought to be a rare example of a size painting that has survived on canvas, but the close resemblance between that medium and tempera makes it very difficult to state which materials were used in a specific work. This confusion clearly demonstrates the close links that exist between the various tempera media.*

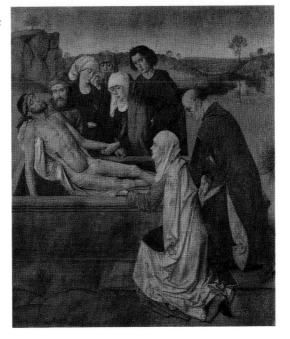

2.5 Oil painting

Early oil painting

This method of oil painting is based on the techniques of the early Flemish masters, such as Jan van Eyck and Rogier van der Weyden. It is a pure oil technique, which does not involve the use of thinners. Thickened oils, boiled oils and resin oil varnishes may all be employed, but their use must be carefully controlled, and at times it is advisable to use them selectively. The effect can be imitated superficially using modern oil and alkyd media, but the superb quality that is possible with this method will only result if painters prepare the oils and colours for themselves. This is a slow method of painting, which requires much patience, and though it can be speeded up if the lower layers are executed in tempera or acrylic, the very best results can only be achieved where oil alone is used.

The ideal support for this type of oil painting is a smooth-surfaced gesso panel with a brilliant white ground. Fine canvas can also be employed if it is given a smooth finish, but panels are to be preferred. The meticulous detail and the numerous superimposed layers required to produce subtle effects of light and shade make it unwise to attempt this technique on a large scale. Not only would it take far too long to complete a painting – even a small work may take six months to a year – but it would also be difficult to sustain the intense concentration and dexterity required for more than short intervals of time.

The early oil technique is capable of producing rich and beautiful works of art and is well worth pursuing if you have sufficient patience. Although the method is reconstructed here in a period style, the technique is perfectly capable of modern interpretation. Aspects of this method will be found again and again in other oil techniques, and the links with classic tempera should also be obvious.

Support and ground
As this technique employs paint thinly, with a good deal of the colour completely transparent, it is essential to begin with a brilliant white ground, so that the colours will appear clear and luminous. To facilitate detail and blending, it must also be smooth and non-absorbent. The only way to achieve all these features is to isolate a gesso ground with a thin priming, which seals the ground, colouring it slightly, while retaining most of its brilliance (*see* below). In this instance the panel was made from $\frac{1}{2}''$ (1cm) thick laminated wood with a layer of light canvas glued over it. The gesso mixture was the same as that described under *Classic tempera* (p. 116), and sun-thickened oil was applied as a priming. A fat boiled oil or a resin oil could also have been used. Gelatine also makes an acceptable isolating layer (either coloured as a priming or left clear) and it has the advantage of retaining a slight amount of absorbency, which ensures that the first layer dries lean without interfering with the working of the paint.

Whenever oil paint is used on a panel, it is advisable to seal the back of the panel at the outset with a protective coating of oil paint or varnish to prevent warping (*see* p. 59).

Drawing and priming
The potential for detail and accurate modelling offered by this technique makes it advisable to begin such paintings with a carefully planned drawing which can act as a guide. In this case a cartoon was made using pen and ink on tinted paper in a linear style, recording only the important contours of the subject. It was transferred onto the support with powdered charcoal and then fixed using black watercolour and a small soft-haired brush, to leave a fairly simple, linear drawing on the surface of the panel. Once this was thoroughly dry, all remaining traces of charcoal were dusted away. (For alternative methods of transferring drawings, *see* pp. 90–91.) It is also possible to draw directly onto the panel with a metal point or hard graphite pencil. The amount of detail you include in the drawing is purely a matter of personal choice, but it can be said from experience that the quality of design in the finished painting often depends on the amount of detail provided in the underdrawing.

Once you are satisfied with the drawing, the next step is to isolate the panel with a thin priming. (This can be put on before the drawing if you prefer.) On no account should the gesso be flooded with the isolating medium, as this can impair its brilliance. A slightly thickened oil or an oil varnish has the advantage of being too thick to penetrate the gesso deeply. Using a small wad of lint-free cotton rag very lightly soaked in oil, or the fingers or palm of the hand, rub the priming into place with a circular motion, and remove any excess with a clean rag or by a sweeping action of the hand. The completed layer should be smooth and very thin, and when dry, it should appear matt. The ground is likely to retain a slight trace of absorbency afterwards, but this is desirable.

An oil or oil varnish used alone will dry to a yellow or brownish-yellow film, which can be used as a toned ground in itself. Alternatively, a tiny trace of colour can be added to the priming as it is put on. Here, a thin veil of red ochre was applied to give a pink ground well suited to the subject matter; raw sienna and raw umber are alternative colourings. Whatever colour is used, it must be applied as a thin glaze, otherwise the white gesso ground, on which the technique depends, will be lost.

Shading
Ideally, the priming should be allowed to dry completely before any more work is carried out – especially where the drawing is executed on top of the priming. However, there is little harm in beginning work immediately, while the isolating layer is technically still wet. The first step is to apply shading to the drawing. This establishes form and will serve as a guide for later applications of colour, as well as acting through the thin, superimposed paint to produce tonal variations. It is laid down in exactly the same way as the shading in *Classic tempera* (p. 116), and may use a similar neutral shade from an earth colour combined with black, or a suitable pure colour, such as burnt umber or raw sienna.

At this stage the modelling should be applied thinly, keeping the shading colour as transparent as possible by adding the smallest quantity of colour to a few drops of slightly thickened oil. A few touches of this rich glaze can then be spread over the painting surface, using a clean brush or the tips of the fingers to produce an exceptionally thin layer. As these shadow glazes are not over-rich in medium, they dry to a more or less matt finish

and do not resist overpainting. If the thickened oil or oil varnish that is added to the paint is too rich to permit this kind of handling it should first be reduced by blending it with some thin and fluid, plain refined oil.

If certain parts of the painting are intended to be worked upon thinly in order to make use of the ground and priming in the finished painting, the shading in these areas should be thinner than elsewhere. Alternatively, these areas may be shaded using an appropriate colour. In the examples on p. 126, the flesh was thinly painted with the pink priming as an undertone. The thin brown shading used elsewhere in the painting was only applied to the darkest parts of the face: around the eye, on the side of the nose, under the cheekbone and across the side of the head. The rest of the shading on the face was modelled in a glaze of red ochre, which remains visible in a virtually unmodified form in the more finished version of the painting.

Dead colouring and underpainting
Once the preliminary modelling of light and shade has been completed, it maybe possible to proceed directly to some dead colouring and underpainting; but most of the painting must be allowed to dry before any further work is carried out. When the panel is dry enough to receive more paint, dead colouring can begin in earnest. This should be applied selectively, using glazes, frotties or body colour, depending on what is most appropriate for each area. This stage does not involve a mere laying down of subdued colour as a vague guide for later painting; every aspect of the underpainting and dead colouring should have a purpose, anticipating later stages in the painting process.

Fairly fluid hand-ground colour may prove satisfactory for this stage of the painting without any modification, but, if necessary, a drop or two of rich medium can be added to make the colour spread more easily. Pale oils, bleached and thickened in the sun, are best for light colours, especially where such colours are applied thinly, while darker boiled oils and resin oil varnishes should be reserved for dark colours and must be used very sparingly if ever they are added to light ones. Media based on stand oil, including blends containing damar and thin alkyd media would make acceptable alternatives, though they do not work as well. If ready-made colours are used, a few drops of medium worked well into the paint on the palette should produce the correct semi-fluid consistency.

In the first illustration on p. 126 the fur collar and trimmings, which are to be glazed, are underpainted in a deliberately lighter tone, consisting of a flat, mid-brown frottie painted into with pure white whilst it was still wet. The second illustration (above right, p. 126) shows a picture that has reached a more advanced stage, using the same technique. To bring the first image to this more finished state, at this point the hat would be painted with a dark grey, and the tunic, set down flatly in a pale grey. Areas to be painted white can be underpainted at this stage in the shadows.

When the dead colouring and underpainting are complete, set the painting aside once more to dry. It should not be worked on again for several weeks, during which time the paint should dry to a semi-matt finish. Additions and corrections can be made within this period, but no further painting should be carried out until these, too, are thoroughly dry.

First painting
As this is an oil-rich technique, the foundation colours may resist further applications of paint when dry. To overcome this, rub over the areas to be painted with a little of the fat oil medium used to thin the colours. Use a clean rag or the fingers to spread the oil so thinly that just the merest trace covers the surface of the painting. It may help to warm the oil a little, as this makes it thinner and more fluid, enabling you to put down an even finer covering. 'Oiling out', as it is known, is essential to enable subsequent colour to adhere and to be placed precisely. It also adds greatly to the subtlety of a painting, as touches of colour can be blended into the oil covering to produce the most delicate glazes and frotties. Remember to use only well-prepared oil, as a poor quality medium will darken and yellow any colours beneath it.

The dead colour and underpainting are now systematically worked up towards the intended finish. A black glaze would be applied to the dark grey hat, to produce a deeper, flatter black than could otherwise have been achieved. (This also makes it far less likely that the pale ground will show through as the thin, dark paint ages.) Areas of white were now painted over with a thin, half-covering film of semi-transparent white. This rich frottie allows the underpainted shadows to show through as pearly half-tones. Elsewhere, the modelling of the dead colouring was strengthened by working over it in the same colours, carefully blended with a clean brush so that the upper and lower layers were brought together visually.

An exceptionally thin frottie of pink, containing hardly any white at all, was applied to areas of the flesh where it was needed to soften and harmonize the modelling. Into this thin, wet layer, touches of white were added to improve the modelling and blended with a clean brush to produce soft highlights around the eyes, nose and forehead. Some detail of the folds and contours of the skin was then drawn in with a darker pink, and again blended with a clean brush to soften the effect. Smaller areas could be painted *alla prima* at this stage.

The blue background was added when the first painting was complete, though it could just as easily have been introduced after the dead colouring stage. A flat blue, of ultramarine and white, was mixed in sufficient quantity to cover the whole of the background and made quite fluid by an addition of boiled oil. This was deliberately used to deaden the brilliance of the blue as it dried, to prevent the effect from being too overpowering.

The first painting may be staggered over a number of sessions, but it represents a period of working which is more or less continuous. Eventually, you will reach a point where the painting can be advanced no further. It must now be set aside to dry before further glazes and details can be added. A period of several weeks should elapse before any more work is carried out, and although after this period the paint will retain its gloss, it should have lost its original hard, glassy quality, indicating that it is ready to receive further colour.

Second painting and subsequent painting
It will again be necessary to rub a very thin layer of oil medium over those parts of the painting to which further paint must be applied. This should not be spread across the entire panel, but applied as precisely as possible to selected areas of the work. In this way you will avoid a potentially harmful build-up of oil films. The colours should again be thinned with medium, to give them a thin, flowing consistency, almost like watercolour.

The second painting adds detail and further modifies colouring and shading, but it should represent only a gradual refinement of what has already been done. This process of adjustment must not be rushed, and though it is possible to advance the work significantly by a second painting, several sessions may be necessary to bring it to completion.

The feather trimming around the hat would only be completed at the second painting (p. 126). This allows it to overlap the blue background, so that the edge can be painted in a very detailed manner. A tiny drop of a rich, syrup-like copal medium can be added to the white used for this purpose, as it thickens the paint and makes it stand out from the picture surface, while allowing it to be finely worked with a small brush.

Final details were now added to the face using an extremely small, finely pointed brush. A warm, delicate glaze was also applied to the side of the head. This was made with a touch of red ochre blended into the film of clear oil with a clean sable

These examples demonstrate the meticulous build-up of
layers in the early oil painting method. The sequence begins
(above) with a drawing transferred by a cartoon. The
pounce marks – visible as dotted lines – were fixed with
black watercolour, before a soft pink priming was put over
the gesso ground to reduce its absorbency. A thin brown
glaze was applied to indicate the basic modelling (cf. the use
of verdaccio on p. 119), and then deadcolouring and
selective underpainting were set down as a foundation for
subsequent layers. One side of the fur collar shows a part-
completed underpainting, while the other side shows the
effect of glazing over it.

The detail of the face (right) shows how thin films of
transparent and semi-transparent paint are built up over
the preliminary modelling. The pink priming is intended to
contribute to the effect of the flesh, and in many places it is
barely covered. Delicate blending can be achieved by
working wet in wet into each paint layer, and by spreading
the colours so thinly that the paint beneath them shows
through. The underdrawing has been painted out on the
right-hand side of the face as it nears completion.

The version of the painting above right shows the technique
at a more advanced stage. Deadcolouring is still visible in
the jewels on the costume, but elsewhere several
superimposed paint layers are active. On the sleeves red
ochre has been painted over yellow ochre, and embroidery
has been added to half the tunic over the grey foundation
set down for it. The head has been taken almost to
completion.

Man in a Red Turban
*(1433) by Jan van Eyck
(c.1390–1441). Van Eyck's
paintings began with a
highly detailed drawing
made onto the ground in
metal point or watercolour.
After the panel had been
primed with an oil medium,
his colours were applied in
layers, getting progressively
richer in medium and
purer in colour. In this
detail, shown larger than
actual size, it is possible to
see the black underdrawing
beneath the lips and at the
side of the nose, and there is
evidence of a thin frottie of
pink over a darker tone
beneath the cheeks. Tiny
finishing strokes are visible
throughout, but their soft
outlines and subtle
colouring suggest they were
painted into a thin film of
medium. The stubble of the
beard was painted as a
final layer using a very fine
brush. Notice how cleverly
Van Eyck contrasts the
inner light of the paint
layers with the highlights in
the painting of the eyes.*

brush. The beard was also completed at the second painting, by scoring into the wet paint with the brush handle.

There now remains the possibility of introducing a subtle dark glaze throughout the painting, to emphasize and unify the shadows. Here, the natural colour of dark resin oil media may be used to advantage: applied as a glaze, with no additional colour, they will produce rich transparent shadows of an amber-brown hue. The slightest addition of brown or black will produce a darker shadow glaze if you prefer, but remember to allow for the fact that such media darken; shadows put down in this manner will in time deepen and enrich themselves. In this particular painting, a thick copal varnish will finally be added to shade the creases in the white linen and to reinforce the form of the costume generally. The same medium will be applied as a final glaze over the fur collar. The face will be touched only slightly, and these final shadows will be restrained, so that the decorative quality of the painting is not lost.

Final comments

Even the most successful painters are unlikely to maintain a constant level of performance, and one of the skills involved is knowing when a passage of work is not quite right and being prepared to discard it and begin again. One of the benefits of allowing the paint to dry between each stage, and of preparing the surface with a thin film of fresh oil before each painting session, is that mistakes can be corrected quite easily. As the work progresses, increasingly detailed and subtle effects are sought, bringing an increased risk of error, but these can be simply wiped away while they are still wet, leaving the dry, non-absorbent paint beneath quite unaffected. The film of oil which separates each layer will encourage the wet paint to come away cleanly. Any residual traces are then removed using a clean rag dipped in fresh oil, and any surplus oil can be wiped away to leave the painting in its original state. Unfortunately, good painting sometimes has to be sacrificed along with bad, so it is advisable to work in sections in the final stages of a painting; any corrections will then affect only a limited portion of the painting.

It is unwise to use solvents for corrections, as they may act upon the dry paint and destroy a carefully built up sequence of paint layers. For the same reason, you should be cautious in employing modern painting media which contain solvents, in place of the traditional oils and varnish media recommended here. Although, ideally, this technique avoids the use of thinners, this should not be taken to extremes; brushes may be cleaned with turpentine or white spirit during the painting process.

Oil painting on a toned ground

This technique employs the pale colour of the ground as an intermediate tone, and is extremely versatile, as different colours and visual effects can be used in the priming. Toned grounds are light enough to avoid deadening thin colour that lies above them, but their contribution to the brilliance of the paint layer is limited. As a result, highlights must be painted with a certain degree of opacity to bring them out, while shadows need be painted only thinly to produce accents of great clarity and depth.

The example on p. 130 demonstrates a complex version of the technique derived from evidence of Van Dyck's working methods. Toned grounds were popular throughout the 17th and 18th centuries, and Rubens and Gainsborough can also be cited as masters whose techniques depended on them. Oil painting on a toned ground is derived from both classic tempera (p. 116) and early oil-painting methods (p. 124). The technique depends on the combined effects of opaque, translucent and transparent applications of colour and on the manipulative qualities of oil paint. It is demonstrated here entirely in oils, but there is no reason why other media should not be combined with oil in variations on the technique.

The tone of the ground is generally dictated by the subject matter, and in this example it is geared to painting flesh. The use of a double ground (p. 64) is a little unusual; pale grey, a honey colour, buff, tan and pink are less complex alternatives, and Van Dyck himself would have used these more frequently.

Support and ground

This type of painting can be carried out on either panel or canvas, but this example was on a light wooden panel with a canvas covering glued onto it. This was sized and given two coats of a red-brown oil ground applied with a large brush. The ground was made from whiting and red ochre pigment bound with an oil-rich emulsion containing boiled oil and animal glue. After about a week, when completely dry, it was covered with a grey priming to convert it into a double ground. This was mixed from black and white oil paint, diluted with turpentine to speed up the drying time. The second layer was put on very thinly, using a good-sized decorators' brush only partially loaded with colour; it was dragged and scrubbed over the red ground to produce a patchy scumble which only half-covered the underlying colour, resulting in an optical mixture perceived as a warm grey. This was designed to act as a middle tone throughout the painting and as a neutral grey under the flesh for its shadow tones.

Once the priming was dry, the support was left for a further week before being painted on, so that the priming would not be disturbed by the turpentine in the first layers of paint. This ensured that the dark red ground was not revealed, thereby altering the tone of the painting; it also prevented the grey from getting into the shadows and destroying their clarity.

Drawing

As this technique involves much forward thinking, it is essential to begin with an accurate drawing; this avoids the need for repainting, so that the tonal value of the ground is retained as part of the finished effect. The outlines of the composition should be drawn onto the ground in soft white chalk, as this shows up well on a toned ground and can be rubbed away to make corrections. Surplus chalk can then be blown away or dusted off with a clean brush to leave much fainter lines that will not interfere with the paint as it is put down. In this particular instance the drawing was transferred by squaring-up (p. 91).

Shading and dead colouring

The first paint is put down very thinly. Where there is to be shading or dark colouring, raw umber diluted with turpentine is used to reinforce the drawing and to wash over the shadows. The final shadows will eventually be glazed over this foundation and, if they are to have depth, it is essential that the pale grey ground remains operative and is not obscured, either by too heavy a layer of dark paint, or by mixing in white, which will make the shadows dull and cloudy. The dark umber wash should be used selectively, avoiding any areas where it might interfere with a build-up of paint that relies on the greyness of the ground for its effect.

When the shading is complete, the rest of the painting can be dead-coloured using a light approximation to the eventual colour in a very thin wash diluted with turpentine. This should be put on patchily with a bristle brush so that areas of the ground remain visible beneath, and large areas of the ground are deliberately left exposed. The shading, the ground and the dead colouring represent three tones which establish the preliminary modelling of forms.

In some cases, the grey of the ground can be used on a large scale as the foundation for a glaze. In this case it may be shaded, but no dead colouring is applied, and highlights in white will be introduced at a later stage. In any area that is to be painted white, the ground can also be useful for representing the darkest areas that are in shadow. In these areas, dead colouring is carried out with white, leaving plenty of grey ground exposed for later use.

These features can both be seen on the left-hand side of the boy's face, in the hair and the collar.

First painting

The first painting is virtually a continuation of the dead-colouring process, though thicker, opaque paint without turpentine is now introduced. It follows the colouring established by the dead colour, but its object is to bring forward the lights and to model the forms more thoroughly. It is also used to establish coloured and modelled foundations for future glazes.

In the case of the flesh, the first painting is applied directly into the dead colour whilst it is wet, so that both layers can be manipulated and blended to improve the modelling. The flesh mixture at this stage should be white with a little yellow ochre and a very small amount of red ochre. More red ochre can be added to produce darker tones for use in shadow areas, but all the flesh tones should be kept paler at this stage than their intended finish. On p. 130, the face of the girl shows how the flesh colour can be put down in different thicknesses, so that it obscures the grey ground to varying degrees. It was put on with a fairly dry brush to allow the right amount of grey to show through. Around the eyes and at the top of the cheeks, the flesh tone was used fairly thickly to produce a highlight, but where the face falls into shadow, it was thin and only half-covering.

The girl's dress was also painted at this stage, using white, blue and yellow ochre as the foundation for a subsequent green glaze. The ground is of little use under this particular colour, so the area was painted quite solidly and roughly modelled using three distinct tones. The clothes of the boy (centre) were painted with white highlights to allow the white, the grey ground and the dark shading to act as a similar foundation for a glaze.

Second painting

When the first painting is completely dry, a second layer of paint can be put over it. The colours can now be strengthened and set down with more certainty, using the previous layers as a guide. The modelling, colour and definition of forms can all be refined at this stage, the object being to work economically, leaving any parts of the first painting that are satisfactory exactly as they are. How far the second painting is taken depends purely on how tight you wish the image to be. Compare the white cloth in the boy's gashed sleeve with the nearby collar (p. 130). This illustrates how the second painting can be used to refine and strengthen the first colouring, where it is felt to be desirable. Repainting the highlights at this stage, especially in areas of white, makes them more solid and gives them sufficient density to obscure the ground. A separate, clean brush should be kept exclusively for the whites.

For the second painting, it is best to add a little rich medium to the colour so that it flows more easily and gives a smoother, richer finish. This is particularly important in the second painting of the flesh: it must form a very delicate, semi-opaque layer, through which the first painting will remain operative. This time a different flesh mix is used, composed only of white and a pure red (in this case, cadmium red light). There are two reasons for this. The first is that introducing red at this later stage creates a lighter and softer pink, because it is floated over the more creamy-coloured foundation layer. The second reason relates to the ageing of oil paint: it is wise to avoid yellow in the final flesh mix, as the oil will itself yellow in time, and paint which might at first appear too pale and pink will eventually take on a more natural flesh tone. This is also considered in the choice of medium; sun-thickened oil ensures that the whites and flesh tones will yellow and darken only slightly.

Glazing and finishing

Once again the painting is allowed to dry thoroughly before areas are glazed with transparent colours over the foundations that have been laid for them. The rich medium is again used at this stage to give the glazes body. They are spread flatly and evenly over the underpainting, and once set down, can be worked into whilst wet using a heavier application of the glaze colour to accent the modelling wherever necessary. Sometimes a little extra highlighting may be necessary, and this can be achieved by wiping back the glaze with a piece of rag. The boy's clothes were glazed with red ochre, and the hair at the right-hand side of his face was glazed with burnt umber.

The final glazes are now applied to the shadow areas, again using burnt umber, and a little of this colour is also taken over into the coloured shadows to create the impression of a continual falling away into darkness and to unify the image.

Oil painting on a dark ground

The major characteristic of this technique is the need to progress away from the darkness of the ground towards light and colour. Only the darkest shadows may lie directly over the ground; all other tones must suppress it to a greater or lesser extent, and highlights must be painted very solidly in order to obscure it completely.

Dark grounds are also known as bole grounds, after Armenian bole, a dark, red-brown clay. This colour has always been popular for dark grounds, though alternatives range from dull orange to a dark brick red. Mid-brown and dark brown can also be used, and dark grey is one of the easier colours to work with. Black and other dark colours, such as olive green, may also prove useful. There is no hard and fast rule about how dark the ground should be, and the dividing line between dark and toned grounds is slim. Dark grounds need not be dull, but their colour and construction are vital to the appearance of the finished work.

Titian is said to have invented the bole ground, though most of his work is in fact on a white ground. Tintoretto, El Greco, Velazquez and Rembrandt all employed dark grounds, and the way in which light and dark are used within their paintings is characteristic of this method of working, as dark grounds are particularly suitable for strong *chiaroscuro* effects. All paintings on a dark ground are inclined to possess a subdued tonal quality, and a strong, dark ground can make an entire painting warm or cool, depending on its own tendency, even when it is covered with more or less opaque paint.

The basic approach

Oil painting on a dark ground consists of a gradual build-up of paint which covers, or partially covers, the ground. Highlights are opaque, while half-tones and soft shadows are achieved by a partial covering of the ground, allowing it to act through the superimposed colour and lower its tone. The ground gradually recedes with the increasing opacity of the paint layer, as a combination of body colour, frotties and glazes are applied in a manner very similar to that described in the previous section. The only difference is that the ground no longer represents a middle tint; it represents shadow. This requires a subtle adjustment in thinking and careful painting in order to create the mid-tones, which do not naturally exist. On a pale or mid-toned ground, the eye is deceived into thinking that those areas of ground which remain exposed represent the middle tone of the colours which immediately surround them. On a dark ground, a partial exposure of the ground is required to achieve the same visual effect, and this is achieved by scumbling or by varying the paint thickness. You should be able to gather sufficient information from the sections on *Oil painting on a toned ground* (p. 128) and *Alla prima on a coloured ground* (p. 136) to attempt this version of the technique for yourself.

Another approach is to underpaint the work directly onto the ground, using either very subdued colour or white and shades of grey to separate out the tonal values, using the ground as a starting point; strong colour is applied later by means of frotties

This painting is on a double ground of grey over red (see top right). The composition was drawn in with chalk using squaring up to transfer the design (left). Next, parts of the drawing were restated in thin brown paint, and washes of deadcolour were added to establish the basic colouring. The dog illustrates this, and shows how the ground is retained to assist in the development of form. Some areas are underpainted in preparation for glazes: the girl's dress is solidly underpainted in anticipation of a green glaze, while the boy's clothes have been derived from the ground in three mono-chromatic tones, then glazed to produce the effect seen here. Finishing consists of applying frotties and glazes (note the boy's head and left arm).

This detail shows how the thickness of the deadcolour is varied to let the ground show through. The line of the eyelids is created by scoring into the paint with a brush handle to reveal the ground beneath.

The boy's face has been finished with a frottie of warm pink. Omitting yellow from this layer improves the ageing qualities of the work. Note also the part-glazed hair and the finishing on the collar.

Princess Elizabeth and Princess Anne: *Anthony van Dyck (1599–1641) painted this delicate oil study from life in preparation for his group portrait of* The five eldest children of Charles I. *A double ground is used here, which accounts for the apparent warmth of the grey. It is used extensively for the half-tones of the flesh, and is barely touched in parts of the linen caps. For a finished work Van Dyck would have sweetened the effect of this* alla prima *sketch by adding frotties and glazes.*

Detail from The Judgement of Paris *by Peter Paul Rubens (1577–1640). Paintings by Rubens are usually on toned grounds – sometimes grey, or honey-coloured – or on white grounds glazed with a streaky brown priming. Much of his painting is* alla prima, *but employs an abbreviated form of the technique described here (pp. 138–9).*

and glazes. The underpainting employs body colour, frotties and scumbles, as in the first version of the technique, to obscure the ground to varying degrees. Two variations on this method are described in the following account. The first example employs both tempera and oil; the second uses only oil. Acrylic or gouache paints could be used in place of the tempera, but might prove less sympathetic towards the other media involved. A painting medium composed of 1 part linseed stand oil and 1 part damar varnish was used in both cases; painting media based on linseed stand oil, sun-thickened oil or an alkyd medium thinned with turpentine would also be acceptable.

In both examples, a lightweight panel was used, though canvas makes a highly suitable support for this method. A coarse-grained canvas is particularly well-suited to large scale works, as the rough texture assists scumbling.

The dark ground

Although solid dark grounds are perfectly acceptable, both of the examples shown here employ glazed grounds, which involve a coloured priming applied as a glaze over a white ground. The inner light which such grounds derive from the underlying white makes them slightly more versatile than dull, solid-coloured grounds, and less likely to darken with age. In the case of the portrait (p. 135), a smooth white gesso ground was laid over a canvas-covered panel, and left without further surfacing to give the basic ground a fine tooth. Once the gesso was thoroughly dry, a thin priming of gelatine, coloured with Indian red broken with black, was brushed on with a large decorators' brush. To obtain an even finish, the panel was first sprayed with water, and the gelatine was applied hot and very liquid. While still wet, it was brushed first lengthways down the panel and then across it, to remove any pronounced brushmarks. The gelatine reduces the absorbency of the ground considerably, but leaves it with a slight trace of absorbency which helps the paint to adhere.

For the still life (p. 135, above) the panel was prepared with gesso as before, and brought to a smoother finish by lightly sanding the surface. A dark priming, which might loosely be described as olive green, was then applied over the ground as a tempera wash made from yellow ochre, a little lamp black and a whole egg beaten together with stand oil. This was dabbed onto the ground with a sponge, first in one direction, and then another, until a uniform covering had been built up which retained a slight surface pattern. Once the tempera priming was dry, the oil-painting medium, thinned to half-strength with turpentine, was brushed over it, both to reduce its absorbency and to limit colour changes that could occur if the ground became saturated by medium or varnish.

Both types of priming are lean enough to accept tempera, while at the same time being well suited to oil colour. On canvas, a more flexible ground and priming would be advisable, though the same principles can be followed. Gelatine and tempera primings are easily scratched and scuffed during normal handling, but such damage is usually so slight that it can easily be painted over.

Preliminary drawing

Paintings on a dark ground need not begin with a drawing, as it is possible to begin work straight away on a roughly modelled underpainting, introducing more detailed drawing with the brush as the painting proceeds. However, too much uncertainty at this stage could lead you to paint too heavily, thereby defeating the whole point of using a dark ground, so only experienced painters should consider this method of working.

It is best to begin with a chalk drawing made directly onto the ground, limiting the sketch to a few outlines and important contours. Surplus chalk should be dusted away before any paint is applied, and, if you wish, the drawing can be reinforced with white paint, preferably applied as a thin scumble to ensure that it

is not lost. This may also prove helpful where a drawing has been substantially reworked, leaving a confusing number of faint chalk marks. Black or dark brown paint may also be used to sketch out compositions where the ground colour is not too dark. Orange-red, mid-brown and dark grey grounds usually combine well with a dark-painted drawing.

The portrait was based on a painted sketch made from life which was of sufficient quality to be used as a starting point for this more formal painting. A drawing taken from the sketch was traced down using paper backed with a thin layer of chalk. The chalk outline was very faint, and so the contour of the shoulder and the top of the head were redrawn in white paint, as their relationship to the face was quite important. The rest of the composition was only vaguely planned at the outset, so further drawing was left until a later stage.

The preliminary drawing for the still life was executed in a manner which can only be employed when the dark ground is glazed. A free-hand brush sketch was made from life in waterproof Indian ink using a size 1 sable brush. (A pen would be equally acceptable, so long as you do not push it too hard into the ground.) This drawing was made onto the white gesso ground, before the tempera colouring was sponged over it. The dense black drawing remains visible beneath the dark priming, though in a subdued fashion, and acts as a guide during the painting process. There is little point in adding too much detail to the drawing, as it will only be obscured, and you should avoid making it too fussy, otherwise parts of the drawing may remain visible in the final work where they are not wanted. This is especially important where parts of the ground are to be reserved, as in this example.

Underpainting

In both of the examples shown here, the principle of under-painting is rather like drawing on a blackboard with white chalk: the highlights are painted in, whilst the shadows are reserved; intermediate tones are achieved by varying the thickness of the highlights. At this stage, your main concern should be to establish tone and form; colour can be ignored, though if you prefer, light pastel tints can be used in place of white to add an indication of colour.

The portrait head was underpainted in oil, in a manner sometimes known as working grey in grey, or, more tradition-ally, as a grisaille. This is monochrome painting which employs white and a series of greys to model form and capture the effects of light by concentrating entirely on tonal relationships. In this example many of the intermediate tones are optical greys produced by the interaction of the ground and a thin covering of white or pale grey; the subtle changes in intensity of the brightest and darkest areas of the underpainting are entirely due to variations in the thickness of the paint film.

The face was underpainted as follows. Using the original sketch and preliminary chalk drawing as an aid, the main highlights were scumbled into place with a round bristle brush lightly loaded with white paint. The next step was to take the lights towards the half-tones, by scrubbing and stippling with the same brush outwards from the highlights and towards areas which should appear in shade. The brush was not recharged except where absolutely necessary, so the paint was deposited as a thin veil-like scumble fading gradually away to nothing. The shadow at the side of the nose and the soft division between light and shade on the cheek were both achieved in this way. At this point, pale grey paint was introduced in place of white to reinforce the impression of half-tones falling into shadow. To complete the initial lay in, a slightly darker grey was used as a thin covering for parts of the flesh in shadow.

As the half-tones and shadows are set down, the initial highlights will appear to lose their brightness relative to the tones around them, and will need to be reworked to restore their true position in the sequence of tones. The half-tones may also

require strengthening in this way. Remember, throughout, to apply any half-tones and highlights with restraint: you can always make them lighter, but it is extremely difficult to make areas darker. Gradually increase the opacity of the highlights and lighten the edge of the half-tones to soften the division between them and the highlights.

At the third painting session the greys of the shadows were strengthened and the detail of the face was precisely drawn in using a soft-haired brush. All this was carried out wet in wet, but the slight pull of the gelatine priming allowed the final touches to be placed as if they were being put down wet over dry. Note that the range of tones in the underpainted face was kept fairly light throughout: the darkest value is a mid-grey, which is paler than the ground, while most of the underpainting lies between white and a light grey. This is to allow for the fact that, once glazed, all tonal values will shift and appear slightly darker. By allowing for this in the underpainting, you will avoid excessive reworking at a later stage. It also minimizes the use of body colour in subsequent layers, as any deficiencies in tone can be corrected by darker glazes without losing the effect of the grisaille. Note, also, that the eyes and mouth were painted in tonal values that were not perfectly matched to the flesh tones. Again, this was to allow for the glazes that would be placed over them later, and was an attempt to anticipate the effect of the grey underpainting combined with the superimposed colour. The eyes were to appear dark brown with a warm, velvety highlight; grey serves as an ideal underpainting for this, whereas white highlights would be required to achieve the sparkling quality so typical of blue eyes. Similarly, the lips were painted relatively dark in order to dull the brilliance of the red glaze that they would receive.

The still life makes more use of the ground, employing it not only as a tonal value, but also as a colour. It was sufficiently neutral to be used as a shadow tone, and although black provides the deepest shadows in certain parts of this painting, it is the ground itself which represents most of the darker areas of the composition. When a dark ground is used in this way, only highlights and half-tones extracted from the ground should be used in the underpainting.

Using white alone

With the exception of the lemon skin, the still life was underpainted entirely in white. Tempera can change its colour, and sometimes even its tone, when it becomes saturated with painting medium or varnish, making it difficult to predict the effects of a coloured tempera underpainting. Using white alone limits the problem to one of controlling tone, as heavily applied tempera white undergoes little or no change when painted over; if applied with sufficient body, even veil-like scumbles will retain most of their value. You must, however, assume that anything less than a pure highlight will appear half a tone darker once it becomes saturated. Providing you can adjust to this concept, underpainting in white on a dark ground is a quick and easy method to employ.

Combining tempera with oils in the manner shown here offers several advantages in addition to that of speed. One is that tempera can be applied with precision and delicacy, allowing a great deal of detail to be introduced into the underpainting which need not be restated at a later stage. Another is that tempera yellows and darkens far less than oil, so colours which are badly affected by oil, such as white and blue, retain their colour and brilliance far better when applied as tempera. All the white that appears in the finished painting is tempera underpainting which has been left untouched; once varnished, it takes on the appearance of oil colour. If, as in this case, a resin oil painting medium is used, you can actually paint into it with tempera while it is still wet. This was done, in fact, in the example shown here, to correct minor deficiencies in the underpainting.

Note particularly the use of the white underpainting in the details of the lemon and fish (p. 135). The darkest areas of the flesh of the lemon and the shadowy patches on the fish-scales are provided by the untouched ground, while the white of the pith and the reflective highlights on the scales are the untouched tempera underpainting. If you look carefully at the skin of the lemon, you may be able to see that its pores and shadows are also derived from the ground. This section was underpainted in tempera yellow, rather than white. The pigment used was barium chromate, a very pale, opaque lemon yellow, which behaves sufficiently like white when glazed to be acceptable in underpainting, while producing a more brilliant colour for the lemon skin when it is subsequently glazed. A considerable amount of detail in this example has been painted with tempera, with only a small amount of additional detail added later using oil.

Glazing

When the underpainting is completely dry, colour is applied as glazes. Artists' quality oil colours are preferable, as good, highly coloured glazes require strong, unadulterated pigment if they are to retain their clarity. Some colours lend themselves to glazing because they are naturally transparent, but you can in fact glaze with any colour, so long as you use it in a sufficiently dilute state. Do pay attention, however, to the permanence of the colours; the light-fastness of some otherwise reliable pigments can be significantly reduced when they are applied as thin, delicate glazes. The amount of oil colour needed to produce a satisfactory glaze will vary according to the strength of the pigment involved.

In the examples shown here the colour glazes obtain their body from a rich resin oil, which is used quite freely, as its particular composition, based on stand oil and damar varnish, makes it unlikely to yellow, wrinkle or crack. Tiny amounts of oil colour were added to it in order to make up the glazes, and where large quantities were required, the glaze was mixed in a dish rather than on the palette. In effect, the oil paint is used very much like watercolour, with the paint medium thinning the colour in place of water.

The effect of transparent glazes over a monochrome underpainting can be seen on p. 135 (below, right), where the portrait head has been glazed once only with suitable colours. Here and there, a richer glaze has been worked wet in wet into the initial application to reinforce the drawing and the form, and the brightest highlights have been wiped back to produce a thinner glaze. Once these glazes are dry, further glazes could be used to modify the effect still further. It would also be possible to underpaint again, selectively, on top of the first glazes to create interleaved layers of opaque and transparent colour.

The still life was glazed as follows: red, blue and green were added thinly to the backs of the fish, and the fins and gills were lightly touched with the same colours. A further glaze of black was applied sparingly to the head, back and tail fin of each fish, and the eyes were glazed in yellow, with solid touches of black for the pupils. A strong glaze of scarlet lake was added for the blood when the painting was nearing completion. The skin of the lemon was glazed with Hansa yellow, touched in places with a glaze of orange made from Hansa yellow and scarlet lake. The cabbage was glazed selectively with yellow ochre, viridian, Prussian blue and *terre verte* applied both separately and as mixtures. Finally, accents were introduced into the darker parts of the leaves using a glaze of black; the background and foreground were glazed, and the final dark shadows were added using a black glaze.

The unique visual effect of this work derives from the fact that in places there may be as many as four glazes interacting with each other, as well as with the underpainting and the ground. How many glazes are used and how thickly they are applied is a matter for the individual. The quickest method is to apply strong glazes and work them wet in wet, but more cautious painters may prefer to build up thinner glazes instead. This requires

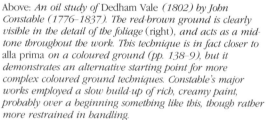

Above: *An oil study of* Dedham Vale *(1802) by John Constable (1776–1837). The red-brown ground is clearly visible in the detail of the foliage* (right), *and acts as a mid-tone throughout the work. This technique is in fact closer to* alla prima *on a coloured ground (pp. 138–9), but it demonstrates an alternative starting point for more complex coloured ground techniques. Constable's major works employed a slow build-up of rich, creamy paint, probably over a beginning something like this, though rather more restrained in handling.*

Right: The Water-Carrier. *Diego Velazquez (1599–1660) is known to have used dark grounds, usually brown or grey. The strong* chiaroscuro *quality of this work is typical of their effect; the contrast of light and shadow lends solidity to the forms and draws the viewer's attention to the most important elements of the composition, as well as creating a highly dramatic atmosphere. This painting would probably have begun with a bold deadcolouring, using plenty of white and some black to establish the main areas of light and shade. That would then be covered with direct painting in full colour, mostly applied wet in wet. Some finishing would also be required, though Velazquez usually sought an immediate effect from his paint.*

This still life was carried out on a white gesso ground glazed with an olive-green tempera priming. This dark ground represents most of the darker areas of the composition, and the remaining areas of the work were underpainted in white. Only the lemon (left) was underpainted in yellow. Note how the ground is exposed to create shadows on the skin of the fish and on the crumpled paper, and see how it is employed for the flesh of the lemon.

This portrait was underpainted in white and shades of grey in the manner of a traditional grisaille (right), before being glazed with colour (far right). Once the background has been set in, covering the expanse of dark ground surrounding the image, the painting will appear much brighter. Painters should anticipate such changes when working on a dark ground.

more patience, but helps to ensure that the full benefit of the underpainting is retained.

Alla prima on a coloured ground

This method represents an abbreviation of the techniques described under *Oil painting on a toned ground* (p. 128) and *Oil painting on a dark ground* (p. 129). The basic principle is to make use of the ground, as both of these methods do, but to shorten the process considerably by doing away with the layered structure and attempting instead to complete the painting in a single layer, while aiming to retain, as far as possible, the sophisticated visual effects of the more complex techniques. It takes skill and the experience gained by practising such techniques, to be able to combine several aspects of painting simultaneously. A single brushstroke, for example, may be required to perform the function of drawing, underpainting and colouring all at the same time. This explains why *alla prima* was originally considered to be the height of achievement (p. 105).

Alla prima on a coloured ground does not necessarily involve a single layer of paint. Sometimes greater certainty of touch can be encouraged by using a sketchy layer of underpainting or a carefully worked out drawing to control the work. The difference lies in the fact that this does not act through subsequent layers of colour in the way that dead colouring and underpainting would normally do. For the most part it is obliterated by the *alla prima* painting placed over the top, unless it is intentionally exposed to form part of the final effect. Where a single layer of colour is applied, its thickness, opacity and colour quality are carefully controlled, with varying effects being created by combining it visually with the coloured ground. Toned grounds are perhaps easiest to work on; they allow the greatest freedom, as you can paint towards either light or dark. Double grounds can be employed to add interest to this technique, and streaky or patterned glazes applied as primings can also enliven the effect. Honey-coloured grounds, shades of grey, pink and buff, and warmer dark grounds all suit the *alla prima* approach. Dark red bole grounds can give acceptable results, but generally the darker grounds do not perform well when painted on in this manner.

As the colour of the ground substantially affects the painting process, two versions of the technique are demonstrated here. The first example may be thought of as classic *alla prima* – the controlled approach, where the object is to paint quickly without loss of quality. The second method demonstrated is the version of *alla prima* sometimes known as *fa presto* painting. It is shown here on a warm dark ground, though it works equally well on paler colours. The technique depends entirely for its effect on variations in the thickness of the paint film. In fact, this is a feature of both techniques described here, though only in *fa presto* painting is it the sole method of control.

When carefully done, *fa presto* can be extremely impressive, but it has its weaknesses. A technical weakness is that the increasing transparency of ageing oil paint may eventually allow the ground to show through more than was originally intended, which can have quite a pronounced effect on the tone and colouring of the painting; this is sometimes described as the 'ground growing through'. It is also claimed that subtle half-tones may be entirely lost as *fa presto* paintings age unless they are painted with sufficient body; once again, the culprit is increased transparency of the paint. You can guard against these problems to some extent by the careful selection of materials.

Another criticism often levelled at *fa presto* painting results from its past assocation with degenerate techniques and the decline in painting standards. *Alla prima* on a coloured ground using paint layers of varying thickness is, in fact, a reasonably sound, sensible and quite skilful way of using paint; but to the untrained observer, or the poorly taught student, its subtleties may not be immediately apparent. It can be superficially imitated using an unvarying body colour which completely obscures the ground, thereby destroying the whole purpose of using a coloured ground.

Whichever method of working painters choose, they should not feel obliged to complete *alla prima* works at a single sitting, or to restrict themselves completely to direct painting methods. The object of traditional *alla prima* painting was to complete as much of the work as possible in a spontaneous manner, but finishing touches can always be added later wet over dry.

In theory, it should be possible to practise these techniques in tempera, gouache or acrylic, though the fast-drying nature of these materials can make it difficult to vary the thickness of the paint film; with oil, too heavy an application can be removed or reworked in order to restore the ground.

Grounds

Both panels of $\frac{1}{2}''$ (1cm) thick processed wood were sized all over with animal glue. The first panel was then given two coats of a white half-chalk ground on both sides and along its edges. This contained animal glue, whiting, titanium white pigment, a little zinc white pigment and some boiled oil. When it had been given a week or so to dry, the surface was skimmed with a pumice stone to remove any roughness. Two thin coats of a grey oil priming were then brushed on in opposite directions to give an even finish. Although opaque, this priming was sufficiently thin to benefit from the white ground beneath it, creating a luminous grey that appeared brighter than it actually was. Like the ground recipe, the priming contained chalk, animal glue and boiled oil, though the oil was present in greater quantity this time. It also contained white pigment broken with a small amount of lamp black. A small amount of yellow ochre in this recipe would produce a grey-green ground, which is also satisfying to work on.

The second panel was given three complete coats of an oil ground made from whiting, yellow ochre, red ochre and a little umber, bound with animal glue and boiled oil. It was left to dry for several weeks before being lightly sanded to remove any surface roughness. This polishing resulted in a slightly streaky appearance. Patchy effects like these are often unavoidable on coloured grounds and should cause no concern, as they disappear completely when painted over. A completely even colouring can only be achieved by careful handling or by using oil paint as a priming.

In both cases the grounds were left to dry for quite some time before being painted on; this allows the oil content to dry out fully, thereby sealing the panel and reducing the absorbency of the ground. A reasonably non-absorbent ground is required for this type of *alla prima* painting, as it is essential that the paint remain workable for at least a few hours. Grounds of this type may undergo a slight colour change when painted on or varnished. To test for this, smear the surface with a wet finger, and if any significant change occurs, allow for it during painting.

Classic alla prima

This version of the *alla prima* technique relies on one of the most important principles of traditional techniques: the separation of drawing, modelling and colouring. By concentrating on one aspect at a time, painters are better able to control and guide their work towards the desired result. In classic *alla prima* these operations form a more or less continuous sequence, but remain identifiable as separate stages in the painting process.

The first example begins as a shaded brush sketch executed directly onto the grey ground. Careful draughtsmanship is essential, as unnecessary covering of the ground will interfere with its use as a middle tone. In this case the drawing was painted in a raw sienna which combines well with the pale grey ground to produce a dull, greenish grey-brown. The paint was prepared as a thin, transparent glaze using a stand oil medium and a small

amount of colour, and applied with a well-charged but not over-loaded brush. Begin by painting in the outlines of the composition, then wipe any surplus glaze from the brush and rework the wet colour, drawing it out over areas of shadow to create a muted half-tone. Think purely in terms of tone, as you do this; do not worry about introducing detail.

The next step is to rework the drawing with a darker glaze of about the same consistency, using a medium-sized, round pointed brush, preferably of sable, to indicate crisp outlines and suggest detail. Once again, the colour should be applied thinly so that it appears rich and glowing as it sits over the pale ground. If you prefer, think of this sequence as involving two separate drawings of the same subject, one executed tonally, the other in a crisp, linear style. Together they are strongly suggestive of form, and because of the choice of colours they combine with the ground to form a three-tone sequence. Once you are satisfied with the quality of the drawing, go over it again, accenting the shadows where necessary with more of the dark glaze. These shadows will be left untouched from now on, appearing in the finished work exactly as they are now. On no account allow white to enter these shadows as the painting progresses, or their deep, luminous quality will be lost.

Next, take some white paint on a bristle brush and gently scumble in highlights, onto untouched areas of ground. This is just as effective as a more formal underpainting, and can now be employed as a guide for the final layers of colour.

Applying colours

It is perfectly acceptable to continue on this sketchy under-painting without interruption, but beginners may find it easier to allow time for the paint to dry. The colours must now be placed with great accuracy, as overworking will destroy their clarity; if they are allowed to mingle with one another where they should not, their effect will be destroyed. First, put on any colours which are to be glazed, thinning them as necessary with the stand oil medium. There is absolutely no reason to avoid glazes in *alla prima*, providing you remember to put them down first, and allow for the fact that their colour will be determined by the tonal value of the ground. Highlights and accents can be added afterwards by painting straight into the wet glaze. Highlights are set in as body colour, with a darker glaze used to accent the shadows. To produce subtle gradations of colour, highlights can be first blended into the glaze to produce an area of frottie, with a second highlight of solid, opaque colour being placed on top of this using a loaded brush. Here, once more, an expanded three-tone system is being used, in which the original colour glaze represents the first shadow tone.

The flesh tones for this particular painting were prepared on the palette as body colour, with some of each tone then being reduced to a frottie by an addition of painting medium. This was left to stand for a while to allow some of the turpentine to evaporate off, resulting in a thickly flowing colour with the consistency of a thin syrup. An alternative way of achieving this would be to work some stand oil directly into the colour with a palette knife, and to thin the colour to the desired consistency using a brush dipped in turpentine.

Once the frotties were ready, they were applied systematically according to the tonal values that they represent. The lowest tone was a pale blue, which was applied sparingly at points where the flesh falls into shadow to reinforce the pale grey ground. The object is to produce a pearly half-tone by contrasting the cool shadow colour with the warm colours used for the rest of the flesh painting: the next tone is a soft pink, beside that is a pale yellow, and the lightest tone is white. The first lay of these colours should be sufficiently thin to allow the ground to operate through them. The whole sequence is then reworked using the same colours, but this time with more body. By placing the additional colour carefully, further gradations of tone can be built up within a single colour, as the more solid the

colour, the brighter and lighter it appears. The paler the colour, the thicker it lies over the ground. In this case, the yellow was applied more thickly than the pink, and the white was reinforced with very solid paint containing hardly any medium, so that in the ultimate highlights the ground was completely obscured. Finally, in order to soften the divisions between these colours, the pink was taken over the blue, the yellow was taken over the pink, and the white was taken over the yellow until they blended visually.

Finishing touches are now put on with body colour made fluid by the addition of medium. It may be necessary at this stage to reinforce certain aspects of the drawing and to apply more detail to the image. It is best to touch the painting as little as possible at this stage, however, as too much fussiness will destroy the freshness of the image. When it is dry minor corrections can be made, and, if necessary, finishing glazes can be applied selectively without undermining the spontaneous *alla prima* character of the rest of the painting.

Fa presto painting

The second example is really very simple: there is no preliminary drawing and the paint is applied directly onto the ground.

To begin with, a pale blue was mixed from French ultramarine and white. As the pigment was ground directly into sun-thickened oil, the paint was sticky and a little difficult to manoeuvre, so it was thinned with turpentine to make it more fluid. The first application of paint was thinned quite substantially and applied with a bristle brush in a scrubbing motion. This deposited the colour thinly and unevenly, allowing the warm red ground to show through extensively. A second, paler blue was then applied in the same manner to create the effect of a rising sky. The next step was to draw in the highlights around the clouds. These, too, were scrubbed on thinly so as not to obscure the ground at this early stage of the painting.

Next, a darker blue was prepared, broken with yellow ochre to produce a dull blue-grey. This was also thinned with turpentine and scrubbed onto the underside of the foreground clouds. Spread thinly over the red ground this appears dark grey. A pale or medium blue not broken by a third colour actually looks brighter and livelier than it really is when it interacts with the red of the ground. By varying the amount of ground that shows through, you can make the colour appear duller or brighter. Compare this use of a red ground with the directly painted sky containing red described in *Alla prima on a white ground* (p. 140). A third colour was then prepared, once again using French ultramarine, titanium white and yellow ochre to produce a dull, pale green which appears greenish-grey when placed over the ground. It was used on the underside of the distant clouds and as the lighter shadow tone beneath the foreground clouds.

In order to bring out form and colour, the ground had to be suppressed by thickening the paint layer selectively. This time, colour was used without turpentine, or at least, with no more turpentine than was required to make it workable. The blue of the sky was repainted using two separate colour values to create the impression of a distant cloud formation. A clean brush was employed to blend the colour slightly at this stage, to soften the outlines and to enhance the impression of distance. Note that although the blue of the sky may appear to cover the ground towards the top of the painting, it does not do so completely, as tiny specks of red remain visible here and there. The paint film is thinner than it may appear, so that the blue is visually warmed by the red behind it.

The thin covering of pale blue at the bottom of the sky was touched only slightly with more colour, as its tone and colour were already felt to be satisfactory. Touches of white were introduced, however, to create the impression of light breaking through the clouds in the distance. The grey-green shadow tones beneath the clouds were then repainted with a dryish

The classic alla prima *example begins* (far left) *with a shaded brush sketch on a grey ground. The ground acts as a mid-tone, while the shadows are accented with a dark glaze, and highlights are scumbled in with white paint. Colour is then applied: the thicker the paint, the paler the colour, and the more translucent the paint, the greater the effect of the ground. Note how seemingly unrelated colours have been used to carry out the flesh painting. The shadows are pale blue, with pink and yellow leading away from them towards a white highlight.*

Although its presence is not immediately apparent, the red-brown ground beneath this fa presto *painting is responsible for most of the colour and tonal effects. The dry brushmarks in the lower half of the image show most clearly how the ground and superimposed colour react together, but even where thicker paint covers the top of the sky, the ground is still active beneath it, and accentuates the deepness of the blue (cf. p. 143).*

Woman at a window *by Edgar Degas (1834–1917). Even in this loosely executed work, Degas exploits the coloured ground to maximum atmospheric effect, by the skilful placing of solid, opaque highlights and accents, and more delicate washes and scumbles of colour. Degas is unusual for his time in making extensive use of the ground, frequently employing the natural colour of his support. By continuing traditional practices, he introduced subtle technical elements into the rather abrupt manner of the Impressionists.*

brush, dragging some of the colours over the shadows on the underside of the clouds, with slightly more white being added to repaint the underside of the clouds in the middle distance. For the highlights in the clouds some white paint was broken with yellow ochre to produce a creamy off-white, and the top-most edges of the clouds were repainted with pure white. Placing yellow and blue on either side of the white highlights in this way intensifies them, and to increase their brilliance still further, the highlights on the clouds were again repainted a day later, when the paint had begun to dry but was still semi-liquid. This was to prevent the highlights from sinking in.

Alla prima on a white ground

This is the simplest of the oil techniques. It has only been employed extensively since the late 19th century and its adoption is related to the loss of traditional skills and to the replacement of studio-made materials by those of a modern paint industry. The stiff, pasty oil colours that are commercially produced lend themselves particularly well to direct painting, and the painter requires little knowledge of media, optical mixtures and coloured grounds. While no disrespect is intended to those who excel at this technique, it must be said that this is an ideal method for the amateur or untutored painter.

The technique chiefly employs body colour, with white used extensively throughout the painting. Thin washes may be employed in lower layers, but glazes are entirely absent, and most of the paint is set down in varying degrees of impasto, with brushwork forming a deliberate element of the technique. Substantial use is made of the three-tone technique (p. 106), with mixed colours set down both to model and to provide colour at the same time. The three versions of *alla prima* on a white ground shown here are loosely based on the working methods of the Impressionists.

This method translates easily into the acrylic medium, and thickly applied acrylic paint can survive better in the long term than oil. The technique can also be adapted for use with size, tempera and gouache, but avoid heavy impasto, otherwise the paint will crack and peel. Some modern pastel techniques also resemble this method of painting (p. 168).

Support and ground

All three examples described here were on a reasonably light cotton duck canvas with a medium to fine weave. It was unbleached, with a fairly clean surface that was clear from knots and other irregularities. The canvases were sized once with animal glue, then primed with two thin coats of a half-chalk ground composed of glue size, whiting, titanium white and a modest amount of boiled oil to give it flexibility and reduce its absorbency. The canvases were allowed to dry for a month before being lightly skimmed with a pumice stone to remove small lumps and areas of roughness. Linen canvas with an oil ground would be ideal as a support for this technique, but there is no reason why ordinary shop-bought canvases should not be used for less serious work. Painters using ready-made canvases should obviously pay attention to quality, and may also wish to modify the ground themselves by adding a thin priming of white oil colour. If you do this, leave the canvas for as long as possible before painting on it. This also applies to oil-based white lead primings, which are still a favourite ground amongst professional painters for use under oil colour. They are adequate for *alla prima* painting of this type, but are by no means desirable in all circumstances.

The ground need not actually be pure white, as it is not exploited here as it is in other methods of painting, and where paint is applied quite thickly, the colour of the ground is virtually irrelevant. Some painters find a stark white ground off-putting, and prefer to tone it down with a thin wash of colour, but as this tends to dirty the colours and to destroy the reflective quality of the ground, the practice is best avoided. It is far better to prime canvases with a silver grey, or cream ground that approximates to white. These are achieved by breaking white with a tiny amount of black or an earth colour, and should be too white to be thought of as a toned ground. A tiny amount of ground charcoal is particularly useful for producing a silver grey.

Alla prima in stages

The female portrait (p. 142) demonstrates a version of the direct technique in which the final effect is built up in stages. These could be considered as a continuous process, but in practice, several separate working sessions may be required, and unless a completely non-absorbent ground is employed with slow-drying colours and diluents, it may even be necessary to finish such a painting by working wet over dry. The fact that this is done with another layer of direct painting, however, means that the concept of *alla prima* is effectively retained. This comparatively slow and carefully controlled *alla prima* method lends itself to the production of reasonably detailed, well-finished images. It also offers greater control over colour and tonal values, as work is concentrated in one area at a time instead of being advanced rapidly across the whole canvas.

The subject was first drawn onto the ground using charcoal. A simple linear drawing is advisable, as this keeps the ground reasonably clean, and any surplus charcoal should be dusted away with a clean rag or brush to leave only a faint trace of the drawing. In this case deliberate use was made of the charcoal pigment. A thin wash of flesh colour made up from titanium white, cadmium red, cadmium yellow and a touch of ultramarine blue was placed over the figure in areas of shadow, and the charcoal of the drawing was picked up in it to produce a greenish-grey flesh tone.

Two more flesh tones were then prepared on the palette: a warm pink of red, yellow and white, in which the red dominates, and a paler, cooler flesh tone, again composed of red, yellow and white, but with white and yellow dominant. These colour values were used to model the flesh using the three-tone system. For the first lay in of colour the paint was slightly thinned with turpentine and brushed on broadly to establish the basic forms and suggest the colouring. Thin washes of pure colour were also applied freely to the background, in order to map out the design and colouring. This was done using oil colour diluted to the consistency of watercolour with turpentine and applied with a large, flat brush. This initial lay in quickly becomes fixed as its solvent evaporates, and will not be greatly disturbed by any subsequent applications of paint. It is advisable to touch every part of the charcoal drawing with a wash of colour, so that none of it is free to mingle with the next layer of paint, otherwise its colour will be impaired.

The pink flesh tone was next placed more precisely as a mid-tone for the flesh. It was brushed out with a dry brush into and over the shadow tone to create a softer transition into darkness. More of the whitish-yellow flesh tone was then placed next to the pink, and the process was repeated to soften the division between the highlights and the mid-tones. The paint should be opaque, but fairly thin, and brush out easily; if necessary, add a little turpentine to prevent too heavy a build-up of colour from occurring too soon. Finally, touch some white into the highlights to accentuate the roundness of the forms, working it gently into the underlying wet paint; as the paint settles, a soft pearly highlight will appear.

Now make up a slightly darker pink, breaking it, if necessary, with blue. Using a small bristle brush with a reasonable point, apply this colour to the contours of the figure in order to reinforce the drawing. Continue working wet in wet, gradually adding a little more of each colour and tone in a continual process of refinement. Use a single brush to work the flesh, and

allow the colours to be picked up and mingled to create subtle intermediate tones which will remove any harshness that may remain in the modelling. Finally, accent the highlights once more with pure white to prevent them from sinking in as the paint dries. You may also add warmth to the cheeks by brushing a touch of pure red into the wet flesh colour.

At this stage the eyes, eyebrows and mouth were painted in with a small bristle brush. A few touches of blue-grey were added around the eyes and chin to create opalescent shadows. The hair was blocked in and the area around the head was painted with criss-cross strokes from a flat bristle brush in two different tones of blue, to break up the flatness of the surface.

The final stages

A semi-absorbent priming such as half-chalk will, over a period of hours, pull some of the medium out of the colour, making it lean and unworkable. This can actually work to your advantage, as it fixes the lower layers of paint and ensures that colour placed over them obeys the rule of fat over lean. If you are working on a paint layer which is still technically wet, however, avoid using solvents as more paint is applied, or the paint may be lifted unintentionally. If you prefer, allow the painting to dry completely at this stage before continuing work.

The figure's hair was begun at this stage and continued in a third session. By this time the flesh and the blue around the head were virtually dry, and it was possible to place the hair accurately, taking it over the surrounding paint where necessary. It was painted wet in wet using burnt umber, red ochre, yellow ochre and white in a three-tone system. The white was brushed directly into the wet highlights to imitate the soft sheen of light falling on chestnut hair. A small, round pointed bristle brush was used to work the colours into one another to create intermediate tones. As the eyebrows had originally been painted rather dark, they were now touched with a little red ochre to create a closer match with the hair.

Corrections are common in *alla prima* as the desire for directness and spontaneity often leads painters to begin without a definite plan; they tend to work from a basic idea which is developed as the painting progresses. You should therefore not be surprised if you do not achieve the desired effect at the first attempt. Even when a picture is apparently finished, it is essential to take another look at it after a short period, and to reassess it with an objective eye.

Placing colour by colour

The second example shows a view across a park painted largely from life. *Alla prima* on a white ground is ideally suited to *plein-air* painting – so popular with the Impressionists – as it is a rapid technique which enables the painter to capture changing light and weather conditions. The quicker the paint can be set down, the better; and the less it needs to be retouched once it has been applied, the more likely you are to convey the impression of the fleeting moment. The first illustration (above left) shows the painting after only a few hours' work; already, the essence of the scene has been fully worked out, and what remains to be done can easily be accomplished in the studio.

There is no preliminary drawing, though some painters may find a light pencil sketch a desirable guide, and the paint is applied directly onto the white canvas as body colour. As you move across the picture surface, areas can be reserved for other colours. Note, for example, the spaces left open for trees. Some medium-sized, long flat brushes and some small brights were used to apply the paint, and their characteristic square brushmark was deliberately retained. The brushstrokes were placed side by side, rather than on top of each other, and at first they covered the surface only patchily, as you can see from the half-painted trees. A springy touch and a slight twist of the wrist from time to time help to add variety and break the monotony of the uniform brushstroke. Gradually, more brushstrokes were introduced, using continual slight variations of colour and tone, until the whole of the canvas was covered. Where modelling was required, darker tones were dabbed on in the same way, though tonal variations were moderate overall in order to suggest a flat, bright light. The result is a shimmering effect which enlivens the flatness of what would otherwise be an extremely simple image.

To promote harmony, the colours should be deliberately broken by introducing colours used elsewhere in the painting, and this effect can be strengthened by limiting the number of colours on the palette. So, for example, to echo the blue of the sky, blue-greens were added to the foliage, while pale blue and dark blue were introduced into the pinks, greens and reds of the foreground and middle distance; the deepest shadows were also painted in blue. Note that pink, yellow and blue-green were also applied to the sky and clouds to complement the colours of the foreground.

All the colours in this painting were quite light in tone, but they were made paler still in places in order to imitate the tendency of all colours to appear paler and slightly bluer as they recede into the distance. (This is known as aerial perspective.) Compare the sky in this painting with the *fa presto* example for *Alla prima on a coloured ground* (p. 137). Here, dabs of alizarin madder were painted wet in wet into the darker blue at the top of the sky, with a little more blue added to suppress the red to the desired degree; the red makes the blue look richer and bluer than it really is. Note also that a yellowy cream is used below the highlights on the clouds to make the white appear more brilliant. In fact, almost the same selection of colours was used in this sky as in the *fa presto* illustration, but the colour of the ground beneath gives each work an entirely different character.

The second picture shows the finished painting with the foreground completed in the studio. This was applied in the same manner, but in the flowerbeds slightly thicker paint was built up in three layers of overlapping dabs of colour applied with a small bristle bright. To enhance the unity of the image, during the second painting session a few of the foreground colours were taken over existing areas of work. This is especially important when paintings are finished in the studio, as there can easily be slight differences between the two passages of work. As with the figure painting the work was studied again a day or two later while the colour was still wet, and a few additional touches were introduced. For example, a change of colour was made to one of the flowerbeds by scraping back some yellow paint with a palette knife and repainting the area with pink. Although this did not reflect the original scene, it improved the visual balance of the painting.

Using thicker paint

The final example combines the thin lay in of the figure painting with the dabbed-on colour of the landscape, and introduces pattern-like brushwork and a thick build-up of impasto. A cursory drawing in charcoal was used to begin this lively painting of a cornfield.

The paint contained a small amount of wax to give it a rich, creamy consistency which is ideally suited to work in heavy impasto. Not only does it respond well to the brush and retain moisture, but it also dries solidly, without wrinkling. The slightly lean ground and lean washes and frotties that were applied first also assisted the build-up of thick areas of colour. A well-loaded brush is essential to create a good-sized, heavy brushmark, though bold, vivacious brushwork can also be introduced after the paint has been applied simply by rearranging the colour with a clean brush. Painting knives can also be used to manipulate the paint, though none were used here, and paint can even be applied directly from the tube. Heavily applied oil paintings of this kind take a long time to dry and must be set aside carefully for several weeks out of harm's way. For this reason, painters may prefer to adapt this method for use with acrylics, which are in any event likely to age better.

The alla prima *technique begins with washes of pure colour, slightly thinned with turpentine, which are brushed on quite freely in order to suggest the colouring and to establish the basic forms. Ensure that all parts of the preliminary drawing are covered, so that particles of charcoal do not discolour subsequent layers.*

Right: Nude in sunlight *by Auguste Renoir (1841–1919). The extreme freedom of the brushwork in the background to this figure – with dabs and smears of pure colour sweeping over the canvas in every direction – is typical of modern* alla prima *techniques. Although it is on a pale grey ground, this work demonstrates a manner of painting more commonly practised on a white ground.*

Three tones of opaque, but fairly thin paint are used to model the flesh. Working wet in wet, the forms are gradually strengthened as the highlights are brought forward. The eyes and mouth can also be painted in at this stage, and the hair and background are blocked in.

At the next painting session, when the paint has dried slightly, further work is carried out to refine details and make corrections. Additions can be made in thicker paint and worked wet in wet, completely covering the lower layers.

These details taken from the same painting at separate stages, show how different textures and methods of application can be combined in direct painting. The loose lay in (above) employs dashes of coloured wash.

In the second example these are overlaid with scumbles of thick paint applied with a fairly dry brush, and dabs of thick red applied from a well-loaded brush. Avoid reworking these touches of colour, or a muddy mixture may result.

Once lean washes had been set down to map out the basic composition of this landscape (opposite), thick, creamy paint containing a little wax was applied as heavy impasto, in the manner of Van Gogh. A well-loaded brush is essential to this technique. Pure colour and bold brushwork combine to create a highly expressive image.

For this view across a park, small dabs of opaque colour were applied straight onto the support to create a shimmering, impressionistic effect. At first, spaces were reserved for different colours, but the forms were gradually defined as more and more colours were applied. Note how dashes of red in the sky enliven the effect of the blue (cf. p. 138).

143

Glazing onto a white ground

Oil techniques based entirely on glazes are unusual; even this technique does not use them exclusively, as minor touches of body colour are permissible – even necessary – in order to bring out the effect of the glazes. Glazed oil paint has a richness and depth which create strong, glowing colours like those of stained glass. Combined with brilliant modern pigments, the effect is sometimes stunning, though it is not to everybody's taste, as it is easy for paintings worked up in this manner to look glassy and even garish. However, used wisely, this method can produce fresh-looking paintings with some of the visual qualities of classic *alla prima* and of the early oil-painting technique.

Applying glazes to a white ground is a method which developed in the 19th century to imitate the appearance of earlier, much-admired paintings. (In fact, any resemblance to traditional oil painting methods is superficial.) The dark resin oil media and white lead grounds which made the technique possible were believed in the 19th century to be traditional materials, while in reality they were products of their time. Modern materials, such as alkyd media and white primed canvases, are descended from these, and are therefore well suited to this particular technique. Stand oil is also well suited to the production of thin glazes, and the technique can be imitated with acrylics, using an acrylic glazing medium to thin the colour. Water alone can also be used, but the work will then resemble a watercolour. Painting with transparent washes onto a white ground is essentially the same as painting with transparent glazes onto a white ground; the only difference lies in the level of colour saturation, which in the case of oil provides a greater range of tone and offers the potential for deeper, richer colours. Alkyd painting medium or alkyd paints could be substituted for the oil media and oil colours used here, and synthetic hair brushes could be used in place of sable, especially in the larger sizes, on grounds of cost.

The occasional use of body colour is essential for three reasons. The first is that as the strong oil glazes are built up, the white ground beneath is easily obliterated, making it virtually impossible to recover lost highlights without introducing pale opaque paint. The second reason relates to the visual effect of glazes applied in quantity. All glazes appear to advance or float, but different colours and tones do so to varying degrees. Too many glazes and too broad a range of visual distortions can produce a very disjointed image, and a little body colour is sometimes required to calm down this effect. The third consideration is that certain colours simply look better as body colour than as glazes, and it would be pointless to ignore this fact. Great freshness can be achieved by applying body colour highlights into wet glazes in the manner described under *Alla prima on a coloured ground* (p. 136).

This account represents only one version of the technique. Another method, invented by Holman Hunt and practised for a period by the Pre-Raphaelite Brotherhood, involves spreading a thin smear of white oil paint over the drawing, section by section, and painting into it while it is still wet using coloured glazes. These must be carefully placed, and reworked as little as possible, to avoid losing the clarity of the glazes. This method demands great patience and a certainty of touch.

Support and ground

This painting was carried out on a medium-weight cotton duck canvas, supplied ready-stretched but unprimed. The weave had a pronounced tooth, but the surface of the cloth was smooth, rather than rough. A fair number of seed cases and small knots were removed during preparation. The canvas was sized and given three coats of a white oil ground composed of gelatine, whiting, titanium and zinc white pigments (to maintain the brilliance of the titanium), and a mixed oil medium containing 2

parts stand oil, 1 part thick copal varnish and 2 parts turpentine. The copal varnish already contained lead dryers.

The first two coats of ground were set down whilst it was warm and liquid, and the third coat was applied cold a day later. They were all brushed on thinly and worked well into the cloth so that the weave was just obscured. The canvas was then set aside to dry for two or three weeks and was not touched for some time, as this could cause oil to rise to the surface resulting in a patchy ground. Like all oil grounds, it yellowed slightly, but the use of stand oil and the inclusion of zinc white ensured only a minor lowering of tone, so the ground remained brilliant and virtually white. This technique demands a ground that is non-absorbent and as white and reflective as possible; the recipe used here is ideal for providing these qualities. If a ready-made canvas is used, it may require some modification to make it suitable. Commercial oil grounds are sometimes quite yellow, and if applied thinly on linen, they may even appear grey, while white acrylic grounds and universal primings may be far too absorbent. In both cases, the solution is to cover the ground with a layer of white oil colour, thinned generously with turpentine and containing a small addition of a dryer. Ideally, the canvas should not be painted on for some time, even in the case of white lead primings, which should, in theory, dry quickly.

Drawing and shading

Glazing onto a white ground demands careful preparation. This is not a technique for impatient painters, nor is it one that should be attempted without the aid of preliminary sketches or other reference material. As the technique lends itself to crisp, well-defined images, it is advisable to begin with a detailed under-drawing. This also helps to avoid reworking and overpainting, which would obscure the ground, thus destroying the very essence of the technique. A delicate linear pencil drawing can be executed directly onto the ground (p. 146) or transferred, preferably by tracing (p. 91). The advantage of pencil is that it can be easily lost beneath a transparent glaze. The harder the lead and the finer the point, the fainter the drawing will be, though too hard a pencil lead may cut into the ground. In this case a 2H pencil was used. Make every effort to maintain the cleanliness of the ground. A soft, good quality eraser was used in this example to make corrections and to clean away smudges of graphite.

The next step was to apply shading using a thin glaze containing only a small amount of colour. Ideally this should be a colour which is easily suppressed, as although it may be allowed to function through superimposed glazes, it is really intended only as a guide to the general pattern of light and shade. Stronger shadows can be applied in an appropriate colour at a later stage. In this case, yellow ochre was chosen as the shading colour, because of its widespread presence in the finished painting. Other suitable colours would be raw sienna, raw and burnt umber, phthalocyanine blue and alizarin madder, providing they are used at a sufficiently low strength. Use your chosen colour to shade the entire drawing, spreading this preliminary modelling with a clean brush or finger wherever an exceptionally thin or tapering shadow is required. Compare this procedure with the use of preliminary shading described under *Classic tempera* (p. 116) or *Line and wash, and classic watercolour* (p. 152).

The glazing medium used throughout was composed of 1 part linseed stand oil and 1 part rich copal medium, diluted with turpentine to varying degrees. For the shading and first colour glazes, 5 parts turpentine were used to 1 part medium. Although the copal oil varnish already contained lead dryers, a small amount of cobalt dryer was also added to the lower paint layers to speed up the painting process. Note that the studio-made copal oil varnish was as thick and syrup-like as the stand oil. It had been allowed to clarify for some time, and the mixture had a pleasant warm amber colour which was barely apparent when the medium was applied thinly.

First colour glazes

Once the shading is dry, begin to apply colour, but in a restrained manner at first, to allow for later developments. The sky and sea were glazed with cerulean blue and cobalt blue, using a slight variant on the painting medium which contained a little more stand oil than copal varnish. This was to reduce the risk of discolouration within the medium, which can have a pronounced effect on these particular blue pigments. Some of this blue was also taken over the rocks to create a blue-grey ground colour. Colour was used more sparingly to achieve this effect, the glazes used for the sky being thinned with more medium. Next, thin glazes of yellow, and yellow ochre were introduced for the sand. They were also taken over parts of the rocks and worked wet in wet into the existing glazes to produce an assortment of broken colour values. Apart from the fact that blending is possible, the technique is very similar to working in watercolour, and at this stage it may be necessary to reserve certain areas of the ground. (All the patches of rock that are to be covered in seaweed, for example, were at this point left open.) You should also avoid laying one glaze next to another which is still wet, as – just as with watercolour – they can run into each other and spoil the freshness of the colours. It is not, however, necessary to wait until glazes are completely dry before working on adjacent areas; as soon as the thinner has passed off, the glazing medium will become thick and tacky, and only careless handling will disturb it.

There will come a point during the application of the first colour glazes where too much wet and semi-wet paint lies on the canvas·to allow further progress without the risk of disturbing the existing areas of paint. At this point, set the painting aside to dry. The thinners and dryers used in this example allowed a second session of painting to commence on the following day, when further thin colour glazes were added. The areas reserved for seaweed and rocks were now glazed in brilliant yellow, and a few other gaps, which had been left to prevent running, were also glazed using appropriate colours. The shadows on the rocks and beach were retouched using a dilute glaze applied wet over dry. At this stage the painting still resembles a partly completed watercolour. It should now be set aside to dry thoroughly. In the case of the example shown, this took only 48 hours.

Second colour glazes

Where glazes are being overlaid to create a combined effect, it is essential that they are allowed to dry thoroughly between layers. However, allowing them to dry for too long will hamper later work, as if too hard and glassy a surface builds up, the next glaze will slide and bead as water does on glass. In the early oil technique this is overcome by oiling out with a carefully prepared oil (p. 125), a method which could also be employed here; but so much medium is already present in the glazes, that it is inadvisable to increase the risk of darkening and yellowing. The best policy is not to allow too long a period to elapse between painting sessions, so that the later glazes are applied onto a surface which is dry, but which retains a residual tackiness; combined with a fatter medium, this ensures that the glazes stay in place. Work on the sea and sky continued with the medium at the same dilute strength, but elsewhere a richer glazing medium was employed, diluted with three parts turpentine instead of five.

The second glazing is a more or less straightforward repetition of the first, using stronger colour and taking colours over each other to create optical mixtures. Glazes of blue and of red ochre were taken over the shadowy areas of the rock, and red and yellow ochre were set down over parts of the sand. Here and there, smears of yellow ochre were applied to the grey-blue of the rocks to break up the flatness of the area and to tone down the colour. The preliminary yellow glaze put down over the rocks was glazed with a very lightly coloured green in an attempt to recreate the dazzling, semi-iridescent quality that is some-times found in wet, mossy seaweed.

The second glazes may be worked into while wet to improve the way in which they interact with the lower layer. For example, they may be partially wiped back to produce a soft, subtle highlight, or scrubbed with a dry bristle brush to expose the lower glaze. They may also be scored into with a brush handle so as to draw in the colour of the lower glaze. If second glazes are applied too heavily, so that the ground is lost, they should be wiped back immediately, and the area can then be repainted with a weaker version of the glaze. Losing the ground will kill the painting, while losing the ultimate highlight is generally less serious, as it can be recovered by lapsing into body colour and working a small amount of white wet in wet into the coloured glaze.

Once again, more than one session may be necessary to complete the second application of glazes, and just sufficient time should be allowed between them for the paint to become touch-dry. This gradual strengthening of colours will darken the overall tone and improve the modelling, while refining the colouring of the painting. A further green glaze was taken over parts of the seaweed to suggest the form of the rock beneath. During the final session parts of the sky may have to be reworked using thin frotties to dampen the visual effect of the glazes, which would otherwise appear to advance. It is not always necessary to do this, but it is not uncommon where atmospheric effects are concerned.

Finishing

When the painting has once more been allowed to dry, a final sequence of finishing may begin. First, the detail of the waves could be added, using cobalt blue as a rich glaze drawn on with a small brush in lines of varying thickness to suggest shadows cast by small waves. (Note that areas of the white ground had been reserved to represent breaking waves.)

It is helpful to add final details by working downwards from the top of the painting, to avoid having to reach over wet paint in order to place details higher up the canvas. This would be particularly convenient here, as it means that the background and middle distance can be finished first. A thin glaze of red ochre could be used to add detail to the distant beach, and stronger colour glazes might be introduced into the foreground to draw in details with a very fine brush. The final illustration (p. 146) shows how some of the rocks and areas of green seaweed have been finished by crisp brush-drawing in a heavy viridian glaze. Note that the use of heavy glazes for drawing continues to deepen the tonal values of the painting, so modelling is being developed at the same time.

Once the necessary detail has been drawn in using colour, all that remains is to strengthen the highlights and shadows. Wait until the drawing is dry, so that if necessary a glaze can be applied very thinly over the top of it to strengthen a complete area of shadow. You may also wish to repeat small passages of drawing using a thick glaze of the shadow tone, to crisp up the forms and to subdue the colouring slightly. Without a unifying shadow tone, the various different colours used to draw in detail and model form in various parts of the painting can produce a jumpy, discordant effect. Finally, any parts of the painting that are to be white should be touched with pure white containing only a trace of painting medium. This also applies to parts of the white ground which have remained exposed throughout. In this example, the crests of the waves must be retouched with white because the ground is not white enough to produce the sparkling highlights required, and because it cannot be relied upon to retain its purity to the same extent as a good white oil paint. Remember to keep a separate brush for white to keep your highlights pure. Any retouching in body colour should also be done at this stage.

Once a delicate, linear drawing has been set down, a transparent glaze of an appropriate colour is used to shade the entire composition (above). *This acts as a preliminary modelling. Begin to apply colour glazes in a subdued fashion, reserving areas of the ground where necessary, as in the watercolour technique* (Chapter 2.6).

Gradually strengthen the glazes and take one colour over another to create optical mixtures (above). *Glazes of blue and of red ochre were used to shade the rocks, and yellow ochre was used over areas of the sand. A light green was applied over the preliminary yellow glaze to create the shining wet areas of seaweed. Final details can be added with a small brush to strengthen the highlights and shadows, or the brush handle can be employed to score through the wet glazes, effectively drawing in the colour of the lower layer. This has been done for the seaweed in this example* (below right).

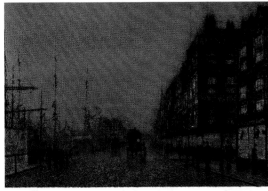

Atkinson Grimshaw (1836–93) evolved a particular form of industrial landscape in which the quality of moonlight and gaslight was captured using rich oil glazes and frotties over a white ground: Liverpool Quay by moonlight *(1887).*

The intense colours and sharp focus of Isabella *(1849) by John Everett Millais (1829–96) were achieved by a painstaking build-up of transparent glazes, painted into a thin wet layer of white paint.*

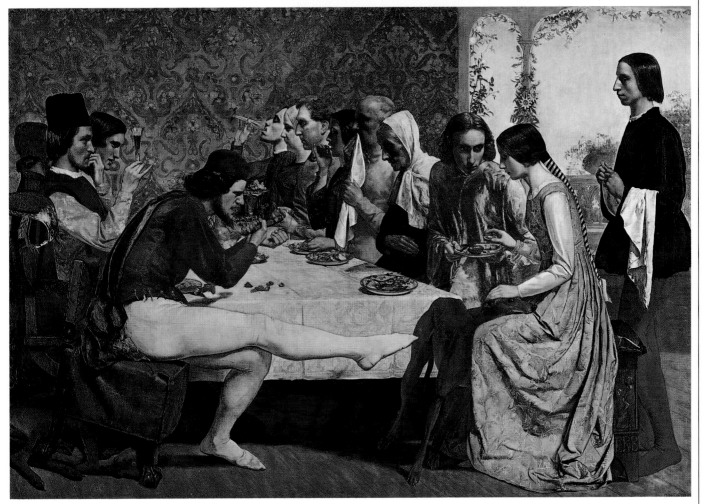

Glazing combined with underpainting

Several of the techniques in this chapter combine glazing with underpainting; the special characteristics of this particular version are the solidity and completeness of the underpainting and the fact that, for the most part, the glazing is simply a finishing process which is not calculated in advance. One way of considering this method is to think of it as two separate paintings of the same subject: the first carried out in body colour in a free, painterly manner, the second using glazes in a tighter, more detailed style.

Although the underpainting varies in thickness in this technique, most of it is applied very solidly so that the ground is completely obscured. In the example given here, a white ground was employed, but it is possible to adapt the technique for use on darker grounds, which offer scope for creating subtle half-tones or more dramatic contrasts between light and shade. The painting on p. 150 was based on a watercolour sketch by Turner, and it follows his oil-painting techniques.

This method is ideally suited to oils, which can provide texture and impasto in the underpainting, and body colour and glazes for the colouring. In theory, this method could be translated into acrylics, which claim to offer a similar technical range, but acrylics do not glaze as well as oil colour. It is possible to combine oil glazes with an acrylic underpainting. Though this is not without risk, as the glazes can eventually slide and crack, it greatly increases the speed at which work can progress, and the continuing elasticity of any heavily applied acrylic underpainting can be a distinct advantage in the long term. Tempera, especially oil-rich tempera emulsions, combines well with oil paint and can also speed up the painting process. A fat tempera emulsion retains texture and limited impasto, but tempera underpainting applied thickly onto canvas will tend to develop hairline cracks, causing paint loss in the longer term. The method is not suitable for other materials, but note the similarity in principle with the method of *Miniature painting* (p. 112), where transparent watercolour is used over opaque gouache.

When oil alone is used, a judicious use of dryers may be advisable. Resin oil or alkyd colours could also be employed in place of ordinary oil colours, to accelerate the drying rate of the underpainting. A heavy oil underpainting can take six weeks or more to become thoroughly dry. As in the case of the early oil-painting technique (p. 124), this method may require six months to a year of intermittent painting to complete a soundly constructed and visually appealing work.

Support and ground

The work illustrated was carried out on a heavyweight flax canvas with a slightly open weave and a medium tooth. It was a rough, hairy fabric, but was carefully sized, and pumiced twice to give a good quality finish and to ensure that the gelatine size had penetrated deep into the cloth. A gesso was then prepared containing animal glue, whiting and white pigment, with a small amount of oil beaten into it. One coat was applied thinly to the sized canvas and worked well into the weave using a stiff brush. Before the second coat, more oil was added to the gesso. At this stage the canvas was allowed to dry, and the next day its surface was pumiced very lightly. Next, a third coat was applied, this time with yet more oil beaten into the remains of the gesso. At room temperature this formed a soft jelly which could be spread easily using the palm of the hand. This final ground layer was rubbed onto the canvas, forcing it into the pores of the cloth and filling them to the level of the surrounding threads. Once the whole canvas had been treated in this way, a wad of cotton rag soaked in warm water was used to smooth out the surface of the ground.

The final canvas had a very smooth and solid ground, which was contained in the weave rather than spread over the cloth.

The object was to produce a smooth, densely white, semi-absorbent ground which filled the weave of the cloth while retaining a degree of elasticity; gesso alone would produce a very brittle ground, but it lends the ground a certain absorbency, which will allow it to draw some of the oil into itself, thereby preserving the colours and automatically ensuring that paint is applied fat over lean. These features are especially desirable here in view of the thickness of the paint layer that will be built up.

The lay in

The painting began with a few simple pencil lines to indicate the position of the boat and the poles sticking out of the water on the left. Turner's watercolour sketch was then used as the basis for a lay in of colour. The paint, thinned with turpentine to make it lean and transparent, was applied exactly like watercolour, using broad, flat washes and large brushes to map out the main areas of colour. A little white was added to some of the washes, giving them a milky consistency which aided the preliminary development of atmospheric effects. A tiny amount of bleached boiled oil was added to the turpentine used to thin all the lower layers of paint in order to improve their drying. As turpentine dries quickly, at this stage the painting progressed just as if it were indeed a watercolour, and typical watercolour effects were deliberately sought. Note, for example, how the burnt umber wash was allowed to run into the surrounding colour to suggest a shimmering reflection beneath the boat and the wooden poles. Where such chance effects are successful they may be retained; any that are not desirable can be painted out. For this reason, the lay in is even freer than with watercolour, as expressive quality is more important than accuracy.

The next step involves a partial lay in of body colour. This can follow on immediately from the wash stage and will substantially repeat it, retaining those areas which are satisfactory and painting out those which are not. Any promising effects which have occurred by chance in the wash layer can now be strengthened, and you are free to bring out suggested forms or patterns of colour. The cloud formation at the top of the painting was developed almost entirely in this way, using flat, pale tints of body colour. A light buff, an ochre tint and a cobalt blue tint were the main colours, as at this stage work was concentrated on the sky. Random patches of the same colours were thrown down roughly onto the lower half of the canvas to suggest a mirror image of the sky, and these would later be developed to represent reflections in water of the sky above.

At the end of this first session, the painting should be set aside to dry. Thanks to the absorbent ground and the boiled oil in the thinner, the painting shown here was ready to receive more colour on the following day. This second session involves a refinement of the initial lay in. Using the same colours to reinforce the previous stage, work wet in wet, allowing the paint itself to suggest shapes, patterns, colour and light effects. The only deliberate placing of colour at this stage was the dead-colouring of the sail using the buff tint already applied to the sky. It had been decided that a finishing glaze would be applied to this area, and this pale foundation was considered ideal as the first tone of the underpainting.

Following this second lay in of body colour, a clean brush was used to pick up traces of each colour so that they were introduced into each other as broken tints. (Until this point they had been kept pure by the use of separate brushes.) This adds to the subtlety of the colouring, as more and more layers are built up. The painting was then left for about a week to dry.

Underpainting

The underpainting is a long, continuous process. In this example, work concentrated intially on the sky. Firstly the lay of body colour was touched here and there with slightly different colour values. This wet paint was then dragged away using an

artists' palette knife, which skimmed the surface fairly cleanly, leaving only a trace of colour. The process was then repeated using an old kitchen knife. As this was more awkward to handle, it did not skim very evenly, so the second deposit of pulled paint was heavier and a little more irregular.

Once the existing areas of colour had been treated in this way, touches of new colour were applied into them. Using a lightly loaded brush, the ochre cloud on the left was scuffed with red ochre, which was pulled away with the kitchen knife to leave a hazy, irregular scumble of a dull pinkish-brown. The same colour was applied to the top right-hand corner and once more pulled away with deliberate awkwardness to produce broken, patchy scuffs of colour. A brush heavily loaded with white was then used to scumble thick deposits of paint into the top right-hand corner, and the bricklayer's trowel was used to smear, scuff, pull and scratch the wet paint to create atmospheric and totally abstract patterns. In the process, traces of colours from surrounding areas were picked up and broken, producing mingled tones in place of the original white. Fresh colours – still restricted to blue, buff, shades of ochre and white – were then painted into the lower part of the picture, more or less repeating the pattern of the lay in, and these were worked over with the knives and trowel, so that the colours were taken over and into one another, and scratched back to reveal each other.

It is important to know how far this random effect can be pushed, as to continue working in this way could produce a muddy and meaningless mess. Once the painting appeared to have reached a point at which it could be taken no further, the knives and trowel were discarded in favour of a brush. Thick, creamy white paint was introduced into the top of the sky and scrubbed back with a large bristle brush to reveal the buff underlayer between shimmering highlights. The edge of the ochre cloud was now defined more precisely, and the rest of the cloud formation was painted in using a large, fairly dry brush. Parts of this cloud formation were taken over the knife-work in the top right-hand corner to suggest that this part of the sky lies behind the clouds. A brush loaded with white was then used to create the sensation of strong light shining through the clouds at the centre of the sky. Two of the darker clouds were at this stage created by the blue of the sky, which can still be seen beneath them; once outlined, they took on the appearance of blue shadow. The third blue cloud (left of centre) was added later by working cobalt blue wet over dry onto part of the ochre cloud, and scumbles of ochre were added to the other two clouds in order to balance their appearance.

At the end of this session the kitchen knife and trowel were again employed to scrape back to the lower layer of blue, where whitish clouds had been placed above the sky at the base of the central cloud formation. This breaks up their form and dilutes their brilliance to create a hazy, atmospheric impression. The painting was again set aside to dry for about three weeks before work began again. By then the ground was completely covered with dried oil paint, and there was no longer any absorbency in the lower layers, so any further applications of paint would take even longer to dry than before. To avoid delay, it is advisable to limit any impasto to a modest thickness from this point on.

As the illustrations show, the underpainting was completed using pink and white. The white was applied first, using a large and a medium-sized brush to highlight the whole of the boat and its sail in preparation for the glaze. On the left-hand side, a dry brush was used to scribble white paint over and around the three poles, to prepare for the glaze by breaking up the shapes and to suggest a shimmering reflection in water. A large, long-bristled flat, well loaded with thick, creamy white was then dragged lightly downwards over the area just below the centre of the painting to suggest buildings in the middle distance catching the light. The pink was applied with a medium-sized brush, and the first few touches were scuffed with a knife to leave broken traces of pink across parts of the sky. The brush was then dabbed, pushed and rolled to produce a line of pink clouds following a pattern suggested by the use of the knife. Although these clouds were applied in a casual manner, their spontaneous appearance masks a loose control exercised over their random formation. Dashes of pink were also applied to the lower part of the painting to suggest the reflections of the clouds. Note that although the main reason for introducing these two lines of pink cloud was to break up the large, flat expanse of blue to the left of centre, they also form a cross, to which the eye is also led by the line of poles and the boat. Whilst this was done intentionally, it had not been planned from the outset. The underpainting was now considered complete, and the work was set aside to dry.

Glazing

The first glazes should be restrained in colour and be put down thinly and flatly over areas where they will enhance or modify the colours of the underpainting. Next, they should be reworked, as necessary, using stronger colour to develop the forms and light effects suggested by the foundation layers.

To promote a harmonious unity, only three main glazing colours were used in this example. They echoed colours already present in the underpainting. A thin glaze of Hansa yellow was applied to the brightest part of the sky, and while it was still wet, the surplus was wiped away to reveal highlights, leaving the glaze only in the troughs of the brushmarks where it emphasized the texture of the paint, as well as enriching its colour. The same glaze was used to strengthen the ochre clouds on the right. An orange glaze was then prepared using the yellow and a little alizarin madder. It was applied to the sail and touched here and there into the sky and water. A darker orange glaze was used to accent the sail, and to block in the whole of the boat. A fairly strong pure glaze of alizarin madder was then applied to the sky and boat, and touched into the water. Its strength was dictated both by the colour required, and by the fact that alizarin is not the most permanent of pigments when excessively thinned.

Before any more glazes could be applied, the painting was left to dry. A viridian glaze was then added to the water and taken over the orange and deep red glazes to create an optical black. A few touches of the viridian were also placed in the lower areas of the sky in order to link the colouring of the upper and lower halves of the painting. The existing glazes were also strengthened a little and some exceptionally thin final glazes were added to unify the colouring of the painting.

If you find you have glazed too heavily, you can use body colour to recover the effects of the underpainting, allowing it to dry before glazing over it again. Scumbles of body colour can also be applied between glazes to build up interesting colour and textural effects. These must also be allowed to dry between glazing sessions, however. All that now remains is to confirm the central focus of the image, using thin darker glazes drawn on with a soft-haired, round pointed brush.

Final comments

In the last stages of painting, you may find it difficult to place glazes and fine detail over the hard, dry surface of existing glazes. Use dilute medium to oil out the previous layer and paint into it with an even fatter glaze. Whenever a work is left for a very long time between painting sessions it should be treated in the same way; otherwise, later paint layers may flake off as the painting ages. Be prepared for some darkening of the glazes where alkyd media or old-fashioned megilp and copal wax have been used. You can allow for this by underpainting in a lighter key.

This technique can be varied by refining parts of the body colour with glazes and adding a great deal more detail than is included here. Glazes could even be applied directly onto the ground, with body colour highlights being introduced before a second glaze is applied. Where delicate final glazes are put down over a complicated image, use the fingers or a dry brush to manipulate the glaze once it is in place.

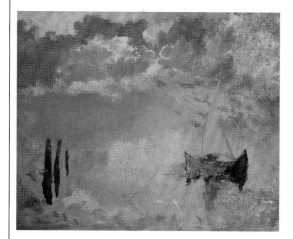

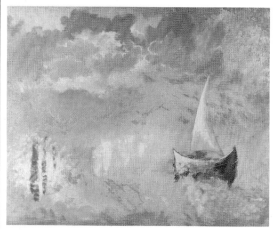

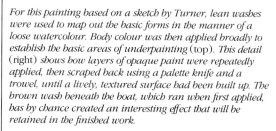

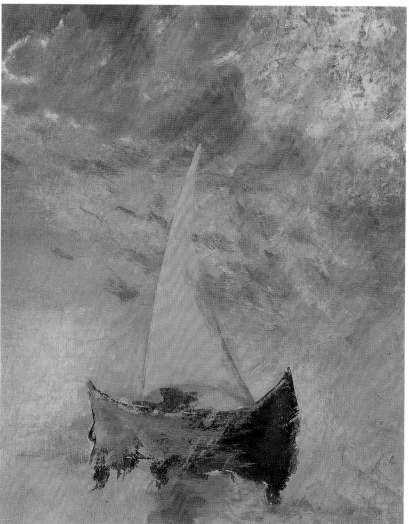

For this painting based on a sketch by Turner, lean washes were used to map out the basic forms in the manner of a loose watercolour. Body colour was then applied broadly to establish the basic areas of underpainting (top). This detail (right) shows how layers of opaque paint were repeatedly applied, then scraped back using a palette knife and a trowel, until a lively, textured surface had been built up. The brown wash beneath the boat, which ran when first applied, has by chance created an interesting effect that will be retained in the finished work.

Above: *The underpainting was worked up in several sessions, with paint applied wet over dry. The pink cloud was added to balance the composition, while white was introduced to create sparkling highlights beneath the subsequent glazes, and to reinforce the white buildings in the distance, where the paint had sunk into the lower layer.*

The colouring of the painting was then enriched and unified by the introduction of three basic glazing colours, and final details were drawn in with dark glazes (right).

The Mocking of Christ
(c.1570) *Despite significant changes in his handling and colouring, Titian remained more or less faithful throughout his life to a technique in which a foundation of body colour was refined and then finished with glazes. According to Palma Giovane, one of his last pupils, Titian used only black, red earth and yellow (presumably with white) to work up his paintings. He would make alterations 'like a surgeon' before finishing them, reputedly with thirty or forty glazes, using his fingers to wipe subtle finishing colours into place. There are probably few superimposed glazes in any given place on a Titian, but there could be a great many separate applications of glaze across an entire canvas.*

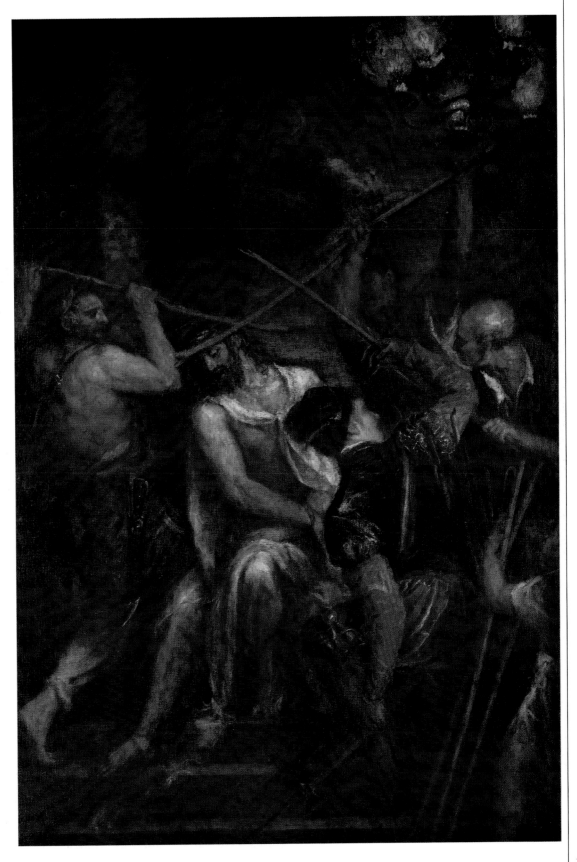

2.6 Watercolour

Line and wash, and classic watercolour

These methods, which are related both technically and historically, are in fact different aspects of the same technique. Line and wash was practised long before pure watercolour painting and is sometimes classed as a method of drawing, since it appears to consist simply of a shaded drawing. The way in which the tonal values of the shading are achieved is significant, however; they are produced by varying the thickness of a single layer of transparent colour so that the lightness of the colour is derived from the white ground beneath.

Classic watercolour is simply a development of line and wash in which colour is superimposed on a shaded drawing. This highly formal method of working has close links with the classic techniques of tempera and oil painting, in that it divides the painting process into separate stages – drawing, tonal values and colour. Although this way of working is quite complex, it allows the painter to concentrate on one thing at a time, making it easier to build up the painting.

Both line and wash, and classic watercolour are important introductory methods for the watercolour technique generally, as they introduce a disciplined approach and the concept of the transparent wash. These ingredients are vital to all successful watercolour painting, and a familiarity with formal versions of the technique is of considerable value when more casual approaches are adopted. Although the methods are demonstrated here in a way that emphasizes their relationship, countless variations are possible on both techniques.

Choice of support

In watercolour techniques the end result is very much affected by the choice of support, and the process of painting can also be helped or hindered by it. A commercial line and wash board was used in this example for purely practical reasons; it is not necessarily the most interesting support that could be used. Line and wash board consists of a fairly soft, absorbent paper glued onto a backing of strong card. The paper has a lower size content than most watercolour papers and is therefore more like a fine art printing paper. Water sinks into it quite quickly and very evenly, so that flat, even washes of colour are easily produced. Bonding it to a backing board overcomes the problem of cockling and distortion which would occur if such a light paper were free to move when wet. This paper takes a pencil line sufficiently well, but does not always respond well to pen.

Watercolour boards faced with a more conventional watercolour paper are also available; but the quality of the backing board and the method of bonding are sometimes doubtful in commercial products of this type. Painters may therefore prefer to prepare boards for themselves by mounting their chosen paper onto acid-free conservation board using gelatine or starch paste. Boards need not be used, of course, and ordinary watercolour paper will probably be preferred by the majority of painters. Line and wash works best on a smooth or slightly textured paper, which also assists the drawing, and both line and wash, and classic watercolour are particularly effective on a laid paper. Both techniques can also be assisted by the use of an off-white paper in place of a stark white support.

Line and wash

Line and wash begins with a drawing. In this example, as illus. 1 on p. 154 shows, it was lightly executed in pencil and was strong enough to be used as a guide for the application of colour, but light enough to be submerged in the wash, so that it did not remain visually dominant. An HB pencil is best for this; a softer lead produces too black a mark, while a harder lead, though it produces a fainter line, is likely to score the surface of the paper. This is hard to erase without damaging the paper surface, and colour from the washes can collect in the score marks, giving them undue emphasis.

Note that the drawing is set down in a very linear fashion, and is not a drawing for its own sake. The subject matter is systematically mapped out in terms of areas, each delicately outlined to separate it from its surroundings and to indicate that the area enclosed is to be treated differently from those around it. No fine details or shading are included; everything is suggested by an outline, which should provide sufficient information to act as an aid to memory. It may help to write notes on the drawing very lightly in pencil. Alternatively, a small patch of detail can be sketched in to indicate that the whole of the area contains whatever is shown in the detail. Such forms of notation can be erased immediately before the tonal washes are applied.

More robust drawings can also be made using a fine pen, such as a mapping pen, in exactly the same way, to break down the image into precisely outlined areas. Close up, this has a harsher visual effect, but at a distance it merely serves to emphasize the pattern-like quality of the tonal boundaries. It is essential to use waterproof ink, and it is also a good idea to dilute the ink slightly or to choose a colour that is not too dark, so that the pen drawing does not completely dominate the painting. A stronger pencil drawing may also be preferred, with detail and shading applied as desired. However, this distracts from the quality of the tonal washes and blurs the crisp outlines of the boundaries between light and shade. It also tends to muddy the washes, as the pencil shading can be picked up on the brush.

Tonal washes

Line and wash is carried out in monochrome, and at one time Chinese stick ink was favoured for the washes, because in its finest grades it offers a particularly good quality black that can be diluted to produce an endless variety of greys. Modern Indian ink, which contains the same pigment (a variety of lamp black), is a satisfactory alternative which has the additional advantage of being waterproof when dry. Since monochrome painting can be a little stark and uninteresting, however, a number of dark, but not entirely colourless pigments have traditionally been popular for line and wash painting. These include bistre, sepia and indigo; none of these is particularly permanent, but the warm brown, brown-black and blue-black that they offer are more attractive and lively than a plain black. All the traditional colours can be imitated and new versions of monotone can be produced by mixing an artists' quality black watercolour with another strong, transparent paint. In the example shown here, a warm brownish-black, similar to bistre, was made from lamp black

and raw sienna. Alternatives include black broken with phthalocyanine blue, viridian and alizarin madder, and several modern pigments are strong enough to be used on their own, without black, if a particularly colourful monotone is required.

Using a china watercolour palette with six separate mixing compartments, prepare a series of graded tonal washes. To separate them out into tonal values is a simple matter. First obtain a satisfactory colour by mixing a strong wash of black and raw sienna in the first compartment and test it on a piece of scrap paper to assess its transparency and colour. Then transfer a few brushfuls of this to the next compartment and add approximately the same amount of clean water. Some of this is then transferred to the next compartment and diluted in its turn. The result is a stepped sequence of washes, each representing a lighter tone than the previous one.

The object of these tonal washes is to record light and shade. The original drawing in this case clearly delineated the areas of tone, and a note to the effect that the light was falling from the left was all that was required to assess the relative value of each area. If a painting is done on site, the shadow values can obviously be judged by direct reference to nature, but even where no note is made it is possible to choose a direction for the light and to invent convincing tonal values for the drawing as a result.

The palest tones are put down first. A well-charged size 8 sable was used for all the washes in this example; it was a good artists' watercolour brush with a fine point for its size, enabling it to be used against quite a fine outline with reasonable precision. If you are right-handed, begin at the top left and work downwards and towards the right, so that you do not block your own line of sight, and do not inadvertently place your hand on areas of wet colour. Left-handed painters should begin at the top right.

To achieve a flat wash, begin by placing the brush just inside the contour line of the area to be filled and use the point of the brush to push the wash into the outline. Then move the wash across the paper by pulling it with the head of the brush, so that the paint is pulled away from the contour line. This draws the wash out more thinly and also helps to keep a wet edge to it, which is essential if it is to dry evenly without brushmarks. Keep filling the outline of the area being painted as the wet edge advances past it, moving the wet edge of the wash progressively across the paper. When you reach the other side of the area, turn the brush and quickly fill the contour line that remains. Pull the wash away from it as before, and join up the two wet edges before either has time to dry. Lift the brush vertically from the wash at its wettest part, or at a wet part of the outline in order to discharge as little colour as possible from the brush as it is removed.

When all the areas of the palest tone have been filled with the palest wash, allow the painting to dry. Then move on to the next darkest tone of wash on the palette and fill in the areas where that is required. Continue in this manner until all the gradations of light and shade have been set down.

Restating the drawing

When the washes have been applied, the painting should resemble illus. 2, with its forms completely modelled in light and shade. The painting could be considered finished at this stage, providing sufficient attention has been given to the original drawing and the areas of tone and outlines have been crisply recorded. However, if greater depth and detail are required, the drawing can be restated over the top of the tonal washes. This is unnecessary if the original drawing is done in waterproof ink or strong pencil.

In illus. 3 a size 00 sable watercolour brush was used to go over most of the contours of the drawing again. Although this was a brush, rather than a pen or pencil – which could also be used – it was used as a drawing instrument, and this final overlay of paint was very much a drawing in spirit. The contours of the sky were not retouched, because the tonal values there were very

pale, and strengthening the outlines of the clouds would give too harsh an effect, destroying the illusion of distance created by the less distinct forms and more subtle variations of tone.

The contours of the middle distance were redrawn finely using the darkest of the tonal values that had been applied as a wash. At the same time, some extra detail was added and certain areas of shadow were accented by means of a strong line. (For example, a strong dark line was set down around the base of the central rock.) The foreground was then drawn in using a tone slightly darker than the darkest of the washes. This produces a greater degree of contrast, which, combined with a greater profusion of detail and suggested texture, creates the illusion of things seen from close up. It is important that the drawing in the middle distance is both paler and less detailed, otherwise the foreground will not be sufficiently separated from it visually. The use of a dark foreground is a classic construction for landscape painting, and it is also a useful device in watercolour.

If the final drawing is executed in pencil or pen, the same effects that have been described for the brush drawing can be achieved using different degrees of pencil or sizes of pen nib. Different dilutions of ink will also promote the same effects.

Classic watercolour

The initial stages of the classic watercolour technique require little description, since they are very like the sequences of line and wash painting. This method begins with the same kind of drawing, and in the example shown on p. 154, exactly the same drawing was used. Painting is executed in separate stages, each of which is dependent on the stage before. In spite of the strong colour of the finished piece, the overall tone is dependent on the monochrome painting that begins it.

Monochrome washes are applied exactly as before to establish the tonal values of the painting. Here, blue was used for the underpainting, instead of the brownish black of the first example, because the painting was intended to be in quite strong colour, and blue is less deadening as a shade colour than brown or black. It also happens to be quite useful in this particular version of the painting, since blue is a major constituent of the intended colour scheme. As you can see from illus. 1, the application of the monochrome is more restrained where colour is to be placed over it, as the interaction of the shading and the colour can be quite strong, and this layer is intended to determine the tone only, and not the colour of the finished piece. For this reason also a few areas were left untouched, where it was clear in advance that the monochrome tint might interfere with the final colour.

The different layers of paint in the classic watercolour method should not be allowed to disturb each other as they are set down, and it therefore helps to use a fairly absorbent paper into which the colours sink and become difficult to remove. Staining pigments are also useful in the lower layers for the same reason – another advantage of using blue. The large amounts of glycerine in manufactured watercolours can hamper this technique, which is one of the reasons why simple hand-ground watercolours were employed in this example.

Deadcolouring the underpainting

Once most of the tonal values have been established in the monochrome underpainting, the first applications of colour can be made over it. These are put down as flatly as possible using washes of pure colour that are sufficiently transparent to allow both the brilliance of the paper and the tones of the underpainting to work through them. As they settle into the paper and dry, they take on the tonal relationships of the monochrome painting beneath, acquiring the variety of tones required in the finished painting. To paint these effects directly would take considerably longer and would require a great deal of colour mixing. Using this method there is no colour mixing at all.

In illus. 2 the rock formation was washed over with a thin layer

Line and wash: (far left, top to bottom) **1.** *A fine linear pencil drawing was executed onto the watercolour paper. Jagged edges were introduced to indicate areas of grass.*

2. *A series of graded tonal washes was prepared using lamp black and raw sienna and these were set down to shade the drawing, beginning with the palest tone.*

3. *Once all the tones had been carefully placed, the drawing was restated with a fine brush. See how the amount of detail decreases from foreground to background to enhance the illusion of recession.*

Classic watercolour: (left, top to bottom) **1.** *This technique should also begin with a detailed drawing, which is then shaded by graded washes of a single colour, such as blue.*

2. *The first washes of pure colour are laid flatly over the blue underpainting, so that they take on the tonal values of the monochrome shading beneath.*

3. *Build up the washes until you achieve the desired effect, gradually strengthening or modifying the colours by super-imposing pure colour washes. No colour mixing is required. Detail can then be drawn in with a fine brush.*

Road through Windsor Forest: *Paul Sandby (1730–1809) was a topographical draughtsman employed on the Ordnance Survey. His works were often executed in watercolour, combining sharp, linear drawing with softer washes of colour in the manner of a pen and ink study.*

Inside the Colosseum: *the English watercolourist Francis Towne (1740–1816) was noted for his ability to simplify natural forms using pure line and flat washes of pure colour.*

of black. This combines with the underpainting to produce a series of blue-greys that are already set out as areas of light and shade. The foreground was washed with a bright green, but since it was applied over blue it appears much darker. Its true colour may be seen in the tuft of grass on the left where the underpainting is very thin. The strip of yellow ochre behind this area has just enough blue behind it to stop it being too bright, without actually killing its colour. The area of grass in the centre was painted in a wash of oxide of chromium. This is an opaque pigment with a strong, but dull colour value, so it must be used very thinly, and blue was avoided in this area because the effect would have been too powerful. Blue was used to indicate the shadows cast by the rocks on the grass, however, and the oxide of chromium wash was taken over that area of underpainting to provide the darker green shadows.

Most of the sky was left untouched, as the initial underpainting is sufficient for the finished effect. A first wash of French ultramarine was applied to the areas of open sky, however, where a stronger, purer blue was required. These areas could have been underpainted in blue to begin with, but there would have been a risk of making the sky too dark, and the richness of the ultramarine would have been dampened by the greener blue sitting beneath it. The white cloud at the bottom right of the sky and the sheep to the left of centre beneath the rocks were reserved, which simply means that they are represented by the untouched white paper on which the painting is carried out.

Second painting and drawing

Not all the intended colour effects can be achieved instantly in the deadcolouring. Some colour washes dry with insufficient intensity of colour, and require a second wash to strengthen them. In other cases a second flat wash of a different colour is needed in order to bring about a combined colour effect with the deadcolouring. Remember that direct colour mixing is not a feature of this technique, so some of the final effects are arrived at by a method which is roughly equivalent to the underpainting and glazing used in various oil-painting techniques.

In the final example in this sequence (illus. 3), a second wash of ultramarine was applied to the areas of open sky. This strengthens the colour and at the same time helps to create a flatness which would be difficult to obtain from a single layer. Other areas of the deadcolouring were pulled or pushed by a second wash of a different colour. The foreground was given a very thin wash of oxide of chromium, because the dead-colouring was a little too bright. The central area, which was originally deadcoloured with oxide of chromium, was washed over with a thin application of Hansa yellow pale. This is a fairly transparent lemon yellow that lifts the central area to the desired stage of brilliance. One dull colour and one bright colour are thus used to achieve an intermediate effect.

All that remains is to draw over the washes using a fine brush in exactly the same way as for the line and wash painting described above. The only difference is that the detail is added in a selection of colours that correspond to the area being painted, instead of in values of a single colour. So, for example, the detail of the bracken, which had been deadcoloured in yellow ochre, was added in red ochre, while the foreground detail of the grass was applied in a dark green, which is a fairly solid application of oxide of chromium; in the middle distance thin black was used to draw detail into the rocks which are a blue grey, and so on. If a more subdued colouring is required, colour can be added to a completed line and wash painting as simple thin washes. If you prefer a more graphic effect, the final drawing can be in ink.

Loose and blocked watercolour

Loose and blocked watercolour are nominal descriptions for two related styles of watercolour painting, which can either be used separately, or combined. Both approaches tend to simplify the treatment of the subject matter by replacing detail and accurate drawing with suggestive shapes and areas of colour, or an atmospheric, imprecise build-up of paint. They imitate the visual effects of distance and seek to capture the essence of the subject with a degree of economy.

Typically, loose watercolour has little or no guiding drawing, and it exploits the potential of watercolour materials to create random effects. It requires a knowledge of how these can be provoked and controlled, and it requires a casual certainty in handling the paint which can only come from repeated practice and accumulated experience. It demands spontaneous action, in which the hand and eye work almost unconsciously together, and concentrated creative thinking to direct the progress of the painting.

Blocked watercolour, on the other hand, does frequently follow a preliminary drawing, though it does so with a deliberate lack of accuracy, once again provoking a random quality from the materials being employed. This method tends to work best on grainy, random-textured papers, and typical features are a hard edge around areas of wash and rough, dry brushstrokes. Texture and solidity of form, together with a certain pattern-like quality, are the desired results of this technique. The links between blocked watercolour and *Line and wash, and classic watercolour* (p. 152) should be self-evident, and as with so many methods of painting, it can be thought of as an extension and development of another closely related technique.

Together, these methods form the basis of many modern watercolour techniques, and as the scope for variations is very great, they are presented here not as definitive statements, but as examples of the technical devices which can be combined to create more complex methods. Painters wishing to explore these techniques will find no better examples than the work of Turner and Cotman (*see* pp. 158–9).

Materials

In the first place, you must have good quality paper. A considerable amount of water is used in both the loose and the blocked technique, with the colour being pulled and pushed while wet to encourage it to behave in a certain way. Only a proper watercolour paper can stand up to this kind of treatment; anything else is likely to disintegrate at the surface and buckle to such an extent that the colour will collect in pools. Rag papers are always preferable, though most wood-free papers give quite acceptable results for broad techniques, and both methods look best on paper with a rough or not (cold-pressed) surface. Hand-made papers with an irregular grain are ideal, as they interact with the colour in a most satisfactory way, and withstand thorough wetting extremely well. Pigment tends to collect in the surface depressions of a textured paper, thereby adding variety to the colour. At the same time, such surfaces encourage a hard, rugged edge to the contours of each wash, which can be exploited as a means of drawing if it is thoughtfully controlled. Both approaches can be used on hot-pressed watercolour paper as well, but the results tend to be less lively, and accidental formations of colour which invite exploration and development are much less likely to occur.

Whatever the surface quality, the amount of water used requires a heavyweight paper or one that is pre-stretched or mounted as a block. Heavyweight papers will increase the degree of control because they remain more or less flat throughout the painting process. There is some advantage, however, in using suitably prepared lightweight papers, as these are more likely to throw up useful random effects.

Loose and blocked watercolour require soft-haired brushes of a good size. Small brushes are of no use in either technique, except for occasional finishing touches. Two or three round pointed sables, sized between 5 and 8 and supported by a substantial squirrel-hair mop, would be an ideal selection for

small and medium-sized paintings. For larger works, you will probably need at least one large sable, which will inevitably be costly. Other, cheaper types of soft hair and synthetic hair can obviously be considered as substitutes, but these rarely allow you to guide the wash as accurately as you might wish. Flat brushes of sable or ox hair can also be employed, and can be used alongside rounds to produce shaped brushmarks and jagged patterns of wash. On good paper, bristle brushes may be employed as well, but they can damage the wet paper, so their use should be considered and selective.

As you might expect, best results are obtained using artists' quality watercolour paints, as only these have the brilliance, the quality and the transparency that are essential to these techniques. Sometimes an extra dimension can be added by using hand-ground colours, which are slightly coarser than the manufactured product. These can collect on the paper or be encouraged to flood in ways which are most desirable. From a technical standpoint, there is never a good case for using sketching colours. However, some versions of the blocked watercolour method are not particularly demanding on the paint, and it is possible to obtain adequate results from quite uninspiring materials. Note, though, that excessive reworking of the colour – often a fault of beginners – nearly always produces a muddy effect when sketching colours are used. Some painters also prefer to avoid staining colours of any quality in loose watercolour techniques, as they make recovery of errors very difficult; this can be a major problem when paintings are partially worked out as they progress.

Loose watercolour

The starting point for all loose watercolour techniques is usually wet paper. The way in which the paint behaves will depend on the wetness of the paper, on the amount of water in the paint, on the capacity of the paper to absorb moisture and on the speed at which it dries. It is necessary to soak some types of paper for a few minutes before beginning to paint, while others may need to dry partially before certain effects can be achieved.

Paper which is flooded with water allows colour to float over its surface, and if the paint is generously liquid as well, spreading, running and whirling patterns will result. The colour will also collect in pockets of greater intensity, particularly where heavy pigments are concerned, an effect which can be accentuated by working on upright or tilted paper, especially when its surface is rough. As the colours trickle down the surface of the painting, random blending and spreading of colours will occur, and by working with the paper flat, but tilting it every so often, you can introduce a degree of control into this otherwise random process. If two colours are allowed to touch while both are wet and the paper is wet too, they will automatically blend, producing subtle gradations of colour between the two parent washes.

As the paper starts to dry and is no longer flooded, but remains surface-wet, other random effects become possible. A new wash of colour or even clean water applied from a well-loaded brush will once again spread of its own accord across the surface of the paper. This time, however, it will push away the existing colours as it creeps towards them, creating an irregular edge where the two areas meet. A brush charged with clean water can also be used at this stage to wash back areas of existing colour and produce subtle variations in intensity. A lot of water will produce a hard edge, but if the brush is wrung out first, very soft, carefully controlled washing-back can be achieved. Pieces of sponge or rag can also be employed to lift excess colour from areas of surface-wet paint, and to create textural patterns or soft transitions of tone. When the paper has dried further, to the point of ceasing to be surface-wet, secondary floods of colour can be placed quite accurately, and the slightly hard edges that they produce can be used to build up the outlines of an image. At this point, a brush moderately well charged with wash can be

used to apply loose brushmarks to chosen areas. These will spread slightly, but remain basically intact, and if the colour is of a high quality and is sufficiently transparent, such marks will take on a limpid appearance. Drops of paint sprinkled onto the paper at this point will take on a similar quality.

Once the wetness has sunk into the surface of the paper, fairly strong colour can be applied with the brush. It will fan out as it is applied to the paper, but if the brush is not too heavily loaded and the paper is not too wet, a feathery line or fuzzy brushmark can be applied quite accurately. Once the paper has dried more thoroughly, clear, transparent washes can be set down using bold brushstrokes. As the paper retains some moisture, these will sink into it; pulled down by the water lying deep within the sheet, and dry flat without an excessively hard edge. At this stage the colour will have a certain dullness, which can usefully be contrasted with the rich washes that will be put down once the paper is completely dry. A wet wash can also be run up against one that is almost dry by tilting the painting at a slight angle while a trace of surface moisture still remains. This causes the colours to mingle and spread at the edges, and creates a build-up of wash along one contour. If this is touched precisely at various points by an adjacent wash put down separately, random bursts of one colour can be introduced into the other.

As more control is gained over the paint towards the end of the sequence, a loosely suggestive, atmospheric image can be achieved. This can be used as the background or foundation to more paint once the paper is dry. Freely applied liquid colour is probably best for such finishing as, stylistically, it suits the existing painting. This later colour will dry with a hard edge, which will contrast effectively with the soft surrounding colours, lending the image far greater visual depth. Strong opposing colours can be applied in the final layer in order to accent these visual differences. At this point it is also possible to restate the image using strong, firmly applied washes.

Obviously, in practice, it is sometimes desirable to confine random effects to specific areas of the work. This can be done by a selective use of water, or by creating barriers with wax. Highlights can be reserved in this way, especially where there is a texture in the paper to hold the wax in place. White wax crayons, a sharpened candle or a stick of white beeswax are all suitable for this purpose. None of these would appear to harm the paper, nor do they discolour or collect dirt, but if you wish, excess wax can be removed once the painting is dry by pressing it between sheets of blotting paper using a warm iron. Some painters find the loose watercolour approach an ideal starting point for work in mixed media, where the random effects do not require such careful direction, as subsequent applications of gouache, pastel or other materials do not rely on the brilliance of the ground.

Blocked watercolour

The basic aim of the blocked watercolour technique is to divide the subject into a pattern of simple areas, each of which represents an approximate colour or tonal value. Once these coloured shapes have been set down, rugged, darker accents are applied, again as clearly defined shapes, with random variations of colour introduced to add texture and to break up the flatness of the overall image. Seen close up, parts of the finished painting may appear to have been crudely stencilled into place following a simple sequence of colour and tone. In fact, such paintings often employ a variant of the three-tone technique, though separate colours tend to be employed, rather than different values of the same colour. Seen from a distance, however, the sharp definition of each block of colour becomes subservient to the overall effect of the painting, and the image takes on a chunky, solid reality. Practising classic watercolour will, incidentally, help you to acquire the necessary skills for this technique, as it teaches the hand and eye to seek out essential areas of shadow and flat, localized colour. In some ways, the blocked watercolour technique is a direct reversal of the classic method,

John Sell Cotman's Greta Bridge *(1810) is a prime example of the blocked watercolour technique. Note the broad, simplified forms, and the restricted palette. The texture of the paper is also an important element in the work's effect.*

Any areas that are to remain white should be carefully reserved in the blocked technique, as the sheep have been in this landscape sketch. The flat areas of colour have an abstract quality that enlivens the surface of the image.

Venice: Looking east from the Guidecca, sunrise (1819) by J.M.W. Turner (1775–1851). This atmospheric loose watercolour would have begun with the yellow, blue and red of the sky being applied onto wet paper. As it began to dry, the line of buildings would have been added in blue; and finally, colour would have been dragged on with a dry brush to indicate the boats in the foreground and to accent the clouds.

This moorland landscape was painted in the loose technique without the aid of a preliminary drawing. The background hills were worked onto wet paper to imitate the haze of distance, and heavy washes were loosely applied to the foreground with a well-loaded brush. Note how many areas of white paper remain untouched.

Loose techniques can also be highly evocative within a more modern, abstract idiom. Phenomena: Hellenic Lost (1962), by Paul Jenkins.

in that flat colour is put down first, with a systematic sequence of shading being placed over, rather than under it. The differences in the finish – one handled roughly, the other worked in fine detail – are really just a matter of style.

Blocked watercolour requires dry paper so that the areas of coloured wash can be placed within more or less accurate boundaries. Dry paper also encourages a hard edge which, combined with a textured surface, can be pleasantly irregular. It also allows paint to be dragged over the paper in a haphazard fashion so that random scumbles of wash are set down. It is not uncommon to apply loose techniques in specific areas of a blocked watercolour painting.

It is best to begin a blocked watercolour with a drawing that can be followed as you apply the paint. Use a textured line and open hatching so that the drawing will not interfere with the quality of the paint washes and will almost disappear beneath the build-up of colour. A soft pencil with a well-rounded point usually gives the best results, but compressed charcoal can also be employed. Pencil offers a technical advantage, in that a wash will not cross it unless it is excessively fluid or pushed by the brush. This makes working up to a pencil line quite easy and allows areas of colour to be filled in with great accuracy.

The actual painting proceeds in a very straightforward manner. One by one, colours are made up into washes and mixed, if necessary, on the palette. For argument's sake, let us say that the first colour is yellow ochre. Every area of the painting which requires that colour is filled in flatly, and as it dries a second colour – a mixed green, say – is applied to each area where it belongs, taking care not to let adjacent areas touch while the colours are still wet. Work continues in this manner until all the blocks of colour have been filled in, except those which lie next to areas of wet paint. Stopping-out media can be used to reserve quite complicated shapes for later painting, but these can be tedious to employ and their use interrupts the creative process. Knowing where, when and how to reserve spaces without these is really a matter of practice and, if anything, the slight inaccuracies that occur when this is done spontaneously can add to the quality of the finished work.

As areas dry, the spaces next to them can be filled in. Each block of wash will already have a firm edge, but you can now guide the new wash over the edge of the existing colour by the merest fraction to produce a dark line which varies in width and intensity, according to the colours used and the extent to which they overlap. This technique can be used to emphasize particular outlines, so that they appear to have been drawn in. Another device is to allow a small irregular gap to remain between two areas of wash. Later, this can be rubbed over with an eraser to remove any pencil that is still visible and to expose an irregular line of white paper; this again emphasizes the contour. Using a fairly dry brush for some patches of wash will also encourage tiny patches of white paper to remain uncovered, breaking up the flatness of the wash and adding vitality to the surrounding colour. As in all watercolour painting, areas which are intended to be white must be reserved from the paper throughout the painting process.

Once all the blocks of colour have been set down, certain areas can be reworked to indicate shadow and to add loose drawing. If the original colour washes are still on the palette, they will by now have strengthened a little, due to the evaporation of some of their water, and a second coating of the same colour is sometimes sufficient to indicate shadow. Otherwise, fresh, deeper washes must be prepared. Always remember, however, that one wash placed over another always produces a darker tonal value than either colour would produce separately. If the original drawing is still visible, it will help you to place the blocks of darker colour with reasonable accuracy. Remember also that pale-coloured shapes can be reserved at this stage from the original patches of wash.

In the final stages of the painting, touches of strong colour and textural marks are introduced to break up any remaining flatness. At this stage you will have to rely on observation and intuition, as the underlying drawing will no longer be of any help. Above all, you must know when to stop, and it is a good idea both in this technique and in loose watercolour painting to stand back from the work at intervals and study it at a distance. Consider any further alterations carefully, and stop the instant you are satisfied; a great deal of spontaneous creativity can be lost if the finishing is pushed too far.

Advanced watercolour

Watercolour is all too easily dismissed as a medium for rapid sketching and tinted drawing. The fact is, however, that watercolour is capable of a high degree of sophistication, and if carefully manipulated, it can produce a range of effects which is almost as broad as the technical potential of oil paint. With the right handling, it can be as intense or as subtle as any other medium, though a thorough knowledge of the methods and materials available is vital to achieve this, especially since errors can hardly ever be recovered, and works which aim at a fine finish on a large scale must therefore proceed with absolute certainty. In other words, the level of experience and ability required is well above that which is necessary merely to paint in watercolour. For that reason, this form of watercolour painting is described here as 'advanced watercolour', though, as you will see, it is not a specific technique, but a drawing together of all the available techniques, using whichever is most suitable for each area within a complex overall scheme.

The following account is an attempt to illustrate how several techniques can be skilfully combined, each of which has its own potential and character that painters can consider and develop for themselves. Other more formal and sophisticated combinations are also possible, and you should bear this in mind as you follow this description. Remember that the choice of subject and degree of complexity are entirely up to you.

The finest examples of advanced watercolour tend to date from the 19th century, following the development of the original watercolour methods and materials. Yet again, Turner must be quoted as the pioneer of advanced watercolour techniques; his virtuosity in the medium has never been surpassed. Cotman's use of rice starch and Samuel Palmer's often unconventional approach may also be regarded as excellent examples of how watercolour can be pushed beyond its normal limits by painters with the technical knowledge and the imagination to do so. Although advanced watercolour should in theory be confined to the principles of true watercolour it is not unusual to see it combined with body colour in order to obtain an even greater range of effects.

Materials
There is no hope of succeeding at this level of watercolour unless good materials are used. Artists' quality or hand-ground watercolours are essential, and for work on a large scale, these should be in tubes rather than pans, as this makes it easier to prepare large quantities of strong wash. Good watercolour paper is also an absolute necessity, as are some brushes of fine sable, though these can be supported by other drawing and painting instruments.

The sketch and drawing
This painting was based on a completed watercolour sketch that had been executed on site some time previously. It had captured the desired image but had become muddy in parts through reworking, so it was ideally suited as a preliminary sketch for a studio version of the same subject. This is highly relevant to advanced watercolour techniques, as a carefully planned sequence of painting is often far too complex to be attempted

outside the studio, and it is often impractical to work on a large painting out of doors. In any case, such conditions tend to force the pace of a work, which could lead to disaster where advanced watercolour techniques are being used. The practical solution is, therefore, to work from a well-developed watercolour sketch, as this allows the painter to recreate the freshness and general character of the original subject while at the same time adjusting and developing it into a more complete painting.

With the sketch set up for inspection, the first act was to redraw the basic design in an enlarged form directly onto the sheet of watercolour paper. To minimize pencil lines, and because precise draughtsmanship was not considered important, this was done freehand, with the necessary enlargements being gauged by eye. Once the essential outlines had been drawn in, parts of the drawing were split up into defined areas, using more lines to indicate generalized areas of light and shade, and of colour. Again, this allows for corrections to parts of the original sketch which are felt to be inaccurate. Faint guidelines were also set down to assist specific brushstrokes or passages of painting that would need to be placed very carefully.

Painting the sky

The sky was painted first, because it was the largest area of the painting that had to be attended to at a single session. It also required extensive use of water, which could easily interfere with other parts of the painting if they were already in place. It generally makes sense to begin with the sky in landscape painting, as in reality everything else appears to lie in front of it, and to mimic this impression the foreground colours and tones should relate properly to the distant colour of the sky. However, painting the sky or the background first should not be regarded as an absolute rule.

Two different blues were employed in the sky, and an ample supply of wash was made up for each colour before painting began. All the brushes to be used were then cleaned in running water to remove any traces of colour from their previous use, and laid out together with two containers of clean water: one to wet the paper and to add to the washes, and the other to rinse out the brushes. This keeps the colours pure and ensures their brilliance. Parts of the cloud formation were painted in using a brush charged with water alone, and left for several minutes until the water had penetrated into the paper. A sideways glance at the paper confirmed – by the way light was reflected – that these areas were now surface-wet, but not flooded. A brush just lightly loaded with colour was then touched onto these areas, causing the wash to spread outwards from the point of the brush in a feathery pattern. By lifting the point and repositioning it several times, it is possible to set down a hazy shape of colour, which has no definite edge and is therefore instantly atmospheric. The contrast between the colour and the white of the paper forms an optical edge which, by reason of its uncertainty, creates an impression of distance. In some places these patches of blue were intended to open out into the rest of the sky, and to achieve this a sponge, and a brush charged with clean water were employed to soften the open edge of the wash, so that a further wash could be joined onto it later without leaving a mark.

The sky was given a few minutes to dry before the main area of blue was set down. Once again, the area was first painted with clean water, taking wetness carefully around the outlines of the clouds and the buildings. This time, however, the blue wash was added while the paper was still flooded with water, more clean water having been added during the mapping-out procedure to ensure that none of the paper dried too soon. (The colour spreads into the water and floats right up to the edges that have already been defined.) As this wash began to dry, but with the paper still surface-wet, the second blue was introduced to certain areas in order to create variations in the colouring. As the paper is still wet, this spreads and blends automatically, without creating any hard edges. A minute or two later, whilst the whole area was still wet, a sponge and a clean brush were employed to remove some of the paint, leaving patches of thinner colour. The whole of the sky was then allowed to dry thoroughly before any further work was undertaken.

To complete the sky, a similar sequence of painting could be carried out to reinforce and adjust the existing effects. More colour would be added, and here and there areas would be washed back using clean water to soften their effect. Final touches could also be introduced using a stronger-coloured wash applied by dragging and stippling with an almost dry goat-hair mop, using torn paper stencils to control its mark.

Underpainting and dead colouring

When the sky was finished, parts of the foreground were underpainted using one of the same blues, following exactly the same procedure as that detailed under *Classic watercolour* (p. 153), though here, more selective use was made of it: only the areas of shadow on the building were underpainted using blue, as dull shadows would be needed there. Eventually, darker shadows would appear in the river, but these would be underpainted separately in a different colour in order to give them greater depth and richness.

The blue underpainting was allowed to dry, and then the areas of colour defined by the pencil drawing were filled in flatly using a light wash of the appropriate colour. (This allows for any strengthening of colour that may be necessary at a later stage.) As these areas were blocked in, spaces were reserved for the other colours, and each wash was taken carefully around the contours of the surrounding sections. Large areas were filled by starting at one edge with a well-pointed sable, and leading the wet edge of the wash across the area with a larger, well-loaded brush until it approached other parts of the outline. The sable brush was then used again to fill the contours and to lead the colour backwards to the wet edge of the main body of the wash. None of these sections of colour were wet before painting, as although this might have resulted in flatter washes, it would have extended the drying time of the paper and slowed down the dead colouring process considerably. As colours were applied to the buildings, the edge of the sky was overlapped in places to create a dark line.

Once all the foreground had been blocked in, the area representing the river was very carefully taken back in places. Washing over the whole of it with clean water would partially lift the colour and remove the sharp definitions between each area, but it would also muddy the colours and risk losing the brilliance of the paper. So instead, the colours were taken back by wetting and lifting, using a vertical motion, as far as possible, that did not cause the colours to shift from their original locations. This was done using a clean, damp sponge and a clean, wet bristle brush, both of which were wrung out to remove excess moisture before they were put to use. As they loosened the colour, it was taken away with blotting paper, and gradually a pattern of colour changes was built up, containing muted gradations of tone and gentle transitions from one colour to another. Throughout this stage, the sponge and brush were cleaned frequently to minimize any unintentional transfer of colour. When a satisfactory effect had been achieved, the whole painting was allowed to dry thoroughly before painting resumed.

Subsequent painting and finishing

A second painting was then applied to certain parts of the existing colours in order to strengthen them, while other areas were overpainted with a second colour to obtain a composite effect. Some of the shadows were restated using washes of richer, darker colour, and some bold shadow strokes were added using a flat brush which had been loaded with colour and then wrung out.

Numerous finishing techniques can be employed. To begin with, quite simple procedures can be carried out, such as restating areas of the drawing using a fine brush. The colour

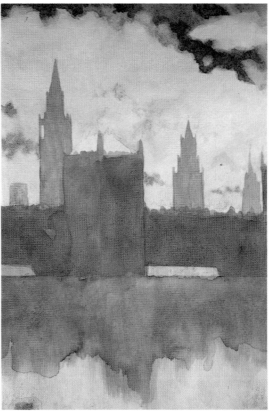

This watercolour of the Houses of Parliament, London, was based on a watercolour sketch that had become muddy through over-working (below right). The second version was undertaken in the studio. It began with a pencil sketch (far left), and the first washes were applied to the sky.

Blue underpainting was used to shade the picture throughout, before light washes of the appropriate colours were blocked in flatly within the contours of the drawing (left). The loose technique was applied to the river in the foreground.

The colours were then restated where necessary to strengthen them, while dark washes were carefully set down to reinforce details (below left). Areas that appear too sharp can be re-washed and pulled with an absorbent material, but avoid making the effect too heavy or repetitive.

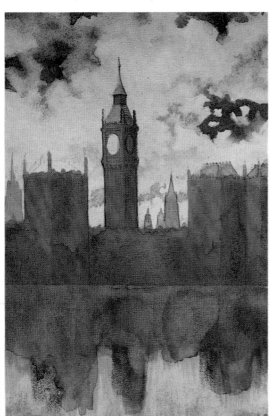

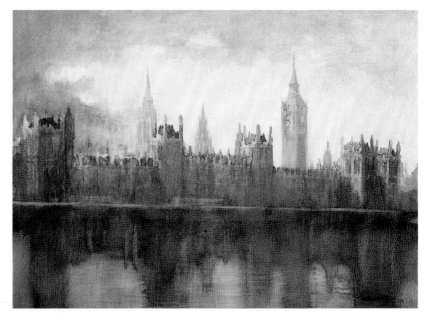

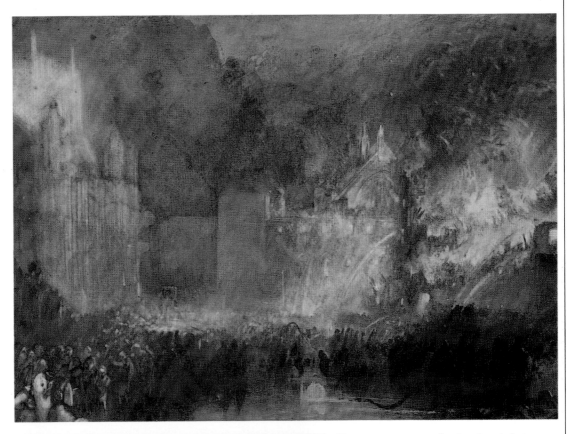

Turner was a master of watercolour techniques
and he experimented incessantly with new ways
of manipulating his materials. His Burning of the
Houses of Parliament combines areas of precise
drawing with loose washes of brilliant colour to
magical effect.

Samuel Palmer (1905–81) was another great
innovator. He combined inks and watercolour –
both transparent and opaque – and added gum
to his paints in order to increase their brilliance.
In a Shoreham Garden is typical of the varied
textures he achieved by stippling with thick,
opaque colour within an essentially linear
framework.

washes should be kept weak, and the brushes, though small, should be well filled. This gives a softer restatement of the drawing which suggests distance and at the same time allows for further crisping up by other methods. Some delicate areas of drawing can be added using a two-brush technique, which involves painting with one brush, while taking paint away with a second clean one. This can produce various results, but perhaps the most useful is the creation of a line with one hard edge and one soft edge. When combined with another lay of colour it can also be used to give an exceptionally fine line.

The shading, colour and atmospheric effects of the painting can then be modified using an assortment of techniques to break up or harmonize the areas to which they are applied. Stippling with a virtually dry brush has already been mentioned, and scumbling by dragging a brush on its side is another fairly basic technique. In addition, watercolour can be spattered from a toothbrush or dabbed on with a sponge to create a random overlay of modifying wash. When watercolour is applied from a sponge it is best to prepare a rich wash of colour containing comparatively little liquid, and to use a dry or virtually dry sponge to apply it.

One unusual way of delivering delicate areas of shading and of breaking up flat colour is to use your fingerprint. This only works if the fingers have just the right covering of paint. To achieve this, rub some wash between the fingers and thumb of one hand – experience will teach you when it is ready from the feel of the paint – then dab fingerprints onto the intended area, changing the direction of your fingers slightly each time. The idea is to touch the paper lightly, so that only a few lines of the print are set down each time, leaving a pattern of fine hatching. The constantly changing direction of the prints produces cross-hatching on a very small scale.

Towards the end of this painting, some of the shadows could be reinforced using a dark wash. A small amount of warm gelatine solution in an extremely weak concentration should be used for this in place of plain water. As it gels on cooling and is then slow to lose its remaining moisture, such a wash can be scored into while it is semi-solid but still soft, allowing the underlying colours to be revealed as drawn-in highlights. The final details are drawn on in medium-strength and strong washes of colour using a small reed pen and a quill pen to apply the paint. The broad line of the reed suits some purposes, whilst the expressive line of the quill suits others. Both work quite well using watercolour instead of ink, and neither type is likely to damage the surface of the paper. This is not the case, however, with metal-nibbed pens which, in any event, move less freely over the textured surface.

The last two stages of the finishing process might involve the application of a dilute solution of gum arabic to the shadows, and the use of a scalpel to scrape out highlights in parts of the river. The gum arabic acts like a varnish, enriching and deepening the shadows. Too much will make them look glassy and will eventually cause the paint to crack or lift, tearing at the paper behind it. At the correct strength it should sink into the paper, leaving just a dull gloss at its surface that is only visible when the painting is viewed from an angle. Scraping out with a scalpel cuts through the thin layers of watercolour and scuffs away a little of the paper surface to reveal a patch of white. (This is obviously unwise on thin paper, as the blade can easily go through.) As a rule, the edge or point of the blade is dragged sideways so that it snags at the paper rather than producing a proper cut. This can be directed, but not accurately controlled, and the exact position and pattern of the scraping out is a matter of chance; it is, nonetheless, an effective method for introducing small white highlights. On good, grainy paper a more subtle version of scraping out can be achieved by dragging a coarse eraser or even a piece of pumice stone gently over the surface of the paper so that tiny particles of it are scuffed away. If too much paper is removed it may be necessary to resize the torn surface

with gelatine before it is retouched with watercolour.

Additional comments

Alcohol and glycerine may be added to the painting water to gain control over the paint, by either speeding up or slowing down the drying rate of the water. Alcohol speeds up the evaporation of the water; it also helps the colour to penetrate into the paper and breaks down the surface tension of the wash, causing it to flow more easily. Some of these effects can also be achieved using ox gall or the surface-tension breakers sold for use with acrylics. A small amount of glycerine, on the other hand, slows down the evaporation of water and is useful where the paper needs to be kept wet for some time. Glycerine must be added cautiously, however, especially where commercially prepared watercolours are being used, as these already contain quite a high proportion of glycerine, and too much can make the colour lift and may interfere with the overlaying of washes. (This was, incidentally, one of the motives for using hand-ground watercolours on this occasion, as they are less prone to unintentional lifting.) Other potential additives for advanced watercolour include starch paste, beaten egg white and acrylic resin.

Watercolour on a prepared ground

Although this chapter attempts to demonstrate the many variations that are possible with watercolour, it must be said that all watercolour painting follows the same basic principles. Thin, transparent colours are applied over a light background, and it is the interaction of these two main features that makes watercolour paintings appear as they do. It is only the methods of manipulating the paint that differ in the various watercolour techniques; the materials remain more or less constant. There is, however, a rather unusual branch of watercolour painting which, while it does not deviate from the basic principles, does employ slightly different materials. This is watercolour on a prepared ground.

In conventional watercolour, white or off-white paper acts as both the support and the ground, but in this form of watercolour, a separate ground is introduced, and different types of support become a possibility, such as wooden panels or paper mounted on canvas. The ground itself remains white, but is a starker and more reflective white than any paper, and the colours in consequence appear more brilliant than ever. The ground also offers an exceptionally smooth surface, which invites a finely detailed approach. This is further encouraged by the absorbency of the ground, which makes broad, flat washes very difficult to achieve and small, accurately placed touches of colour visually more effective.

This potential for detail and for richness of colour is clearly demonstrated in the examples shown here (pp. 166–7), but the technique can be adapted to quite different purposes, giving a broader, fresco-like effect, for example. Given a suitable support, this type of watercolour painting can be combined with any other media that you may care to think of, and even when used alone, if finished with a varnish it can take on a most unusual appearance for watercolour. Although this method follows the basic principles of watercolour, they should not be considered sacrosanct, and you may wish to deviate from them for the sake of a particular effect. Highlighting with gouache is in fact quite common, though as the bulk of the painting is carried out using transparent washes, the overall technique remains faithful to the concept of watercolour.

There are some similarities between detailed watercolour on a prepared ground and the methods employed in *Miniature painting and illumination* (p. 112). There are also links with *Classic tempera* (p. 116) and the oil technique of *Glazing onto a white ground* (p. 144). As the technique is slow and meticulous,

detailed watercolours of this kind are seldom very large, but there is no reason why a freer version of the technique should not be employed on a larger scale, especially where it forms part of a mixed-media technique.

Support and ground

The support in this case was illustration board prepared with two coats of white gesso, bound with gelatine and containing a high proportion of white pigment in order to enhance and preserve its whiteness. The gesso was applied straight onto the board, without sizing, and when dry, was finished to give a smooth surface. Various other types of support make suitable alternatives; acid-free museum board would make a more permanent support, and millboard would make a stronger one. For small-scale works, heavy watercolour paper coated with a ground would be perfectly adequate, and on a larger scale, a wooden panel could be used. Mounted paper coated with a ground also makes an excellent support for this type of painting, and paper mounted on canvas is especially pleasant to use.

One or two layers of white gouache or tempera paint could be employed in place of gesso for the ground. Good gouache paint can often create a whiter ground for an equivalent number of coats, as gesso contains filler, but both gesso and tempera have the advantage of being less soluble in cold water, which makes it easier to apply paint to them in the initial painting stages. Two coats of gesso sanded smooth and then finished with a layer of white egg tempera is another alternative.

If white watercolour is to be used for the highlights, it is possible to employ a ground with the merest hint of colour. A very pale blue, for example, can be quite effective, as can a soft pink or warm cream. If a tinted ground is used, it is possible to underpaint thinly in white before applying the transparent watercolours, taking the technique even further away from conventional watercolour, though the basic principles are still observed in the final layer.

Drawing and washing in

A good draughtsman may be able to paint a finely detailed watercolour directly onto the ground without any preliminary drawing. Most painters, though, will feel more comfortable with something to guide them. Unfortunately, pencil produces a very noticeable mark on a prepared ground, and thinly applied watercolour is not always able to obscure it. This means that any drawing must be carried out very lightly, avoiding harsh lines. In any event, it is usually a good idea to use a separate, carefully worked drawing for reference as you paint. This can be transferred to the ground by carefully tracing the original drawing, then rubbing over a second sheet of paper using a soft graphite pencil. This sheet is placed carefully over the ground so that the surface covered in graphite touches the surface of the support. The traced drawing is then laid on top of this sheet and a hard graphite pencil sharpened to a fine point is used to draw around the traced outlines. Both sheets of paper are gently removed from the ground, leaving a transferred drawing on the ground composed of faint grey lines. The double thickness of paper softens the impact of the pencil, and the sharp, hard pencil point keeps the line narrow. The slim, light mark that remains can be used as a guide for painting, or if you prefer, the drawing can be repeated following the traced lines using very dilute watercolour on a small brush. The choice of colour is important, as it should blend into the overall colouring and be easily lost when the rest of the paint is applied. Once the drawing has been fixed in this way, the faint pencil lines can be removed with a soft eraser, leaving nothing to show through the thin, superimposed washes.

Painting begins by washing in areas of colour. Since the ground is very absorbent, the position of each brushstroke is quickly fixed, which means that even quite small areas cannot be treated flatly, and the washes must be weak and watery if they are not to prove excessively ragged. The colours also tend to dry pale and dull, so from the outset a small addition of gum arabic should be made to the water used to dilute the colours. Under no circumstances should this be enough to give the colours a gloss, however. (Incidentally, a thin coating of gum arabic and glycerine can be set down before applying any colour, to seal the ground partially and to provide a receptive layer for the watery paint that follows.) The first washes of colour should be thin and merely hint at the colour yet to come. They should simply map out the location of colours without obscuring the ground, and should be weak enough to allow slight changes in colour as the image is worked up. When all the colours have been washed in, take a clean, wet brush from which all excess moisture has been squeezed, and use it to remove or soften any unwanted marks.

Building up the colour

Watercolour paint that has been recently applied to a ground is very sensitive to moisture, even when it appears to be dry, and any attempt at setting down a further layer using sweeping brushstrokes will only result in the removal of existing paint. The only way to overcome this is to place each new colour with small, accurate brushstrokes, with the minimum of movement. At first, areas of shadow and outlines can be stated weakly, using a watery wash of a fairly light colour such as blue, green or crimson. Small areas can be blocked in with one deft stroke from a medium-sized brush, or filled by repeatedly placing small, identical brushstrokes side by side with a small brush.

Always remember that the light is derived from the ground and work gradually away from brightness towards shadow, using increasingly richer washes of colour. Once you have executed some preliminary modelling, set down individual touches of colour, either by hatching or by stippling with the brush point, putting down one dot of colour at each touch. Begin with the brightest colours, such as yellows, and add subsequent colours according to their tonal value. This allows the ground to be suppressed gradually, and means that in the finished painting, light is retained in the shadows, making them lively and more realistic.

When the colours have been gone through once, begin the process again, this time overlapping tiny touches of the colours in order to produce intermediate values. Wherever possible shade with colour, rather than darkness, and use colours selectively, so that each shadow is sympathetic to its surroundings – for example, shade green with blue, or yellow with red, and shade red with blue. Only in the final stages should any really dark colours be introduced, and for the most part these should be strong, pure colours used to restate the drawing and to accent the shadows where necessary. Finally, a dark wash can be added to the deepest shadows throughout the painting. This should be thin and transparent and should not disturb the existing colour, otherwise it will become muddy. The finished image should be crisp, and the colours should glow as if light were falling on them. If you want to deepen the shadows further, weak gum arabic can be applied to them, while the highlights can be touched with white to bring them forward. Corrections can be made with gouache or by scraping back the paint using a scalpel, so that painting can begin again on that particular section.

The study of a blackberry branch (right) *shows a watercolour on a prepared ground at various stages. A soft pencil drawing was first carried out on the stark white gesso ground* (above), *and washed over with dilute watercolour to fix the image, before the pencil was rubbed away.*

The colouring is then mapped out with watery washes that sink into the absorbent ground and quickly become fixed (above). *Small, accurate brushstrokes are gradually built up with a fine brush. Do not obscure the ground and keep the colours pale and transparent.*

Primrose and Bird's Nest *by William Henry Hunt (1790–1864). This detailed, naturalistic style of working is ideally suited to watercolour on a prepared ground.*

Europe a Prophecy: 'Ancient of Days': *William Blake (1757–1827) trained as an engraver, and often combined watercolour with engraved images. This relief etching, for example, was colour-printed, then worked up in watercolour. He experimented constantly with his materials, and even invented a form of watercolour 'fresco' technique which employed watercolour on a gesso ground. The tiny dabs of colour in the figure are characteristic of the technique, and the white lines could be created by scratching through the paint to reveal the white ground underneath. Blake's knowledge of white-line engraving techniques may have inspired such experiments.*

2.7 Pastel painting

Complete pastel painting

Although this book is mainly concerned with painting methods, pastels are included here because in some techniques they can be used rather like paints, with the crayon thought of as a loaded brush, rather than as a drawing instrument. As with painting techniques, the work is built up in layers, and once the colour has been applied it can be blended and manipulated just like paint. Complete pastel painting also resembles traditional methods of *Oil painting on a toned ground* (p. 128), though since the pastel medium does not allow for glazes, it is, perhaps, closer in character to the direct and semi-direct methods described in Chapter 2.5 as classic *alla prima* and *fa presto* (p. 136). In fact, pastel paintings are easily mistaken for oil paintings, sometimes even on quite close inspection.

Perhaps the greatest advantage of pastel painting is its speed – a work equivalent in quality to an oil painting can be produced in a matter of hours – and contrary to popular opinion, pastels are capable of quite intense colouring and offer a very broad range of tonal values, although dark colours do tend to lack depth. Select pastel colours to suit your subject matter, just as you would a palette of paints, but avoid using too many colours, as far fewer shades and tints are required than you might imagine. The colour of the ground should also be chosen carefully, as it

The 'Belle de Zuylen' *(1766): a celebrated 18th-century French pastellist, Maurice Quentin de Latour combined vivacity of handling with delicate lighting to produce portraits of great sensitivity.*

can be exploited in exactly the same way as a coloured ground in other painting techniques. One negative feature of pastels is their fragility. Fortunately, however, this can be largely overcome by using a good support and careful framing. Fixatives are not essential, but in the long term they can enhance the stability of the painting.

The example described here is based on a work by Maurice Quentin de Latour and it demonstrates how the medium was employed during the 18th century when pastel painting flourished, becoming an art form in its own right. Similar techniques would have been used by Jean Etienne Liotard, Jean Baptiste Perronneau, Francis Cotes and John Russell. Though time-consuming, this traditional method is well worth pursuing, since it offers a high standard of finish that modern pastel techniques cannot equal. You need not, of course, follow the procedures exactly as they are set out here. Other supports are equally suitable, and the colour range, subject matter and methods of handling are all open to individual interpretation.

Materials

A stretched, but unprimed canvas; a sheet of medium-weight toned and textured paper; a soft graphite pencil; a stick of charcoal and a small selection of hand-made pastels bound with resin, including white, three flesh tints, a deep sanguine shade, a grey-green tint and a moderately strong blue (*see* p. 78); an assortment of clean brushes, mostly of bristle; some sable brushes (genuine fitch would be ideal); a double-ended stump of rolled chamois leather and a large needle mounted in a dowel handle. Some freshly-made gelatine was employed for the mounting operation explained below, though starch paste could also be used.

Support and ground

A sheet of Ingres paper was selected from a reputable manufacturer's range. It was in the heaviest weight available and was acid-free with permanent colouring. The tint was a greenish blue-grey with a darker grey fleck that gave the paper a slightly mottled appearance.

Once the preliminary drawing and a little basic colouring had been completed, the full support was made up. This consisted of a piece of heavy, unbleached calico with a fine weave and a fairly smooth surface mounted onto a stretching frame. (A heavier cotton duck would have been more appropriate had the work been on a larger scale.) A freshly made solution of gelatine was then brushed thinly over the front of the taut canvas and over the back of the sheet of paper, and the two glued surfaces were brought into contact. To avoid trapping air bubbles, the paper was laid carefully onto one corner of the canvas and smoothed outwards across the surface of the cloth. The whole support was then turned over and placed face down on a sheet of clean paper. The back of the canvas was rubbed with the hand to remove any remaining traces of air and to create a good bond, and the composite support was set aside to dry for at least a day before any further work was carried out.

A few small bubbles in the paper surface are often unavoidable, and you should not risk damaging the paper in trying to get rid of them; as a rule, they will disappear as the paper dries and shrinks. Try at all costs to keep the gelatine or starch paste away

from the surface of the paper, as it will interfere with the subsequent application of colour, and bear in mind that the paper will be extremely fragile while it is wet, so try to handle it as little as possible during the mounting operation.

This should result in a support that is more rigid than a canvas, but with a slight 'give'. If properly prepared, it will make a low resonant note like a bass drum when tapped with the finger. Do not try to trim the paper to match the dimensions of the canvas whilst they are still wet: either cut it to size before applying any glue or wait until the support has dried. If you wish to make a large support of this type, you may need to use several pieces of paper overlapped at their edges. The joins will be reasonably discreet if the sheets are torn rather than cut to size.

It is always advisable to begin the pastel painting before making up the composite support, as this will avoid wasting valuable time and materials if you make any errors. According to some authorities, the mounting procedure also helps to fix the preliminary colouring, thus making the surface more ready to receive further pastel. Another obvious advantage is that, providing you begin the work on a piece of paper larger than the canvas, you will be able to reposition the subject matter in order to adjust the composition.

Drawing and first colouring

As already indicated, a pastel painting normally begins with a light preliminary drawing executed directly onto the paper. It is best to do this using a graphite pencil, as its mark is easily lost beneath the pastel pigment, so there is no need to correct minor slips. An eraser could, in any case, break open the surface of the paper, causing it to take the pastel badly. Once you are happy with the design, take a piece of willow charcoal sharpened to a point with a studio knife and go over the drawing again, emphasizing the main outlines. Blow away any surplus charcoal and use a bristle brush to lighten any areas which are too dark. Any large areas of dark shadow can now be underdrawn in charcoal. Hatch lightly with the stick and then rub over the shading with a finger or the chamois stump to spread the charcoal thinly. A delicate veil of black is required through which the ground can still operate, and you should guard against using the charcoal too heavily. (Note the area of underdrawn shadow just below the shoulder of the jacket, above right, on p. 170.) When the main areas of shadow have been indicated in this way, blow or brush away any excess charcoal.

Before adding any colour, you may now wish to touch in the highlights with white pastel. This converts the piece into a tonal drawing, which you can then use to guide the precise application of colour. Be sparing with the white, however: put in only the ultimate highlights, and rub them into the paper to form the shadows, so that they will not create problems as they are worked over. Note, for example, how the neckerchief consists of only a few white highlights and black outlines, while the greater part of it is taken up by the background colour of the paper, which acts as the middle tone. Those areas of the painting which are to remain grey and white can, of course, be set in quite boldly from the outset.

Although it is easier to highlight with white, the traditional technique is to use the palest tint of each area of colour. Once again, apply the slightest touch of colour from the pastel stick and then smear and rub it into the paper surface. The object is to produce a rough lay in, rather like the dead colouring of an oil painting, but take great care not to obscure the drawing or the ground. This is why the colours are used so thinly to begin with, and why they are used to model, rather than being laid flatly.

A few strokes of stronger colour can be introduced at the end of this first session in order to reinforce the drawing, then once again, any loose pigment should be blown away and any excess removed by scraping back. If you are satisfied that the work is going well, now is the time to turn it over and mount it onto a canvas support (*see Support and ground*, p. 168).

Colouring in

As far as possible, employ the pastels in a three-tone technique as you apply colour. Begin by restating the highlights very gently, then place the middle tone near to each highlight, though not right next to it, and finally do the same with the shadow tone. Now take a brush and blend them together just as if you were blending paint. Where neutral shadows are required, use the brush to ensure that the ground is covered very thinly. Try not to take the colour over its intended boundary and keep it away from areas of ground that will be left exposed throughout the painting – otherwise, you can work quite freely. Once the initial colouring is complete, stand the canvas upright and tap the top of the stretcher sharply, so that any loose pigment is shaken off. You will now be able to work over what remains without disturbing it.

Next, repeat the three-tone procedure starting with the shadows. Put the colour down gently in an open pattern of hatching and use the finger or leather stump to spread this out, repeating the process until you have built up the right intensity of colour. Having established the deepest shadow, move on to the areas of mid-tone, gradually increasing the thickness and strength of the colour. Hatch a little of the middle tone over the edges of the shadow tone and lightly blend the two together to produce an intermediate value. Finally, move onto the highlights and repeat the process there. At the end of this sequence, stand the canvas upright and tap it once more to remove excess pigment. From now on, try not to touch the shadow tones, but repeat the middle tone and the highlight, and then repeat the highlight once more. In this way the ground is increasingly suppressed by having a thicker layer of colour in the highlights than in the mid-tones, and a thicker layer in the mid-tones than in the shadows. Using a bristle brush at this stage could remove pigment that you wish to remain in place, so from now on employ a sable brush for blending. Incidentally, each time you use a brush, flex its hair with the thumb to throw off any pigment it has picked up; this will help keep your colours clean.

On p. 170 (below), the face has been built up, following the method described above, using three quite strong tones of flesh colour which are quite distinct from one another. By varying the thickness with which they were applied, blending them at the various stages of application and allowing the ground to show through in untouched patches, it was possible to give the impression that many more tints were used.

Drawing in colour

By now your pastel painting should have both form and colour, but will lack detail and firm definition. This is added by drawing with pastel over the top of the existing colouring. Hand-made pastels are an advantage here, as they can be sharpened quite easily, and the sharper the point, the more accurate the drawing. This time apply more pressure, so that a thicker layer of pigment is put down. A dark, red earth colour was used to outline and accent the face, to define the eyes and to draw in the nose and mouth (p. 170). It was also used on top of the original shadow tint to create the dark shadow beneath the nose. Once these details had been set down, the original flesh tones were re-applied, this time being hatched broadly across the face following the existing pattern of colouring. A little of the lightest shade was hatched on throughout to harmonize the colouring and tonal values. The edges of light areas were also redrawn quite firmly, and the ultimate highlights were further reinforced by being drawn in with pure white.

Next, a stick of the charcoal with a freshly sharpened point was used to emphasize the nostrils, the pupils of the eyes and the darkest part of the eyebrows. You may need at this stage to restate the colours and accents several times over, gradually building up the desired effect from a series of subtle adjust-ments. The final image will depend on the optical interaction of several layers of colour. In the example shown here, for instance,

Mounting paper on canvas produces quite a stable support for pastel. The paper should be cut fractionally smaller than the canvas, as shown here (right).

Initially, colour is applied tentatively and blended into the paper to develop the modelling. Wherever possible, the paper is used as a mid-toned ground. It is especially active in the neckerchief (far right), *where only highlights and accents are drawn in.*

Fine finishing strokes are applied over the blended pastel. These can be seen on the side of the face and nose. Crisp accents and highlights are set down with a sharpened pastel, and can be refined with a needle (note the highlights in the eyes).

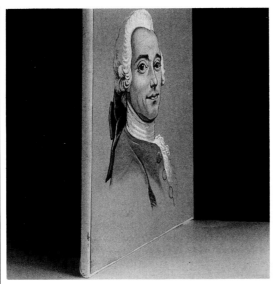

the darkest tones were achieved by combining black charcoal with sanguine, while the softest highlights were produced by hatching an open lattice of pure white over the existing colours, so that the lower colours could be seen through it. The two layers combine visually to create a pale, glowing tone. Colours can also be used to trick the eye into seeing what it expects to see, rather than what is actually there. For example, the eyebrows were executed in red, black and grey, but are perceived as brown, partly because that is what is expected. Exactly the same colours were used for the eyes, but this time they are assumed to be blue. In fact, the nearest colour to blue is the grey ground, which is also used for the stubble of the moustache and for the shadows on the neckerchief and wig.

The final stage in this example involved the placing of ultimate highlights using pure white. These appear on the lips, the wig, the laced ruff and, most importantly, in the eyes, as these must sparkle to give life to the painting. To obtain a solid highlight, sharpen the pastel, then apply it with a certain amount of pressure and a slight twist, so that a thick, compressed deposit of pigment is put down. It is almost impossible to place this exactly and it invariably results in too large a mark. The solution is to place the highlight as accurately as possible, and then to scrape it back using a sharp needle, leaving in position only the amount of white that you need. Any pastel mark can be trimmed down in this manner; and fine lines can also be derived from the ground at any stage by scratching through the pastel with any instrument with a suitable point. When the final highlights have been added, stand the canvas upright and strike it twice along its top to shake off any loose pigment which may be standing in peaks on the white highlights; any that now remains in place will be reasonably secure.

Final comments

Although the final stages of this technique have been described as 'drawing in colour', this process should not be treated like a drawing technique. The final touches are equivalent to the last brushmarks on a painting, and should merely be the culmination of what has gone before. They must be set down directly from the crayon in order to give the pastel layer body; only in this manner can thicker, heavier pastel be laid on top of existing colour, as pastel is actually quite difficult to work over once it has

reached a certain thickness. This can be overcome by starting thinly and continually shaking away loose pigment as the work progresses. The only alternative is to fix the pastel painting between each layer of colour to allow further work to be carried out with a minimal risk of disturbing the lower layers. This is particularly advantageous for blending in the later stages of the painting, as the lower layers are less likely to be disturbed by the pressure of a brush, finger or stump.

Fixatives should always be used sparingly, otherwise delicate colouring effects and carefully graded tonal values will be lost. Pastels reflect light directly from the pigment particles, which stand above the surface of the painting, and if these become saturated with fixative, they collapse into a single, flat layer which resembles a conventional paint film. The colour then changes and loses most of its opacity, altering the overall effect entirely. Some pastel painters regard the risks associated with fixatives as more serious that the loss of pigment or smudging, and therefore prefer not to use them at all.

The best results can only be achieved if pastels are kept clean, as the freshness of the effect depends a great deal on the purity of the colours. Traditional advice is to keep pastels in bran, which keeps them clean and, at the same time, cushions them against accidental breakage.

Pastel and gouache

Pastel and gouache have been combined since the end of the 18th century when both media become popular at about the same time. Unlike most mixed-media techniques, where there is a strong contrast between the two elements, pastel and gouache offer very similar colour values, tonal ranges and flat reflective surfaces. The main difference lies in their mode of use, which results in a solid, even layer of colour in the case of gouache, and a broken, more lively surface in the case of pastel. These characteristics can complement each other in a highly satisfactory way: gouache can be used to supply the solid build-up of colour in the lower layers of a painting – so difficult to achieve with pastel – while pastel can provide an accurately detailed and delicately blended final layer, which is capable of far greater subtlety than even the most carefully worked gouache. Another obvious advantage of using these materials together is that gouache can be used to correct pastel by overpainting, and can then be worked over with pastel to achieve a uniform finish.

To combine the pastel-painting technique with gouache, simply substitute a layer of body colour for the first layer of pastel, and then proceed in pastel exactly as before. The result will be stronger than with pastel alone, especially in the lighter areas, and the work will resemble an oil painting even more in its finish and richness of colour. The gouache can be used to create optical effects, with broken colours and veil-like coverings of pastel behaving rather like glazes.

Pastel and gouache were originally combined to create highly finished paintings which followed a traditional style. Towards the end of the 19th century, however, the combined technique was revived by artists such as Degas, who experimented with it and introduced a rougher, more impressionistic quality into mixed-media works. Such an approach deliberately seeks contrast, texture, interactive colouring and bold effects, in place of more traditional subtleties. In this type of work both the gouache and pastel can be clearly seen side by side in the finished work. Pastel is not applied as an overall covering, forcing the gouache into a secondary role, but is drawn on in bold strokes or applied flatly using the side of the crayon, so that the individual characteristics of each medium are retained. This style of pastel and gouache painting, which is demonstrated below, is much easier to master than traditional pastel-painting techniques. It remains popular today with a broad range of painters because of its ease of use and potential for variety.

Deux danseuses dans la loge: Degas' sound technical knowledge enabled him to make endless trials of various media. He combined pastel with watercolour, or spirit-thinned oil paint, with gouache and with tempera.

Materials

An unbleached, flax canvas; animal glue and finely powdered pumice; commercially produced gouache colours (size colour, tempera or acrylic paints could also be used); broad bristle brushes in a selection of sizes and shapes; commercially produced artists' soft pastels; and a fixative.

Acrylics offer certain advantages as the foundation layer in this techique: their flexibility ensures better long-term performance on canvas than gouache, and their tacky surface helps to keep the pastel pigment firmly in place on what is a rather unstable support for this medium. Fixative was used quite frequently in this example to counteract potential movement in the support.

Support

A fairly heavy flax canvas was used as the basis of the support; it was unbleached, with a brownish-grey colouring. Its surface was slightly rough, since it was made up of coarse threads of varying width, and it also contained an assortment of impurities and tiny knots. No attempt was made to remove these, as texture is valuable both for its visual quality and for its ability to help the pastel adhere. A piece of this canvas was stretched over a processed wood board and tacked down along its edges and onto the back, as if it were a normal stretcher, in order to protect the back of the canvas and to give it greater stability. It also prevents any further tightening of the canvas, since there are no wedges. Another method for employing canvas beneath pastel is to mount a prepared canvas backwards on its stretcher. The unprimed cloth then faces the front, whilst the priming at the back protects it and reduces its potential for movement. All these measures help to reduce pigment loss. The stretched canvas was sized with animal glue containing finely powdered pumice, to provide extra tooth for the pigment to adhere.

Gouache painting

The illustration on p. 173 was painted from life, and was begun with a simple charcoal sketch that was fixed before the paint was applied to prevent any discolouration of the gouache. A little powdered pumice was added to the water used to thin the gouache and agitated at intervals to keep it in suspension. This compensated for the fact that the paint would cover some of the pumice on the support by ensuring that the gouache itself had a fine tooth.

The painting was then blocked in, in a fairly broad manner, using middle tones and light middle tones that were roughly approximate to the colouring of the subject matter. Strong lights and darks were avoided so that each area could be brought towards the extremes as subsequent layers of pastel were applied. Throughout the preliminary painting the colour was kept thin, to prevent cracking and flaking, but was given ample body by the use of white. Here and there, patches of canvas were left exposed, allowing parts of the charcoal drawing to show through; this adds variety to the surface of the finished work. The canvas was then allowed to dry for half an hour.

Pastel drawing

Pastel can now be applied in bold hatching strokes. Start by putting in the lightest tones, dragging them over the existing colours to round out the modelling and break up the flatness of the gouache. To create interest use lively, contrasting colours for these paler tones in place of the obvious tints. For example, yellow can be used to highlight red instead of using pink, or both can be combined for an even more striking effect. Scumbles, scuffed-on marks and broad strokes of pastel can be used throughout to redraw the subject over the top of the gouache painting and to bring the colouring, modelling and design to a satisfactory degree.

Dark accents should be introduced last, using colour in preference to black, and applied sparingly so as not to overstate the shadows. In this style of pastel painting, colour and texture are more important than crisp outlines and clearly defined forms, and it should be sufficient to hint at the shadow accents in a linear manner. If, during the build-up of pastel, it becomes difficult to apply more colour on top of the existing pigment, use a fixative to stabilize the existing pastel, then apply more pastel over the top as necessary.

Reworking

Providing the initial layers of gouache are kept thin, you can rework any unsuccessful parts of the painting by fixing the existing pastel layer and then overpainting in gouache. If you wish to preserve most of the existing work, whilst improving upon it in particular areas, apply the gouache as a rough, half-covering scumble wherever it is needed. Once dry, this can be worked over with pastel again, and several layers of pastel and gouache can be interleaved, if necessary, to produce a complex effect similar to the use of scumbles and glazes in oil painting. If strong pastel colours are available, it is possible to achieve unusual colour effects by rubbing pastel over a layer of gouache in a quite different colour so that the pastel is forced into the texture of the surface, whilst the raised parts of the gouache remain almost unaltered. This resembles the use of coloured glazes over coloured underpainting, though the optical quality of the pastel means that it resembles a thin scumble rather than a glaze.

Although blending is not particularly relevant to this technique, it is possible to rework the pastel colour before fixing if you desire a more subtle effect. Smearing the first layer of pastel with a brush, a stump, a paper torchon or a finger will remove any harshness from the gouache to give more softly modelled forms. Note, however, that where pumice is applied to the support or added to the paint, smearing and blending are more difficult. A brush is then the most effective blending instrument, as it can be worked between the particles of pumice in order to manipulate the pigment. However, where the support itself has a rugged surface, the smooth, controlled blending that is typical of traditional pastel painting is virtually impossible.

In the example shown on p. 173, the drawing will finally be reworked with charcoal to reinforce the most important elements of the composition, though a final restatement of the drawing is by no means an essential element of this technique. The work will then be fixed once more before being framed under glass.

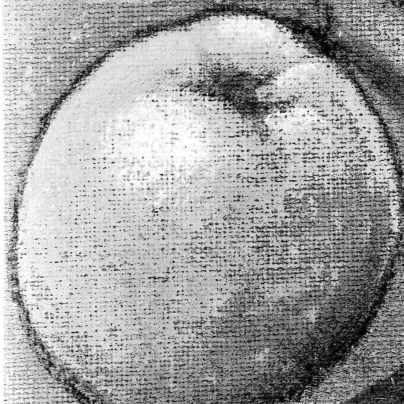

Above: *Once the charcoal drawing had been set down, the image was painted in with gouache to indicate colour and establish the forms. The gouache should not fill the weave of the cloth support (see the apple, left).*

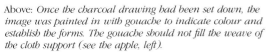

Pastel is then worked over the gouache to improve the colouring and modelling, and to add detail, such as the flecks of light on the apple skin (above right). Note how the weave fills up with pigment as layer upon layer of pastel is applied.

The natural colour of the cloth acts as a coloured ground, and the extent to which the weave is filled creates variations in tone and intensity of colour. The rough texture encourages thin scumbles, but it may be packed with pigment, as for the highlights of the glass bottle (right).

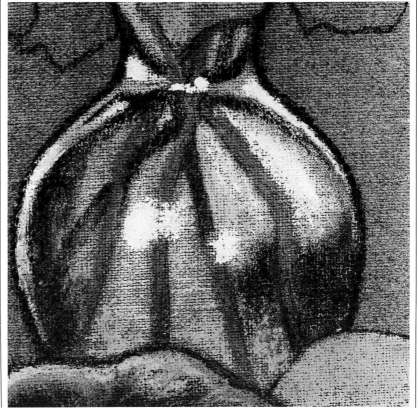

2.8 Other techniques

Acrylics

Imitation of other media

According to most manufacturers of artists' acrylic paint, it is possible to match the techniques of all other media using their materials. Although it is true that acrylics are versatile, there is a great deal that oils, tempera and watercolours can do, that acrylics cannot, and though the range of techniques in which they can be employed is certainly wide, and they can in many instances imitate other media quite closely, they cannot specifically match the capabilities of any other materials; any resemblance is more often than not only superficial. Their most positive contribution is to the speed at which a painting can be executed.

To imitate tempera, acrylics should be thinned with water to the consistency of milk or thin cream, which is the normal thickness for tempera. Providing they are applied in the same manner as tempera – especially if they follow the classic tempera technique – they will produce paintings that appear very similar to works in tempera. This similarity can be further encouraged by the use of a true gesso ground, instead of an acrylic gesso or universal priming, as acrylic paints respond well to traditional gesso. In appearance and performance, acrylics most resemble egg tempera, which is hardly surprising since both are emulsions and have a number of physical properties in common. Acrylics are less like size colour or gouache, but if the technique is kept broad and simple, they can make passable alternatives to these materials. As a substitute for gouache, acrylic has the advantage of being insoluble in water when dry, which makes over painting a little easier.

You can do more or less the same things with acrylics that you can do with tempera, though acrylics do not allow quite the same degree of control over the materials. The main problems with acrylics are the difficulties of scraping back, and of colour matching fresh paint to existing layers. Errors in tempera can either be released with warm water, or scraped back with a scalpel, right down to the ground if necessary, whereas dry acrylic paint is completely waterproof and too rubbery to be taken back cleanly using a knife. As for colour matching, the technical trick with tempera is to dampen the existing colour slightly so that wet is matched against wet. This is not, unfortunately, possible with acrylics, and colour matching can, in fact, be sufficiently tedious to dissuade many painters from adopting the acrylic medium. It is a particular drawback when imitating tempera, as the speed of painting may actually be slowed down, offering no advantage whatever over the original materials. Acrylics do, however, offer a more flexible paint film and they are the ideal medium for adapting tempera techniques to use on canvas.

If acrylic paints are thinned to a wash using water, they are theoretically capable of producing the same effects as watercolour, though compared with genuine watercolour, thinly applied acrylic can appear dull and flat. This can be overcome to some extent by adding a small amount of acrylic gloss medium to the water used to thin the paint. A surface-tension breaker intended for use with acrylics may also be included to improve the flow of the wash, so that it behaves even more like watercolour.

There are only two drawbacks to using acrylic paint in the manner of watercolour, and their importance depends entirely on the technique being used. Once dry, an acrylic wash is permanent. If you wish to lay one wash over another so that colours are optically mixed, this is an advantage; but if you want to modify an existing wash, it is a major obstacle. With watercolour, if you misjudge the strength of a wash it can be taken

back using water and blotting paper, and the same technique can be used to wash out subtle highlights. Similarly, a hard edge can be removed by manipulating dried watercolour with a damp brush. But if acrylics are used, the effect obtained at the first attempt cannot be altered. To the experienced painter this may not be a problem, and for broadly handled basic sketching, it scarcely matters. However, in a complex watercolour technique it removes any room for manoeuvre, so that if your painting does not go according to plan, you may be forced either to abandon it, or to introduce body colour in order to correct it. The second problem is that superimposed layers of acrylic, no matter how thin, gradually build up a satin-like gloss which, if excessive, can take on a particularly plastic appearance. This may become a visual distraction, as areas of a painting where more than one wash has been applied will suffer from this effect while other parts do not. Adding extra acrylic medium to the painting water can obviously aggravate this effect, but it may also be employed to even it out. If extra medium is added to the first washes but not to the later washes, relative differences in the surface gloss will be less apparent. (This technique is borrowed from size painting, where it is normal to reverse the process of painting fat over lean.)

One further point in this context is that unless brushes are kept scrupulously clean, wear and tear can eventually interfere with their performance. In the case of sable brushes, this can be costly, and if this encourages painters to use other types of brush, limitations may be placed on the amount of control that the painter has over the paint. Nevertheless, this is only relevant where complex and subtle versions of the watercolour technique are being attempted in acrylics.

The temptation to imitate oil painting techniques with acrylics is one that most artists find hard to resist. However, acrylic paints are far less able to match the effects of oil paint that you might expect; even when they are modified by additives, the true qualities of the oil medium are scarcely approached. It is interesting to observe that painters who use acrylics to imitate oil painting have often been unable to master the oil medium itself and have chosen acrylics as an easier alternative, while those who have mastered oil techniques are seldom attracted to acrylics, in spite of their potential speed and the superior claims made for them by the manufacturers. The explanation lies in the rich technical potential of oil paint, which offers a wide variety of optical and textural effects, as well as a fairly diverse range of handling qualities, some of which cannot be matched by other media. When these characteristics are combined with the various different types of ground and support, the variations possible with oil techniques become virtually endless. Acrylics are unquestionably versatile, but from the painter's point of view, they cannot compete with oils. Their only attraction is the speed at which they dry.

In basic *alla prima* techniques, where paint is applied directly from the tube, acrylics can be substituted for oil paint quite successfully, and for heavy impasto, acrylics are actually superior to oil paints because of their speed of drying and long-term flexibility. Painting wet in wet is not a serious possibility with acrylics, however, and methods such as scraping back have a far more limited application, as the rapid drying of acrylics does not allow sufficient time for the painter to consider the work's progress. This theoretically spontaneous method of painting can thus be reduced to one which is over-hasty and haphazard. One solution is to adopt a wet over dry technique where wet in wet painting would be employed in oil. Repeated overpainting can then be used to make corrections and to compensate for the loss of manipulative control as the paint dries. This can also be assisted by various media: liquid media, which are usually available with either a gloss or a matt finish, may be used to thin the paint to the consistency of a glaze; gel media also thin the paint, but retain its body; and, perhaps most important of all, retarding media slow down the drying rate. Unfortunately, none of these media have the capacity to flow that is typical of oil-based painting media, and they merely thin or enrich the paint, without improving its handling qualities. The paint will still dry quickly, even when a retarder is added, and brushmarks will remain in place unless a very watery mixture of colour and medium is used. This makes true glazing difficult, a problem compounded by the fact that acrylic emulsions are opaque before they dry, making it almost impossible to assess the colour value and degree of transparency of an imitation glaze. The only answer is to create the appearance of a glaze by applying a series of

tentative washes, one on top of another, until the desired degree of smoothness and colour is achieved. Blending – so easily carried out with oil paint – is also difficult to achieve with acrylics. Retarding gels help a little, but the usual solution is to stipple or hatch colour so that it thinly overlaps the adjacent area of paint, which is, of course, a tempera technique. When combined with textural and impasto effects, this can be easily mistaken – at a distance at least – for the more intimate blending of colours associated with oil painting.

The final drawback of acrylics used in oil-painting techniques is the extent to which colour values change during drying and varnishing. Oil paint changes colour only very slightly as it dries, and even when the paint is fairly lean the colour changes brought about by varnishing are not excessive. Generally, what you see is what you paint, and what you paint is what you get. Unfortunately, this is not the case with acrylics. Mixed colours, in particular, can appear quite different when dry, and even pure colours will change slightly from wet to dry. It is possible to overcome this problem by painting in slightly lighter tones than you wish the final painting to have, but this requires considerable experience of acrylics and, even then, is a haphazard method. Touching-in when resuming work on a painting after a prolonged time presents the greatest difficulties, and even straightforward techniques modelled on *alla prima* oil painting can become tedious if subtle colour matching is involved.

Since acrylic paints dry to a different finish, they must be varnished if you wish them to resemble oil. At this point, the intended relationships and harmonies may be lost. Matt varnishes tend to be less damaging, but there is no obvious solution to this problem except, perhaps, to seal the painting with a thin layer of acrylic medium before applying the final varnish, thus reducing its penetration into the colour layer. Note, however, that acrylic media should be confined to use as intermediate varnishes that are subsequently covered by a removable varnish of a different type.

Specific acrylic techniques

Perhaps the most suitable way of employing acrylics is to borrow techniques from other media without imitating them too slavishly. In addition, there are three specific techniques which are particularly well suited to acrylics.

The first of these is the so-called 'hard edge' technique, which involves using masking tape to block off areas or create stencils through which the acrylic is applied (p. 103). As soon as the paint is dry, the tape can be peeled back to reveal a stencilled shape in acrylic paint. Quite delicate forms and thin lines can be produced in this way if sufficient attention is paid to the masking of the painting. The paint should not be applied too thickly where it crosses the masking tape, otherwise it will not produce a clean edge when the tape is removed. Since the tape will not lift acrylic paint beneath it, unless it is on an unsuitable ground, the masking process can be repeated on separate layers to build up quite complicated patterns.

Staining, another acrylic technique, consists of applying paint to unprimed cloth so that it penetrates the fibres. It is not a new technique, as many water-based paints were applied to cloth in a similar fashion as long ago as the Middle Ages, but it was re-invented with the introduction of acrylics, and is now chiefly used for randomly applied abstract works. Acrylics are well suited to this method, since they are permanent when dry and will not harm the cloth. A variety of effects can be achieved by wetting the cloth, adding a surface-tension breaker or a small amount of liquid soap to the paint. Applying acrylics directly onto cloth in this way is theoretically sound, but if staining is combined with thicker paint layers, some distortion of the cloth is quite likely. Since cloth tends to change colour as it ages, stained acrylic paintings are also unlikely to retain their original appearance.

The airbrush is by no means exclusively reserved for acrylic paints, but in fine art, as opposed to commercial art, it seems to be employed more often with acrylics than with any other medium. In layman's terms, an airbrush is a spraygun which can be finely controlled and handled with great delicacy to create subtly graded tones and finely blended colours by overlaying thin mists of paint. Such effects are normally impossible with acrylic paints, and an airbrush can help to imitate the character of oil colour.

However, sometimes the effect can be too smooth and plastic, a style which suits photo-realism, but which is out of place in other types of painting. Airbrushes can also be employed selectively to produce decorative effects which add interest to acrylic paintings. Typically, airbrushing may be combined with stencilling and masking to produce either hard- or soft-edged spray patterns. The spray can also be made fine or coarse by adjusting the airbrush controls, and unusual effects can be achieved by airbrushing onto an area previously sprayed with water or with a stopping-out medium. This results in random patterns, where the sprayed area is broken up by irregular patches of ground or underlying colour. Some of these effects can also be created with a simple mouth diffuser, a toothbrush or a nailbrush used to spray and spatter acrylic colour.

Encaustic techniques

Applying hot

Encaustic colours, made from wax and pigment with or without an addition of resin, are solid at room temperature. When heated, they become liquid, but as they soon solidify when removed from the heat source, for painting they must obviously be applied hot. One way of doing this is to place a metal palette with recesses for liquid colour over a container of boiling water or gentle direct heat. Suitable palettes, preferably with a coating of enamel, are reasonably easy to obtain, though they may not be intended specifically for encaustic painting; a household baking tray with separate compartments makes an acceptable alternative, for example, and will hold considerable quantities of colour. The palette can be laid by pouring molten wax into each compartment and, while it is still hot, stirring pigment into it with a brush. (Be sure to keep a separate brush for each colour.) To keep the colours liquid, the palette should be placed over a heat source which must be at least hot enough to slow down the cooling process of the wax.

Bristle brushes are used for encaustic painting as they are sturdy enough to manipulate the paint as it congeals. As it is not practical to clean brushes between colours, a separate brush must be available for each one. (This can, of course, be the same brush that was used for mixing each colour on the palette.) Painting may begin with the pure colours on the palette being set down flatly and thinly. Return the brush to the paint frequently to keep it warm and free to move. After the first painting, rework the same areas with more tentative touches of the same colour, using a swift brushstroke that ends with the brush lifted from the surface of the painting. In this way the lower layer is not remelted, and the brush does not stick in the fresh wax as it cools.

Once all the areas of pure colour have been put down you may proceed to the mixed colours. If there are spare compartments on the palette, further colours can be mixed there, but it is often advisable to have a separate palette reserved exclusively for mixtures. Mixed colours and tones are prepared from the colours on the original palette, using a brush that has already been used with one of the colours involved to mix and apply the new paint. This avoids excessive brush-cleaning and keeps the number of brushes to a reasonable number. The secondary colours are then applied in the same manner as the first. Any final touches can be mixed directly on the hot palette using the original colours and secondary mixtures to create new colour values. The painting may also be accented by returning to the original colours, since they will be the darkest tones available. If a brush must be used with more than one colour, it should be flattened and scraped with a flat knife whilst the wax on it is still warm, and when it is introduced to the new colour it should be lifted out quickly, so that it does not dirty the colour on the palette. Turpentine may also be used to clean brushes between colours, but remember not to bring it anywhere near the heat source, as there is a risk of it igniting.

A second, more ancient method of encaustic painting involves the use of a heated implement for applying colour. The coloured wax, previously prepared with pigment, remains cold, while a hot metal tool is used to apply it. The Greeks and Romans used an instrument called a *cestrum*, which appears to have had a small flat blade at one end and some form of point at the other. The nearest modern equivalent would be a small-

Portrait of a princess *from Fayum, in Egypt (11th c.AD). This striking work is executed in encaustic on wood and is still in excellent condition.*

bladed painting knife or a tool improvised from a scraper-board cutter or lino-cutting implement. It is easier if you have several painting knives or tools of this kind, but this is not essential as the tools can be cleaned easily by wiping them on a rag whilst the wax is molten, or by scraping them clean when it has cooled. Electrically heated palette knives and modelling irons intended for working wax are available and make excellent painting instruments for this type of encaustic work. Where more basic implements are being used, a strong heat source is required to warm them. Painters should take care that this is safe.

During painting, the hot tool is used to remove colour from the cold wax block, and carry it to the painting, where it is dabbed or spread into place while still liquid. As it begins to cool, it may also be given a degree of impasto, by pressing and lifting the tool with a twisting action. The colours are applied in small patches side by side, rather like a pointillist painting; as the work progresses, they are encouraged to overlap, and the heat of the tool is used to cause partial blending. When enough colour has been applied, a clean painting implement is used to blend and manipulate the surface of the wax, by re-melting and re-positioning a tiny patch of colour at a time, roughly corresponding to a brushmark in any other type of painting. The skill lies in knowing how long to leave the hot blade in contact with the wax and at what point to lift it away. Sometimes it is sufficient to hold the tool near to the wax instead of letting it actually touch, and at other times, a hot point may be preferable to a hot blade; moved quickly through the wax at the right depth it will allow quite delicate control over the colours. Areas of paint which are too heavy can be cut back when cold, and fine detail can also be introduced by cutting into the cold wax. The slightest touch with a hot instrument will then give the reworked colour the characteristic appearance of encaustic.

Both methods are best employed on a rigid support, and a white gesso panel is particularly recommended. (This also applies to the cold methods which follow.) If you wish, the painting can begin with a drawing sketched onto the ground to indicate where the main areas of colour will go. Ideally, the colour of the wax will be intense enough to obscure any preliminary drawing while being translucent enough to allow light to reflect back from the white ground. Heavy, dense encaustic paint can also be applied directly onto wood and other rigid materials without any preparation. Wax will adhere to most surfaces when applied hot, but it tends to come away rather too easily from smooth, non-absorbent materials, such as ceramics and metal, when it is cool.

Applying cold

Solid wax colour may be applied cold in one of two ways. In each case it is a good idea to incorporate at least a small amount of drying oil into the wax or wax and resin blend, in order to make it more malleable. As in the previous example, each colour is prepared separately and cast either as a block or crayon. In the first cold method small pieces and strips of wax are cut from the block as required and kneaded in the hands until they begin to soften. They are then placed on the support and pressed down firmly so that they stick in place. Thin strips of coloured wax can be rolled out and shaped with the fingers as they are applied to define outlines or linear detail. The entire painting is set out in this way, using the small pieces of wax like the tesserae of a mosaic or the single brushstrokes in a painting. The completed image will be rough, with uneven thicknesses of wax and gaps between each piece, but that is all part of its charm.

The next stage of the process will remove some of this roughness, but the object is to retain it in places, so that the finished painting has an element of texture and low relief. The wax is now driven in, with direct heat or a clean hot spatula being used to melt and blend the surface of the wax. Driving in should be carried out with the painting laid flat, to prevent the hot wax from trickling. If the heat source is removed at the right moment, there will be a pleasant contrast between the coarseness of the original colour and the softness of the molten wax.

The second cold method is to use crayons made of wax softened with oil to a point where they will draw freely. Passable results can be obtained using oil pastels, but specially made beeswax crayons are better. The method need hardly be explained. Different coloured crayons are simply used to draw the painting, by covering the

ground with repeated strokes and overlaying colours until a satisfactory finish is achieved. Then the colours are driven in and, if necessary, more work is done over the top, again using crayons. This too can be driven in, if you wish, or left in its natural state to provide a contrast with the enamel-like finish of the lower layer. If an assortment of crayons is prepared using various recipes, this technique can offer considerable scope for variety. Different line thicknesses and more or less solid deposits of colour, as well as variations in the degree of translucence and colour intensity, can be combined with a white ground and selective driving in to produce remarkably fine works of art. The crayon method also offers considerable potential for mixed media work, where it can be successfully combined with watercolour, tempera and oil.

Wax pastes and liquid wax

Wax pastes made from turpentine and wax, or oil and wax, with or without further additions of resin, are soft enough to brush out cold. They are handled rather like oil colour, and are brushed out thickly or thinned with turpentine to make them flow more easily. Wax or wax and resin pastes should only be used on rigid supports, but wax and oil mixtures are suitable for canvas as well. Once applied, they may be allowed to dry like ordinary paint or heat-treated to give an encaustic effect. Note, however, that if a hot method of painting is used to continue a work started with a wax and turpentine paste, there should be a modest time lapse between these stages to allow most of the flammable solvent to evaporate. Also, the heat treatment of wax pastes containing oil should not be left too long, as the oil will begin to dry and a skin will form over the colour; this will interfere with driving in and with the use of a hot painting knife.

Thick wax pastes are well suited to heavy impasto, where the colour is applied from a loaded brush or knife. In fact, for heavy impasto thick mixtures of wax and oil actually perform better than plain oil. (The best results are achieved with stand oil.) Heavy wax impasto can be heat-treated, and it is possible to build up thickly modelled layers of colour which have smooth, flowing surfaces of a kind that would be impossible to achieve in other media. Wax, oil and resin pastes also happen to be sticky, which makes them highly suitable for works which combine collage with painting. (Panels make the best supports for both encaustic and collage works.) When treated with heat, such materials can hold quite heavy objects in place, allowing unusual composite creations, and adventurous painters may wish to explore other possibilities, such as carving into the wax, employing resist techniques with other media, and a sgraffito technique which involves scratching through different-coloured layers of wax.

Wax emulsions are water-thinnable liquids or soft gels which become liquid when warm. They most resemble tempera and gouache, and are generally used in similar techniques to those materials. Their most attractive feature is their translucence, which far exceeds that of ordinary tempera and has a soft, subtle charm which is quite unique. They also offer the option of burning in, though this is seldom exploited, as it destroys the pearly, matt surface which is generally regarded as desirable. As a rule, they are left in that condition or lightly burnished when completely dry. Wax emulsions give good results on gesso and on good quality paper. They are seen to best advantage on white grounds, which combine favourably with the translucent quality of their colours. Wax mixed with animal glue appears to have been the basis for the ancient *cera colla*, used for mural painting in Byzantine times, and possibly before. It is said to produce soft, fresco-like effects and to be reasonably reliable on suitable walls.

Driving in and burnishing

The name encaustic is a reference to the use of heat, and although it is now applied generally to painting techniques involving wax, in the strictest terms encaustic painting must involve some form of heat. Driving in, or burning in, as it is sometimes called, is an alternative to the direct use of heat. It involves bringing a hot object close to the surface of the painting so that the wax in the colour begins to melt without actually being touched. This makes it flow, and if it lies on an absorbent surface it will be drawn down into the ground or support, so that it rests within it as well as upon it. Like direct heat, driving in produces a smooth, enamel-like surface, which represents flowing liquid

colour fixed at the moment of cooling. If driving in is carefully done with a light touch it should be possible to melt the top layer of wax without disturbing the heat-sensitive colour beneath. It should also be possible to heat-treat a small area without affecting surrounding colour, and to catch the process half-way, so that some texture, such as brushmarks or the track of a palette knife, is retained in combination with smoother and more rounded surfaces. This obviously requires a certain amount of practice, and even where you are not attempting a sophisticated effect, driving in should always receive careful attention, as the slightest error can undo the entire painting. From a safety point of view, note that any form of heat employed for encaustic painting should be treated with due respect, so that accidents do not occur.

Burnishing is another way of finishing paintings which contain wax. It is done with a soft cloth, preferably of lint-free cotton, folded into a pad or rolled into a loose ball and passed over the surface of the paint with a gentle circular motion. If the surface has already been driven in, burnishing will bring it to a high polish, but if it has not been heat-treated, it will produce a silky, semi-matt sheen. This only applies to paintings executed in wax pastes or wax emulsions, and these should be completely dry before they are burnished.

Fresco

Fresco is a method of mural painting which was once a major art form, but for most modern painters, it is too complicated and too demanding a technique to regain its former popularity. The account given here offers a brief introduction to the technique.

Fresco involves painting directly into wet lime plaster. The colour has no binder and consists simply of pigment ground in water. As the colours are brushed on, they mingle with the surface of the plaster, and as it dries, the pigment particles become physically trapped within the substance of the wall. The method is only possible with lime plaster, which must now be made specially for fresco painting. The lime is calcium hydroxide, produced by slaking quicklime with water. This produces a chemical reaction which generates an enormous quantity of heat, and the process is potentially dangerous. To achieve the proper quality, the slaked lime should be matured so that impurities settle out and the consistency of the material improves; it can take at least two years for the lime to reach an ideal state. As the lime plaster dries, it combines chemically with carbon dioxide in the atmosphere and returns to its original state of neutral limestone; it is this action which entraps the colour.

Given favourable conditions, fresco paintings will last for a very long time. They survive best in warm, dry climates on internal walls. However, dampness from within the wall, poorly slaked lime, salty or polluted air and inadequate plastering can all hasten their destruction.

Selecting colours
Lime plaster is extremely alkaline, and only those colours which are resistant to alkali can be employed in the true fresco technique. More of these exist now than ever before, but it is still advisable to restrict your selection of colours to those which can be relied upon absolutely. All the earth colours are stable in lime, so any of the red or yellow ochres, Mars pigments and umbers can be employed. Bright, golden-yellow ochres and warm, orangey-red ochres are especially valuable and may be substituted for bright yellow and red. Hansa yellow is the best bright yellow for fresco, as cadmium yellow is unreliable. Cadmium orange is said to perform well, but it is perhaps best to regard it as doubtful. Cadmium red and toluidine red are the best bright reds for fresco, though neither is perfect. There is no shortage of blues: cobalt blue, cerulean blue, French ultramarine and phthalocyanine blue are all sound, though ultramarine can suffer in a polluted atmosphere. Prussian blue is worthless, as are all alizarins. Viridian, oxide of chromium, cobalt green and phthalocyanine green also suit fresco. All black pigments can be used, but Mars black tends to be favoured because it mixes more easily with water than other blacks. White pigments are not used in fresco, since the lime itself is

white, and tints are made by mixing colour made with water with a little of the slaked lime. If you are at all in doubt about the permanence of a particular colour, mix a sample with lime and set it aside. If, after 24 hours in the wet lime, it remains unchanged, it is unlikely to cause problems.

Preparing the wall

First of all, the wall must be inspected to see that it is suitable. It should be dry and contain a damp-proof course. If it does not, then it should be in a position where it is unlikely to suffer from rising damp. Good ventilation is also required, and ceiling frescoes must be protected from condensation by an adequate flow of air. Walls made of brick or stone make suitable supports for fresco paintings; concrete cannot be used. Old plaster must be removed as part of the preparation process, and brick walls should be roughened with a hammer before the new plaster is put on.

Before the wall is plastered it must be thoroughly soaked with water, and you should spend at least a day making it wet enough. Three coats of plaster are then applied to the wall, the last and finest of which will receive the painting. Each coat has a traditional name. The first is called the *trucela* and is made from 1 part lime mixed with 3 parts clean, coarse sand. This is applied evenly across the wall in a layer $\frac{1}{2}''$ (1.5cm) thick, and allowed to dry. The second coat, the *arricciato*, consists of 2 parts fine sand and 1 part lime, and should be somewhat thinner than the previous coat. The final coat is called the *intonaco*. This contains 1 part fine sand and 1 part lime, and should go on thinly – no more than $\frac{1}{4}''$ (0.5cm) thick – covering only the area intended to be painted immediately. Each layer of plaster should be brushed down and wetted before the next layer is applied, and the final coat may be worked with a wet brush and trowel to make it smooth before painting commences.

The day piece

As fresco painting only works when the colour is applied onto fresh plaster, only one part of the wall at a time receives its final *intonaco* coating. Ideally, this will correspond to an area of painting which the artist expects to complete in a day, and at the end of that day, the area which has actually been painted should be divided off by cutting around it through the soft layer of *intonaco*. (Make this cut at a slight angle so that the plaster applied on the next day can be joined onto it neatly.) Any unused plaster is then removed and remaining traces of lime are washed off the underlying layer. Each section of work is known as the *giornata*, or day piece, for obvious reasons. If possible, these areas should be worked out in advance so that the divisons between them fall along convenient outlines which form part of the design. As a rule, cracks will eventually appear round each day piece, but if the sections have been carefully planned, these will be concealed. It is also practical to work downwards and across the wall in order to keep finished sections out of harm's way. A right-handed painter should begin in the top left-hand corner and follow a sequence of sections across the top of the wall before returning to the left-hand side and repeating the sequence lower down.

Fresco technique

The original fresco method would begin with the entire composition being drawn out and lightly painted on the second layer of plaster before the *intonaco* was applied. Although this was obscured by the final coat of plaster, it was only covered up a piece at a time, so that the painter could work spontaneously onto the wet plaster, filling in the missing section of the design. A more usual method is to work from a full-sized cartoon, which is laid over the plaster and either pounced with charcoal (p. 90) or scored with a stylus to leave an incised mark in the soft surface. The cartoon is then removed, and painting begins. Colours may be put down as broad, thin washes or as flat, fairly solid areas of tone, and the design can be stated quite simply, with a dark outline and a few highlights, or carefully modelled using overlapping areas of hatching. The ideal is to keep the brushwork simple but to employ the highlights and accents skilfully, so that form and colour are suggested with the minimum of effort. Colours can be blended with a wet brush, to a certain extent, but the paint allows very little working time and the

Conversion of St Paul *(detail), from the Sistine Chapel ceiling by Michelangelo. Note the cracking that has occurred around the margins of the fresco day-piece, or* giornata.

essence of the fresco technique is speed and certainty of touch. The key to success is to keep in mind how the work will appear as a whole when viewed from a distance, and the style should be suitably broad and monumental.

A typical modern approach might be to block in each area of colour with a thin, transparent wash. Allow this to sink in, and while it is being absorbed by the plaster, take up a darker colour on a fairly small brush and redefine the main outlines. Next add the highlights using colours mixed with lime white, and to complete the sequence, place heavier accents in strong colour. Earlier techniques would have begun with a thin, dark wash used to draw and shade the subject matter. Colour would then have been applied to the design and modelling thus planned, starting with the shadow tints and moving systematically through a three-tone system towards the lights. Most of the colours would have contained white and some areas of the painting would have been underpainted. The lower layers would remain visible through gaps in the superimposed paint created by hatching and cross-hatching. The technique was in fact very similar to tempera painting, and it is clear that the two methods were once very closely related.

Fresco secco

Fresco secco is not true, or *buon fresco*; it involves painting onto a dry wall using paint that is similar in appearance to fresco, in that it produces light colour tones with a matt or semi-matt finish. Water-based materials are generally used, such as size colour, egg tempera or paints bound with casein, as well as emulsions of these materials made with drying oils. Acrylic paints and lean oil colours could also be classed as *fresco secco* materials. Temperas and tempera emulsions should be used on bare plaster, but plaster should be sized before applying oil colour.

Fresco secco is frequently used to retouch genuine frescoes, which are seldom completed without some minor error, and it can be deliberately applied over true fresco in a two-layered structure, in order to introduce greater detail and sophistication. It can, of course, be used for its own sake, too, and an entire mural can be executed using *secco* materials. It is obviously more convenient, since it does not involve plastering, and it will be reasonably durable given favourable conditions. Certainly, for decorative works, *fresco secco* is perfectly adequate. Mural painting which is not true fresco is not necessarily *fresco secco*. Other techniques exist, such as marouflage, and *fresco secco* assumes an untreated wall, which is often not the case with modern murals.

Silica painting

Silica painting is a modern mural technique which should in theory be durable on external walls for up to 100 years. The latest generation of materials are called organo-silicates. These can be used on most types of wall, including concrete, and are said to be capable of a broad range of effects, from glazes to impasto. If anything, silica painting is even more complex than fresco. The pigments employed must withstand both acid and alkali, and a carefully prepared mortar foundation is recommended to prime the wall. The binders involved require complex preparation and have a short working time; they also require powerful solvents if they are thinned. However, ready-made silica paints, which are widely available as decorators' products, are easier to use and may be thinned with distilled water. They are particularly recommended for use on concrete, but are not suitable for painting directly onto brick or stone. When they are used for external murals a fixative should be applied to improve their weather-resistant properties.

Painting on glass

Apart from stained glass, there are two ways of painting on glass. The first imitates stained glass by applying a thin covering of transparent oil-colour glazes. It is very similar to painting in watercolour, and white should on no account be employed in any of the colours. In the second technique, which is somewhat eccentric, but highly effective, the

glass acts as a varnish, with the paint being applied to its back in reverse order: the painting begins with the last layer of colour, containing detail and final accents, and works systematically backwards towards the flat foundation colours. Meticulous planning is necessary, and preliminary studies can help by determining the position of brushstrokes and colours in advance. The easiest way of painting in this manner is to lay the glass over a sketch that is executed only in flat colour, and to begin setting down glazes, so that the two layers seen together appear like a finished painting. Note that the sketch must show the finished painting in reverse to obtain the image you desire. When the glazes are dry, repeat the flat colours of the sketch over the glass. When the glass is turned over the glazed details will assume their proper place in front of the foundation colours because of the order in which they were painted.

The most effective material for these techniques is oil paint diluted with a rich glazing medium. Before you begin painting, wipe the glass down with alcohol to remove any traces of dirt or grease. It is usually best to lay the glass on a sheet of white paper, on which there may, of course, be a drawing to guide the hand.

Painting on ivory

Ivory is now scarce, but it makes an excellent support for miniature painting (p. 57). The ivory acts both as a ground and as a support, the proper method being to seal it with a thin coating of gum arabic and glycerine in order to provide a receptive surface for the watercolour and to improve its handling qualities. At the same time, it prevents the atmosphere from gaining access to the ivory, which tends to discolour and yellow easily. A drawing made in Indian ink on paper can be used to guide the brush, as at its proper thickness for painting, ivory is sufficiently translucent to allow the drawing to show through when the ivory is placed over it. The technique then employs straighforward watercolour methods adapted to the small scale and detailed work. At all times the paint is kept as thin as possible, so that the opalescent quality of the ground is not lost. Placing body colour and heavy watercolour over ivory is a complete waste of time, and the more delicate the colours and the more sensitive the painting, the better the result will be. Soft shadows and subtle colouring effects need not be painted directly. When the work is almost complete, the back of the ivory can be painted selectively in strong, heavy colour. When seen from the front, this will appear distanced and subdued because it is partially obscured by the ivory itself, resulting in a delicacy of tone which is impossible to achieve by any other method.

As the ivory is so thin, it is sometimes pasted onto card, just as vellum is in certain other forms of miniature painting (p. 112). This would obviously interfere with the use of an ink drawing and reverse underpainting described above, so if these techniques are employed, mounting should be left until the painting is complete. Paintings on ivory should be protected from extremes of temperature and should be framed or stored in a way that limits access by the atmosphere.

Painting in enamel

Painting in enamel actually involves painting with glass. The colour is applied as a paste or liquid and then fired in a kiln so that it fuses into a continuous layer. Metals – usually copper – or ceramics are employed as supports, as only these can withstand the high temperatures involved. The colours are bright and clear, and virtually everlasting, but the technique is extremely complex, as certain colours withstand firing unchanged, while others alter slightly and some even change completely. This means that the painter must deliberately employ the wrong colours in some instances in order to create the desired effect after firing. It is hardly surprising, therefore, that works in enamel are seldom attempted on a large scale, and painters who master the technique are few and far between. The method does, however, have the potential for use in a broader manner, perhaps even for abstract painting.

2.9 Finished paintings – Care and preservation

Varnishing

A picture varnish is a protective layer applied to paintings to preserve them from atmospheric pollutants; it may also improve a painting's appearance by giving its surface an even finish, and by giving the colours greater brilliance and depth. Varnishes are normally applied to oil paintings, and sometimes to acrylics and tempera; very occasionally, they may be used with works on paper, though it is better to frame such works beneath glass. Some painters also prefer to frame tempera and acrylic paintings under glass, and even oil paintings can be protected in this way.

Since varnish stands between a painting and the outside world, in the course of time it is itself attacked: it will accumulate dirt, may crack and splinter, and eventually discolour or lose its clarity. Ideally, therefore, a varnish should be removable, so that it can periodically be replaced to refresh the appearance of the painting. The most suitable varnishes are solutions of natural or synthetic resins in spirit, as these dry by evaporation alone, and the process is easily reversed using their original solvent. (Note, however, that the solubility of these resins tends to decrease progressively as they age.) Water-based materials are very rarely used as varnishes, but occasionally they are applied as an intermediate varnish that sits between a lean paint layer and the final varnish to prevent excessive penetration of the paint by the varnish, thereby avoiding pronounced colour changes.

The basic choice available to painters is between a gloss or a matt finish. (Semi-matt finishes can also be made from a mixture of both types of varnish.) The finish is generally a matter of personal choice, though there are certain technical considerations. A thin, temporary varnish should always be applied to paintings which are comparatively new, and ideally, even when a painting has matured, its first varnish should be applied thinly; a second layer can be added at an even later date. Ease of application is a consideration in some circumstances, as, for example, where a painting has a heavily textured surface. A thick varnish, especially a wax varnish, would collect on parts of the painting and would not give a thin, even covering.

The colour of the varnish should also be taken into account. Synthetic varnishes are generally crystal clear, and damar solutions, if not too rich, are nearly colourless when applied thinly. Mastic, on the other hand, has a pronounced yellow colour and a mellowing effect that may or may not be appropriate. Amber-coloured varnishes, usually based on copal, are undesirable as they are not reversible. They are sometimes valued for their colouring, but if you require a varnish with a warm, neutral tone, it is better to tint an ordinary spirit varnish with a tiny trace of paint.

Ideally, a varnish should be compatible with the painting it covers, but sufficiently different from it to avoid complications during cleaning. As a rule, painting media should not be used as varnishes, except where dilute medium is used as a retouching varnish, or where painting and binding media are used as intermediate varnish layers. Gelatine, for example, may be used as an intermediate varnish over tempera, and acrylic medium may be applied to acrylic paintings to enrich their surface before a final spirit varnish is applied. Acrylic medium should never be used as a final varnish in its own right, however, as it will encourage the surface of the painting to become soiled, and the painting will be at considerable risk if any attempt is made to remove it. Gum arabic, gelatine and gum tragacanth may be used selectively on watercolour paintings to increase the depth of shadows and to enrich colours, but they are not varnishes in the conventional sense, and are never applied flatly as an overall covering. Preparations of gum arabic, egg white and animal glue may be used as varnishes in order to imitate the effect of craquelure.

When to apply

It is essential that paintings are thoroughly dry and have reached a stable state before they are varnished. Unfortunately, while they are young, oils and resin oils are susceptible to the solvents used in spirit varnishes, and as they also take a very long time to dry thoroughly, they may be damaged if a varnish layer interferes with the drying process. An ordinary oil painting becomes reasonably stable after about six months, and may at that point be given a light, intermediate varnish. This will not prevent further drying and is most unlikely to disturb the paint. A final, thicker varnish should not be applied until the painting is at least a year old, otherwise there is a danger of cracking.

Where mastic or damar is used in the paint there is an increased risk of damage from solvents, and the oil content of the picture must be thoroughly matured in order to build up a satisfactory degree of resistance. At least a year, and preferably 18 months, should be allowed before such paintings are varnished. Fortunately, the surface quality of works in resin oil is usually of a high standard and there is no need to varnish merely to improve the visual effect of the painting during the early stages of its life. This is also true of paintings that employ fat oil media, which will also benefit from a long delay between completion of the painting and the first varnishing. Eventually, all paintings in oils or associated media should be varnished or placed under glass as a general protection.

Works in egg tempera or in tempera emulsions containing oil should not be varnished immediately, as although they appear dry, they take about a year to mature fully. Varnishing soon after they have been completed will not actually cause physical damage, in the way that it might to an oil painting, but there are positive benefits to be gained from waiting. The first is increased permanence, because the thorough drying of the paint film is not interfered with. The second is the preservation of the painting's intended visual effect: if a tempera painting is varnished when new, the varnish penetrates deep into the paint layer, increasing the saturation of the colours; their light, airy quality is lost, and there may be a shift in the tonal relationships which distorts the painting's appearance. Leaving tempera paint for about a year renders it much less absorbent, so that the varnish penetrates less deeply and there is a less noticeable change in colouring.

Acrylics take only a matter of hours to reach a stable state, and as their resin content is not susceptible to solvents, after one or two days they will be ready for varnishing. Like tempera, acrylic undergoes colour changes when varnished, but maturing the paint by delaying varnishing will not improve on this. In fact, as acrylics are inclined to pick up dirt, the sooner they are varnished, the better.

Varnishing
1. *Avoid obvious sources of fibres or dust. Do not wear wool and tie back long hair.*

2. *Warm the varnish, the painting and any other equipment to remove all traces of moisture.*

3. *Test the strength of the varnish on some dry colour, on an old palette, for example.*

4. *Brush the varnish out thinly and work back towards varnished areas when the brush is re-charged to avoid thick patches.*

5. *Remove excess varnish from the edge of the painting by drawing the brush along it.*

6. *If you prefer a low-gloss finish, drag a clean brush over the varnish before it dries.*

7. *Once the initial wetness has passed off, hang the painting at a slight tilt or prop it face to the wall to dry.*

Works in gouache and watercolour are seldom varnished, but when they are, it is best to allow at least a day before varnishing, so that no trace of moisture remains.

How to apply

Varnishing should be taken seriously if it is to be successful. To begin with, the room in which the varnish is applied should be free from dust, and any draughts which might cause dust to circulate should be prevented as far as possible. To prevent impurities from sticking to the varnish layer, cover any clothing which is likely to lose fibres with overalls or a smock. The work area should be cleaned before varnishing, and it is advisable to put down protective sheeting in case of accidental spillage.

To reduce the risk of blooming, both the painting and the varnish should be warm: it is generally sufficient to stand both in a warm room for an hour or two. Varnishing should take place at, or slightly above, normal room temperature – that is, 60°F or 20°C approximately. The painting itself should, of course, be dusted before varnishing, and any dust around areas of impasto or surface texture should be completely removed using a clean dry brush. To allow the varnish to flow without running, it is usual to lay the painting flat, though this is not always desirable where there are extremely deep brushmarks or textural effects in the paint surface. The following account describes the use of liquid spirit varnishes. The procedure for other types of varnish is similar, but may require slight modifications.

When you are ready to begin, check the consistency of your varnish by testing it on a suitable surface, such as the edge of the painting or some dry colours on a palette, to see how it lies. Do not be afraid to thin it if it looks too thick, and if it drags on the brush, it should certainly be diluted further. It is essential to use a brush of an adequate size, as the object is to lay a thin, even film without ridges, drips or brushmarks, and this can only be achieved if the varnish is put on quickly and brushed out thinly. A 2″ (5cm) varnish brush at the very least is usually required, even for very small paintings. White bristle brushes are best, though black-bristled decorators' brushes are cheaper.

Apply the varnish from the top to the bottom of the painting, or from a top corner outwards, to avoid reaching over areas of wet varnish; there is then no risk that it will be accidentally touched, and dust and fabric fibres are much less likely to fall onto it. Work quickly, spreading the varnish before the brush, and as the brush runs dry, draw more varnish from the area already laid, rather than recharging it, to ensure a thin covering. Only reload the brush with varnish when it is completely exhausted, and begin a little in front of the varnish line, brushing back to meet it, to encourage a thin and even distribution. Use the tip of the brush to work the varnish well into any texture on the surface of the painting, but avoid doing this with a well-loaded brush, as it will cause varnish to collect in the recesses of the surface. If needs be, wring out the brush and rework these areas to brush out excess varnish.

Once the whole surface has been covered, quickly wring out the brush and use it to take away any drips of varnish from around the edges, or to rebrush any areas where the varnish appears too thick or uneven. Note, however, that a final varnish very quickly becomes tacky, and further working will destroy the smoothness of the surface. A slight drag on the brush as it is drawn along indicates that the varnish is about to turn tacky, and once it has reached this point, you should not rework it.

Most gloss varnishes lose a little of their brilliance soon after they have dried, but even so, some painters dislike their harsh, glassy effect and prefer a more subdued gloss. This can be achieved by dragging the very tips of the hairs of a clean varnish brush across the wet surface of the varnish, first one way and then another, until it begins to pull. As the varnish turns tacky it loses its capacity to flow and retains any disturbance of its surface caused by the brush. When dry, its gloss will be slightly lower than normal, because its surface is not quite smooth.

When you are satisfied that the varnish layer is complete, leave the painting where it is and withdraw from the room until it has had time to dry. Avoid handling paintings with wet varnish, and if they have to be put somewhere else to dry, place them in a near vertical position to reduce the chance of dust falling on them. If a temporary cord is attached to the back of a painting, it may be hung from a wall with a forward tilt, so that the wet varnish is protected from dust. Paintings with wet varnish must not be stacked face-inwards against a wall, as the varnish will stick at the edge; but varnished paintings which are touch-dry may be stored in this way whilst drying is completed.

Finally, remember that the solvents used in varnishes can be unpleasant and even harmful if they are inhaled too deeply and for too long. Working in a sealed room may be good for the painting, but it could be bad for your health, and you should avoid staying in the room for too long. If several paintings are being varnished at once, it is advisable to take a short break between each one, in a fresher atmosphere. On no account should you smoke, or allow any naked flame or source of ignition, which might set off the solvent fumes.

Care and preservation

Whether or not they consider themselves great artists, most painters would like to feel that their efforts have not been in vain, and that their work will survive to be appreciated over as long a period of time as possible. Although even the most meticulously executed paintings must contend with outside influences – neglect, accidental damage, or just old age – there is much that a painter can do, by way of skilful selection of materials and careful technique, to increase the durability of his or her creations.

Paintings should always be treated as objects of value and as living things, which, like human beings, can only survive comfortably in certain conditions; they dislike intense cold and extreme heat, and are unhappy in damp or excessively dry conditions. Most of all, they do not like abrupt fluctuations in temperature and humidity, as this causes sudden physical changes which over a period of time fatigue both the paint and its support, resulting in damage. Although paintings cannot be allowed to dictate the conditions of life, as they might in the controlled atmosphere of a gallery, they should be accommodated thoughtfully within them. For example, avoid hanging paintings near sources of heat (e.g., over a radiator or in strong daylight) or on external walls that are at all cold or damp. To allow air to circulate around them, hang paintings with a slight forward tilt; this has the added advantage of keeping dust off the surface. Paintings should not be hung or stored near water pipes, leaky roofs and suspect guttering. Finally, where paintings are kept in a centrally heated room, plants should be introduced to encourage a more natural level of humidity.

Paintings on panels

Panels of natural wood react strongly to their surroundings. Too warm and too dry an atmosphere is likely to cause shrinkage, which in the case of solid wood supports may result in cracking along the grain, or in the separation of joints. Panels of processed wood are also affected by dryness, and will shrink as they lose moisture; this may lead to some minor distortion, but the solidity of their sheet structure and the even distribution of strength prevent serious mishaps. Moisture, too, is often responsible for warping, as it causes unequal expansion in each side of a piece of wood. Such behaviour can be prevented simply by ensuring that both sides of a panel are prepared in the same way (*see* p. 59). A coating of paint or varnish on all exposed areas of wood will also discourage woodworm.

Panels must never be fixed permanently into frames which fit exactly, as this does not allow for expansion in either the panel or the frame, and if one resists the movement of the other, quite

Protecting a canvas
1. For a double canvas, stretch a layer of cloth with thumb tacks. Size and prime it, and let it dry.

2. Remove the thumb tacks and turn the canvas over on its stretcher. Now fix it permanently with proper tacks.

3. Stretch a second canvas over the top of the first; size and prime that surface for use.

4. Alternatively, the back of a canvas can be protected by enclosing the frame with a lightweight backing board.

serious damage can result. Frames around panels should therefore always allow a small gap for movement. This is more important, the bigger and more solid the panel is, as lightweight panels can distort, if necessary, to take up stresses and strains, while solid panels cannot. Gaps may be plugged to prevent panels from being too loose in their frames using materials which will not resist movement, such as foam rubber, cork or small rolls of card. Large paintings on fairly thin sheets of processed wood will undergo continuous minor distortions throughout their lives, even when they are fixed to a framework of battens or mounted in strong, rigid frames. Such movement should be accepted, as attempts to correct or prevent it are more likely to cause damage than the movement itself. A small amount of warping or buckling is barely noticeable, and the chances are it will correct itself in its own good time.

In the longer term, paintings on panels may develop a slight craquelure effect because of movement in the support. On a well-prepared panel, however, this will be hardly visible. Noticeable surface cracks are most likely to occur where the underlying panel has a pronounced grain, though this can be prevented by applying cloth to the panel when it is prepared.

Paintings on canvas

Like panels, canvases constantly expand and contract in response to heat and moisture, though in the case of canvas, this movement is potentially far more damaging. The stresses and strains caused by the ever-changing tension of the canvas cannot be accommodated by brittle paints, such as tempera, which explains why only oils and, more recently, acrylic paints, have proved lasting on canvas. Even oil colour, though, loses flexibility as it ages, and may crack and flake away as it becomes unable to respond to movement. Canvas may also be distorted by the slow and uneven contraction of thickly applied paint as it dries. The painting and the ground on the front surface of a canvas protect and stabilize it to some extent, but its reverse side remains vulnerable. Moisture and bacteria can enter and may attack the size layer and the ground; the canvas may simply rot away, weakening the support and increasing the likelihood of accidental damage. Canvases are in any event easily damaged during handling, and even a finger pressing into the surface can cause quite severe distortion. Sharp objects, like the corners of frames, can puncture canvases easily, and the older and weaker the canvas, the more likely it is that such occurrences will cause major damage.

These risks may be reduced by sealing the back of the canvas to protect it from outside influences. A layer of size and ground applied to the back of a canvas, as well as to the front, is one way in which this can be achieved, but it is not recommended as, by preventing access to the canvas, it may make future conservation more difficult. A better policy is to employ a double canvas; here, two canvases are mounted on the same stretcher, one on top of the other. The first layer of canvas is exposed at the back of the stretcher, and protects the back of the canvas on which the painting is actually carried out. It is best to use a sized, primed canvas mounted on the stretcher with its prepared surface facing backwards. If the priming on the back canvas is at all absorbent, it should be protected by an additional layer of paint, so that moisture cannot penetrate. When the front canvas is placed over it, the vulnerable backs of both pieces are isolated completely within a sandwich of impervious coatings. Canvases prepared in this manner have a much better life expectancy, and the extra cost and effort involved in preparing them are well worth while. A canvas reinforced in this way is also better able to withstand pressure and impact, and double canvases are especially advisable where lightweight cloth is used on a large scale, as they increase the strength and stability of the support.

An alternative is to cover the back of the stretcher with a sheet of a lightweight material, such as card, thin plywood or hardboard (Masonite). Another suitable material, likely to find

favour because of its low weight is polystyrene foam. This is now supplied in sheet form, sandwiched between thin layers of card, and is available in different thicknesses. If the stretcher is deep enough, the protective backing may be mounted within it, rather than over it, as this is neater and can be done so as to allow access to the wedges without removing the backing. Very occasionally, stretcher pieces are actually machined to hold protective backing panels within their framework. Such a stretcher, together with its panels, is known as a blind stretcher; these give excellent protection, but are expensive. As a temporary protection against dirt and damp, the back of the canvas may be covered with a sheet of sturdy paper attached to the stretcher with masking tape.

Like panels, canvases should not be fixed too firmly into their frames, as the stretchers are made of wood, and some small allowance must therefore be made for movement. Stretchers should never be nailed directly to the frame, and canvases should be held in place with clips, wedges or tangs that will not restrict the painting's movement. When canvases are mounted in deep enough frames it is, of course, possible to back the entire frame with a protective sheet, rather than applying a protective backing to the canvas stretcher.

If accidental pressure on a canvas causes a bump, it can be removed by lightly rubbing over the area on the back of the canvas with a wet finger. If this is not sufficient, more moisture may be dabbed onto the canvas with a sponge, but take great care to avoid making the canvas thoroughly wet. Distortions can sometimes be remedied by passing a cool iron over the back of the canvas. Where pressure on the canvas has actually caused the paint to crack, ironing from the back may help to reduce the apparent damage. Small tears and punctures may be patched from the back using canvas of the same type. The piece should be larger than the tear by at least 2" (5cm) all round, and should be frayed around its edge to disguise its presence. The traditional adhesive is beeswax, or beeswax and damar, and the patch is applied using an iron just hot enough to melt the wax. Modern alternatives to this glue are now available, but on no account use glues which are not of conservation quality. When any of these operations is carried out the canvas should be placed face down on a flat surface, supported from underneath with a blanket covered with a piece of strong paper (preferably brown craft paper or a silicone release paper). Never attempt to repair damaged canvases unless you are completely sure of what you are doing, and where works of value are concerned, it is best to refer the damage to a professional conservator.

If canvases become slack, do not automatically tighten the wedges. As in the case of large flimsy panels, minor distortions in stretched canvases are likely to correct themselves. If wedges do have to be tightened, do not drive them in any more than is necessary, otherwise you may crack the paint; cheap, commercially prepared canvases may even be ripped by overtightening. Paintings on canvas should never be removed from their stretchers for a prolonged period, as the cloth may relax, and will then be difficult to restretch. On no account allow canvas off its stretcher to become wet, as the unrestrained shrinkage of the cloth will seriously damage the painted surface. If canvases are removed from their stretchers and rolled for transportation, they should always be rolled with the painting on the outside, as there is then less risk of cracking and of paint loss.

Works on paper

Apart from being fragile, good paper is fairly durable. Its main enemies are dirt, damp and migrating acid from inadequate framing materials, or from poor paper with which it is stored. Whenever possible paper should be handled only at its edges, so that it is touched to the minimum. If paper must be handled repeatedly for any reason, it is advisable to wear cotton or lightweight disposable gloves. Tears may be repaired with thin, acid-free tissue paper applied as a patch using a suitable

Repairing canvas

1. *Canvases are easily dented during storage and handling, but bulges can be removed by shrinking the cloth.*

2. *Moisten the back of the canvas where the dent occurs with wet fingers. The canvas will usually dry flat.*

3. *Repair tears with a patch of canvas held in place by a mixture of beeswax and damar softened with picture varnish.*

4. *Fray the edge of the patch and coat it with the wax-resin glue. Iron it into place on the back of the canvas.*

conservation glue. (Arrowroot starch is perhaps the most readily available substance, but other specialized products are available from some suppliers.) Holes and lost pieces may be repaired by a combination of tissue patching and filling in, using new pieces of identical paper. Once again, it must be stressed that whilst such repairs are not beyond the majority of painters, they should be left to professional conservators where the quality of the work and the extent of the damage make it advisable.

Surface dirt can be removed from paper by brushing with a large, soft-haired brush, and ingrained dirt may be removed to some extent by dabbing with a kneadable eraser, sometimes known as a putty eraser.

Foxing, or fox marks, are small, red-brown dots which are encouraged by damp and poor framing. They spread if they are not attended to, eventually obliterating and destroying the entire work. Foxing can be arrested, and the marks removed by bleaching, but this is really a job for a trained conservator. It is better to prevent foxing in the first place, by keeping works on paper well away from damp and by ensuring that they are suitably stored and framed using acid-free materials.

Paper is at considerable risk in a normal artists' portfolio, as these are seldom made of acid-free materials, and over a period of time, they can 'attack' their contents. A sketch on poor quality paper may also be responsible for damage to good paper, if it is stacked among other works and left in contact with them for a period of time. Card separators can be responsible for similar damage. The solution is to store paper in boxes of acid-free card, or to line portfolios and storage units with acid-free tissue, unless they are known to be of conservation quality. Acid-free tissue is recommended as a cheap material, but separators and protective wrappings of any good quality, acid-free artists' paper will perform as well.

In framing, it is the window mount (or mat) and backing board which are the potential threat. To preserve the work, they must be of conservation or museum quality; this means that they are acid-free and, in the case of the best museum boards, are made of 100 per cent cotton rag. In addition, they may be buffered with chalk to neutralize any acid that gains access from the atmosphere or which is produced by slow degeneration of the framing materials. Adhesives should only be used with paper if they are acid-free and reversible. Repairs should never be made with adhesive tape, nor should paintings on paper be attached to mounts using materials of this kind. Starch pastes, gelatine and gum arabic make acceptable paper glues, so long as they are carefully prepared, and new types of conservation glue are now coming onto the market.

Paintings in oil on paper and heavily painted works in acrylics will benefit in the long term from being mounted onto a stretched canvas or firm panel. All large works on paper will, in any event, gain stability and strength from being mounted on canvas. (*See Pastel painting, p. 168*)

Framing

A frame can make or break the visual impact of a painting. Always bear in mind that a frame represents the junction between the work of art and the environment in which it hangs, and it must create either a clear visual barrier or an area of harmony, in order to bring the two together. This is one reason why gold has traditionally been used on picture frames; its brilliance is striking, yet at the same time, it has the capacity to reflect surrounding colours and tones, so that, in theory, a gilt frame will fit into any location. Modern framing suppliers now offer an extraordinary range of mouldings, some of which are clearly linked to fashions in interior design. Their potential is excellent, but the process of matching mouldings and mounts, and selecting the right frame for specific works is an art in itself.

It is possible to offer several practical hints on framing as a starting point. Always ensure that the frame is deep enough to enclose the painting properly. The frame should carry the painting, not vice versa, and the cord from which it hangs should be attached to the frame, not to the back of a panel or to the stretcher pieces of a canvas. Ideally, the cord should be placed just above centre, so that the framed painting hangs with a slight forward tilt. This allows air to circulate around the back of the painting, and helps to keep dust off the picture itself. Where frames are glazed, paintings should always be separated from the inside of the glass by a beading or mount. (Framers may refer to the special beading used for this purpose as a slip.) Seal the glass to the frame with gummed tape on the inside, out of sight, to prevent access by small insects, and close the back with tape pasted over the frame and the backing board; this will also protect it from the atmosphere. Applying tape to all the internal surfaces of a frame, especially where it is a large and deep one, also prevents small particles of dirt, splinters of wood and similar debris from falling into the frame as the picture is inserted. Wherever possible, fittings of iron or steel should be avoided, as they are likely to corrode – brass is to be preferred. Metal fittings should not be used near, or in contact with works on paper, otherwise serious staining can occur.

Typically, conservation framing is carried out as follows. Firstly, the inside of the glass is sealed with fabric tape pasted with acid-free glue. The painting should be held in a hinged mount which fully encloses it. This has a window mount, or mat, at the front, and is taped along one edge to the backing board on which the painting is actually mounted. Both pieces shoud be made of acid-free card. The tape is once again a fabric tape pasted with acid-free glue, and the painting is held to the backing board using tiny hinges of acid-free tissue or some similar paper, also pasted with a neutral adhesive. Once the painting and its mounting unit have been inserted into the frame, a further layer of backing board can be added, and the frame sealed at the back using more fabric tape. One of the benefits of using a fully enclosed mount is that the painting may be removed from its frame and stored in safety or inspected without being touched. If several works are fitted to mounts of the same size, the contents of a frame may be easily changed for exhibition purposes, thereby avoiding the cost of a large number of frames. If, for any reason, works on paper are framed using materials of an inferior quality, sheets of good watercolour paper should be placed between them and the framing materials, so that there is some protection against acid migration. Once again, the advice of a professional conservator is recommended if you are at all in doubt about which methods of framing are best suited to particular works. The field of conservation framing and the understanding of how paintings can be preserved against various forms of deterioration is constantly expanding, and new, improved methods may well become available in the near future.

One final comment concerns undesirable optical effects. Sight lines within a picture may interact with the lines of the frame to create an optical illusion. Occasionally this is due to the choice of frame, or to some peculiarity within the work, but more often it is a simple matter of proportion. Too narrow a mount, coupled with a thin moulding on a fairly large frame, may give the frame a bowed appearance. The most common error, however, is to place the window in the mount at the exact centre of the frame. Commercial framers often do this as it saves time, but visually it can be most off-putting. By a trick of sight, in a square or oblong frame, a centrally placed window always looks lower than it actually is. To compensate for this, the bottom of the mount should be slightly deeper than the top and sides. Various theories exist on the precise proportions, but in general a 20–25 per cent increase in depth at the base of the mount is sufficient to correct the illusion.

Guide to further information

Publications tracing the historical development of painting techniques and materials from the classical world to the present day, including primary sources.

Greek and Roman Methods of Painting, A.P. Laurie, Cambridge (1910)
De Diversis Artibus (12th century), Theophilus: trans. as *The Various Arts*, C.R. Dodwell, London (1961)
The Materials of Medieval Painting, D.V. Thompson, New York (1936)
Il Libro dell'arte (c.1390), Cennino Cennini: trans. as *The Craftsman's Handbook*, D.V. Thompson, New York (1932)
Della Pittura (1436), Leon Battista Alberti: trans. as *On Painting*, J.R. Spencer, Newhaven (1956; revised ed. 1966)
The notebooks of Leonardo da Vinci, selected and ed. I.A. Richter, Oxford (1980)
The Lives of the Artists (1550, 1568), Giorgio Vasari: trans. G. Bull, Harmondsworth (1965; revised ed. 1971)
Vasari on Technique, trans. L.S. Maclehose, New York (1907; revised ed. 1960)
The Letters of Peter Paul Rubens, trans. and ed. R. Saunders Magurn, Cambridge, Mass. (1971)
A treatise concerning the arte of limning (c.1600), Nicholas Hilliard: ed. R.K.R. Thornton and T.G.S. Cain, Manchester (1981)
Artists' pigments c.1600–1835, R.D. Harley, London (1970; 2nd ed. 1982)
A study of Richard Symonds: his Italian notebooks and their relevance to 17th-century painting techniques, Mary Beal, New York and London (1984)
Polygraphice: the use of the Pen and Pencil or, the most excellent Art of Painting, 2 vols., W. Sanderson, London (1658)
The Excellency of the Pen and Pencil, exemplifying the uses of them in the most exquisite and mysterious arts of drawing, etching, engraving, limning, painting in oyl, washing of maps and pictures, anon., London (1688)
Portrait-painting in England: Studies in the technical literature before 1700, M. Kirby Talley, London (1981)
Artists' techniques in Golden Age Spain, ed. and trans. Z. Veliz, Cambridge (1987)
The Notebooks of George Vertue (1700–50): 6 vols., London (1929–52); *Anecdotes of Painting in England*, 4 vols., Horace Walpole (from the Vertue Notebooks), London (1763–71)
The Art of Drawing and Painting in Watercolours, anon., London (1732)
The Artists' Assistant, anon., London (1738)
The Practice of Painting and Perspective made Easy, Thomas Bardwell, London (1756)
Life of Sir Joshua Reynolds, J. Northcote, London (1813)
Reynolds, ed. N. Penny, London (1986)
Thomas Gainsborough, J. Hayes, London (1980)
Encaustic, or Count Caylus's Method of Painting in the Manner of the Ancients, J.H. Müntz, London (1760)
The Complete Drawing Master, anon., London (1763)
Elements of Painting with Crayons, John Russell, London (1772)
The diary of Joseph Farington: first pub. 1922–28; vols. 1–6, ed. K. Garlick and A. Macintyre, Newhaven (1978); vols. 7–12, ed. K. Cave, Newhaven (1983)
Collected correspondence of J.M.W. Turner, ed. J. Gage, Oxford (1980)
The Works of the Late Edward Dayes, ed. E.W. Brayley, London (1805)
Anecdotes of painters, E. Edwards, London (1808)
The Art of Painting Portraits, Landscapes, Animals, Draperies, Satins &c. in Oil Colours, J. Cawse, London (1840)
A Treatise on Fresco, Encaustic and Tempera Painting, E. Latilla, London (1842)
Methods and Materials of Painting of the Great Schools and Masters, 2 vols., Sir Charles Lock Eastlake, London (1847); New York (1960)
Treatises dating from the XIIth to XVIIIth centuries on the Arts of Painting, 2 vols., Mrs Mary P. Merrifield, London (1849)
Ancient and Modern Colours, from the earliest periods to the present time, W. Linton, London (1852)
A Memoir of Thomas Uwins, RA, Mrs S. Uwins, London (1858)
Workshop Receipts, 4 vols., Ernest Spon, London (1873–92); new and revised ed. in 5 vols., London (1909–30)
William Morris Hunt on painting and drawing, London (1896–98); New York (1976)
The Painting Methods of the Impressionists, B. Dunstan, New York (1976; revised ed. 1983)
The Letters of Vincent van Gogh, ed. M. Roskill, London (1963; revised ed. 1983)
The Science of Colours and the Art of the Painter, M. Boigey: trans. J.B. Hewitt, London (1925)
David Hockney by David Hockney, ed. N. Stangos, London (1976; revised ed. 1988)
Artists on Art: From the 14th to the 20th Century, ed. R. Goldwater and M. Treves, New York (1974)

Publications providing general information on artists' materials and techniques.

Ayres, J. *The Artist's Craft*, Oxford (1948)
Cole, R.V. *Perspective for Artists*, New York (1976)
Elskus, A. *The Art of Painting on Glass*, New York (1982)
Fabri, R. *An Artist's Guide to Composition*, New York (1986)
Gettens, R.J., and G.L. Stout *Painting Materials: A Short Encyclopaedia*, New York (1965)
Grafe, J. *Secreta: Three Methods of Laying Gold Leaf*, New York (1986)
Hackney, S. *Completing the picture: materials and techniques of twenty-six paintings in the Tate Gallery*, London (1982)
Hours, M. *Secrets of the Great Masters*, London (1964)
Hubbard, E.H. *Materia Pictoria. An Encyclopaedia of methods and materials in painting and the graphic arts*, London (1939)
Laurie, A.P. *The Painter's Methods and Materials*, New York (1926)
Maskall, K.A., and D.W. White *Vitreous enameling: A Guide to Modern Enameling Practice*, Oxford (1986)
Mayer, R. *A dictionary of art terms and techniques*, London (1969)

Murray, P. and L. *Dictionary of Art and Artists*, London (1959; revised ed, 1968)
Osborne, H. *The Oxford Companion to Art*, Oxford (1970)
Owen, P., and J. Sutcliffe *The Manual of Airbrushing*, London (1985)
Sassoon, R. *The Practical Guide to Calligraphy*, London (1982)
Schmid, F. *The Practice of Painting*, London (1948)
Thompson, D.V. *The Practice of Tempera Painting*, New York (1936)
Wolchonok, L. *Lessons in Pictorial Composition*, New York (1969)

Sources of information concerning modern conservation procedures.

Bomford, D., 'Conservation and Storage of Easel Paintings', in *The Manual of Curatorship*, ed. J. Thompson, London (1984)
Bromelle, N., and P. Smith (eds.) *Conservation and Restoration of Pictorial Art*, London (1976)
Colleran, K. *The Collector's Guide to Conservation* (Available from Bankside Gallery, London)
Fairbrass, S. *Conservation Framing of Prints, Drawings and Watercolours* (Available from Atlantis Paper Company Ltd., London)
National Gallery Technical Bulletin, London (1977–)
Studies in Conservation (International Institute for Conservation), London (1952–)

Sources of technical information relating to artists' materials.

An Introduction to Paint Technology, W.M. Morgans and J.R. Taylor (eds.), London (1976)
Artist Beware, M. McCann, New York (1979)
Formulas for Painters, R. Massey, New York (1967)
American Commercial Standard CS98–621
British Standard BS 2876: *Powder Pigments for Artists' Use*
Colour Index, 7 vols., The Society of Dyers and Colourists, Bradford, UK

In addition, the catalogues, brochures and technical literature issued by the manufacturers and suppliers of artists' materials, and the raw materials from which they are made, are often a valuable source of information.

Sources of the illustrations

The following abbreviations have been used: a, above; b, below; l, left; r, right.

Stedelijk Museum, Amsterdam 104; Collection Halvor N. Astrup, Oslo 71; Walters Art Gallery, Baltimore 102 a.; British Rail Pension Fund 131 a.; Bulloz 101; Detroit Institute of Arts 100 a.; National Gallery, Dublin 171; Board of Trinity College, Dublin 114 a.l.; Fischer Fine Art Ltd, London 119 b.; Uffizi Gallery, Florence 12; Musée d'Art et d'Histoire, Geneva 168; Giraudon 14; Merseyside County Art Galleries, Liverpool 147 b.; British Museum, London 11, 155 b., 158, 163 a.; Courtauld Institute Galleries, London 107, 139; National Gallery, London 53, 54, 100 b., 105, 106, 109 a., 123 a. and b., 127, 131 b.; National Portrait Gallery, London 13a., 16; Tate Gallery, London 17a., 57 a. and b., 94, 109 b., 147 a., 159 a., 166; Victoria and Albert Museum, London 114 a.r., 115 a., 134 a., 155 a., 159 b.r., 163 b.; Wellington Museum, Apsley House, London. (Courtesy of the Victoria and Albert Museum, London) 134 b.; Musée des Beaux-Arts, Lyons 102 b.; Whitworth Art Gallery, Manchester 167; Mas 13 b., 95; Alte Pinakothek, Munich 151; Metropolitan Museum of Art, New York 17 b., 177; Museum of Modern Art, New York 65; Louvre, Paris 14, 93, 101, 142; Private Collection 95; Scala 118; La Granja, Segovia 13 b.; Cappella Paolina, Vatican 181; Pinacoteca, Vatican 118.

Original photography by Nigel Watmough

Index